BK 709.4 B363B 1968
BAROQUE PRINCIPLES, STYLES, MODES, THEMES
 /BAZIN, GER
 1968 .00 FV

3000 186814 30010
St. Louis Community College

709.4 B363b 1968
BAZIN FV
THE BAROQUE

 27.50

JUNIOR COLLEGE DISTRICT
of St. Louis-St. Louis County
LIBRARY
7508 Forsyth Blvd.
St. Louis, Missouri 63105

THE BAROQUE

THE
PRINCIPLES

BAROQUE

STYLES MODES THEMES

GERMAIN BAZIN

CONSERVATEUR EN CHEF AU MUSÉE DU LOUVRE

NEW YORK GRAPHIC SOCIETY

GREENWICH, CONNECTICUT

TRANSLATION BY PAT WARDROPER

BLOCKS MADE BY KLISCHEEWERKSTÄTTEN
DER INDUSTRIEDIENST, WIESBADEN, GERMANY
PRINTED BY DUMONT PRESSE, COLOGNE, GERMANY
BOUND BY VAN RIJMENAM N.V., THE HAGUE, HOLLAND

LIBRARY OF CONGRESS CATALOGUE CARD NO. 68–25737

© 1968 THAMES AND HUDSON, LONDON
ALL RIGHTS RESERVED
PRINTED IN WESTERN GERMANY

Contents

INTRODUCTION

What a strange monster is man: a curiosity, a
prodigy, a chaos, a contradiction, judge of all things
and wretched earthworm, repository of truth and sewer
of doubt and error, glory and dross of the universe.

BLAISE PASCAL

M OST WORKS OF THIS KIND follow a set pattern; the author considers the artistic production of each country in turn, and within each country the 'descending' scale of the various arts—architecture, sculpture, painting, minor arts. I have nothing against this plan, having used it myself in a short historical study; but for the present book, which is a work of synthesis, it seemed to me more advisable to seek, in the vast mosaic which is European art in the seventeenth and eighteenth centuries, a principle which overrides nationality. The divisions within this book are based on style alone. I have preferred not to regard formal concepts such as classical and baroque as diametrically opposed. Our modern tendency to see these terms as absolutes would have surprised the men of seventeenth and eighteenth-century Europe, whose tastes were eclectic rather than exclusive. Indeed, the exploratory fervour with which they set out to exploit all the possibilities of form and image has not been matched by the men of any other period. The first and fourth parts of this book therefore set out to define the unifying principles which underlay both life and art in the seventeenth and eighteenth centuries, and the second and third parts examine the enormous variety of modes of expression employed by the artists of the period.

To distinguish between the different 'styles' which were those of the baroque age may be thought merely to substitute one mosaic for another; but this kind of analysis is, I think, necessary for an understanding of a civilization whose richness lies in its contradictions.

The age of baroque and rococo was the golden age of Western art. This was a time when life was impregnated with art; life itself was an art. The artistic creation of this period cannot be considered in isolation from its milieu; but this is not to say that we should follow Taine in his determinist view of the history of art; on the contrary, art was not so much conditioned by life as life by art.

The men of the age had within them many contrary impulses, whose expression in art goes far beyond the classical-baroque antithesis defined by Wölfflin. The source of these contradictions is to be found in the disruption of the unity of the civilized world which occurred at the time of the Renaissance.

Medieval man enjoyed that sense of continuity between the psyche, nature and the supernatural world which is characteristic of all primitive civilizations. The medieval Christian was at one with himself and with the world—a world in which every creature and every thing came from God, and returned to God. Sin, an apparent flaw in God's handiwork, was an integral part

of this harmony; it was the price of the liberty of man, created by God in his own image. In Creation was included Redemption. The hatred of heresy sprang from the instinct of self-preservation which led society to seek to maintain its unity at all costs. The split, when it came, did not come from heresy; it grew insidiously with the development of reason, which the theologians had tolerated only as the 'handmaiden of the faith', but which eventually turned aside to take Nature as its object—and created science.

That which separates is sin, and the Renaissance committed the second original sin. Though not openly in conflict with God, the human intelligence dissociated that which is God's from that which is Man's, offering human nature a path of its own, the path of knowledge. The Greeks had become conscious of a similar dichotomy between the divine and the human at the time of the Sophists. Socrates' 'Know thyself', revived by the Renaissance, launched the individual upon an adventure of self-discovery; and now that 'I know' was no longer a synonym of 'I believe', self-discovery went hand in hand with the discovery of the physical world. Of course 'modern man' was a believer—even a passionate believer—but he no longer believed so naturally, so instinctively, as the medieval Christian. The result was a conflict leading to what Freud would have called a neurosis—and to a tremendous fever of creativity. Now nothing could be achieved without a struggle; to know demanded the repression of belief, and to believe demanded the repression of knowledge. Believers even came to accept that faith was necessarily absurd: '*credo quia absurdum*'. Pascal was to say: 'Take holy water and be stupid'. This from a mathematician! Pascal's controversy with the Jesuits illustrates the deeper significance of this conflict. The Jesuits, the apostles of Christian humanism, endeavoured to recapture the lost unity of Christendom in a fusion of natural and divine law such as had been achieved in Thomas Aquinas' *Summa Theologiae*, inspired by the Aristotelian conception of the world as governed by harmony. But Pascal was torn by the agonizing problem of Grace, which in the seventeenth century renewed in Protestant and Catholic alike the inner conflicts of St Augustine; and like the saint, seventeenth-century man was torn between the Christian faith and the attractions of humanism.

In a penetrating study of Macchiavelli, Marcel de Corte sees the neo-Platonism which supplanted Aristotelianism as one of the sources of Macchiavellian pessimism. Neo-Platonism, which is purely intellectual, distinguishes between the world of ideas, which is governed by harmony, and a material world entirely without principles of order. The result is a kind of new Manichaeism in which the world of ideas represents absolute good and the material world ultimate evil. 'Macchiavelli, who observed Renaissance man with the acute vision of an entomologist, saw him as the victim of a tension between the disparate elements of his own nature' (Marcel de Corte).

Man could resolve this tension only by the acquisition and exercise of power; in order to affirm his identity, he was forced into the role of conqueror. Sixteenth-century man gave himself up to a pursuit of power which could find satisfaction only in unlimited aggrandisement. '*Plus oultre*' ('yet further') was the motto of Charles V, and Hercules the symbol of the monarch. This was the primitive age of power.

Then came the 'classical' age: power was no longer a tendency but a state, concentrated in one exceptional being who owed his excellence to the fact of belonging to an elect dynasty. Power was thus no longer something the prince had won; it was his by divine right. This man, in whom everything was more than human, held his power not by right of conquest but by virtue of a metaphysical political idea. 'The Nation is not the same thing as France,' wrote Louis XIV in his *Instruction* to his grandson the Duc de Bourgogne; 'it resides entirely in the person of the king.' Of this same king, Bossuet could write: 'All the State is in him, and the will of all the people resides in his will.' The *condottiere* in search of power, in that land of tyrants that was Macchiavelli's Italy, had given way to the king who possessed power in all its fullness. Louis XIV was able to replace the symbol of Hercules, the demigod chained to his endless tasks, by Olympian Apollo. Circumstances predestined the French monarchy to become the incarnation of the royal ideal. The rival dynasty, that of the Hapsburgs, suffered at once from its dependence on an outworn concept of empire and from the fact that it presided over the destinies of territories too shifting and too various to give it firm support. Louis XIV, undisputed possessor of a heritage gathered around the monarchy by the slow work of centuries— and to which he himself had contributed by the annexation of new provinces—could enjoy, within the kingdom of his fathers, an unequalled glory; he could justly proclaim it *'nec pluribus impar'*: 'equal to many [together]'.

The men of the seventeenth and eighteenth centuries withdrew from their inner conflicts by living on two planes at once, one real and one imaginary. Perhaps the most surprising feature of baroque art—in which everything is designed to astonish—is how men who in thought and deed created new worlds could indulge in childish games of make-believe. One might pretend to be Apollo, Rinaldo, the Grand Turk, or even Confucius, but never simply oneself: as if the art of living consisted in flight from the self. As we shall see, the idea was put forward that one might even disguise oneself as oneself . . . On reaching man's estate one put on a mask: the wig borrowed from the accessories of the ancient theatre, which set the wearer apart from the common herd. It was worn until the very end of the act—when it had perforce to be taken off to leave the way clear for the blade of the guillotine. Here history repeats itself: again there must be conquests and still more conquests, again the ruler must always press 'yet further' to satisfy his lust for power. Europe is trampled underfoot by the successor of the ruined monarchy, a hero whose disguise is his armour. Louis XIV in his own kingdom was able to think of himself as Louis the Great: Napoleon the conqueror could be content with nothing less than the final paroxysm of power, an empire, which like all empires was foredoomed to disintegrate.

The period encompassed by the sixteenth and the nineteenth centuries we call baroque; but the time between Louis XIV's maturity and the French Revolution could well be given the name of classical; it was an age in which many European monarchs were models of classical restraint. Once Europe had emerged from the terrible wars of the first half of the seventeenth century, a tacit *entente* reduced clashes of arms to limited conflicts in which all the combatants were really pursuing the same end, the preservation of the balance of power. Thus we see Louis XIV, by the Treaty of Utrecht, establishing his grandson on the throne of Spain, but renouncing

for him the throne of France; only one kingdom was needed to be a king. Louis XIV did not so much desire the crown of Spain for his own dynasty as wish to prevent what would have passed the bounds of moderation—that it should be united with the crown of Austria.

Louis XV, visiting the battlefield of Fontenoy with his son the Dauphin, later father of Louis XVI, made one of the noblest comments on the horrors of war ever made by a king. 'You see how much blood is the price of a triumph! The blood of our enemies is the blood of men; true glory consists in sparing it.'

So strong was the feeling that a balance was necessary for the health of Europe, that to the greatest minds the conqueror appeared as the enemy. Frederick the Great wrote an *Anti-Machiavel*; and Montesquieu showed himself to be a true Anti-Machiavel when he said: 'A prince believes he will be the greater by the ruin of a neighbouring State. On the contrary, the condition of Europe is such that all its States depend on one another. France needs the opulence of Poland and Muscovy, as Guienne needs Brittany and Brittany needs Anjou. Europe is one State made up of a number of provinces.'

Before the royal ideal, the image of a monarch solidly established within his realm, could gain acceptance, there had to be a weakening of imperial pretensions. Even Francis I of France, who in the true Renaissance spirit found conquests attractive without regard to their practical usefulness, allowed himself to be provoked by the pretensions of his rival Charles V into adopting this rather contradictory formula: 'The king of France is emperor in his own kingdom.' But it was left for the ensuing age to formulate the idea of kingship as the absolute possession of a limited territory.

To be a king, all that is needed is a kingdom; and some kings were content with the narrow confines of a stage. Under the treaties of Westphalia and the Pyrenees a host of petty German princes were deliberately set up and maintained in power by the French government because they afforded a safeguard against Hapsburg power without involving France in unprofitable annexations of territory. Each of these princelings needed no more land than was necessary to mount a repeat performance, with continual embellishments, of the inimitable pageant first staged at Versailles.

The chronic insecurity of powers in decline (Spain), complex powers (Austria), and miniature powers (the principalities of Germany and Italy) led their monarchs to seek compensation in dreams of power and transcendental glory, creating what the psychoanalysts call a substitute universe. This is the essence of the baroque.

In Rome, the Church abandoned the attitude of contrition which it had adopted during the Counter-Reformation, and invented a baroque formalism which expressed, in terms of triumphal pomp, a spiritual sovereignty which is an implicit renunciation of the temporal power dreamed of by the Renaissance popes.

In England, a new political system led to the subordination of the power of the king to that of the nation, and a new conception of power arose which was based on a combination of political, industrial and commercial strength. English art largely lacked the stimulus of royal patronage; but England steered a course between classical and baroque, true always to a dream

of classical antiquity which is really the same mirage of the South that so often haunts northern peoples.

For 'classical' and 'baroque' are not opposites. More reason enters into the composition of the one, more fantasy into the composition of the other; but both are facets of a lost world of make-believe. If we smile at the spectacle of grown men amusing themselves with fiddles and furbelows, perhaps we do so for fear of weeping at the state of our own real world. It is true that we can still enter the enchanted kingdom, but only by first finding the way back to our own lost innocence. Then, and only then, the baroque heavens will open for us.

ERRATA

TEXT

p. 78 *for* Galeazzo Alessi *read* Pellegrino Tibaldi
p. 104 *for* Giuliano da Sangallo *read* Antonio da Sangallo
p. 126 *for* Joseph Anton Feichtmayr *read* Joseph Anton Feuchtmayer
pp. 105, 317 *for* Mocchi *read* Mochi
p. 297 (fig. 17) *read* Antonio da Sangallo the younger (1483–1546). Palazzo Farnese, Rome
p. 325 *for* Ardmont *read* Admont

CAPTIONS

XXIII *for* porcelain *read* Dutch faience
pl. 39 *read* Louis XIV and other figures in the carrousel of 1662
pl. 58 *for* 1888 *read* begun 1893
pl. 73 *read* Pellegrino Tibaldi (1527–96). Santa Maria presso San Celso, Milan, after 1583
pl. 78 *read* Lorenzo Lomellini. Décor of nave, Santissima Annunziata, Genoa, begun 1591
pl. 301 *for* Desk *read* Chest of drawers
pl. 303 *for* Desk *read* Bureau de dame
pl. 372 *for* Mocchi *read* Mochi
pl. 392 *for* Ardmont *read* Admont

I PRINCIPLES

1 Definitions

The period of art which is the subject of this book extends from the decline of Roman mannerism to the rise of neoclassicism—a period of about two centuries, from 1580 to 1780. The title *The Baroque* in this context embraces the whole range of artistic expression which evolved within Western civilization in the course of these two centuries.

The dates that open and close the period are not the same for every country. Although mannerism had come to an end in Rome by the 1590s, it survived almost everywhere else (and even in certain parts of Italy) until the 1630s and later, in forms which thus come within the chronological scope of this book. In certain Latin American countries the baroque retained its religious significance until 1850 and even later, rather as the Gothic did long after its period of vitality. Baroque churches were still being built and decorated (for example São Francisco de Paula at Ouro Preto, Brazil) long after the neoclassical style had been adopted for secular architecture. To make things more difficult, it sometimes happens that within one country different arts are at different stages of development. In Roman churches in the early seventeenth century, mannerist interior décor was combined with purely baroque architecture until the two were harmonized by the genius of Bernini. The Pauline and Sistine Chapels in Santa Maria Maggiore in Rome are still entirely mannerist in feeling, at a time when Carlo Maderno was building churches in the baroque style; while Caravaggio's *Crucifixion of St Peter* and *Conversion of St Paul* in Santa Maria del Popolo are set in a second-rate mannerist interior which cramps their effect. In Flanders, the painting of Rubens gave Europe perhaps its most profound expression of baroque feeling at a time when both architecture and interior decoration remained unequivocally mannerist—architects having proved incapable of absorbing the new ideas except through the medium of a 'manner' which, being within their tradition, came more easily to them. Rubens, for his part, did not 'absorb' the baroque at all; he created it for himself.

During the period covered by this book European art manifested itself not only in Europe, including some of Russia, but also in all the overseas territories where colonies had been established—chiefly in the Americas, but also as far afield as Goa in India. These two centuries were the most productive in the history of European art. Each nation made its own contribution, and expressed its own particular genius, within a common heritage.

It is useless to try to reduce the art of the baroque age to a non-existent unity, or to a formal antithesis between the classical and the baroque; this was an age which produced an abundance of styles. In 1955 John Rupert Martin took the critical step of recognizing this fact; but the

period is richer and more complex even than he thought. It is in fact possible to distinguish at least seven distinct stylistic tendencies within the art of the baroque age:

two residual styles, *Gothic* and *mannerism;*
one style which is an elaboration of a renaissance concept, *classicism;*
three new styles, *realism,* the *baroque* and the *rococo;*
one anticipation, *neoclassicism.*

The age also contains five eternal 'modes' of the human imagination:

romanticism and *exoticism;*
the strange phenomenon of *regression* or involution, a tendency to return to the forms of medieval art, which is most marked in popular art and in European art outside Europe;
the fascination with natural forms which leads *Art Nouveau;*
and finally *academicism,* if a systematic sterilization of the creative impulse can be called a mode of the imagination at all, and the persistent motif of deception, *trompe-l'oeil.*

The task of distinguishing between these various tendencies is made no easier by the fact that they frequently interbred or appeared side by side in close proximity. It sometimes happens that their curves of development mirrored each other. The baroque age is the great crossroads of the history of art.

The clarification of the principles that govern the art of these two centuries was achieved in the course of almost three-quarters of a century of exegesis, always starting from a single term—the word 'baroque'. To understand the significance of this term we must give at least a brief account of the various stages of its interpretation.

In 1855 the Swiss historian Jakob Burckhardt, in his *Cicerone,* defined the principal distinguishing feature of Renaissance art as an ideal beauty, derived from the study of nature and the imitation of antique models, and inspired by the principles of Neo-Platonism. According to these principles, the value of a work of art is intrinsic and has no relation to spectator or creator; it represents the conquest of an eternal truth contained in the essence of things, and concealed by the illusion of appearances. After the perfection achieved by the Renaissance there followed, according to Burckhardt, a 'wild' and 'barbarous' art known as 'baroque', the degenerate bastard of the Renaissance.

The word *baroque* appeared in current speech in France at the end of the sixteenth century, to designate something unusual, bizarre, even badly made. Montaigne uses it in this sense in his *Essais.* It is still used by jewellers to describe those irregular pearls known in Spanish as *berrueco* or *barrueco,* in Italian as *scaramazza,* and in Portugese as *barroco;* in the mannerist and baroque periods these odd shapes were used (mainly in Germany) in precious settings to form figures of sirens, centaurs and other fabulous creatures. Perhaps this technical use of the word 'baroque' was the origin of its use as a term of art criticism.

It has also been suggested (by the philosopher Benedetto Croce) that the word comes from *baroco,* the name given by scholastic philosophers to a type of syllogism. The objection is that this does not convey the idea of irregularity, which seems in fact to be the basic one. To this day

15

the dealers who buy up empty bottles from Paris wine-cellars divide them into two categories, *normale* (litre bottles and claret bottles) and *baroque* (bottles of unusual shapes such as those used for burgundy, champagne and the numerous varieties of apéritif). Perhaps the Spanish word *berrueco* itself is derived from the latin *verruca*, which means a slight flaw. The word *barroco* is used in Portuguese to describe an excavation or a hilly or uneven piece of ground; it is said to be derived from the Arabic *barga*, and is a common place-name in Portugal and Brazil. Its similarity to the word 'baroque' seems however to be purely coincidental.

The adjective *barocco* existed in Italian at the end of the seventeenth century; but it was little used. The French preacher Mabillon, studying manuscripts in Florence, came across the word and asked the Florentine scholar Magliabecchi what it meant. Magliabecchi could not answer at the time, but several years later, in 1688, when Mabillon was back in Paris, Magliabecchi found the answer in a book by a certain Mazzi, and asked his friend Michel Germain to tell Mabillon the meaning: in Mazzi's book *barocco* meant a fraudulent operation, a crooked deal. By the early eighteenth century the work *baroque* was in use in French to denote anything irregular, imperfect or bizarre. Saint-Simon uses it in this sense in his memoirs; the *Dictionnaire de l'Aca-démie* (1718) gives it as an alternative word for 'irregular'; Pernetty in his *Dictionnaire portatif de peinture, sculpture et gravure* (1757) applies it to Tintoretto; in 1769 a French traveller, Lalande, applies it to Salvator Rosa's *Martyrdom of St Cosmas and St Damian* and to the hunting-lodge of Stupinigi in Piedmont.

In the second half of the century the term takes on an aesthetic significance. Quatremère de Quincy, in his *Encyclopédie méthodique* (1788), defines it as 'bizarre to a degree', 'the superlative of bizarre'. Millizia, in his *Dizionario delle Belle Arti e del Disegno* (1797), repeats the definition and applies it to the architects Borromini, Guarini and Pozzo. Jean-Jacques Rousseau, in his *Dictionnaire de la Musique* (1778), uses the word to denote a 'confused harmony'.

Thus from its very beginnings the word 'baroque' had as bad a reputation in the sphere of aesthetics as 'Gothic'. In fact post-Renaissance and post-mannerist art had been condemned long before the word 'baroque' itself appeared; Palladio, in *I quattro libri dell' architettura* (1570), pours scorn on what he foresees to be the architectural tendencies of the coming century, and Bellori, an admirer of Poussin, attacks the complications of the art of his time in his *Vite de' Pittori Scultori e Architetti moderni* (1672).

The pejorative sense of the word 'baroque', meaning a style of decadence, died hard. Indeed, it still survives in countries, such as France and England, where the baroque never really took root; and Italian or Italianate enthusiasts for the Renaissance, such as Berenson and Benedetto Croce, have continued to regard it as 'the art of bad taste', as Croce describes it in a work on the baroque period in Italy which appeared in 1929.

It was left to the historians and art critics of the German-speaking countries, where the baroque had flourished in its full glory during the eighteenth century, to rehabilitate baroque art. Cornelius Gurlitt, author of several works on baroque, classical and rococo art, was followed by the Swiss art critic Heinrich Wölfflin, who in his work *Renaissance und Barock* (1888, revised 1907), was the first critic to refer to the baroque as an independent category, a positive concept contrasted

with the Renaissance which had preceded it. Later, going beyond the concept of the Renaissance, he defined the classical position in general (*Die klassische Kunst,* 1898), and in his *Kunstgeschichtliche Grundbegriffe* (1915) he carried his ideas one stage further by treating the notion of the baroque, like that of the classical, as above history, and formulated a theory according to which the evolution of form in art is governed by two opposing principles which have much in common with the Apollonian and Dionysiac principles postulated by Nietzsche in his *Die Geburt der Tragödie* (1870). In aesthetic terms, Wölfflin defines the classical-baroque dualism in terms of five pairs of opposites: linear and pictorial; plane and depth; closed form and open form; form which weighs down and form which takes flight; unity and multiplicity.

pls 1–8

In essays written between the two world wars, Eugenio d'Ors discussed the philosophy and aesthetics of the baroque, seeing it as an *aeon,* a term used in Gnostic philosophy to denote the emanations or aspects through which the Supreme Being acts upon the world. Not without humour, he outlines the taxonomy of the baroque; in the genus *Barocchus* he distinguishes twenty species, the newest of which are *fin de siècle* baroque (*B. finesecularis*) and post-war baroque (*B. posteabellicus*).

This rehabilitation of the baroque was not enough; in the end there was a reversal of values and it was the classical, not the baroque, that was thought of as the 'degenerate bastard'. The Viennese scholar Strzygowsky (1898) develops the theory that the development of European art has been governed by a tension between two great centres of culture: one centre lies in the south, and its art is the art of empires, the servant of authority, the breeder of academicism; the other centre, which the Austrian writer considers the more favourable for artistic expression, lies to the north, where the creative impulse can take wing in complete freedom. It is not hard to recognize in these two centres, in a new guise, the concepts of Nietzsche's Apollonian and Dionysiac, Wölfflin's classical and baroque, and even the two contrasted forms of eloquence which Quintilian had called Atticist and Asianist.

Meanwhile art historians were applying themselves to the problem of defining the origins and tracing the development of the baroque as a specific historical phenomenon. Marcel Raymond, in his *De Michel-Ange à Tiepolo* (1912), makes a distinction between the austere 'Counter-Reformation baroque' and the triumphal baroque of the seventeenth century.

This idea that the baroque was the product of a movement of religious ideas originating in the Counter-Reformation is the basis of W. Weisbach's book *Der Barock als Kunst der Gegenreformation* (1921), and of Emile Mâle's iconographical study *L'Art religieux au temps du concile de Trente* (1932). In a more recent work, the Spanish critic José Camon Aznar goes so far as to name the early baroque the 'Tridentine style' (*El Estilo Trentino,* 1952). This approach to the question of the origins of the baroque inevitably carried the enquiry beyond the purely artistic field into that of cultural history.

From the purely artistic viewpoint, the key to the process by which the Renaissance engendered its antithesis, the baroque, lies in the concept of mannerism. This is the name given to the Italian art produced between the death of Raphael (1520) and the foundation of the academy of the Carracci (1585), the period sometimes wrongly described as the 'proto-baroque'. The term

'mannerist' comes from the Italian word *maniera* (from *mano*, hand), inherited from the days when the mechanical arts included the plastic arts; it had been used since the Middle Ages (*Trattato della Pittura* by Cennino Cennini, *c.* 1390) to mean an artist's personal style, an idea which Vasari in his *Le Vite de' più eccellenti architetti, pittori, et scultori italiani . . .* (1550) develops into an aesthetic concept, offering artists a choice of a number of different 'manners' each of which is embodied in one of the great creators of the Renaissance. Clearly, this attitude implies the notion of conformity, and hence of academicism. As Georg Weise has pointed out, in the Italian literature of the sixteenth century (Ariosto, Bandello, Bernardo, Torquato Tasso) 'mannered' is synonymous with 'refined', 'artful', 'precious', though not in a pejorative sense. The pejorative meaning seems to have developed about the year 1600, at the time when, under the influence of the Carracci and Caravaggio, there was a revival of naturalism and a condemnation of the *maniera* in the sense of 'painting without a model and with no reference to nature'; Bellori uses it in this sense. The rehabilitation of mannerism as a positive cultural element is the work of a Viennese historian of Czech origin, Dvořák, whose work on the history of culture enriched the history of art by demonstrating its close relationship with all the intellectual phenomena of its age (*Kunstgeschichte als Geistesgeschichte,* 1924). At a congress in 1924, Dvořák read a paper on El Greco and mannerism which led to a revaluation of the concept of mannerism as a whole. In Dvořák's view the subjectivism of the mannerists, as opposed to the objectivism of the Renaissance, far from being a phenomenon of exhaustion, indicated a reawakening of the imagination, and of the spiritual impulses of the pre-Renaissance period. The mannerist movement has since been the subject of extensive studies by Hans Hoffmann, a pupil of Wölfflin (*Hochrenaissance, Manierismus, Frühbarock,* 1939), Walter Friedländer (*Mannerism and Anti-Mannerism in Italian Painting,* 1957) and above all Gustav René Hocke, who has made a study of all the European examples of this style (*Die Welt als Labyrinth: Manier und Manie in der europäischen Kunst,* 1957).

In the light of these studies, mannerism stands revealed as the inevitable consequence of a conflict between the artist's conscious desire to conform and his instinctive rejection of classicism. In psychoanalytical terms, this conflict led to a complex, a sense of frustration, even of revolt, in the face of barriers which the artist was unable to cross and which he sought to by-pass by departing from the principle of imitation; replacing *mimesis* by *phantasia* (to use the Platonic categories). This vain rebellion against constraint resulted in a tendency to consider art as a game (the play instinct) and tended to make artists temperamentally gloomy and melancholic. The world of forms thus created is a 'substitute universe', an artificial system which replaces not only the external world but also the legacy of classical formalism. Mannerism, which from Italy spread throughout Europe, was uneven in its achievements, but it served as the 'culture-medium' in which, as we shall see, there developed in Italy and in Germany the evolutionary elements of baroque and rococo.

Baroque differs from mannerism in its renewal of contact with the external world, its joyous *pls 4, 7* release of the imaginative forces hitherto imprisoned in the closed cycle which Gustav René Hocke aptly calls a 'labyrinth'. From the point of view of form, what clearly distinguishes a mannerist

work, whether of architecture or painting, from a baroque work is its fragmentation, its violation of formal unity, the lack of co-ordination between its component parts. The baroque tends towards the re-establishment of unity. Throughout the two centuries of its development it sought to integrate every sort of artistic expression into a harmonious whole. This synthesis, as we shall see, was not achieved until the eighteenth century, the age of rococo, when painting, architecture, sculpture and the applied arts combined to form what is known in German as the *Gesamtkunst-werk,* the 'total work of art'. The rococo might indeed be called the 'symphonic style'.

These distinctions make it justifiable that a book devoted to the baroque age should have its starting-point after mannerism. Mannerism cannot be considered as a proto-baroque, although baroque incorporates certain of its after-effects, and benefits from the morphological experiments pursued with such passion by the mannerist artists.

It is noteworthy that most of the words used to designate the great artistic styles of the West were originally derogatory. This is the fault of a classicist prejudice which has been with us since the sixteenth century and which, particularly in France, in defiance of changing tastes and fashions, has persistently consigned to perdition everything which is not itself. 'Gothic', 'baroque', 'mannerist' were all terms of disparagement; the same is true of 'rococo'. In mid-eigh- *pls 12–16* teenth-century France this was a term used in artisan's language to describe the rocaille style of decoration, which was deep-cut and sinuous. The world comes from *rocher,* 'rock' and derives from the artificial grottoes which had been popular in gardens since the sixteenth century, and which were encrusted with shells; hence by transference the word for 'rock' came to refer to the shell-like forms repeated *ad nauseam* in the decorative art of the eighteenth century. The word 'rococo' was applied as a term of contempt to the ornately worked style of the eighteenth century by the first advocates of neoclassicism. The engraver Cochin, one of the earliest and most enthu-siastic supporters of the neoclassical reaction, uses it in his writings, notably in his *Supplication aux Orfèvres* of 1754, to ridicule artists and artisans who worked in the rocaille style. The term 'rococo' remained a pejorative one until the twentieth century, in spite of a short-lived revival of the style in furniture design after 1850.

Some historians like to see the rococo as a decadent form of baroque. An example is Hans Rose, who in 1921 devoted a work to the 'late baroque' (*Spätbarock*); he regards the rococo as the 'baroque of the baroque', thus neatly juxtaposing the pejorative and non-pejorative senses of the word. But this is no more correct than Paul Hofer's attempt in 1956, to identify rococo as 'a new mannerism'. Rococo is not the decadence of the baroque—nor indeed does it transcend it; it is the natural consummation of its evolution, its fulfilment as a style.

2 From Italian Europe to French Europe

Throughout the first half of the seventeenth century European civilization was dominated by Italy and Spain; their languages were spoken wherever there were men of culture.

Since the wars of the sixteenth century, Hapsburg Spain had been the great power of Europe. Unremitting pressure from France, and internal conflicts, brought the period of Spanish political supremacy to an end in the first half of the seventeenth century, at the very time when Spanish influence in the field of manners and literature was at its strongest. In 1636, Corneille's *Le Cid,* inspired by the play by Guillén de Castro, had its first performance in Paris; and in the same year the Spaniards took Corbie and advanced as far as Compiègne, only to be finally repulsed in the course of the next few years. The seventeenth-century mind regarded wars as political contests which did not necessarily involve feelings of national hatred.

In 1648, just when the Treaties of Westphalia, which set the seal on the eclipse of Spanish power, were about to be signed, a book appeared in Spain which was to become a manual of *savoir-vivre* for all Europe, and which expressed better than any other the ideals and code of behaviour of baroque man: the *Oraculo manual y arte de prudencia* of the Spanish Jesuit Baltasar Gracián. This work, which commended to the man of quality the code of 'excellence', had a wide and immediate sale. An excellent French translation by Amelot de la Houssaye (under the title *L'Homme de cour,* 1684) brought it before an even wider public; this version, its Racinian purity of language contrasting with Gracián's florid style, became the basis for subsequent translations into many languages including Hungarian, Polish and Russian.

In the field of visual art, however, Spanish influence—in Europe at least—was almost nil. Somewhat isolated on their peninsula, Spain and Portugal each developed an indigenous art, which drew upon Italian sources in the seventeenth century and came under French influence in the eighteenth. Apart from the Kingdom of Naples, to which it gave Ribera, Iberian art had no real communication with the rest of Europe; its field of expansion was overseas, mainly in Latin America, where imported baroque art, grafted on to native stock, produced magnificent and often strange flowers. But while Bernini and Rubens were famous men received in the courts of Europe as ambassadors, Velázquez was a 'local' painter; in 1688 Félibien, the neoclassical theorist and admirer of Poussin, described him as an unknown painter 'showing the qualities found in those who are not of the first rank'.

In the visual arts it was Italy that set the tone in Europe until the end of the reign of Louis XIV, when French influence began to make itself felt. Rome, the heir to the treasures of ancient and

Renaissance art, was the artistic capital of Europe at the beginning of the seventeenth century. Artists flocked there from everywhere north of the Alps to admire the masters and become their pupils; nowhere else, it seems, could one learn to paint. The court of France, which under Francis I and Henry III had been an influential although secondary artistic centre (recognized as such by Vasari, who called Fontainebleau 'the Rome of the north'), declined when the monarchy was enfeebled by the Wars of Religion. France lost some of her greatest painters to the Eternal City: Le Valentin, Poussin, Claude. The Dutch, Flemish, German and Lorrainese artists who lived in Rome formed a clearly-defined, close-knit community; their way of life is described by the German painter-historian Sandrart in his *Academia todesca*. In this cosmopolitan Roman milieu even a minor painter such as the German Elsheimer was able to play a very active role for a short time. The hospitable Italians adopted and re-christened the émigrés: Pierre de Francheville became Francavilla, his colleague Nicolas Cordier, from Lorraine, became Il Franciosino, and Gerard Honthorst of Utrecht earned the name Gherardo delle Notti for his night scenes. Foreign painters who had come to Rome found many sources of inspiration—ancient and Renaissance art, Caravaggio, the Carracci—and foreign architects learned a new style which the Jesuits were helping to spread throughout the world.

Seventeenth-century Italy enjoyed a peace which favoured artistic activity; the country suffered only marginally from the effects of the Thirty Years War. Originating in a religious and nationalistic conflict in Bohemia, this soon became a European conflict involving all the great powers, France, Austria, Spain, England, the German princes—and Sweden, which at one point, carried forward by the military genius of Gustavus Adolphus, seemed about to dominate Germany. The use of mercenary armies, without commissariat or lines of supply, resulted in devastation and ruin for the countries through which they passed. France was affected only peripherally, and in spite of a virtual civil war, the Fronde, recovered easily thanks to its economic strength and expanding population. Germany, on the other hand, lost half its population and remained enfeebled for a long time. Prague, which Rudolph II had established as a centre of mannerist art on a par with Rome and Florence, was totally eclipsed, and the German-speaking countries were not to see another period of artistic prosperity until the eighteenth century.

In the Low Countries, however, the wars did not prevent the arts from flourishing. Still under the Spanish yoke, the southern Netherlands enjoyed in the first half of the seventeenth century their finest artistic flowering since the fifteenth century. Antwerp, where Rubens had his studio, became one of the artistic poles of Europe. The United Provinces, to the north, had their autonomy recognized *de facto* at the truce of 1609 and *de jure* by the Treaties of Westphalia in 1648. On the fringe of a theocratic and absolutist Europe, they created a highly original artistic civilization, essentially realistic and 'democratic' in character. England, torn by civil wars that ended with the execution of a king—an event unprecedented in European history—remained artistically more or less a tributary of Holland, except in architecture, in which the dominant influence was Italian.

The real victor of the Thirty Years War was France. By means of the Treaties of Westphalia (1648) and the Treaty of the Pyrenees (1659) she completely overthrew the power of Spain, and

by guaranteeing the 'German liberties' went some way towards destroying the significance of the 'Holy Roman Empire of the German Nation' which was soon a power in name only. Paradoxically, the political fragmentation of Germany, where some 350 principalities and free cities existed side by side, created a very favourable environment for the arts by making possible the development of absolute monarchy on a small scale—one of the conditions which stimulated the baroque genius. The model for all these princes was no longer the Holy Roman Emperor but the king of France, Louis XIV, who in his palace of Versailles personified the absolutist ideal.

But although the Hapsburgs of Austria had lost the effective tutelage of Germany as an instrument of their power—and Prussia in the eighteenth century was to become a formidable rival—their power increased as that of the Spanish Hapsburgs declined. By the Treaty of Utrecht (1713–14) they recovered from Spain the Spanish Netherlands and Milan, thus establishing themselves strongly in Northern Europe and Italy. They compensated for their loss of influence in Germany by strengthening their hold on Bohemia and by conquering the whole of Hungary, which became their hereditary possession at the Diet of Pressburg in 1687. The decisive victories (1683–6) by which the Austrian armies recovered territories occupied by the Turks for two hundred years lent the Hapsburg empire a glory which resounded throughout Europe; the princes of Germany rallied to the defence of the West. As an 'imperial' power, founded on a group of different nationalities, Austria contrasted with the strongly centralized 'royal' power of France. This situation gave the Hapsburg empire a new significance both as a political and a religious force, which was to find artistic expression in creations of a truly 'European' character.

Court art in the eighteenth century consequently took two forms: 'royal' art, as represented by the king of France and his absolutist imitators throughout Europe, and the 'imperial' art diffused by the Austrian Hapsburgs. Two types of monument symbolize these two forms of monarchy: *pls 344–6* the princely palace inspired by Versailles, and the palace-monastery derived from Klosterneuburg and ultimately from Charles V's Escurial.

The decline of the power of Spain was completed by the Wars of the Spanish Succession. The Treaty of Utrecht placed the grandson of Louis XIV on the throne under the title of Philip V. The Spanish crown thus eluded the Hapsburgs of Austria, but the Emperor Charles VI, the last Hapsburg king of Spain, retained from his brief stay in the capital of Philip II a profound impression which reinforced his absolutist tendencies and also had far-reaching consequences in the field of the arts.

In spite of successful endeavours to re-establish Spanish power in Italy, largely the work of Philip V's ambitious queen, the last of the Farnesi, who brought Parma and the Kingdom of the Two Sicilies under Spanish rule, Spain in the eighteenth century was culturally isolated from the rest of Europe. Notwithstanding French influences—which were largely restricted to artists working for the Bourbon court—Spain found a means of expressing her deeper nature in that wonderful flowering of the baroque which is erroneously termed 'Churrigueresque'—a style that was to appear in new varieties in the overseas colonies.

French influence was stronger in Portugal, which had taken advantage of the decline of Spain to recover its independence in 1640. John V (1707–50), whose recently discovered gold and dia-

mond mines in Santa Cruz (i.e. Brazil) made him the richest king in Europe, initiated a tendency to magnificence, in both secular and religious decorative art, which extended to the rich colony of Santa Cruz itself.

Eighteenth-century Europe was French, as seventeenth-century Europe had been Italian. The spread of French thought made the French language an indispensable medium for all intellectual or diplomatic exchanges. It would not then have been necessary, as it had been in the previous century, to translate Descartes' *Discours de la Méthode* into Latin to make it accessible to a wide public. This fashion for French was nowhere stronger than in the courts of Germany, where children were taught French before German in case they should pick up a bad accent. Frederick the Great, who had no love for France, made French compulsory in the proceedings of the 'Académie royale de Prusse', and in 1782 this academy organized an essay competition on the subject of the universality of the French language. When Napoleon invaded Russia in 1812, French actors continued to act in French in the leading theatre of St Petersburg. French fashion played its part in the spread of French influence, and every elegant princess in Europe sent to Paris for her dresses.

A systematic reform of military organization, initiated by Gustavus Adolphus, was completed during the lifetime of Louis XIV. The ruffianly, lawless mercenary armies of the Thirty Years War gave place to disciplined bodies of men, commanded by professional officers from their own native countries and provided with commissariat, stores, an internal liaison system and proper strategic lines of communication. As a result, the wars of the eighteenth century were shorter and less bloody than those of the seventeenth, and above all less destructive for the countries where they took place. On the whole the eighteenth century was a period of relative peace, which favoured the development of the arts all over Europe. This period also saw the rise of a new European power. Inspired by the genius of Peter the Great, Russia emerged straight from the Middle Ages to adopt the baroque style, and artists from Western European countries, chiefly Italy and France, were called upon to bring her up to date with the art of the day.

Although Italy now had to share the limelight with France, she had lost none of her prestige as a centre of European artistic life. France herself contributed to this by organizing a system whereby the best students of architecture, painting and sculpture, selected by open competition, were sent to the Académie de France founded in Rome in 1666. Italy retained its attraction for artists from all over Europe. English architects and decorators in particular were under the spell not only of Rome but also of the Veneto, where stand the works of Palladio, 'god' of English architects. In the other arts, especially painting, England looked to Flanders and to the United Provinces, whose stadholder William III was also king of England from 1689 to 1702.

The 'European' moment of English artistic history came with the triumph of the neoclassical or Palladian principles originated in England as a reaction against the rise of the baroque; at the end of the eighteenth century Rome became once more the artistic capital of Europe, enjoying a new splendour as the shrine of neoclassicism. It was in Rome in 1784 that David exhibited the *Oath of the Horatii,* which enjoyed an enormous success. In painting, this work must be considered as marking the conclusion of the baroque period.

23

The prevalence of absolute, centralized monarchy—the *ancien régime*-gave rise to considerable unity of thought and opinion throughout Europe. The French Revolution, by freeing peoples from this absolutist system, unleashed the forces of nationalism and bequeathed to the nineteenth century a situation in which absolute monarchies had to coexist with republics and parliamentary monarchies. The result was a conflict of patriotic interests that had not existed under the *ancien régime*. Great Britain, after directing all her energies against Napoleon's attempt to unite Europe under his own rule, now became 'isolationist' and tended to regard the Continent as wholly alien. But in the eighteenth century, in spite of her wars, which were matters of policy rather than patriotism, Britain had been one of the great unifying factors in Europe. When in 1762 Laurence Sterne decided to visit France, which was then at war with Great Britain, he simply made his way to Versailles and applied to Louis XV's minister, the Duc de Choiseul, for a passport. Such a case makes our modern 'total' wars look like a reversion to barbarism.

In the eighteenth century it was part of the education of every Englishman of standing, whether he was aristocrat, philosopher or man of science, to do the Grand Tour. He would go to Switzerland to pay homage to Rousseau and Voltaire, to Germany to hunt with the princes, to France to learn the refinements of court and city life—the tour included the provinces—and to Italy to admire the landscape, the antiquities and the art treasures. In Rome and Venice tourists were so numerous that specialist painters (including Canaletto until his departure for England in 1746) made a business of selling them views (*vedute*). French tourists making the journey to Rome and Naples bought their *vedute* from compatriots who had settled in those towns. In Germany every gentleman, every man of breeding, was expected to have done the *Kavaliertour*, which took him to France, Italy, Holland, and occasionally even Spain. Much the same convention existed in Russia, where Peter the Great had set the example. Diderot, writing from Paris in 1773 to Falconet at St Petersburg, tells him: 'Our hotels are always full of Russians'. Towards the end of the eighteenth century, two salons received all the philosophers of Europe; those of Catherine II in St Petersburg and Madame Geoffrin in Paris.

Travel had been no less popular in the seventeenth century; and artists were among the most assiduous travellers of all. As an example, the German painter Sandrart, author of *L'Academia todesca,* born in Frankfurt in 1606, went to study in Prague with Sadeler and in Utrecht with Honthorst, whom he followed to England; he then travelled to Italy, and thence to Holland, lived first in Amsterdam and then in Augsburg, finally making his home in Nuremberg in 1688. We can scarcely keep track of Rubens' journeys to Mantua, Rome, Genoa, Paris, Madrid and London. The Italian architect Guarino Guarini, who visited Paris in the 1660s, at almost the same time as Bernini, designed one church there and one for his own order, the Theatines, in Bohemia. In 1665 Wren came to Paris, where he met Bernini. The Frenchman Libéral Bruant was consulted on the building of the Palace of Whitehall in London. Italians were called in everywhere in the seventeenth century, and still more in the eighteenth, as specialists in all the arts; they travelled to Austria, Germany, France, Spain and Portugal, as well as Latin America and Russia, and in the eighteenth century they worked alongside French architects, painters and sculptors. In Central Europe, the fusion of Italian and French influences gave rise

to the unique and original growth of German rococo. Artists from the Netherlands, following an emigration route dating from the Middle Ages, were attracted towards France. In the eighteenth century many of the goldsmiths and workers in bronze, and most of the cabinet-makers, working in France were of Netherlandish origin, notably the Dutch craftsmen who used as their mark the initials BVRB, recently identified as representing the family of Bernard van Risen-burgh.

pls 302-3

The concept of nationality was vague, and the true homeland of any artist was wherever conditions were most favourable for the development of his talent. Political upheavals drove many artists to settle abroad. The Czech engraver Wenceslaus Hollar, driven from Bohemia by persecution in 1627, was brought from Germany to London by the Earl of Arundel in 1636, and in 1642 was drawing-master to the little Duke of York (later James II). The revocation of the Edict of Nantes in 1685 was economically disastrous for France, for it resulted in the loss of much specialized talent and the dissemination abroad of the industrial techniques that Louis XIV's minister Colbert had been at such pains to establish. Huguenot refugees took the French clockmaking industry to Switzerland; and Geneva became the home of numerous French embroiderers, painters, goldsmiths, masons, carpenters and engravers. Daniel Marot, born in France, became an important Dutch painter; and the celebrated London goldsmith Paul de Lamerie was the son of a Huguenot who had taken refuge at 's Hertogenbosch. By the end of the seventeenth century 120 French goldsmiths were working in London alone.

Art in the eighteenth century was international; many centres of the applied arts produced more for foreign customers than for the home market. The finest French silver was made for Catherine the Great and Prince Orlov in Russia, and for John V and his successor Joseph Em-manuel in Portugal. The finest Sèvres porcelain was made for the courts of Austria and Great Britain. The ceramic craftsmen of Holland were called upon to produce tiles for use in interiors of a size unknown in their own country, where none but modest bourgeois houses were being built. The finest examples of their work are to be found outside Holland: in the Pagodenburg and Amalienburg pavilions in the park of Nymphenburg near Munich, in the Elector Palatine's palace of Falkenlust near Bonn, in the Château de Rambouillet in France, and in the PL. XXIII church of Nazaré in Portugal.

In the arts, an important factor in the maintenance of stable traditions and active cultural exchange was the existence of a number of prolific 'dynasties' of artists, many of which span the whole history of the age of baroque, and which scattered their individual members all over the European world. France was rich in families of portrait-painters, portraiture being the French art *par excellence;* from the sixteenth century to the eighteenth we can cite the families of Clouet, Dumonstier, Quesnel, Elle, Beaubrun, Drouais, de Troy and Van Loo. The Van Loo dynasty, of Flemish origin, was so prolific that there was always a member available to meet foreign demand—there were a 'Prussian' Van Loo (Charles-Amédée), a 'Spanish' Van Loo (Louis-Michel), an 'English' Van Loo (Jean-Baptiste) and an 'Italian' Van Loo (Carle). In France the families of Mansart, Hardouin, de Cotte and Gabriel, all linked by marriage, had been masons and architects since the sixteenth century, the Hardouins since the fifteenth century

when artisans and master craftsmen of this name had worked on Beauvais cathedral. At the end of the seventeenth century, a French architect, Beausire, settled in Rome, and there founded a line of architects which came into prominence in the Papal states in the neoclassical period, and which has continued to produce talented artists down to the present day.

Certain poor regions, where little building was done, produced great schools of craftsmen. In the German-speaking world, what is known as the Vorarlberg School consisted of a number of families of architects, stucco-workers and decorators who spread beyond the Austrian province of Vorarlberg itself into Switzerland and the countries of the Danube, maintaining a unified style. The principal families were the Thumbs (11 members), the Moosbruggers (56 members) and the Beers (29 members). The region of Lake Como and the Ticino, which since the Middle Ages had sent out the famous *maestri comascini* to all the countries of Europe, continued to be a cradle of architects and builders. These included Domenico Fontana, his nephew Carlo Maderno, Carlo Fontana and Francesco Borromini (all of whom worked in Rome), Cosimo Fanzago and Picchiati who worked in Naples, and the Carlone family of Scaria, who introduced baroque decoration to Austria. The Moosbruggers were rivalled in fecundity only by the two branches of the Carlone family, which produced between them no less than fifty-three architects, sculptors and painters.

Mention should also be made of the influence of Italian theatre designers and decorators, the art of stage design being an Italian speciality. Throughout nearly a century and a half the Bibiena family, of Bologna, sent its sons all over Europe and built theatres in Bologna, Parma, Piacenza, Milan, Livorno, Mantua, Padua, Rome, Naples, Vienna, Dresden and Bayreuth.

The greatest international achievement of the art of the age of absolutism was the creation during the eighteenth and early nineteenth centuries of the baroque and neoclassical city of St Petersburg, to which virtually all Europe contributed. It was the work of Italians (Tressini, Rastrelli, Rinaldi, Quarenghi, Tombara, Gonzaga), Frenchmen (Nicolas Pineau, Leblond, Vallin de la Mothe, Thomas de Thoron, Richard de Montferrand), Germans (Andreas Schlüter, Gottfried Schädel), Scots (Cameron), and Russians (Bazhenov, Starov, Volkov, Voronikhin, Zakharov).

European unity was maintained by a political doctrine from which there were few dissentients outside Great Britain and the United Provinces: the doctrine of absolutism. Even England, which pursued the idea of liberty to the point of killing an absolutist king, soon compromised with the prevailing system. The theoreticians of absolutism, in England (Hobbes), in France, and even in the republican Netherlands, were numerous. Spinoza says in his *Tractatus theologico-politicus* that 'the will of the sovereign must be obeyed, whatever absurdity he may command'. This theory was supported by the belief that royal power, like the power of the Pope, was derived from divine right. Bossuet, bishop of Meaux and tutor of Louis XIV's son the Dauphin, declared: 'As there is no public authority without the will of God, any government, whatever its origin, just or unjust, peaceable or violent, is legitimate; any person in authority is sacred, and revolt against him is sacrilege.'

In France the doctrine of absolute monarchy had to contend with serious challenges from the *parlements* (judicial rather than legislative bodies) and the nobility; but it gradually consolidated itself in the first part of the seventeenth century. The critic Doubrovsky has traced its development through the plays of Corneille: in *Le Cid* (1636) the maintenance of the state is in hands of nobles whom the king is powerless to prevent from destroying one another; in *Horace* (1640) the king of Rome, in his final judgment, holds the balance in accordance with a code imposed by the State. *Cinna* (1640) marks the transition from king-judge to king-hero, from the aristocratic to the monarchic condition, in which heroes exist only by virtue of their participation in the nature of a supreme hero who by divine right stands aloof from historical forces. Thus Corneille's thought reflects the political debate which was exercising the minds of his countrymen at the time of the Fronde, and which was concluded by the triumph of absolute royal power in the person of Louis XIV.

The disputes between Pope and monarch which had loomed so large in the Middle Ages and the Renaissance were largely resolved by the doctrine of divine right, which allotted the monarch a divinely ordained temporal power over the bishops. But the king remained the Defender of the Faith, not its prime mover. Only in England, despite all the checks placed on royal power by the parliamentary system, did the king have one title which was denied to the absolutist monarchs of the Continent: head of the national church.

The concept of imperial, as distinct from royal absolutism, developed by the Austrian Hapsburgs and embodied in Leopold I, Charles VI and Maria Theresa, was rather different.

Its roots lay deep in German tradition. The title of Holy Roman Emperor, held by successive Hapsburg sovereigns (although not by Maria Theresa whose husband Francis I held it on her behalf) was now no more than a shadow; but the mere fact that it was an elective dignity gave its holders a certain moral authority. Their power, although absolute in their hereditary dominions and ultimately derived from divine right, was nevertheless theoretically based on the consent of the governed. The monarch, like the German chieftains of old, was 'raised on the shield' by his subjects. Divine right became his not by inheritance but by virtue of his coronation; although it was in fact acknowledged even in emperors-elect. In 1764, when Joseph II went to Frankfurt am Main to receive the title of King of the Romans, which conferred on him the right to succeed his father Francis I as emperor, the Landgrave of Hesse-Cassel, a man of seventy-five, racked by gout, rose from his bed to throw himself weeping at his sovereign's feet, calling him master and refusing all injunctions to be seated in his presence.

When Joseph II eventually came to power, he endeavoured to be an enlightened despot. He considered that by secularizing his imperial power he ruled not by virtue of divine right but by virtue of the duties of state laid upon him by the will of his peoples. Along with Frederick the Great of Prussia he was one of the first rulers to give effect to the abstract idea of the sovereign state, as later elaborated by German thinkers, by contrast to the more vital and less disciplined concept of the Nation, which was taking shape in France, and which could be realized only through the overthrow of monarchy.

In all the buildings created for the Viennese Hapsburgs—for example the enormous library of the Hofburg, with its dome where allegories of the arts gravitate around the portrait of Charles VI, or the domed ceiling of the oval salon in the imperial apartments of Klosterneuburg, *pl. 25* decorated by Daniel Gran with an allegory of the *Glory of the House of Austria,* we can sense a universality which is truly imperial. The dome, more than any other form, symbolizes the radiance of imperial power.

Versailles, a royal palace, contains no domes; this form which inspired so much superb architecture in Italy and Germany had little appeal in France. Versailles concentrates the attention on the person of the semi-divine monarch himself; it is a celebration of the superhuman *pl. 10* virtues which are symbolized in the royal effigy. So although Bernini's design for the palace of the Louvre did not find favour with Louis XIV, the artist's journey to Paris in 1665 was not wasted; the meeting between the prince of artists and the master of Europe resulted in a work *pl. 23* of genius. Bernini's bust of Louis XIV, his face radiant as the sun, aureoled with glory, emerging from a whirlwind of draperies as if from the clouds of Olympus, makes a revealing contrast with *pl. 18* the same artist's earlier bust of Francesco d'Este (1651); the two works together symbolize the transition from the Renaissance idea of the prince to the seventeenth-century idea of the king. Even more instructive is the comparison between Bernini's bust of Louis XIV and the fine *pl. 17* posthumous head of Louis XIII which Simon Guillain had carved eighteen years earlier, in 1647, for a monument on the Pont du Change in Paris. Guillain's Louis XIII has a face which shows both beauty and intelligence; but although a monarch, he is still a man. Bernini's Louis XIV is a god.

Curiously, the Hapsburgs felt no need to be turned into heroic figures, except by the external trappings of royalty. The artists who portrayed Leopold I and Charles VI, both of whom were *pl. 22* afflicted with the grotesque Hapsburg jaw, made no attempt to attenuate the ugliness of their sitters.

The contrast between the two great monarchical systems of Austria and France, empire and kingship, is further revealed in the allegorical emblems chosen to represent them. At Versailles Apollo reigns supreme; like the king, he is the fount of glory and the source of light; his divine rays fall on all his subjects, who shine only by his reflected light. Dedicating a work to the minister Colbert, Félibien put it thus: 'It is for God alone to know the worth of Kings, and for Kings alone to know the worth of other men.'

While not entirely neglecting the symbolic significance of Apollo, the Hapsburgs held fast *pl. 29* on the whole to the idea of Hercules, the chosen emblem of the Renaissance princes and a royal symbol in France up to the time of Louis XIII. Hercules, the glorious labourer, the benefactor of mankind, had been chosen as a symbol of empire by Charles V. Hercules is a hero, not a god; he roves the world in search of a service to render to man. The symbol of the Pillars of Hercules (which once adorned the temples of Melkarth, the Phoenician Hercules) and the proud motto 'yet further' had been the emblems of an empire which claimed, like that of ancient Rome, that its destiny was to rule the earth.

The France of Louis XIV preferred the symbol of Apollo, the vital principle which lies at the heart of all things. Ever since the medieval Capetians with their notion of the 'square pad-dock' (*pré carré*), the central object of French policy has been the consolidation of national power within the country's natural frontiers, the famous 'hexagon'. France has embraced an imperial destiny only sporadically and almost reluctantly.

Under the influence of this concept of royalty, the duties of state came to include magnificence in all its forms; great buildings and art collections, rich materials, opulent clothes and adorn-ments, and ceremonies some of which had their origin in biblical antiquity. Nature itself was transformed into a setting for a royal residence. This magnificence was the monarch's way of reigning, and even perhaps his way of governing; through it he wove a spell to enslave the hearts and enchant the imaginations of his subjects. This way of wielding power had been known to Nero, that true successor of the pharaohs; like Louis XIV in some ways, he was an artist-king, master of all the enchantments by which a king may impress his image on his people.

Louis XIV set an example of this royal ideal which in the eighteenth century all the absolute sovereigns of Europe, great and small, sought to imitate. It even seemed at times as if some mon-archs sought to compensate for the minuteness of their domains by the vastness of their royal works and the splendour of their courts. John George II, Elector of Saxony 1656–80, was one of the first of the so-called 'apes of Louis XIV', and his grandson, Augustus the Strong (1694–1733), king of Poland as Augustus II, seems to have carried the cult of the superhuman to its *pl. 21* extreme. 'Augustus II,' writes Louis Réau, 'who had twice been received at Versailles, was dazzled all his life by the splendour of the "sun king", whom he strove to emulate with a display of Asiatic magnificence.' The Margravine Wilhelmina of Bayreuth, a sister of Frederick

the Great, who was much frustrated by the limited resources of her own margravate, was envious of the Saxon capital of Dresden where 'magnificence was carried to excess'. In his taste for venery, Augustus the Strong not only imitated but far outdid Louis XIV; he kept a seraglio of his country's most beautiful women. 'When he died,' says the Margravine, 'it was estimated that he had had 354 children by his mistresses'.

Frederick the Great, sparing for political reasons with his pomp and his money, summed up the situation in many eighteenth-century German principalities in his sarcastic comment: 'Everyone, down to the youngest son of an apanaged line, sees himself in the likeness of Louis XIV. He builds his Versailles, he embraces his Maintenon.'

The idea of absolutism dominated individual as well as collective psychology in the baroque age, each man governing his life like an absolute monarch. Baltasar Gracián advises the courtier: 'Let all your actions be those of a king, or at least worthy of a king in due proportion to your estate.' Every man was inwardly a king. The ego, or the superego, became an entity which recognized no limits beyond itself. One of Corneille's heroines, in a moment of disaster, replies to her confidante's question: *Que vous reste-t'il donc?*—'What is left to you now?'—with a cry from the depths of her being: *Moi, moi, vous dis-je, et c'est assez.* 'Myself, I say; that is enough.' When the heroine of Mme de la Fayette's novel *La Princesse de Clèves* refuses to marry the Duc de Nemours, whom she loves, even after her husband's death, she is similarly retreating into the inviolable stronghold of the self.

> *Il ne faut point servir d'amour qui nous possède,*
> *il ne faut point servir d'amour qui ne nous cède.*
> 'There must be no serving a love that possesses,
> There must be no serving a love that yields not,'

says a character in Corneille's youthful comedy *La Place Royale*. The possession of the self by the self is the ultimate good.

> *Je suis maître de moi comme de l'univers,*
> 'I am master of myself as I am of the world,'

says the Emperor Augustus in Corneille's *Cinna*. This is the ideal of absolute sovereignty, a power without outer or inner limits.

The baroque artist exercised this sovereignty 'in due proportion to his estate' as Baltasar Gracián would have any man do; that is, in his art. The seventeenth century produced artists who, if not solitaries, were at least independent men; such were Nicolas Poussin, Claude Lorrain, Jan Vermeer, Rembrandt, Hercules Seghers, Caravaggio, Jacob Ruisdael, who considered their art, even if it depended upon commissions, as a personal activity, allowing no limits to be placed on their creative power. The same independence inspired artists of a more sociable temper such as Rubens and Bernini. Methods of painting bore the stamp of this individualism; whereas in the Middle Ages and the Renaissance virtuosity consisted in concealing one's methods in the anonymity of craftsmanship, the baroque artist sought to assert his virtuosity

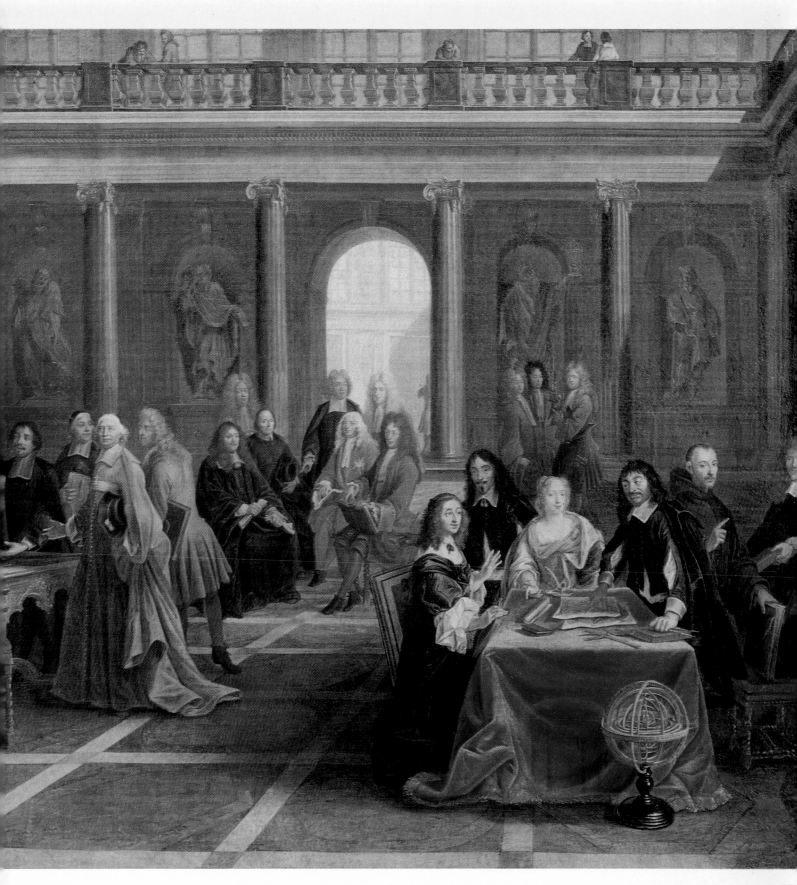

1 Pierre Dumesnil (seventeenth century). Queen Christina of Sweden with Descartes and other scholars

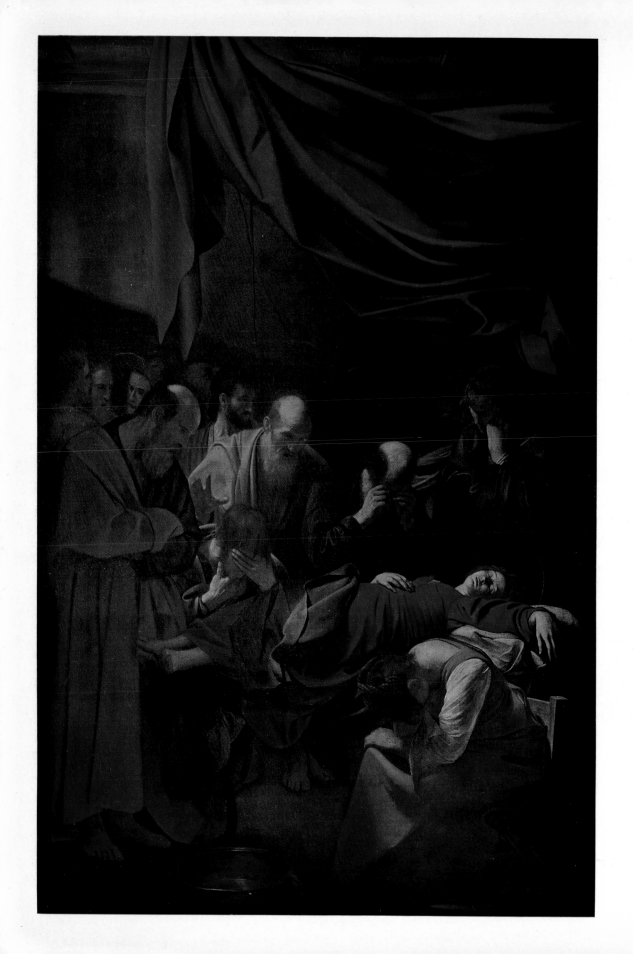

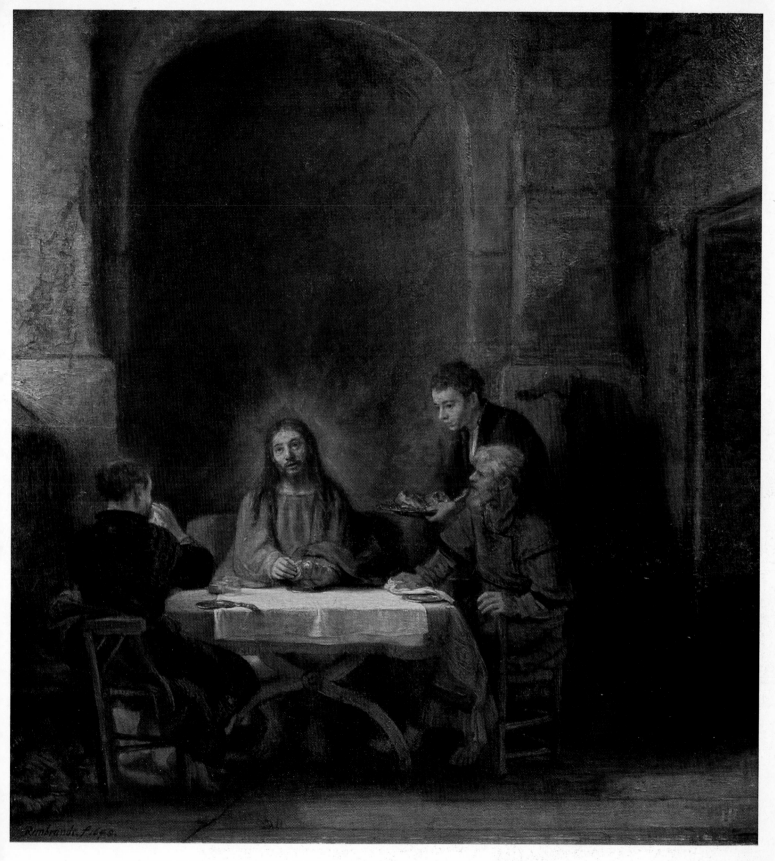

III Rembrandt van Rijn (1606–69). Pilgrims at Emmaus

II Michelangelo Merisi da Caravaggio (c. 1562–1609). Death of the Virgin

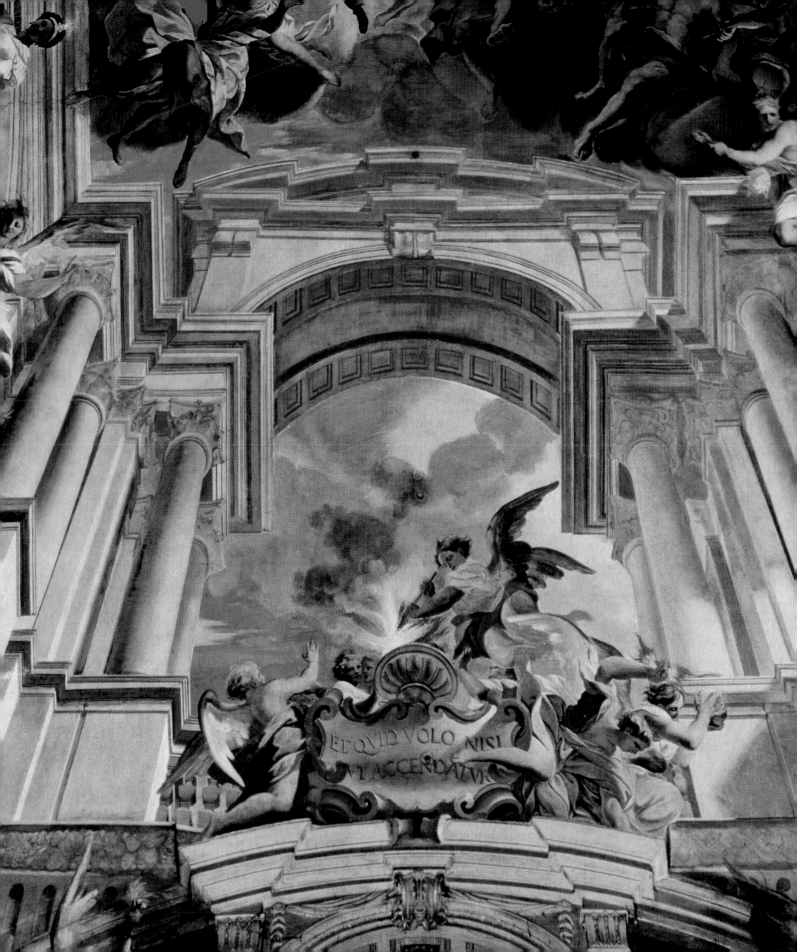

by establishing a manner which was peculiarly his own. In the conception of a work of art he acted as a demiurge, transforming fact into fiction, unreal into real, organic into inorganic, inorganic into natural. *Trompe-l'oeil* was one of the ways in which this power was expressed. Andrea Pozzo in Sant' Ignazio, Rome, Tiepolo in his Würzburg staircase, act as if they were lords of space, breaking its barriers at will.

pls 316, 362, PL. IV

The transcendental power bestowed upon the self should not be confused with romantic individualism, in which the artist is in a state of open revolt against a bourgeois society which refuses to acknowledge the concept of genius. Caravaggio is often mistakenly quoted as an example: but even in his life he was more of an eccentric than a rebel, and if there were conflicts in his career as an artist they were only with the Church, for he enjoyed the admiration of both collectors and artists. When the Roman parish of Santa Maria del Popolo refused his *Death of the Virgin*, and the Duke of Mantua, following the advice of Rubens who was then his court painter, bought it for a large sum, Roman artists concerned at the loss of such a masterpiece insisted that before being sent away it should be put on show for eight days. All Rome came to admire it.

Holland can offer 'romantic' examples of ill-starred or misunderstood painters such as Rembrandt, Vermeer, Ruisdael, and Frans Hals, but this is because Dutch society already provided exactly the bourgeois, 'democratic' milieu in which genius—that which sets a man apart—constitutes a scandal. In aristocratic society, on the other hand, genius held an honoured place. Men who possessed it, such as Rubens and Bernini, were treated like princes, for in aristocratic society the worth of a man resided in the excellence which it was proper to manifest according to one's estate. The lords spiritual and temporal who commissioned churches and palaces were hungry for sensations; as enthusiastic spectators they expected the artist to bring into play all his talents, his gifts of invention, his *ingenium*.

To cultivate excellence within oneself did not set one at odds with society; on the contrary, it was a sign of respect for society's values. Romantic individualism, which tends to separate rather than to unite, is foreign to this form of the cult of the self.

After the terrible upheavals of the Reformation, whose final reverberations shook Central Europe in the Thirty Years War, the Catholic Church left the schismatics to their fate, and considered it a triumph not to have foundered in the storm. It recouped its losses by spreading the Gospel outside Europe. There was a huge new demand for churches and monasteries in many parts of the world, and the appearance of many new religious orders increased the number of commissions. Many earlier churches, now thought old-fashioned, were demolished and replaced by structures in the style of the day. Others were adapted, improved, 'baroquized'.

God reigns over men's souls as the king reigns over his subjects. Orthodoxy having become firmly established within reformed Catholicism, the Church was to pass through no real crises until the advent of atheism. The few heresies that did arise, such as Jansenism and Quietism, did not present a serious challenge; nor did even the problem of 'free thought'. The anxious questionings of the age of Louis XIV on the problem of Grace were speculations of an intellectual order, which did not involve the great mass of believers.

35

◀ IV Andrea Pozzo (1642–1709). Apotheosis of St Ignatius (detail), in Sant'Ignazio, Rome

In order to impress its sovereignty on its own members the Church responded to the same need for architectural magnificence as did the king in his palace, making lavish use of precious materials, and employing elaborate liturgical ornaments and ceremonies on solemn occasions.

French Catholics today, accustomed to the bareness of medieval churches, find these baroque 'palaces of God' profane and unfitted for prayer. They forget that the present-day austerity of our medieval cathedrals is due to the fact that most of them have been stripped of their decoration. This taste for austerity can be traced back to the influence of the seventeenth-century Jansenist movement. The Jansenist M. Hamon had no hesitation in recommending to the devout laymen of the Port-Royal community that they should close their eyes when they prayed in too beautiful a church. Mère Angélique Arnauld, who had all the images and ornaments removed from the chapel of the Port-Royal sisterhood in Paris, and who forbade the growing of flowers in her convent, went still further. 'I love all that is ugly,' she said; 'art is nothing but lies and vanity. Whosoever gives to the senses takes away from God.'

I can only suppose that these views are shared by those present-day priests who, with the connivance of their superiors, are engaged in laying waste their own churches. By doing away with anything that has historical associations, and turning temples into abstractions, they think they are bringing Catholicism up to date. But the true tradition of Christian art is one of luxury, deployed to do honour to God and to appeal to the senses of the faithful. Whether Byzantine, Romanesque or Gothic, Christian art has always been a practical application of 'sensualism', employing audio-visual and even olfactory stimuli. The Renaissance, inspired by Leone Battista Alberti who was imbued with Platonism, had attempted to conceive a church with the purity of an idea, the homage paid by the human intellect to the Holy Spirit, a church which should sing the Creator's praise in the beauty of numbers and the harmony of proportions. From Alberti to Bramante, the church became an ideal place, attaining the Divine through a Platonic sense of essentiality, providing intellectual delectation for a few refined spirits, but in which the faithful could no longer feel any spiritual warmth. Such a building was Michelangelo's St Peter's before it was extended and adorned in the seventeenth century.

When the Counter-Reformation produced sober churches, it was returning, by a sort of neoclassical impulse, to the Renaissance canons which had been violated by mannerism—a school which designed churches like pieces of jewellery (San Benedetto Pò, near Mantua, by *pl. 73* Giulio Romano, Santa Maria presso San Celso, in Milan, by Galeazzo Alessi). The Counter-Reformation produced an immense ideological effort to reaffirm, by means of allegory and symbolism, the articles of faith and the victory of the saints over sin and of orthodoxy over heresy; and this effort was immensely productive of works of art.

Faith to the Catholic can never be placed in question, even by sin. In the seventeenth century at least, artists who worked for the Church, such as Rubens, Bernini, Guido Reni and Carlo Dolci, were deeply religious men. In Munich in 1733–5 the Asam brothers built opposite their own great palace a church, larger than the palace itself, on which they lavished all their *pl. 77* artistic skill. At Scaria d'Intelvi, near Como, the brothers Carlo and Diego Carlone decorated the parish church of their native village at their own expense. In the eighteenth century, mainly

in France, the spirit of the Enlightenment fostered agnosticism and even atheism among the élite, but the inroads of scepticism did not shake the profound faith of the people, which found fulfilment in ornate churches which provided the humblest worshipper with a vision of fabulous splendour, an image of the supernatural world.

It is in the many pilgrimage churches of the German-speaking world above all that we realize the intense popular appeal of the ostentation of baroque art. Renaissance art, by contrast, is the art of a cultivated minority. Simple people could hardly be expected to understand the complicated allegories of the baroque world of images; but were the abstractions of Byzantine art or the theological speculations of Gothic porches and stained glass any more accessible to the mass of worshippers? Because these things passed their understanding, worshippers found in them the true meaning of faith. In a state of exaltation they allowed themselves to be overwhelmed by the continuous dramatic representation of the divine world which the Church offered them. The aristocrat too felt at home, among ceremonies and rituals similar to those in use at court: exactly as the Byzantine dignitary recognized in church mosaics the same liturgical ritual which surrounded his earthly monarch the *basileus*. If our knowledge of Byzantine art were based on more than the few remnants that have come down to us (as far as secular art is concerned, there is little more than written evidence) we should be more conscious of its analogies with baroque art. Both artistic traditions are essentially religious, and both belong to civilizations in which temporal power is regarded with a sort of religious awe. Significantly, the residence of the *basileus* was known as the 'sacred palace'.

For the great festivals which marked the rhythm of the seasons, and for pilgrimages, consecrations and canonizations, the Church provided a wealth of indoor and outdoor ceremonies to which the people were invited; little remains of them today beyond our poor Corpus Christi processions. The people had a part in the festivities associated with tourneys, ceremonial entries into towns, processions, cavalcades, triumphs, and firework displays, but they also had celebrations of their own: masquerades (of which our carnivals are a feeble survival), grotesque processions not unlike those of present-day Flanders, athletic and acrobatic contests (nowhere more picturesque than in Venice), games of skill, water-jousting, regattas, boxing matches, *pls 26, 369* archery and crossbow contests, acrobatic shows, bullfights (in which great nobles appeared before the public as *toreros*), not counting the civic festivals. Dr Friedrich Sieber has devoted a whole book to the contribution made by popular culture to the princely festivals mounted by Augustus II and III in Dresden.

Under our democratic systems, in which governments nominally based on the consent of the governed have in fact to protect themselves from constant threats of violence, it is hard to conceive that the palace of Versailles was actually open to the public. Any subject could, if he wished, be present when the king dined; all that was required was that he should be decently dressed and display the outward appearance of a gentleman, which meant he must wear a sword and carry a plumed hat under his arm. These accessories could be hired from the palace *concierge* for a small sum. The gardens were public; when Louis XIV wished to walk in them, a way had to be cleared through the crowd for a certain distance in front of him. The monarch thus put

his royal dignity on show; and this ostentation was in itself an instrument of power, since every subject—even the humblest—existed only in relation to his royal person. The parks of great country houses served as a place for public festivities, and peasant weddings were also celebrated there; walls were mostly added in the nineteenth century, when the domain of a lord became the property of a bourgeois.

Nowhere was the life of the prince lived closer that of his subjects than in the small states of eighteenth-century Germany, where monarch and people were often on familiar terms. For his palace, Mon Plaisir, William Henry of Nassau-Saarbrücken chose the motto *Je veux que mon plaisir soit le plaisir de mes sujets*, 'I wish my pleasure to be my subjects' pleasure.' The princes of the church were amiable rulers; and a proverb, 'Under the crozier life is good', has survived to prove it.

It is true that dark impulses occasionally rose to the surface in Germany, a country that had been so often ravaged by war. In the age of the Enlightenment, the principality of Ansbach was ruled by an extremely cruel Margrave, brother-in-law of Frederick the Great, whose only passion was shooting; his habit of taking pot-shots at his own subjects earned him the nickname of 'the Mad Margrave'. He died of apoplexy at the age of forty-five, and at his funeral the common people broke through the guard of honour and danced round his coffin. But his successor who had been brought up in the French tradition, a man of culture and an ardent music-lover, displayed all the qualities of a most worthy prince.

An attempt has been made to view the baroque as the product of a still-feudal society whose economy was basically agricultural. This is the conclusion drawn by Victor-L. Tapié from his knowledge of the situation in Central Europe. On this view, the baroque would tend to have a rural character, whereas in fact it is an art of the court, essentially urban. Furthermore, the baroque age was a period of great commercial and even industrial development, particularly in the eighteenth century.

Other historians have claimed to see a link between classicism and the bourgeoisie; but the facts are against such a narrow interpretation, for the upsurge of the bourgeoisie in the eighteenth century should have favoured the development of classicism, whereas on the contrary this was the age of rococo, a 'super-baroque'. It would, I think, be truer to say that baroque art is the product of a Catholic and monarchic society, whose highly complex elements were united spiritually round God, and in the temporal sphere round the prince.

It was in the strongholds of Calvinist power, in Germany and especially in the United Provinces, that there existed an exception to the system we have just described. Democratic institutions in Holland were, it is true, combined with a principate which, although parliamentary in origin, was confined to the House of Orange—except for a brief eclipse—throughout the seventeenth century. However, the princes of this house, like other members of the nobility, conformed to the bourgeois ethos by living in rich houses rather than palaces. It is true that they built a few great country houses; but, strangely enough in a country where so much else has been preserved, these have almost all disappeared. The sole exception to this rule of austerity

that still exists today is the Huis ten Bosch, the 'house in the forest', near The Hague, with its *pl. 24*
central rotunda, the Orange Room, adorned by Amalia von Solms with allegorical paintings
in honour of her dead husband the Stadholder Frederick Henry. This is a modest, somewhat
maladroit example of the princely ostentation which characterized the baroque age elsewhere.
But it is noteworthy that the Catholic southern Netherlands, under the rule of Spain and later
of Austria, were in a similar situation; the only building anywhere in the Netherlands which
is comparable with a palace in Rome or Germany is the old town hall in Amsterdam. This is *pls 115–6*
a fine expression of the humanist spirit, designed by the famous Constantijn Huygens, secretary
to Frederick Henry. It addresses its learned imagery not to the courtier but to the citizen, and is
dominated not by the monarchic ideal of power but by that of justice. All the elements of
nature, earth, air and sea—or rather their mythological equivalents—are employed to celebrate
the greatness of Amsterdam in peace and democratic order.

In spite of the opposition of the Arminians, which was quickly suppressed, Calvinist church
buildings are deliberately abstract, making no attempt to channel the ideas of the faithful, their
complete bareness leaving complete freedom to individual devotion. This is the reverse of the
Catholic baroque. 'Nothing to attract the eye or hold the attention', writes the Calvinist E. G.
Leonard. 'Everything predisposes to an interior emptiness, to a vacuity of the spirit, which,
being nothing, has nothing to give, and is in a state of waiting. The believer has only to close
his eyes, and the poor walls, the simple ceiling, the plain furnishings, disappear; he is no longer
between these walls, beneath this ceiling, he is in the immense void filled with God.' *pls 335–6*

The Dutch artist, deprived of palaces and churches to decorate, was compelled to work on a
smaller scale. Painters painted easel pictures that could find a place in bourgeois homes; sculp-
tors worked on busts and memorials. Businessmen with little imagination demanded that
artists should provide them with representations of the world in which they lived. In this atmos-
phere of bourgeois peace and security scholars found a favourable climate for their work. 'What
other country is there,' wrote Descartes, 'where one can enjoy such complete liberty, where
one's sleep is so untroubled, where armies always stand ready to guard one, where poisonings,
treasons, and calumnies are so seldom seen, and where there remains so much of the innocence
of our forefathers?' At a time when politicians of other countries were dogmatizing on royal
sovereignty and Divine Right, Hugo Grotius laid the first principles of the Law of Nations,
which were to earn his country the pre-eminence in international law which it has retained to
this day. While the presses of Antwerp concentrated on the production of missals and religious
manuals, Amsterdam and Leyden were achieving the high standard in the publishing of
learned books that they have kept until the present day; nowhere but in Leyden could type be
set in all the languages of the globe.

The peacefulness that informs Dutch painting should really be seen as a release of tension, if
one recalls that while these calm pictures were being painted the heroic little country was engaged
in a bitter struggle for existence, was politically disunited (like all democracies), and was torn
by the same religious controversies on the subject of grace and predestination that racked certain
Catholic countries.

4 Ethic and Aesthetic

In the transition from Renaissance to baroque, the centre of gravity of European art shifted from the object to the subject; logic gave place to rhetoric.

Whether a Renaissance artist chose to pursue *beauty,* the higher reality, as did Raphael, or *appearance,* the immediate reality, as did Van Eyck, his aim was truth. The work, once completed, became in a sense detached from its creator and took on an *objective* value, offered for admiration.

The artist of the baroque age sought, not to attain a truth, but to demonstrate it; here the spectator enters the process as an essential element in a dialogue with the creator of the work. The work is no longer an end but a means. Recent studies have shown that the methods employed by the artists of this period were borrowed from the technique of classical rhetoric, as it was known from the works of Cicero, Quintilian and Aristotle. Curiously, the theories themselves were propounded by classical artists and theorists; the classical temperament was better suited to this sort of critical analysis than the impulsive baroque mind. The essentials of a great orator, said Cicero, are to instruct, to delight, and to move (*docere delectare et movere*). The same terms are used by Poussin, by his admirer Bellori, and also by Boileau, who, however, neglected the third. The artist must pursue his art in order to instruct (*docere*) while giving pleasure (*delectare*) to the spectator; and he must also move him (*movere*), that is stir him to action.

Baroque art is thus an art of persuasion; this is obviously true of religious art, but also applies to the artistic ethic of the period as a whole. The methods of persuasion employed by artists are expression and metaphor.

Expression is the externalization of the passions of the soul (to use Descartes' term); it forms the subject of the second book of Aristotle's *Rhetoric.* The passions are externalized through action, which is an imitation by the body of the movements of the soul. The lectures of the Académie de Peinture et de Sculpture, which was founded in France in 1648, continued throughout the second half of the seventeenth century to deal mainly with theories of expression. In 1678 Le Brun gave a lecture on the subject which was printed in 1698; and another lecture of his, of which unfortunately only the outline has survived, deals with the art of knowing men by their physiognomy. Le Brun uses Descartes' theory of the passions as a basis for his account of expression in general, which is followed by a discussion of the modes of expression, admiration, esteem, veneration, delight, scorn, horror, dread, simple love, desire, hope, fear, jealousy, hatred, madness, physical pain, joy, laughter, weeping, anger, extreme despair, and rage, and the ways of rendering them.

The *Cabinet des Dessins* in the Louvre possesses a large collection of sketches which were made to illustrate Le Brun's second, lost lecture, and which, by virtue of his position as 'first painter to the king', entered the royal collection on the artist's death. In these sketches Le Brun juxtaposes human facial types with heads of animals, thus anticipating the latter-day students of 'morphopsychology'. Lavater, in his *Mémoire sur l'art d'étudier la physiognomie* (1772) and his *Fragments physiognomiques* (1774), echoes the theories of Le Brun; he studies the face, 'the mirror of the soul', not as the physiognomists or morphopsychologists of today would do, in its structure, but in its play of expressions; he had a great admiration for Le Brun's drawings, which artists still came to study in the Louvre throughout the eighteenth century. Le Brun himself was inspired by the work of the founder of physiognomy, the Neapolitan natural philosopher Giambattista della Porta (1541–1615), author of a treatise, *De humana physiognomia,* which was translated into French in 1655. A direct reflection of Della Porta's theories is to be found in the *Entretiens* of Félibien (1685).

pls 34–5

Expression occurs by means of bodily movements governed by the passions of the soul. The impulse of the passions produces within the person who is determined to remain in command of himself—an essential principle throughout the baroque age—a profound conflict which artists expressed by contrary movements, either of the head and the body, or of the eye and the head. There is a whole system of gestural rhetoric, which appeared at the time when passion itself first found artistic expression, that is in the fourth century BC in the tormented art of Scopas. Artists of the seventeenth century employed the rhetoric of gesture constantly, either having observed it in antique art or more probably borrowed it from the art of acting, of which it is still an essential element. 'Watch the way I do this,' the actor Pierre Lafond used to say to his pupils. 'This is essential in the theatre. When my body is here, my head is the other way; this is the only way to give forms their full value.' This technique of contrary movements balancing one another round one or several axes is so essential a part of all baroque art that in the rococo phase it inspires the technique of ornamentation, and even governs the whole architectural and decorative design of a building.

pl. 43

In Italy at the time of the Counter-Reformation, poets turned to the expression of religious feeling, and in order to touch the emotions of the faithful paraphrased the lamentations of the saints. This lachrymatory verse was so successful that it was put together in collections (*Nuova raccolta di lagrime dei più illustri poeti,* 1593). One of the favourite themes of such pious poetry was the 'Tears of St Peter', to which the Italian writer Tansillo devoted 336 verses. The French poet Malherbe imitated him in one of his early poems, which he later disowned, but which was an enormous success. 'The Tears of the Magdalen' was another popular subject. Painters found a rich source of inspiration in these two themes, particularly the second; the theme of the 'Penitent Magdalen' offers some of the best material for study for anyone wishing to understand the conflict between asceticism and sensuality within seventeenth-century religious feeling.

pl. 38

Throughout the seventeenth and eighteenth centuries, artists—whether we classify them as classical or baroque—developed their technique by means of exercises in the expression of the passions. Fragonard, for example, drew a group of heads expressing the terror caused by a lion

(*Cabinet des Dessins,* Louvre). Such exercises could also attract sculptors; thus the twenty-year-old Bernini, as a prelude to his whole artistic achievement, carved the *Blessed Soul* and the *Damned Soul*. These two busts, in which the artist, freely and with no reference to any particular theme, portrays two extremes of expression, joy and suffering, may seem to us naive and somewhat artificial, but they are nonetheless essential to an understanding of his art and of baroque art as a whole.

pls 36–7

The other technique of eloquence defined by Aristotle is metaphor. This is the indirect approach, and consists in using the qualities of one thing to express those of another, thus avoiding the dryness of mere definition and reinforcing the expression by arousing the imagination. In the plastic arts, metaphor takes the form of allegory, and this underlies the whole immense symbolic repertoire of the art of the baroque age; it was employed by both classical and baroque artists, the former often proving more obscure than the latter. Despite recent attempts to decipher them, the mythological allusions of Poussin's paintings are more difficult to comprehend for the modern mind, unfamiliar with humanism, than the systematized symbolism of the monastery of Melk or the Amsterdam town hall. But seventeenth-century man, steeped in biblical and classical learning, found Poussin's allegories not only accessible but a source of the delight which, for Poussin, was the object of all painting: they produced a reverie of the imagination. From this point of view, the language of classicism was certainly less easy for the popular mind to follow than that of baroque, which offered a *mise-en-scène* calculated to produce an effect on the simplest understanding. The complexity of baroque, charged as it is with mystery, by no means alienated ordinary people; on the contrary, it captivated them. When the popular imagination enters the realm of plastic art it shows a spontaneous tendency towards the baroque; this is well illustrated in the famous Palais Idéal of Hauterives, built between 1879 and 1912 by the postman Cheval. This creation is, in fact, the last echo of the myth of the enchanted castle, expressed in literature by Ariosto, Tasso, and La Fontaine (in his novel *Psyché*), and in art by so many baroque buildings.

PL. X

pls 29, 115–6

Influenced by the persuasive pen of Emile Mâle, the imagination of French readers has been captured by the religious symbolism of the Middle Ages; and the iconologists, led by Erwin Panofsky and Rudolf Wittkower, have studied the pagan symbolism of the Renaissance and of modern times. But the religious and secular symbolism of the baroque age has somehow been regarded as of less interest. Baroque symbolism falls heir to the medieval tradition (which it certainly does not reject completely, as has sometimes been claimed); it offers a rich field of study, which, however, demands great classical and theological learning. If we take the trouble to try to 'read' the allegories that abound in the architecture of the baroque monasteries, we cannot fail to be moved by their poetic quality. What subtlety there is in the symbolic design of the monastery of Melk, a sacred triangle formed by the marble hall (Marmorsaal), the library and the church. In the marble hall, *Hercules heroicus,* once chosen as an emblem by the emperors Nero and Commodus, symbolizes the prince, or excellence in the human sphere; in the library *Hercules Christianus,* adopted in the Renaissance as a speaking emblem of Christ, signifies that this excellence can only reside in Christian perfection, which the prince must possess. The

pl. 29

'mental fight'—the psychomachy—which is the theme of the Marmorsaal, and the celebration of divine wisdom which is the theme of the library, are united in the sanctuary where the triumph of the Church Militant is symbolized by the martyr apostles Peter and Paul, the two athletes of the faith who constitute the Christian Pillars of Hercules.

Confronted by a multiplicity of symbols, the mind leaps from form to form, from subject to subject, in an intoxication of ideas, glad in the end to find the beauty of an overriding order in so much complexity. A whole system of interchanges between pagan and Christian mythology reminds us that baroque humanism reconciles revelation with the wisdom of antiquity. One of the most remarkable examples of this reconciliation is the sanctuary of Bom Jesus do *pls 33, 204* Monte, near Braga in Portugal, a 'holy mountain' on the slopes of which are set the Stations of the Cross. Adjoining some of the Stations there are fountains, each dedicated to one of the gods of Olympus, some of whom also represent planets. In the chapel of the Resurrection there is a fountain showing Hercules the Christ-Bearer, who has truly found his right setting here. Half-way up the slope the Way of the Cross is interrupted by a superb stairway, the *Escadorio dos cinco sentidos,* on which a magnificent orchestration of fountains and statues illustrates, on five successive levels, the five senses of Man, represented by characters from the Old Testament and originally also by mythological figures (these were later removed by the purists of the Inquisition). At the foot of the staircase, water gushes in a magnificent fountain from the five wounds of Christ. It is thus clearly conveyed that the Saviour's sufferings have atoned for the sins committed through the desires of the five senses, which the priest touches at Extreme Unction. I think the symbolism is more complex than this; the fountain of the five senses, from which flows water symbolizing the blood of Christ, also teaches us that he possessed our human nature in its totality. The association of the Old and New Testaments with mythology, the stars and the various sensory aspects of human nature make the holy mountain a kind of symbol of the universe, considered, in the medieval view, as polarized about a single end which is Redemption. Bom Jesus do Monte was created between 1723 and 1774, the Stairway of the Five Senses being built as a result of a donation from the Jesuits of Braga, to whom we need not hesitate to attribute the symbolic conceptions which it embodies.

Anything might serve as a pretext for religious eloquence, above all the circumstances of death. At the funerals of princes, immense catafalques called *castra doloris* were set up in the church, on which allegorical figures and gesticulating skeletons affirmed the vanity of the world, while the preacher delivered the funeral oration (a form of eloquence of which the French preachers Bossuet and Massillon were the greatest exponents). Baroque tombs and funerary chapels remain as evidence of these ceremonies. Emile Mâle has shown how the image of death reappeared in Italian art as a reaction against the funeral imagery of the Renaissance, which had celebrated the virtues of the deceased and regarded death as an opportunity for the exceptional man to achieve immortality through fame. Several later historians have drawn attention to this extraordinary baroque rhetoric of death, an astonishing example of which survives today in the 319 marble funeral slabs, each one the tomb of a knight, which form the floor of the cathedral of St John in Valetta, Malta. It has perhaps been wrong to regard this new approach to the

ceremonial of death only as an austere meditation on mortality, inspired by a Pascalian view of human destiny. This is, it is true, the spirit of many works by Georges de La Tour, Zurbarán, Rembrandt and others, and of the category of still-life known as the *Vanitas,* a favourite subject of all the schools of the seventeenth century; but in considering baroque funerals altogether too much emphasis has been put on death, and too little on the pomp and circumstance which surrounded it. One has only to read Bossuet's *Oraisons funèbres;* the orator would not dwell so lovingly on the glory of the illustrious dead if his sole aim were to demonstrate man's insignificance in face of the greatness of God. In the presence of the mortal remains of the Great Condé, he cannot resist extolling the *immortality* of his genius. In a number of tombs, chiefly those of military heroes, death appears not as a bogy, reminding the Christian of the uncertainty of his destiny, but as the bringer of glory. Glory can be won only by death, but only death (strange paradox!) confers immortality; the ephemeral living being must perish before man can enter the ideal world, the home of gods and heroes. On the tomb of Marshal Maurice de Saxe by Pigalle in Saint-Thomas, Strasbourg, and on that of Louis William, Margrave of Baden-Baden and comrade-in-arms of Prince Eugene, known as *Türkenlouis* for his prowess as a slayer of Turks (d. 1707), death is shown only as crushed underfoot by the hero, amid a host of allegories that explode around him in a burst of glory.

pls 30–1

In an age in which every object embodied a message, none did so more than the instrument of religious eloquence, the pulpit, which in Dutch was called *de stoel der waarheid,* 'the chair of truth'. In Bohemia, Austria and Silesia we find some pulpits in the form of a fully-rigged ship; others in the form of a net for those 'fishers of men', the priests; others in the form of a whale from which Jonah, the preacher, emerges victorious over death. In the cathedral at Córdoba the pulpit is supported by huge effigies of the four Beasts of the Apocalypse. In Flanders the pulpit often constitutes a veritable encyclopaedia of religious truth, as if the priest had shaped it with his words.

pl. 32

pl. 276

Architecture itself carries a message of truth for those who can read it. The two strange free-standing pillars, inspired by Trajan's Column, which stand before the Karlskirche in Vienna, the church built by the Emperor Charles VI in thanksgiving for the end of an outbreak of plague, are multiple symbols. They represent *Constantia* and *Fortitudo,* virtues proper to the church's patron St Charles Borromeo, and an allusion to Charles VI's own motto; and they are also Pillars of Hercules, the imperial emblem of Charles V and also possibly a reference to Charles VI's ambitions for the Spanish crown. Perhaps, too, they can be seen as Jachin and Boas, the twin columns of the Temple of Solomon, erected here by a latter-day Solomon.

pl. 169

In the strange dome of Guarini's Capella della Santissima Sindone in Turin, the contrasts of light and shade above the shrine which contains the shroud of Christ have the symbolic significance of Life and Death.

There is no architectural form more expressive than the dome, symbol of the centre of the world since the time of Nero, who in his 'Golden House' built one in the form of a planetarium which revolved to show the movements of the stars. Thus the order of the Empire was patterned on the order of the cosmos, an ancient magical idea which is also found in ancient Chinese

cosmology. Eugenio d'Ors connects the dome with the concept of monarchy. Indeed, wherever the notion of sovereignty finds expression, there is a dome—as in St Sophia, Constantinople, symbol of Orthodoxy radiating light upon Justinian's empire; and St Peter's, Rome, the emblem of Catholicity. In many baroque churches the dome depicts the heavens, peopled with saints and angels (the earliest of these celestial visions beneath a dome is perhaps the exquisite one painted by Gaudenzio Ferrari in the church of Madonna dei Miracoli, Saronno, near Milan, *pl. 321*
1534). But over a rotunda (such as the Collège des Quatre Nations, Paris, now the Institut, which once housed the tomb of Mazarin), or even in a church with a nave, but centring on a tomb (such as the Eglise de la Sorbonne, Paris, built over the tomb of Richelieu) the dome has a funerary significance derived from the early Christian *martyrium*. This in its turn was the successor of the antique *heroön*, the origin of which no doubt lay in the oldest dwelling erected by man, the round hut. This form gave us the burial mounds of Celtic chieftains, the tombs of the Medressa, the so-called Tomb of the Christian Woman in Algeria, the tomb of the Emperor Augustus, and the mausoleum of Hadrian in Rome. The receptive visitor who enters the baroque church of San Sebastiano in Milan is moved to find that it is a rotunda, a tomb for St Sebastian, Christian hero and martyr. Baroque churches are the repositories of a cultural heritage which reaches back to the very dawn of humanity.

The study of the ancient traditions of mankind in the light of the science of comparative religion and Jung's theory of archetypes tends to show that even the most sophisticated mythical constructs are founded on ancient beliefs which have persisted in the popular imagination into the age of industrial civilization. One author has argued that the subject matter of Botticelli's *Spring* stems from a twelfth-century Byzantine poem; others have seen it as a direct reference to classical sources. André Varagnac has demonstrated that this learned assemblage of allegorical riddles has its source in the ancient May festival, derived from primitive nature religion, which annually celebrated the return of spring.

The aristocrats and intellectuals of the sixteenth and seventeenth centuries were not cut off from their roots in popular culture; all of them had heard fairy tales, legends and stories of ogres and werewolves from their nurses or their mothers in earliest childhood; and these tales acted as a stimulus to the imagination which they were to exercise in intellectual speculation. Descartes, who declared that his religion was that of his king and his nurse, said that 'the charm of fables awakens the mind'. We can have no conception of the poetic world in which children of old grew up; we have rejected it.

The contact between popular culture and learned culture in the baroque world must be borne in mind if we are to appreciate how the common people could be drawn into the poetic world of baroque churches and palaces, a world which they did not comprehend but for which they felt an instinctive sympathy. The Neapolitan cribs serve to remind us of this. These anonymous human beings, who crowded the churches and filled the public places to watch festivals, have no history of their own; but they must not be ignored. By living, they did hardly more than pass life on and with it their store of fables, beliefs and natural lore; but out of their poverty came forth much of the imaginative wealth which made possible the creation of so many

masterpieces of art. Visiting the 'open-air museums' of Northern Europe and seeing the farm-houses, some dating from the seventeenth century, in which man shared the same roof with his domestic animals and his crops, one is overwhelmed by the simplicity, but also by the poetry, that was passed on from age to age. The farm was the centre of its own universe, where the farmer, as the master of nature, was sovereign, like the monarch, in his own kingdom.

The grand staircase of the Palazzo Ducale in Parma leads to the great atrium where the Farnesi held court; on the right and left are the ducal apartments, and at the far end a gigantic *pl. 44* door leads to the court theatre built by Giambattista Aleotti in 1617–19 (and now rebuilt after being destroyed during the Second World War). Like all the court theatres of the period, it also served as a ballroom. It was inaugurated by a series of masques which included the inevitable mock sea battle. The theatre thus stood at the very heart of courtly life. Paciotti, Vignola and Testa had designed the *cortile* of the Palazzo Farnese at Piacenza on a similar pattern.

Every royal or princely palace had its theatre; some even contained several, and sometimes a garden theatre like that of the Palazzo Boboli in Florence. In Bayreuth the Margravine Wil-*pl. 47* helmina, who in 1748 employed Carlo Galli Bibiena to build the exquisite rococo theatre adjoining her palace, later built the nearby Felsengarten Sanspareil, a rustic theatre constructed *pl. 349* of rocks. Some works of architecture, like the Zwinger in Dresden, are conceived as vast open-air theatres. Theatre was one of the essential features of the life of the period; it was certainly the most characteristic art form of the time, especially in the guise of opera, a spectacle which made use of all the arts, calling on the talents of architect, perspectivist, costume-designer, painter, librettist, composer, engineer, musician, singer, stage designer—and finally the spectator himself, for whom it was essentially a social occasion.

The theatre had a considerable influence on the formal language of the other arts: figures in motion were frequently based on the conventions of stage movement, in particular the ample *pl. 43* gestures required on the baroque stage (Bernini's *St Longinus* in St Peter's). There are some paintings which take the form of plays performed before spectators who can be seen in galleries (Guido's *Massacre of the Innocents*). In the Cornaro Chapel in Santa Maria della Vittoria, Bernini *pl. 40* (himself a librettist and theatrical designer) stages the *Ecstasy of St Teresa* for the members of the Cornaro family who sit chatting in boxes on either side. The Asam brothers follow his example at Osterhofen, where they have installed lifelike painted figures of the founders in stage boxes *pl. 42* flanking the high altar. In the Oratory of San Lorenzo, Palermo, Serpotta carves religious scenes on minature stages, complete with curtains. From the theatre, no doubt, came the taste for monumental staircases, and for palaces built with the effect of a series of perspectives; real palaces seem gradually to have come to resemble the sham ones created on the stage. A study of the relationship between the notion of space in the theatre, and in painting and architecture, would undoubtedly throw light on the bonds of understanding between these arts, for it was painting that anticipated the theatre, as is shown by the conception of Raphael's *Dispute* in the Stanza della Segnatura in the Vatican.

An important form of theatrical activity was the allegorical masque, often in the form of a ballet put on for some ceremonial or political occasion. The sovereign himself did not disdain

to take part in these dramas, acting his role of monarch in costumed guise. In a carrousel (a tournament in costume) in 1662, Louis XIV, dressed as a Roman Emperor, led his own group *pl. 39* of knights, or 'quadrille'. In the entertainments he gave at Versailles in 1664, the theme of which was *Les Plaisirs de l'Isle enchantée*, 'The Pleasures of the Enchanted Island', Louis XIV himself, costumed as Ruggero, stormed the palace of Alcina. The celebrations organized in Dresden in 1719 for the marriage of Augustus the Strong of Saxony and Maria Josepha of *pl. 349* Austria included a masque of the planets in which Augustus appeared as Mars; the myth of Jason, a symbolic reference to the Order of the Golden Fleece conferred on Augustus by the Emperor, was performed on the Elbe. In Vienna in 1669, on the occasion of another wedding celebration attended by the ambassadors of all the states of Europe, the 'Glory of the House of Austria' had been the theme of a masque in which a temple of Eternity and Glory opened on the roof of the Hofburg to reveal a statue of the Emperor, and which culminated in the appearance, *deus ex machina,* of the Emperor himself.

These entertainments, whether they took place in the theatre, the palace or in the open air, lasted several days or weeks, sometimes even months. In 1607, several hundred guests came to the castle of Bisc in Hungary for the wedding of Judith Thurzo, second daughter of György, Grand Palatine and kinsman of Erzsebet Bathory, the 'Bloody Countess'; they stayed at the castle for nine months, making merry, hunting, feasting and gaming while they waited for the entertainments to begin again to celebrate the birth of the first child. The most extravagant of these festivities, and a model for all the others, were those given in 1579 for the marriage of Francesco de' Medici, grand duke of Tuscany, and the enchanting Bianca Capello. In preparation for them the Neo-Platonic Accademia Fiorentina worked for a year to provide Vasari and Allori with symbolic material. Decorators, poets and musicians could have wished for no more splendid theme than the marriage of two famous lovers (*Amor et Arma*), and through them of the leading cities of the Renaissance, Florence and Venice.

Even in the remotest overseas colonies, cultivated people had a passion for such festivities; a description published in 1734 has preserved a record of the 'Eucharistic Triumph' held in Ouro Preto, Brazil, in 1733 to accompany the solemn transfer of the Holy Sacrament from the chapel of the Rosario to the newly-built parish church of Pilar. The procession included figures representing the Planets, the Gods of Olympus, the Seasons, the Parts of the World, the two mountains of Ouro Preto, the town itself, the parish church of Pilar, Turks and Christians, heroes from Roman history and characters from Scripture, all '*vestidos a tragica':* costumed like actors.

The Jesuits did not neglect the educational possibilities of the theatre. They created a whole sacred drama, putting on the stage martyrs and saints (taking care not to forget their own) to be acted by the pupils of their schools both in Europe and overseas.

The actor, that despised figure who in the seventeenth century did not even have the right to Christian burial, may thus be seen as typical of the whole baroque age, when man seemed to act his life rather than live it, continually projecting himself into a fictitious, ideal existence. Works of art themselves, like stage sets made of canvas, marble or stone, seemed constantly to beckon the spectator to become an actor in the play.

It was in seeming, rather than in being, that the individual found his true substance. Baltasar Gracián justifies his choice of the peacock as a model by debating the much-discussed problem of the relation between reality and appearances. 'Of what use would reality be without appearances?' he asks. 'The greatest art is the art of seeming . . . A little ostentation is worth more than much hidden reality . . . Outward show . . . gives a second life to all things'. God himself is called as a witness to absolve the peacock from blame; he has sanctified ostentation by creating light (and thus glitter) first of all.

But a necessary concomitant of ostentation is dissimulation. According to Gracián a man must make himself impenetrable in order to carry on the struggle against his fellow man: a masked duel. A French moralist, the Chevalier de Méré (1610–84), arbiter of manners and taste, letter-writer and critic of Voiture, goes so far as to say that one should be 'a good actor in life', 'regard what one does as a play, and imagine one is acting a part'.

But if a mask is to be effective it must constantly be changed. Inconstancy is one of the most popular themes among seventeenth-century poets; we find it celebrated by the Frenchman Du Perron, who raised a 'temple to Inconstancy'; and by Etienne Durant, who dedicated some *stances* to it. John Donne devotes an elegy to *Variety:*

> The heavens rejoyce in motion, why should I
> Abjure my so much lov'd variety?
> Pleasure is none, if not diversified . . .

Marino extols the 'New Chameleon', *Il Novel Cameleonte;* while Etienne Durant wonders how it is possible to be anything but inconstant, since

> *Le passé n'est plus rien, le futur un nuage,*
> *Et ce qu'il tient présent, il le sent fugitif,*
> 'The past is nothing, the future a cloud,
> and what he holds present he knows is fleeting'.

As the Portuguese poet Agostinho da Cruz puts it; all things change at last:

> *Tudo se muda em fin, muda se tudo.*

These quotations, collected by Jean Rousset, the historian of the literary baroque, could be matched by many more. One hero of the age is Proteus, and another is Hylas, the inconstant shepherd of d'Urfé's long novel *L'Astrée,* who became a favourite figure in the pastoral literature of the early seventeenth century. From Shakespeare, Lope de Vega and Corneille to Goldoni, Marivaux and Beaumarchais, masks, pretence, disguise, doubles, lies, shams, decoys and misapprehensions were the very stuff of comedy and also of opera. In the work of Marivaux and Beaumarchais, especially, the human being seems almost to dissolve in the myriad facets of seeming. The most moving of all expressions of this flight from the self is perhaps Mozart and Da Ponte's *Le Nozze di Figaro,* a lovers' roundabout in which no one knows where to bestow his love, each lover believes that he loves someone who is not what he loves, pretends to love

one in order to be loved by another, and, thinking to meet one, meets another or sometimes even a false semblance of himself; only the innocent and vicious Cherubino, who like Hylas is the 'lover of all women', has any solidity. At the end of the course each individual finds himself to be what he always was, and what he believed he did not wish to be; in an intricate dance human beings are fragmented as they are in the mirrors of baroque *châteaux*. The music of Mozart captures this flight from the self in a masterpiece touched with deep emotion.

Impermanence and change were the dominant themes of baroque opera; the favourite scenic device was now the transformation scene, an instant change from sunlight to storm, sea to land, forest to palace; in a world where all was ephemeral, the characters themselves, whether borrowed from Ovid or from Italian romance, were similarly lacking in consistency. The true quality of the characters seems to reside in the 'enchantment' that carries them out of themselves and changes them into beast or god, fairy or demon, finally to become men again, as if this 'ordeal by metamorphosis' were a kind of initiation into humanity.

In baroque art the object offered for the spectator's admiration is no more straightforward in its nature than the spectator himself. Its function is to astonish, excite, enchant, transport. The poet's true goal is wonder, writes Marino; he must know how to stupefy, or he deserves a drubbing:

> *E del poeta la fin la maraviglia:*
> *Chi non sà far stupir veda alla striglia.*

Even today, in several Romance languages, the strongest word of praise for beauty is 'stupendous'; *stupendo* in Italian, *estupendo* in Spanish and Portuguese.

In eighteenth-century gardens there is one feature the name of which is a gasp of astonishment, the ha-ha. This is the ditch or sudden drop which, at the end of an avenue, conceals the wall of the park so as not to interrupt the vista—causing people taking a walk, coming to the edge of the drop, to exclaim in surprise. Descartes, the master of reason, who himself read romances for amusement, said: 'The nature of men is such that they value only those things which arouse their admiration, and which they cannot entirely grasp.'

Accustomed as we are, since romanticism and existentialism, to the probing of the self to its very depths, we might perhaps be tempted to see this perpetual dissimulation as an escape from reality. Present-day French Catholics, still more or less Jansenists at heart, deny the possibility of praying in a baroque church, since for them prayer consists only in contemplation, not in 'effusion'. It was not so in the seventeenth century, when each believer could in his own heart come close to the mystery of the 'effusion' of the saints whose gestures were displayed in all parts of the church. Are we justified, in the name of truth, in condemning that ostentation which was the accepted form of self-expression in the baroque period? We tend to think of semblance as the negation of reality, or a garment at the most. But is not appearance the revelation of essence, its shining forth—as the Book of Proverbs says, its splendour? Pure Being consented to come down into the world of semblance—our own—taking on our nature through the Son who is, says St Paul, 'the effulgence of his glory'. All the Christian mystics have celebrated

49

the 'beauty of appearances'; St Augustine, St Francis, the Blessed Henry Suso, and even St John of the Cross, most profound of the profound, were all filled with the joy with which the very stones and stucco of the baroque churches vibrate, amid the sound of organs, the glitter of gold and the smoke of incense.

Why should we see as mere vanity the bearing ordained by baroque ideas of decorum? It was not weakness, surely, that made each man take as his guiding principle the nature of the king, thus imposing on himself 'an order of majesty'. The Chevalier de Méré advises the gentleman to be 'a good actor in life', but he also says: 'to appear so, one must in fact be so'. One must act, but act out one's character—fitting the mask to the face, appearance to reality.

Consequently, are not all these masks and disguises really attempts to achieve a matching of the real and the ideal? The men who so much enjoyed acting a part were not all mere frivolous courtiers; among them were shrewd ministers, astute politicians, great military leaders, skilful financiers, economists, engineers, artists, pious churchmen—and even saints. St Ignatius of Loyola, in his *Exercises,* recommends a kind of spiritual training which uses audio-visual methods; in other words, 'appearances'. For St Philip Neri, music was the vehicle of spiritual elevation; he passed on this tradition to the Oratorian Order, and Borromini built a music room next to the church of the Order in Rome.

The search for a true equilibrium between being and seeming produced baroque humanism. It must, however, be admitted that this perpetual swing from the self to the 'other', this need to escape, to be 'transported', suggest by their excess an anxiety which must have had both spiritual and psychological origins. It is true that in the seventeenth century the Christian faith ran deep; but the Catholic of that time was too much a Catholic by self-persuasion not to have within him some hidden anguish. The serenity of the Church had been profoundly shaken by the Renaissance and the Reformation. If Christians indulged their sense of the fictitious, they were seeking consolation in pagan myth for the anguish caused by the uncertainties of Divine Grace. This desire for escape, this passionate need to project one's life by means of make-believe into an ideal existence—whether expressed in the classical or the baroque mode—surely arose to fill the void left by the contemplation of a future life in which Christian man had passed so many centuries, measuring this life in terms of the hereafter, and awaiting death as a day of birth.

In the secular field, seventeenth- and eighteenth-century man must also have instinctively sensed the hollowness of a civilization based on assumptions which were being contradicted, slowly but surely, by the progress of philosophy and natural science and by the imperatives of life in a new society.

The condemnation of Galileo by the Holy Office in 1633 deeply disturbed many thinking men; it caused Descartes to retreat from some of the consequences of his doctrines and obliged him to declare in his *Principes* that the earth was stationary, although, as he confessed in a letter to Mersenne, he was convinced of the contrary. In 1701, as a counterblast to the learned journals that were spreading new ideas throughout Europe, the Jesuits founded the *Journal de Trévoux* in which one Père Castel, whom Voltaire called the 'Don Quixote of mathematics', undertook a long refutation of the theories of Newton and Leibnitz. As late as 1766, the torture and

execution of the young Chevalier de La Barre for the crime of defacing a crucifix caused a scandal which Voltaire publicized vigorously throughout the Europe of the Enlightenment. Facts such as these are evidence of deep contradictions within European civilization, contradictions which drove spirits tormented by uncertainty to take refuge in a hedonistic mirage, an artificial world.

The critic Jean Starobinski, in an attempt to dispel the 'myth' of the eighteenth century, has described it as traversed by drama, anguish and uncertainty, moved by powerful undercurrents which were to unleash the revolutionary apocalypse. And yet, in the Louvre or at Versailles or in the Wallace collection in London, looking at the French art of the period, one inevitably finds such an interpretation hard to accept. Was this the age which was to suffer the birth pangs of the modern world? Never in the history of the arts has there been a century in which there was such a gap between the serene image which society had of itself and the dark reality of the hidden depths. Beneath this mask of optimism, the collective psyche of the French nation was slowly becoming charged with violence. The aristocracy was nursing its revenge for the humiliations inflicted by Louis XIV; the bourgeoisie for being excluded from the centre of power by Louis XV; the oppressed masses were losing confidence in their natural protector, the king. No longer the father of his people, the king, in the person of Louis XVI, was to become the scapegoat for all their ills. Meanwhile a 'censor' prevented all aggressive impulses from crossing the threshhold of consciousness, and instead of the expression of reality here were the myths of reason and sensibility. To this mask of civility we owe the most amiable artistic style in history, a style which gave rise in the tragic nineteenth century to the myth of a golden age, the century of the sweet life.

Posterity has regarded Descartes as the epitome of seventeenth-century rationalism; it therefore comes as something of a surprise to discover that his career was that of a ne'er-do-well, a drifter, a thoroughly unstable character. This man who was one day to abandon a book for fear of finding himself in conflict with Catholic orthodoxy began his career by enlisting in the Calvinist armies of Maurice of Nassau; he was then twenty-two (1618). After journeyings which took him as far afield as Poland and Hungary we find him in the army of the Catholic Duke Maximilian of Bavaria, still refusing his pay so that his enlistment should remain an act of free will. Who knows what dreams of chivalry may once have possessed the author of the *Discours de la Méthode*? He eventually 'demobilized himself' and resumed his travels; and even when, in Holland, he at last found an atmosphere congenial to his work, he continued to move about from town to town. What demon possessed him to settle first in Franeker, then in Amsterdam, then in Daventer, then Amsterdam again, then Utrecht, Leyden, Santpoort ..., Leyden, Endegeest, Egmond? Descartes' life is in contradiction with his work; it demonstrates, in fact, the tension between contrary impulses which was the source of the wealth of early seventeenth-century culture.

PL. I

At a time when Europe was rent by conflicts, the spirit of individualism was emerging, although it was soon to be brought into line by the power of monarchy. The France of Louis XIV was the prime example of a society in which all things revolved round the man who embodied the State. The first half of the century also saw the emergence of powerful personalities

in art, men of genius, who created a world of their own. From the reign of Louis XIV, however, art became truly 'collective' in character, tending towards the total work of art, in which many elements are integrated in a harmonious whole; this was also a period of great achievements in music, which again is an expression of the collective, unifying impulse. From within this perfect harmony there re-emerged, in the eighteenth century, the force that was to oppose and destroy it—the spirit of individualism, an individualism that was itself profoundly self-destructive. The seventeenth-century myth of Don Juan was succeeded by the eighteenth-century reality of the Marquis de Sade.

The first master of *angst* was Caravaggio; in a penetrating study, Argan shows how his figures, reduced to mere bodies, indicate a sense of abandonment by God, of the emptiness of the world. After two centuries of light, Caravaggio created darkness—a darkness whose nature was metaphysical. Henceforward, darkness was like a mantle of nothingness, a habit of mourning, *pl. 53* enveloping the monk in his cell (Zurbarán), the philosopher in his den (Rembrandt) and the *pls 48–9* hermit in his retreat (Caravaggio), and bending the back of Crespi's St Charles Borromeo, who eats his meagre repast of bread and water without lifting his eyes from his book, for life is short: the days of man are numbered. Sometimes the darkness is broken by the short-lived flame of a candle, like the light of the human spirit burning with passionate enquiry. The *pl. 50* philosopher, in the paintings of Ferdinand Bol, appears as a specialist surrounded by scientific *pl. 51* apparatus: Rembrandt sees him, more clearly, as stripped of everything, alone with himself, *pl. 52* meditating in the soft light that falls from the window. In Velázquez this darkness, a symbol of absence, gives way to a baleful ashen half-light which overwhelms and threatens to destroy *pl. 54* the figures, reduced to trembling black shapes. In one painter alone, Terborch, the feeling for silence characteristic of Calvinist Holland mingles with the metaphysical silence of Catholic Spain. This strange conjunction shows how the anguish of the human condition (which in the seventeenth century found expression among Catholics and Calvinists alike in the great controversy on the nature of Grace) worked on men's minds in different ways. The little portraits of Terborch, withdrawn into themselves as if shrinking from the prying gaze of the painter, are shrouded in a half light borrowed from Velázquez—quivering shapes that arouse in the spectator a painful sense of the solitude of man amid an unresponsive universe.

One man carries within himself all the conflicts of the age—Rembrandt. No one is more in love with make-believe, fantasy and outward show. No one, constantly scrutinizing his own face, finds it at once so agreeable and so wretched. Being and seeming, appearance and reality, ostentation and withdrawal, are at war within him; now he piles on emotion so heavily that its effect is lost, now he reduces it to its barest essentials. Rembrandt was the greatest religious painter of his century. The stripping away of religious ornament ordained by the Reformation, the rejection of fifteen hundred years of Christian symbolism, forced him to refer himself directly to the Old and New Testaments, which enabled him to come close enough to the divine to *PL. III* feel it bearing on his heart. In his *Pilgrims of Emmaus,* the darkness becomes warm as it envelops the light which is the gentle radiance of love—a light so brief that the pilgrims cannot tell whether it is still before their eyes or already within their hearts.

PRINCIPLES

Wölfflin's antithesis

In the same subject handled by two artists of the same school, with less than twenty years between them, the classical-baroque dualism defined by Heinrich Wölfflin is apparent. Titian's painting, like an antique bas relief, is a static, closed composition in which each element, while contributing to the action, retains an autonomy analogous to that of a statue, with which it shares its qualities of weight and distinctness. Tintoretto's composition, on the other hand, is dynamic. Space does not unfold in breadth but in depth; the surface is crossed by a violent spiral movement; its vector, so to speak, is the gesture of the woman in the foreground. The action begins in front of the picture plane and continues behind it. The forms, indissolubly linked in an organic unity, are animated by a levitational force.

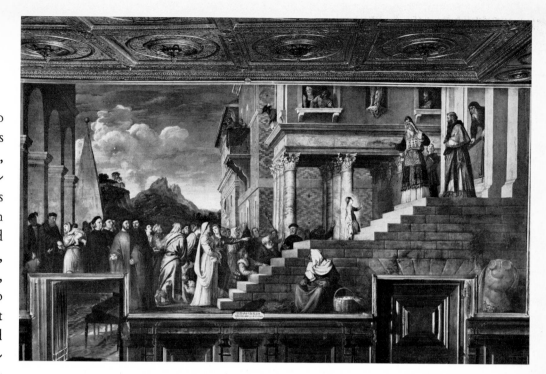

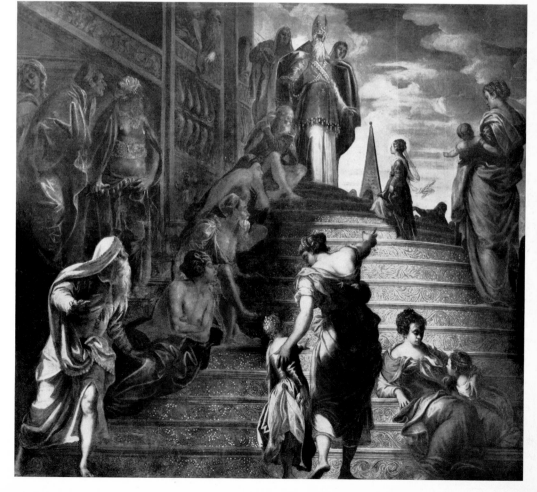

1 Titian (1489–1576). Presentation of the Virgin in the Temple

2 Tintoretto (1518–94). Presentation of the Virgin in the Temple

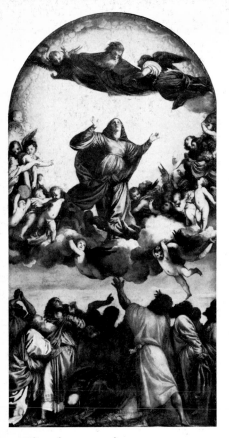

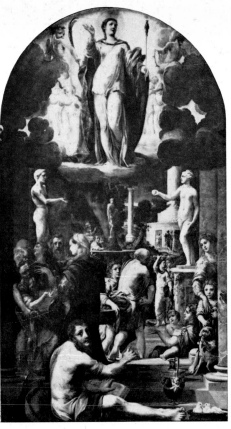

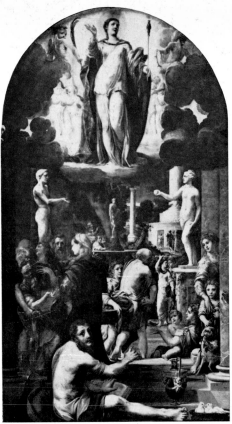

3 Titian (1489–1576).
Assumption of the Virgin

4 Girolamo Bedoli Mazzola (1500–69).
Immaculate Conception

5 Peter Paul Rubens (1577–1640).
Assumption of the Virgin

The life of forms

The three successive evolutionary stages, classicism, mannerism and baroque, are reflected i
each of these two groups of paintings. The mannerist stage introduces confusion into th
rigorous composition of classicism; the baroque recaptures the lost unity. In Titian's *Assump
tion* the Virgin is enclosed in a circle, her feet resting on clouds as if on the ground. In Ruben

6 Fra Bartolommeo (1472–1517).
Virgin and Child with saints

7 Jacopo da Pontormo (1493–1557).
Virgin and Child with saints

8 Peter Paul Rubens (1577–1640).
Mystic marriage of St Catherine

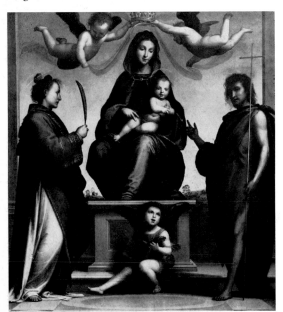

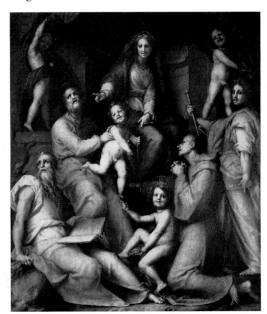

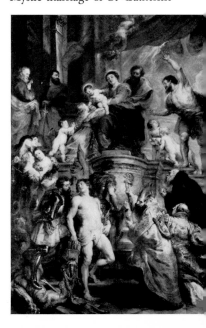

handling of the subject, with its diagonal composition, she takes wing and seems about to soar out of the picture. The *Virgin and Child with Saints* of Fra Bartolommeo is divided into equal masses as if by a balance; Rubens introduces a spiral movement into his basically static subject. Pontormo's *Virgin and Child with Saints,* with its haggard, uncoordinated figures, is filled with an undirected agitation.

Obliquity

The sacristy of the Escurial, in the Renaissance spirit, is arranged as a perspective composition. In the seventeenth century, Sánchez Coello, called upon to paint a picture to hang above the altar, broke the symmetrical perspective, which a classical artist would have retained, by letting the lines of his composition slip away at an angle.

The battle of the colonnade

The great classical-baroque debate is nowhere better exemplified than in the numerous projects made for the colonnade of the east front of the Louvre. Bernini's later projects, although much toned down by comparison with his first, are still baroque in spirit; the façade rests on a rusticated base, and the intervals are varied to produce a syncopated rhythm. The colonnade was finally built to a regular French design.

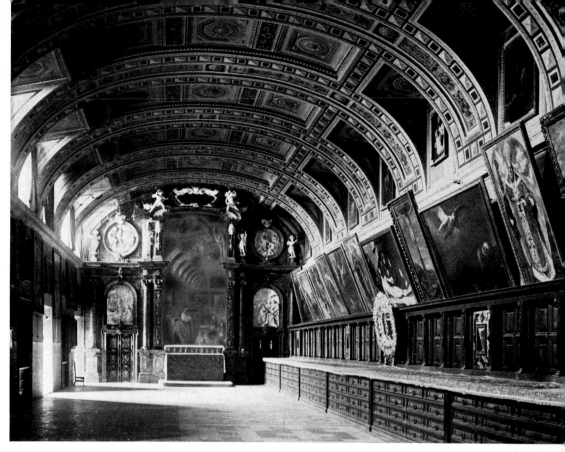

9 Alonso Sánchez Coello (1515–90). Sacred Form, in sacristy of the Escurial, Madrid

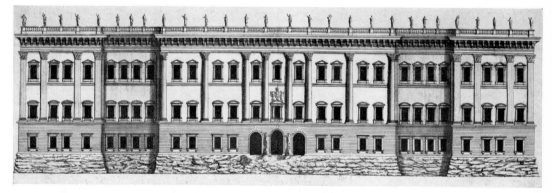

10 Giovanni Lorenzo Bernini (1598–1680). Third project for east front of the Louvre, Paris

11 East front of the Louvre, Paris, 1667–70

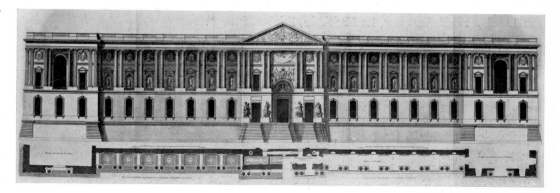

14 J. Satteling. Silver candelabrum, Amsterdam 1770

15 J. Caffiéri. Silver three-branched girandole, Paris, eighteenth century

16 Bernhard Heinrich Weye. Silver baptismal ewer and tray, Augsburg, 1745–47

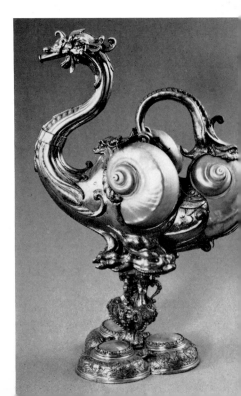

12 Detail of rocaille ornament, La Madalenha, Falperra, Portugal

13 Nicolaus Schmidt. Silver ewer, Nuremberg 1586

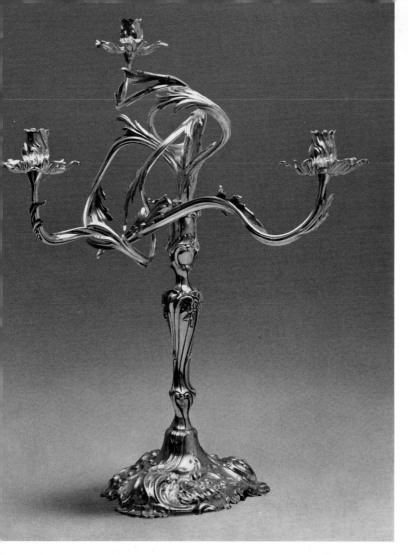

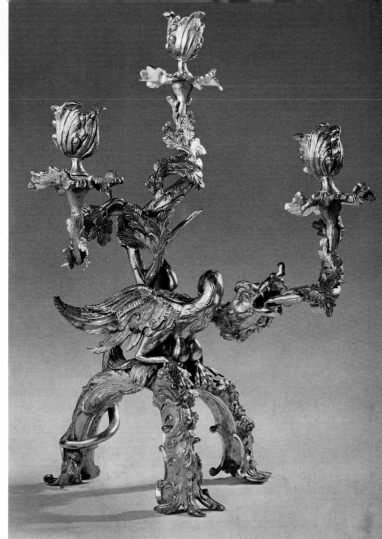

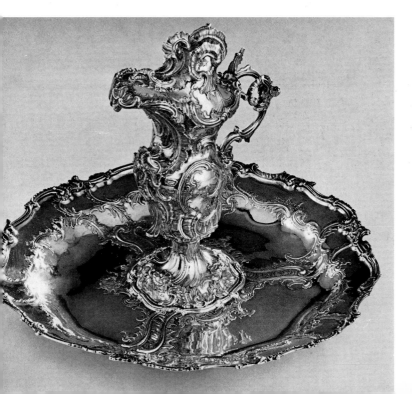

Rocaille and rococo

The word 'rococo' stems from the word 'rocaille', used to designate the shell-like forms which were used from the sixteenth century onwards in the construction of artificial grottoes in gardens. Sometimes the form of the seashell itself is reproduced; it sometimes happened that jewellers set real shells in precious mounts. More often, however, rocaille produces an ornate outline, with complex curves, which reveals little of its naturalistic origin. As the engraver Cochin saw very well, in his 1754 manifesto of protest against this style, the ductile materials used by goldsmiths and silversmiths were particularly well adapted to the complex convolutions and the rhythmic counterpoint which are characteristic of rococo.

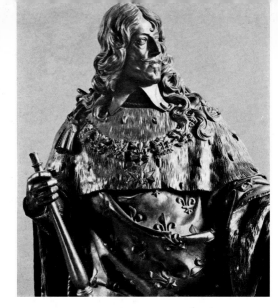

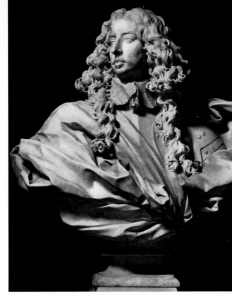

Ceremonial portraiture

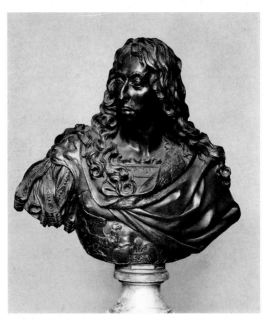

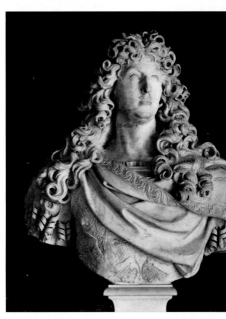

Magistrate, bishop, prince or king, the man of quality is represented as a hero, in all the intensity of an imaginary action, marked by a movement of the head which reveals the nobility of a temperament above the common run of mortals. It was Bernini, in his bust of Francesco d'Este, and later in that of Louis XIV, who created this type of heroic portraiture which inspired artists all over Europe.

17 Simon Guillain (1581–1658). Louis XIII (detail)

18 Giovanni Lorenzo Bernini (1598–1680). Francesco I d'Este

19 Antoine Coysevox (1640–1720). The Great Condé

20 Antoine Coysevox (1640–1720). Louis XIV

21 Paul Heermann (1673–1732). Augustus the Strong

22 Anon. (c. 1695). Emperor Leopold I

23 Giovanni Lorenzo Bernini (1598–1680). Louis XIV

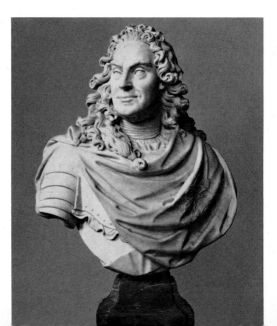

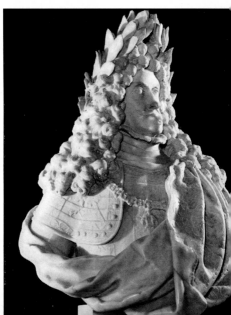

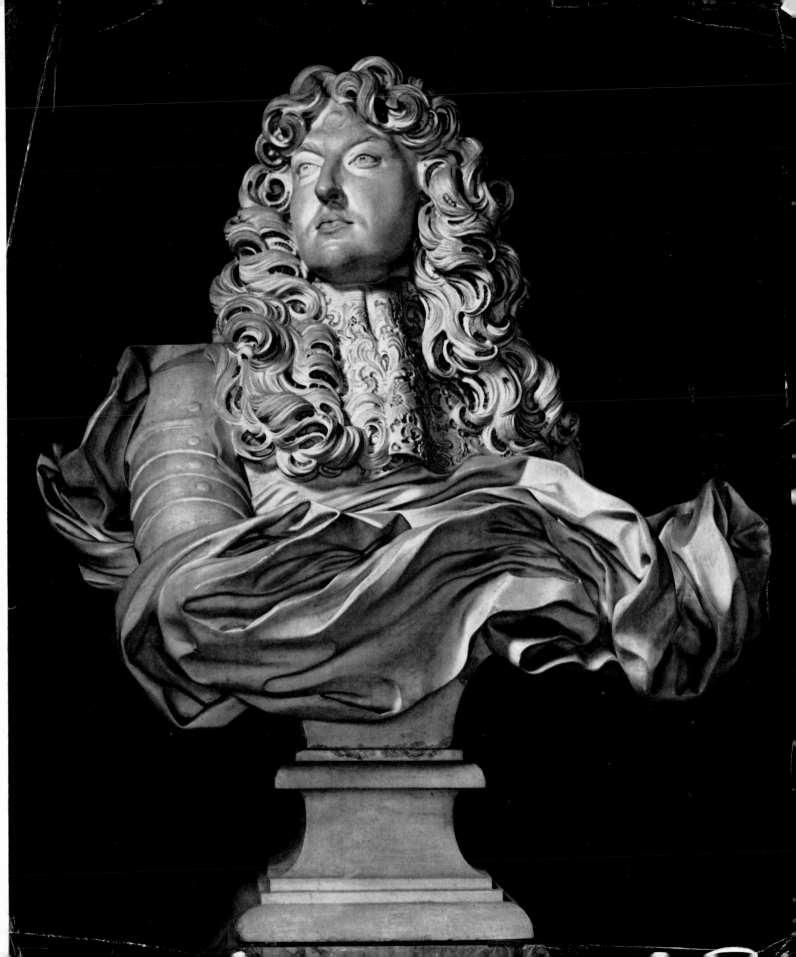

24 Jacob Jordaens (1593-1678). Triumph of Prince Frederick Henry (detail), Huis ten Bosch, Netherlands

The royal myth

In the great sculptured or painted compositions which celebrate the glory of the monarch, he is represented in a mythical universe, living on familiar terms with gods and demigods, sur/rounded by a world alive with allegories. Mythological figures foregather to illustrate his virtues, his victories, his power and his mag/nanimity.

25 Daniel Gran (1694-1757). Emperor Charles VI surrounded by allegories, Hof burg (Nationalbibliothek), Vienna, after 1722

26 Joseph Vernet (1714–89). Sporting contest on the Tiber at Rome (detail)

The life of the people The common people and the ruling classes, who in the Middle Ages lived in a commonweal based on religious faith and the solidarity inherent in the feudal system, grew apart in the course of the baroque age. The culture of the masses remained faithful to immutable ancestral traditions; élite culture invented new forms. These two universes met in the great aristocratic festivals to which the common people were invited as spectators. Sometimes, too, the roles were reversed, and the populace became the actors and the aristocracy looked on. It must not be forgotten that the wealth of artistic creation produced, at enormous expense, by the baroque age was founded on the hard labour of the common people, for many centuries the only source of wealth.

27 Giacomo Ceruti (*fl.* 1750). Woman spinning, with beggar

28 Los Hoes, farm-house at Twente, Netherlands, seventeenth century

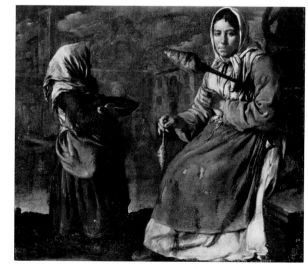

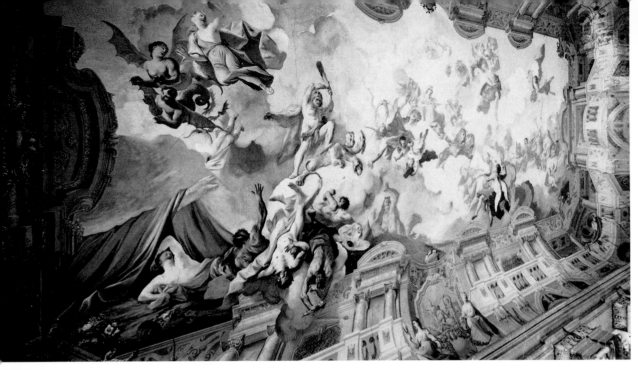

29 Paul Troger (1698–1762). Ceiling of the Marmorsaal, Melk, Austria, 1731

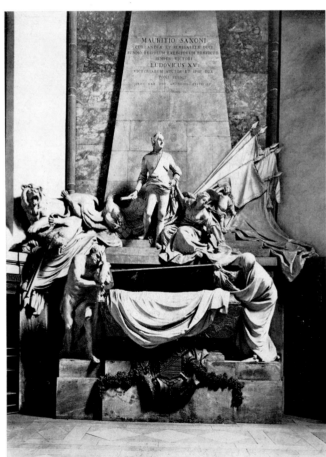

30 Jean-Baptiste Pigalle (1714–85). Memorial to Marshal Maurice de Saxe, in Saint-Thomas, Strasbourg, 1773

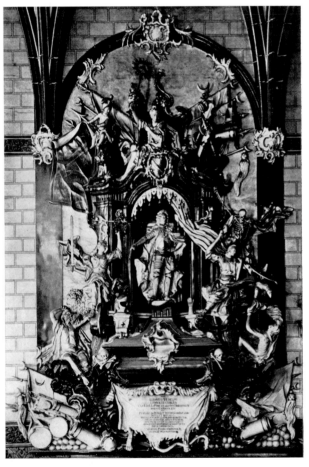

31 Memorial to Margrave Louis William of Baden, 'Türkenlouis', in Stiftskirche, Baden-Baden, eighteenth century

The transcendental world

Sacred or secular, the world of imagery which celebrates the glory of great men or the mysteries of faith never proceeds by objective reference but by the indirect language of allegory and symbol. This is a world peopled with signs, figures and emblems, where all objects and all beings (including rational beings) exchange attributes and properties in a perpetual semantic shift. Educated men and humanists took pleasure in inventing and construing this secret language, which seemed to them to be charged with superhuman or supernatural power. Its unearthly magic overwhelmed the simple souls for whom were built the pilgrimage churches laden with figures and symbols which seem to translate into visual terms the metaphors of the preachers.

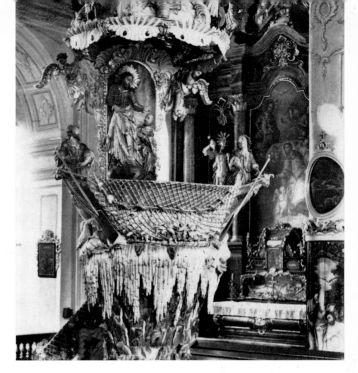

32 Pulpit, Traunkirchen, Austria, eighteenth century

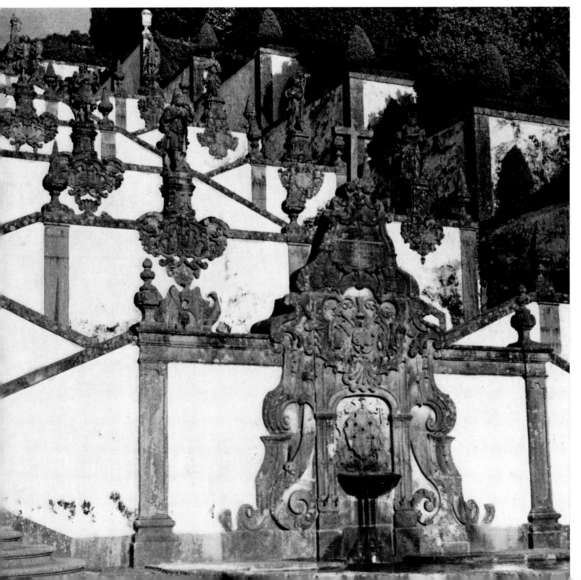

33 Stairway of the Five Senses, Bom Jesus do Monte, Braga, Portugal, 1730–37

63

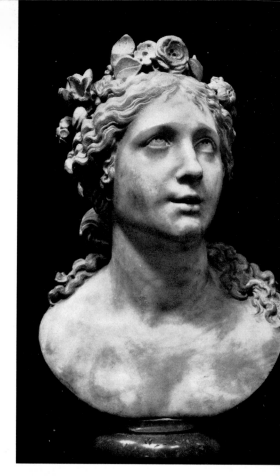

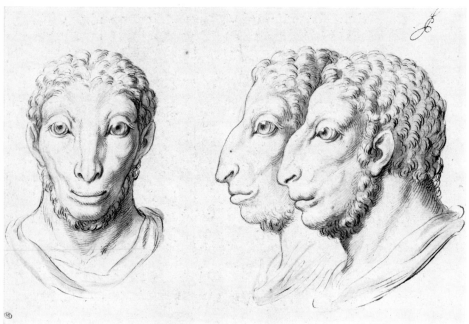

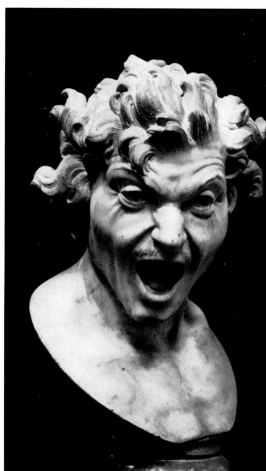

34–5 Charles Le Brun (1619–90). Studies of expression: profile and full face of a ram and a man

36–7 Giovanni Lorenzo Bernini (1598–1680). Blessed soul and Damned soul

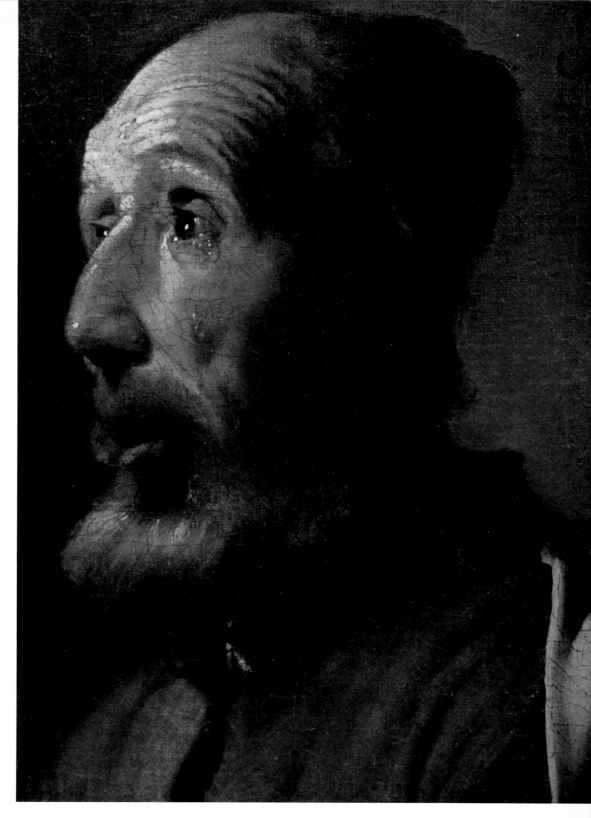

38 Georges de la Tour (1593–1652).
St Peter repentant (detail)

Expression

The main goal of the figurative arts in the seventeenth century was expression, the externalization of the passions of the soul by means of mime and posture. At the beginning of his career, Bernini had sculpted, as a technical exercise, two busts expressing the two extremes of expression, felicity and fury. Inspired by the work of the Neapolitan savant Della Porta, Le Brun outlined a theory of expressive technique based on comparisons of human and animal physiognomy.

The remorse of St Peter and St Mary Magdalen, expressed in tears, was a favourite theme for seventeenthcentury poets, and often served to inspire painters.

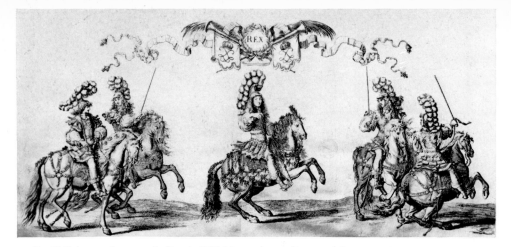

39 Israël Sylvestre (1621–91). Louis XIV in a carrousel, watercolour

40 Anon. (seventeenth century). Bernini's *Ecstasy of St Teresa* (see PL. XIII) in its setting

On stage The man of the seventeenth century lived in a continual performance. Celebrations, operas, concerts, impromptus, carrousels, ballets, comedies, tragedies, funerals, secular and religious ceremonies: everything was a pretext for festive display. The visual language of all the arts is dominated by that of the theatre. The gestures and attitudes of the actor continually reappear in the work of artists such as Bernini. In the Cornaro Chapel in Santa Maria della Vittoria, he shows the members of the Cornaro family watching the *Ecstasy of St Teresa* from two stage boxes. Serpotta treats his religious themes entirely in terms of stage performance.

41 Giacomo Torelli (1604–78). Set for *Les Noces de Pélée et de Thétis*

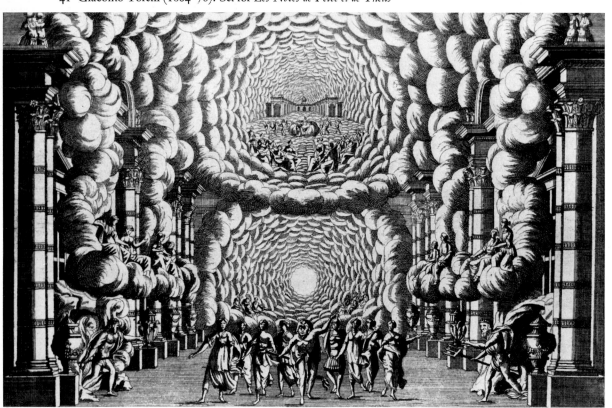

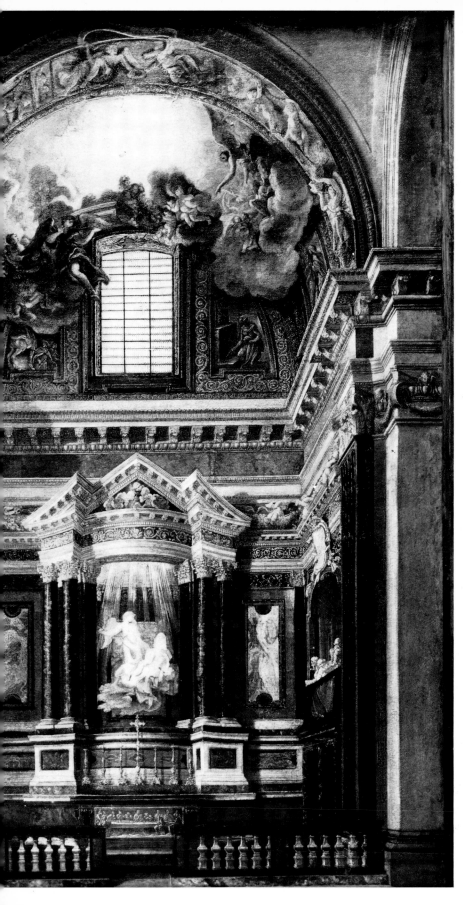

42 Giacomo Serpotta (1656–1723). Temptation of St Francis (detail), in San Lorenzo, Palermo

43 Giovanni Lorenzo Bernini (1598–1680). St Longinus, in St Peter's, Rome

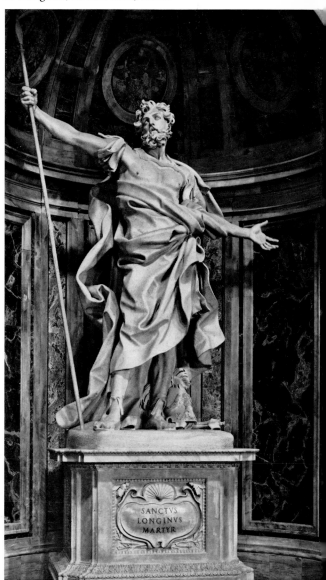

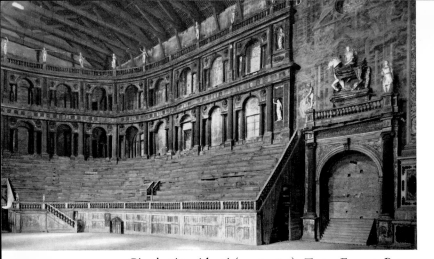

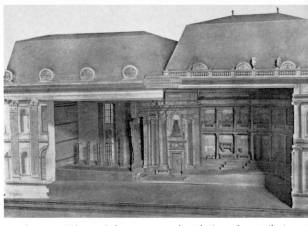

44 Giambattista Aleotti (1546–1636). Teatro Farnese, Parma
46 Jean-Louis Desprez (1743–1804). Stage set, Drottningholm, Sweden

45 Gaspare Vigarani (*c.* 1586–1663). Théâtre des Tuileries, Paris, 1662 (model by Durignaud)

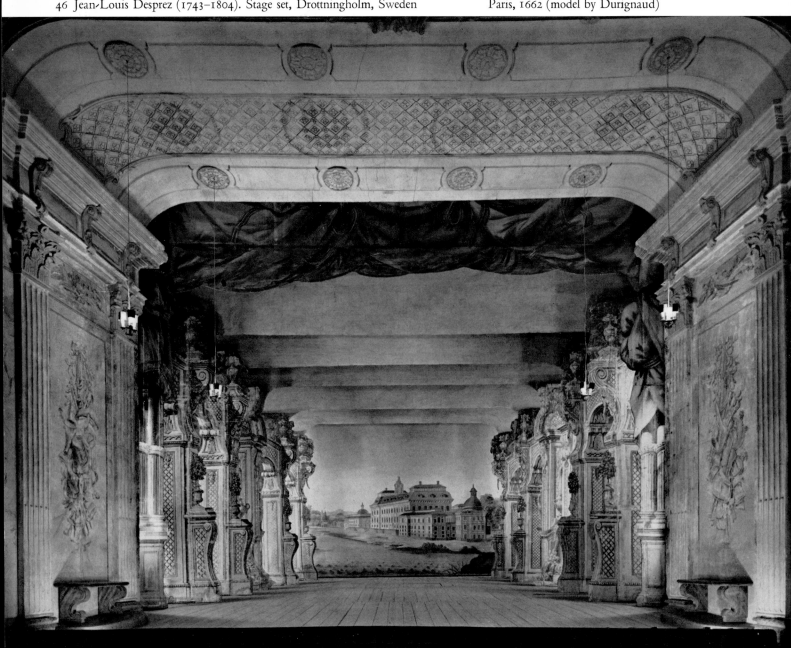

The theatre The modern theatre is perhaps the most characteristic of the architectural forms created by baroque culture. In previous ages there had existed palaces, churches, monasteries, hospitals, universities, market halls, exchanges, town halls, all the classes of building necessary for the life of society; but theatrical performances had taken place in a variety of temporary premises or in wooden theatres. The first theatre to be built in stone, the Teatro Olimpico in Vicenza, designed in 1580, is an imitation of an antique *odeon*. Subsequently, architects created architectural forms organically related to the staging of contemporary dramatic and musical works. In the course of this evolution, the Teatro Farnese in Parma (1617–18) marks the transition between ancient and modern forms of theatre.

47 Giuseppe Galli Bibiena (1696–1757) and Carlo Galli Bibiena (1725–87). Auditorium of Markgräfliches Opernhaus, Bayreuth, 1748

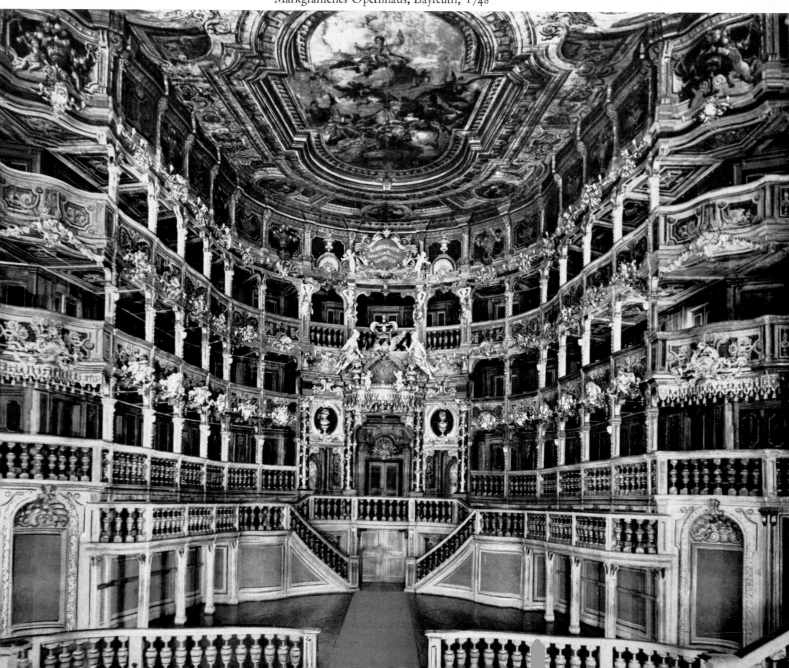

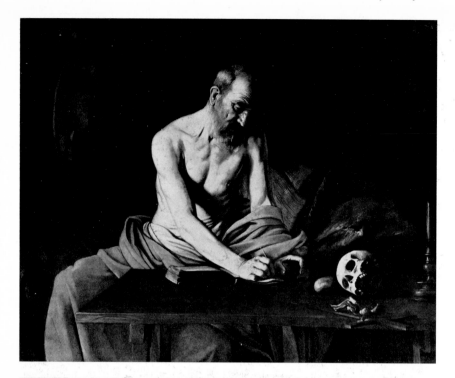

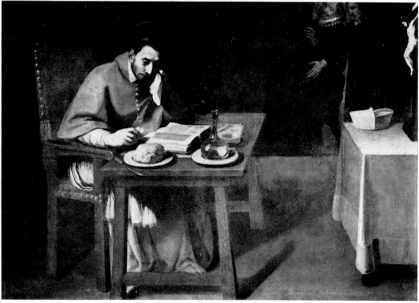

Inner life

The ethic of the baroque age is founded on ostentation: the individual projects his life beyond himself in a perpetual self-dramatization, and all his acts seem to be dictated by the need to establish his identity in relation to others. However, some individuals felt an inner disquiet which led them to seek in solitude the secret of the mystery of being, whether by philosophical meditation or by prayer. In the seventeenth century many painters depicted this state of solitary meditation, to which Rembrandt gave its most sublime expression. The shadow which was taken by mystics as the symbol of the inner life was the ally of introspection, in an age when sources of artificial light were feeble and invariably strictly directional.

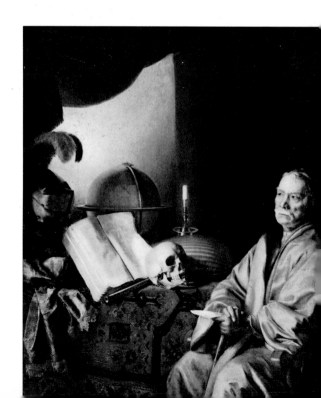

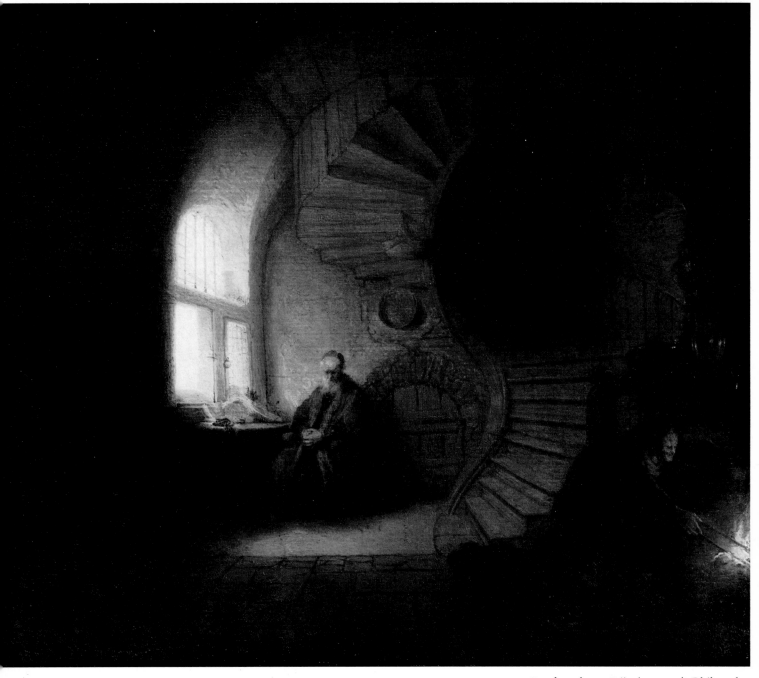

51 Rembrandt van Rijn (1606–69). Philosopher

48 Michelangelo Merisi da Caravaggio (c. 1562–1609). St Jerome

49 Daniele Crespi (1598/1600–1630). St Charles Borromeo at table

50 Ferdinand Bol (c. 1610–80). Philosopher in meditation

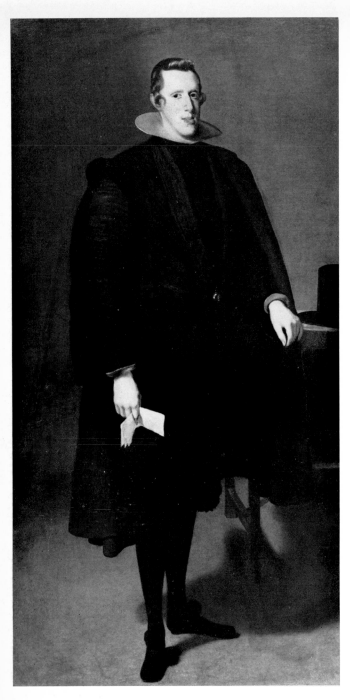

52 Diego Velázquez
(1599–1660). Philip IV

53 Francisco de Zurbarán
(1598–1666). Fray
Francisco Zumel

54 Gerrit Terborch
(1617–81). Portrait of a
man

Metaphysical silence

While the Italian or French portrait exalts the virtues of the individual and cele-
brates his glory, in profoundly Catholic Spain, and sometimes in Calvinist
Holland, the human beings who sit for portraits—even kings—seem isolated in
an ashen half-light which seems to exclude all possibility of a dialogue with the
outside world. The unresponsiveness of the environment leads the soul to with-
draw upon itself in silence. Ostentation and meditation are the twin poles of the
baroque ethic; the essence of the baroque is the harmony of extremes.

II STYLES

1 Gothic

The Gothic style was created *ex nihilo* on logical and natural principles; together with impressionism, it will undoubtedly remain France's principal contribution to Western art. The whole history of Western architecture since the seventh century BC has known only two morphological vocabularies; the antique and the Gothic. The antique, which survived in Italy well into the Middle Ages, flowered again in Florence in the fifteenth century, and was the source of the styles of the modern era. As for the Gothic, it was despised by the Italian Renaissance, which christened it *tedesco* ('German'), a term of disparagement which the French translated as *gothique*. Critics of the seventeenth and eighteenth centuries were no kinder towards it; Jean-François Félibien (the son of the biographer André Félibien) in 1699, Boffrand in 1741, and Jacques-François Blondel in 1752 condemned it, in the name of rationalism, as an imitation of an anarchic form, the forest. John Evelyn, author of *Sylva*, had had the same idea in 1664; but being a great lover of trees he counted it among the cathedral's virtues that it was 'the sylvan City of God'.

Contempt for Gothic architecture was by no means universal. In 1669–70, the Abbé Picard measured the arc of meridian between Amiens and Paris. In describing this feat some time later, the geometrician Maupertuis (1698–1759) stated that the Abbé could hardly have chosen two buildings in the whole of Europe as lasting and as beautiful as Notre-Dame of Paris and Notre-Dame of Amiens, to use as his terminal points. The elder Félibien, who was himself so deeply imbued with academicism, speaks with sympathy of the Gothic manner of building, 'which gave the buildings an appearance of lightness and delicacy, and a boldness of execution, calculated to astonish the spectator'; he distinguishes between 'the most ancient churches which lack neither solidity nor beauty' and the more recent, degenerate examples, 'formless masses of ornament'. But Gothic was hard to kill; it has lived on, in spite of disapproval, into our own times.

Earlier ages had left a legacy of unfinished medieval buildings. Most were finished in the style of the day, but occasionally it was decided to continue them in their original style, and of this practice I shall cite a few examples.

pls 56–8 The most famous is that of Milan cathedral, the masterpiece of Italian Gothic. Although work on it had continued steadily during the Renaissance, it was still incomplete by the sixteenth century. The façade, in particular, still remained to be built. Pellegrino Tibaldi proposed a front in the Mannerist style, and Francesco Richino, at the end of the sixteenth century, a dis-

tinctly baroque design inspired by Carlo Maderno's façades for Santa Susanna and St Peter's. In 1656, however, Francesco Castelli designed a façade in a kind of Neo-Gothic mixed with some classical elements. The façade designed by Carlo Buzzi in 1653 is in the same spirit, but purer in form. It was this version, adopted and refined by Giuseppe Brentano, that won the international competition of 1886 and was then executed.

In the course of the eighteenth century slow progress was still being made on this seemingly endless task. When the President Charles de Brosses visited the site in 1739 he was able to remark: 'A school of Gothic taste is even being run here for the workers engaged on the building'.

What uninformed observer would believe that the splendid nave of Orleans cathedral, one of the most lyrical expressions of the vertical impulse of flamboyant Gothic, is, with the exception of two sixteenth-century transepts, the work of the seventeenth and eighteenth centuries? When the body of the cathedral had finally been rebuilt after its collapse in 1568, west front and towers had still to be designed. Louis XIV's architects proposed a tower in the style of the dome of the Invalides and a façade in imitation of St Peter's, Rome. But in 1707 the king himself intervened, cancelled the contracts already signed and ordered new plans 'conforming to the Gothic order'. During the eighteenth century a façade and towers in Gothic style were slowly *pl. 55* built according to a design by Hanault, revised by Robert de Cotte and fixed in its final form by Jacques Gabriel. Inspired by the west front of the cathedral of Toul, the design is successful in its overall effect, but the detail betrays the classical sculptors' inability to adapt successfully to a Gothic style.

In 1725 the Cistercians of Alcobaça, in Portugal, gave their fine early Gothic church a strange façade of bastardized baroque-Gothic. The efforts of the French Benedictines were more successful; but through their antiquarian tradition they had never lost their link with the Middle Ages. They were the first to take a real interest in historical authenticity in architecture. The Wars of Religion had left the church of the Benedictine monastery of Caen in such a state of ruin that in 1662 a contract was agreed for the demolition of the choir; but this was strongly opposed by the energetic Prior, Dom J. de Baillehache, who subsequently carried out a complete restoration with such exceptional archaeological accuracy that modern experts can barely distinguish the restored parts from the original.

In France the roots of Gothic ran very deep, and classical prejudice never succeeded in ousting it from the popular imagination. In the seventeenth century, churches ruined by the Wars of Religion were usually restored in the original style, sometimes even in Romanesque (the church of Andlau, Alsace), while in the country the tradition of erecting purely Gothic buildings ran on uninterrupted throughout the seventeenth century and even the eighteenth century, chiefly in Brittany and the northern provinces—Flanders, Artois, Boulonnais, and Haute-Normandie—but also in Franche-Comté, Alsace, and Savoy. Manors in the pure flamboyant Gothic style were built in Boulonnais, Artois and Flanders even as late as 1660. We find a similar situation in the Netherlands; Belgian baroque is the creation of town-dwelling artists working for the State, the municipalities, the monasteries or the nobles, whereas throughout

the seventeenth century village churches continued to be built in the flamboyant Gothic style. The same was true in the Rhineland and Westphalia. In Belgium the first churches built by the Jesuits in the early seventeenth century were Gothic, and churches there also tended to retain the medieval plan of nave plus side-aisles.

Even the Protestant Dutch, although committed to classicism, occasionally resorted to Gothic *pl. 69* for decorative motifs, as in the wrought iron screens of the St Nicolaaskerk and the St Catha- *pl. 334* rinakerk, Amsterdam. The exterior of the famous Nieuwekerk in The Hague leads one to expect a rigorous classicism; it comes as a surprise, on entering the church, to discover a compli- cated network of carved wooden false vaults.

The place of Gothic in the German-speaking countries is less easy to distinguish, for it is latent in everything produced by Germany until the advent of neoclassicism. It permeates German mannerism, which survived into the seventeenth century; while German rococo, *pl. 65* particularly in sculpture, reverts to the vegetal forms of *Spätgothik*. Thus the *St Anne* (1722–4) *pl. 64* by Franz Joseph Ignaz Holzinger in the church of Metten, or the *St Hubert* by Thomas Weiss- feld (d. 1722) in the monastery of Kamenz in Silesia, recalls the violent movement of late Gothic wood-carvings such as those of the altars at Breisach (1523–6) and Niederotweiler (1527). The abbots who demolished and replaced old churches collected their Gothic works of art in museums, as at the monastery of Sankt Florian in Austria. It is to this practice that we owe the preservation of the major part of the work of Altdorfer. Often a fine Gothic statue was 'set in *pl. 63* glory' in a baroque framework, like the *Madonna* by Pacher in the Franziskanerkirche, Salz- burg. In some cases old churches were not replaced but 'baroquized'; examples are the mon- *pl. 66* asteries of Salem in Swabia and Zwettl in Austria. In the latter, the integration of baroque lyricism with the verticality of the German Gothic 'hall church' has been carried out so suc- cessfully by Munggenast that we might almost believe that the old church was preserved not for reasons of economy but from choice. The baroque décor of the church of Santa Chiara in Naples (destroyed in the Second World War) was designed by Antonio Vaccaro to harmonize with the famous Gothic tomb of Robert of Anjou. In the province of Moravia there was an actual renaissance of Gothic architecture early in the eighteenth century; Johann Santin Aichel (an architect who also practised the baroque) created churches which are pure pastiches of *pl. 61* Gothic, such as that of the Benedictine monastery of Kladrau (1712–26). In the church of Saar he adapts the reticulated vaults of the 'hall church' to a central plan.

pl. 67 Italy offers a few examples of the use of Gothic elements in a baroque décor, as in the Prefettura of Lecce, which revives the flamboyant Gothic *accolade* design. The baroque architects who introduced the use of concave-convex curves, Borromini and Guarini, both seem to have made *pl. 68* a close study of the Gothic; both draw inspiration from Gothic rib vaults (Borromini's Collegio di Propaganda Fide, Rome, *c.*1660). Guarini, who had visited Sicily, may have been inspired *pl. 331* by Saracen domes in designing the dome, mounted on intersecting arches, of his San Lorenzo, Turin, from which is derived yet another Turin dome, that of Santissima Sindone.

pl. 241 There were painters, too, of a fantastical turn of mind ,who exploited the exotic and fabulous side of Gothic. Monsù Desiderio used it as he used the antique, to evoke lost civilizations;

Magnasco painted gatherings of mad monks in Gothic cloisters. Stage designers, too, sometimes used the Gothic style, especially for scenes set in castles.

In England Gothic retained its importance as a style for churches and universities throughout the seventeenth century and into the eighteenth. Archbishop Laud, who under Charles I dominated the Anglican Church, had a preference for Gothic architecture; when Chancellor of Oxford University from 1630–41 he erected several buildings in this style. His example was followed in Cambridge by Matthew Wren (uncle of Sir Christopher) in the chapel of Peterhouse, and also by John Cosin.

No architect was ever a truer classicist than Sir Christopher Wren, creator of St Paul's, yet four of his London churches were Gothic (St Alban, Wood Street, St Michael, Cornhill, St Mary Aldermary, and St Dunstan-in-the-East). Above all, his Gothic Tom Tower at Christ *pl. 60* Church, Oxford (1681–2), bequeathed to Nicholas Hawksmoor an example which the latter improved upon in his grandiose rebuilding of All Souls College, Oxford (1734). *pl. 59*

Hawksmoor's Gothic is something of a hybrid of Perpendicular, Tudor and Jacobean, with classical elements. In the second quarter of the eighteenth century, however, the idea arose of reviving Gothic on the basis of a study of medieval architecture; the result is sometimes called Gothick, or modern Gothic, to distinguish it from the survival of medieval Gothic. In 1742, Batty Langley (1696–1741), author of several architectural treatises, wrote his *Gothic Architecture, Improved by Rules and Proportions, In Many Grand Designs of Columns, Doors, Windows, Chimney, Pieces, Arcades, Colonnades, Porticos, Umbrellos, Temples and Pavilions, etc.* In 1751 Waburton recognized in Gothic, regarded by the French as mere anarchy, the rational architecture *par excellence*—a remarkable opinion for the time. William Kent was the first to attempt an 'authentic' Gothic style, building a wing of Hampton Court Palace in the Perpendicular manner (1732) on the advice of Horace Walpole.

The style was made fashionable among the nobility by two amateur architects, Sanderson Miller (1717–80) and Horace Walpole (1717–97). Sanderson Miller was responsible for the building of several Gothick castles, the most remarkable of which is Lacock Abbey, built between 1753 and 1755 for John Ivory Talbot. The outstanding architectural work of Horace Walpole is his own house, Strawberry Hill, at Twickenham (*c.* 1750–70) with its library designed by *pl. 72* John Chute. During the same period Sir Robert Newdigate transformed his Tudor mansion, Arbury Hall, by giving it a Gothic interior which is a remarkable example of rococo taste. *pl. 71* Newdigate employed several architects, among them Robert Keene, Surveyor of the Fabric at Westminster Abbey, who also created other Gothic buildings (including Hartwell Church, 1753).

There was another form of Gothic which flourished in the gardens of the eighteenth century, first in England, then in Germany and France—the fantastic: sham castles, sham ruins of churches or mansions, rustic cabins. This is a Gothic one step removed from Chinese and Moorish art, each borrowing features from the other. Thus the Pavillon du Philosophe, at Bagatelle, near Paris, built by Bellanger in 1782, contained beneath its incurved, pagoda-like *pl. 70* roof the windows of Louis IX's Sainte-Chapelle.

2 Mannerism

The baroque was born in Rome of an effort of reason (Vignola, the Carracci) and a passionate impulse (Caravaggio), both directed at putting an end to mannerism. In the rest of Italy, however, and particularly in the north, the baroque seems to have been an ordering of the overcharged

pls 73-5

exuberance of mannerism rather than an aggressive reform. Three Lombard façades built in the second half of the sixteenth century illustrate the way in which the baroque emerged from mannerism by a gradual process of refinement. These are Santa Maria presso San Celso, Milan, by Galeazzo Alessi (1565), Madonna dei Miracoli, Saronno, by Seregno (1596), and Sant' Angelo, Milan (c.1600). The same relationship can be detected between the façade of San Fedele, Milan, by Pellegrino Tibaldi (1569) and that of San Paolo Converso, in the same city, by Giovanni Baptista Crespi (1611).

The stucco church interiors of Lombardy reveal the same slow biological process of evolution. The décor of the nave of Madonna dei Miracoli, Saronno, is still mannerist in feeling, and the immense work of decorating Santa Maria Maggiore, Bergamo, on which craftsmen from Ticino spent fifty years, from 1610 and 1660, preserved its mannerist style from first to last. The ebullient vitality and freshness of invention which are so characteristic of mannerism in northern Italy

pl. 76

lend a subtle charm to the little church of San Lorenzo in Laino, in the Intelvi valley near Lake Como, a Romanesque structure adapted in a baroque style. Its earliest stuccos, those by Frisone in the aisles, date from 1616, and the latest, those in the nave by Gian Battista Barberini, from 1664-7. The mannerist spirit appears in the juxtaposition of different elements and in the spontaneous, picturesque invention of the décor, which was initially inspired by the Italian grotesque ornamentation of the sixteenth century. In the same delightful green valley, the

pl. 77

exquisite parish church of Santa Maria, Scaria, decorated with frescoes by Carlo Carlone, and with stuccos by his brother Diego, in the mid-eighteenth century, shows that Lombard decorative art did not achieve until late in the day the characteristically baroque integration of all elements into an organic whole.

pl. 78

The same spirit inspires the famous church of Santissima Annunziata in Genoa, which retains the pillared basilical elevation of the Renaissance and whose décor of stuccos and pictures, (the work of several artists including Assereto and Giovanni and Gian Battista Carlone) is compartmented in the same way; another example by the Carlone family is San Siro.

In Florence, the décor of marble, bronze and precious stones by Mattei Negriti for the princes' chapel in San Lorenzo (1604-10) is in the jewel-like mannerist idiom. Naples very quickly

assimilated the Roman style. A few traces of mannerism can be found in architecture, however, as in the cloisters, still Renaissance in conception, of the Certosa di San Martino (1623–31) by Cosimo Fanzago, sculptor and architect from Bergamo, and also in the Gerolamini, which was built by the Florentine, Giovanni Antonio Dosio, in a basilical form which was widely imitated in Sicily in the eighteenth century (cathedral and Santa Annunziata at Comiso; San Pietro and San Giorgio at Modica; cathedral and San Giorgio at Ragusa; cathedral, San Crocifisso, and Collegio at Noto). *pl. 364*

The dominating influence of Bernini stifled any tendency towards mannerism in Italian sculpture, but his authority did not apply to painting. What might be called the romanticism of Italian provincial painting in the seventeenth century derives largely from mannerism, and in particular from the mannerist formula of elongated forms (Bernardino Cavallino in Naples, *pl. 95* Magnasco in Genoa, Maffei in Vicenza). *pls 238, 244*

In Northern Europe, architecture remained essentially mannerist throughout the first half of the seventeenth century. With its basilical plan and its compartmented façade, the Jesuit church of Saint-Charles-Borromée, Antwerp (1615–21), by François Aguilon and Peter Huyssens, be- *pl. 82* longs to the mannerist rather than the baroque school; the same is true of the Jesuit Collège de La *pl. 79* Flèche (1612) in France by Père Martellange. France was then divided between mannerism and baroque, as is shown by other Jesuit churches of the period built after the Roman baroque type such as the chapel of the Collège d'Avignon (1617); this was the work of the same Martel-lange who had built the mannerist La Flèche, in which his style had perhaps been cramped by an earlier plan by Métezeau.

If sculpture in France under Henry IV and Louis XIII shows almost no trace of mannerism, this was due to the solid classical and realist foundations that had been laid a century earlier by Jean Goujon and Germain Pilon. It was a different story in painting, which remained mannerist (Deruet, Varin, Vignon) until Simon Vouet, returning from Rome in 1627, converted the *pls 93, 96* Court to the baroque. Certain provincial studios stayed faithful to mannerism, and so did Jean Tassel (1608–67) of Langres, although he had lived in Rome for a time. *pl. 97*

Until the classical reform of 1630, Dutch architecture, like that of Germany with which it had close affinities, continued in the mannerist tradition which it had adopted in the sixteenth century under the influence of Vredeman de Vries (the town halls of Leyden, 1597, Hoorn, 1613, Boleward, 1616, and Lieven de Key's meat market and fish market of Haarlem, 1602–3). *pl. 80* Traces of mannerism were also evident in Dutch painting (Pieter Lastman, Abraham Bloe-mart).

Mannerism had firmly taken root all over Europe. In Spain it survived the purist reforms of Juan de Herrera (the Escurial and the cathedral at Villadolid). The baroque movement in Spain emerged slowly out of mannerism (façade of the hospital of La Caridad, Seville, 1647, façade of Santa Teresa, Avila, 1631–54). The fine classical structure of the altarpiece of the *pl. 83* Escurial (1579), although imitated in the Portuguese cathedral of Portalegre and in the Carmo at Coimbra (end of the sixteenth century), was little appreciated in Spain, and the next phase in the evolution of the Spanish altarpiece was the result of an attempt on the part of Estebán

Jordan to bring unity to the fragmentary composition of the mannerist altarpiece of Santa Maria de Medina at Rioseco, which had been left unfinished by Becarra.

During the first half of the seventeenth century Portugal remained faithful to the severe art of the Counter-Reformation, which she slowly transformed into baroque, creating in the process, about 1650, a short-lived form of mannerism.

pl. 132 In the first years of the century, Montañés in Seville brought an end to the mannerism of the sculptors of the *Bajo Renacimiento;* in painting the change was made by Herrera the Elder (d. 1656) *pl. 94* and Ribalta (1551–1628) who abandoned the mannerism still practised by Juan de las Roelas (d. 1625), and, in his early work, by Pacheco (1564–1654), the master of Velázquez. It can be seen from these examples how complex was the evolution of Portugal and Spain in the first half of the seventeenth century, when widely differing styles existed side by side.

In England, the Elizabethan style might have been expected to find a natural continuation in Jacobean. This part of Europe seemed ideally suited to a prolongation of mannerism; but England often reacts in surprising ways. The influence of Inigo Jones reversed the evolutionary process: mannerism gave way to classicism. Mannerism nevertheless had considerable *pl. 207* staying-power; it seems absurd that a work as Palladian as Queen's House, Greenwich (1616– *pl. 81* 35) by Inigo Jones should be contemporary with the Schools, Oxford (1600–36) or the Canterbury Quadrangle of St John's College, also at Oxford (1632–6). Mannerism was tenacious; the gate of the Citadel in Plymouth, built as late as 1670, is mannerist in inspiration, while the hybrid English Gothic of the seventeenth century also helped to keep the mannerist spirit alive.

The essential role played by mannerism in the genesis of the baroque is most clearly illustrated by the example of Germany; but the German art of the decisive first years of the seventeenth century, unlike that of other European countries, cannot usefully be approached from the standpoint of architecture. Ever since the 1530s the pace had been set by the ornamental arts, jewellery, bookbinding, printing and engraving, all of which drew inspiration from pattern books published by Renaissance engravers such as Hans Sebald Beham and Daniel Hopfer. Perhaps the greatest achievement of the goldsmith's art, which had already risen to such heights in the work of the Jamnitzer family of Nuremberg, is the crown made in the workshops of the Hradčany in Prague for Rudolph II (1602), to which Matthias, his successor, added an orb (1612) and a sceptre (1612–17). On a tiny scale, they represent an unparalleled feat of virtuosity in the handling of detail, the intricate parcelling-up of space and the use of *Rollwerk,* ornament constantly curling back upon itself.

After 1550, French and German translations of the architectural textbooks of the Roman Vitruvius and the Italian Serlio introduced the classical orders of architecture into Northern Europe. A thesis by Erik Forssman of the university of Stockholm describes the wild variations on classical themes in which German, Netherlandish and Scandinavian architects indulged. Their 'subjective' use of the orders is authorized by Serlio in the fourth part of *L'Architettura* (1537–51). While Vignola, in his *Regole delle cinque ordini* (1562), regards the orders as abstractions based purely on relationships of proportion (the Vitruvian *modulus*), Serlio elaborates a whole *ethos* of the column describing how each order has its own particular object: the Tuscan all

that is military, the Doric all that is manly, the Ionic the gods, Diana, Apollo and Bacchus, the Corinthian honour and virginity (the Virgin Mary), the Composite the idea of empire.

These ideas struck a spark somewhere in the northern imagination. It might be said that while the Italian baroque (like French classicism) springs from Vignola, German baroque is inspired by Serlio. Some authors have even gone so far as to regard Vignola and Serlio as representatives of Nietzsche's Apollonian and Dionysiac principles. The first northerner to take up these theories and develop them was the Dutchman Hans Vredeman de Vries, author of numerous architectural and ornamental pattern books; he led the way by virtually treating the orders as poetic themes, proposing five versions of each one of them. In his *Theatrum vitae humanae* (1577) he carries anthropomorphism to the point of making the orders correspond to the different ages of man's life in a way which rather surprises us today; Composite, from birth to sixteen; Corinthian, from sixteen to thirty-two; Ionic, from thirty-two to forty-eight; Doric, the prime of life; Tuscan, old age; and the ruin, death. Vredeman de Vries takes columns and stretches them, manipulates them, loads them with realistic or symbolic ornaments. He has a predilection for caryatids and especially for terms, figures with flat-sided or column-shaped bodies, which form one of the most popular elements of mannerist architecture.

It may seem surprising to us that symbolic meanings should be attached to architectural elements; but this came quite naturally to the men of the sixteenth and seventeenth centuries, to whom all art was eloquence. In Spain, Juan Ricci developed similar ideas in his *Tratado de la Pintura Sabia,* composed c. 1659–61, in which the orders (including some not mentioned by Vignola) are identified with Christ, the Virgin and the Saints.

The northern imagination was also stimulated by the inexhaustible repertory of 'grotesques', a decorative element revived from the antique, in which the artist encloses within ornamental scrolls, like 'quotations', gods and demigods or decorative beasts and plants. This theme, which appeared in engravings from the end of the fifteenth century onwards, was the subject of endless ornamental variations in the second half of the sixteenth century.

The renewal of the Gothic spirit, as Dvořák and Georg Weise have pointed out, was in fact one of the features of mannerism. It affected Italian mannerism very early, about the year 1530; at that time medieval Gothic still survived in Germany, at least in architecture (*Spätgothik*). Then the Renaissance came to Germany; but three-quarters of a century later there was a Gothic revival in the German-speaking countries which thus fits in exactly with the normal time-lag between artistic developments in Italy and those in Northern Europe.

The ornamental work required for the numerous temporary buildings erected on festive occasions all over Europe from the mid-sixteenth century onwards offered further scope for mannerist fantasy—especially as the materials used, wood, leather and cardboard, were well suited to pattern-cutting.

Mannerist fantasy reached its height in the *Architectura* of Wendel Dietterlin (Nuremberg *pl. 87* 1598), an encyclopaedia of ornament in 209 engraved plates, classified according to the five orders and containing a whole arsenal of Christian, mythological, 'grotesque', zoological and botanical motifs. A comparison with Vredeman de Vries reveals a marked growth of

interest in Gothic ornamentation and a feverish absorption in *Rollwerk,* an endless series of variations on the theme of the scroll in which the spiral forms seem to express an inward-turning fury born of the artist's powerlessness to resolve complexity into unity.

These pattern books are of great importance, not only on account of their immediate influence on architecture and decorative art, but because they contain in themselves all the seeds of rococo. We occasionally find in them a tendency—though a confused one—towards the contrapuntal organization and the asymmetrical ornament that were to be characteristic of the rococo. An *pl. 88* engraving done by Johann Smiescheck before 1620 seems almost to have come out of a Cuvilliés woodcarving.

This frenzy came to an end around 1650 with what the Germans have termed the *Ohrmuschel-* *pl. 86* *stil* (from *Ohrmuschel,* 'shell of the ear'), as practised by Lukas Kilian and Friedrich Unteutsch. Its shapes depart from the slender forms of mannerism and swell under the influence of the baroque into monstrous excrescences. This style still appears in the drawings of Simon Cam- mermeier as late as 1670, just before the introduction of baroque foliated ornamentation from Italy into Germany.

The true source of the evolution of German architectural and decorative art up to the Thirty Years War lies in the creativity of the woodcarvers who turned the interiors of bourgeois houses in sixteenth-century Germany into elaborate carven caskets. The two wings of the castle of Heidelberg, the Otto-Heinrichsbau (1556–63) and the Friedrichsbau (1601–7), are both directly inspired by the engravings of Vredeman de Vries. The jewelled decoration of the gold *pl. 89* room of the castle of Bückeburg (1605) is like a literal transcription of the engravings of Dietterlin. The same delirious profusion of ornament reappears in the capitals, window tracery and pediments of the Lutheran Marienkirche at Wolfenbüttel (1608); and it plays a particularly important part in the early seventeenth-century monuments which are among the treasures of *pl. 90* many German churches, and in certain altars, such as the high altar by Jörg Zürn (1613) in the Münster at Überlingen, which would not be out of place in a rococo church. From Germany the style spread to Denmark, Sweden and Poland. Denmark possesses one of the finest examples *pl. 92* of this style in the castle of Frederiksborg (1602–20), with its extraordinary chapel which is like a monumental piece of jewellery made of bronze, stucco, marble, alabaster, silver and rare woods.

There was in Germany at the same period another form of mannerism, not indigenous but imported from Rome. This first appeared in Munich as a result of Duke Albert V's nostalgic love of Italy; an example is the façade of the Michaelskirche (1583–97). The famous gold room at Augsburg (1620), unfortunately destroyed by fire during the second World War, was a later form of the same style. The fine bronze *Virgin (Patrona Bavariae),* by Hans Krumper (1616) is similar in feeling to the bronze statues made by Hubert Gerhard in the time of Albert V (*St Michael* in the Michaelskirche, 1588), but this is court art. The statues on the high altar of Überlingen by Jörg Zürn (1613), and Eckbert Wolff's altar in the church of the castle of Bückeburg (1608), on the other hand, are truly native products, derived from the pattern books of Dietterlin; they would not look out of place alongside the carvings of the great Bavarian rococo sculptor Joseph Anton Feichtmayr.

Had it not been for the Thirty Years War, the German rococo might perhaps have appeared much earlier; but when the war ended at last and Germany began to recover strength, the spell was broken. Before a true national style could be found again, Germany had first to assimilate imported baroque.

For a time, German architects turned for guidance to the Roman mannerism of the very early days of baroque; a façade like that of the Martinskirche, Bamberg (1690), shows a strong family *pl. 84* resemblance to that of the Michaelskirche, Munich, built a hundred years before. The Martins-kirche makes a revealing contrast with the Neumünster in Würzburg (1711) which is conceived *pl. 85* on the same structural principles. A generation has passed, and German architecture has assimilated Roman baroque and rediscovered its true genius.

3 Realism

In art, the baroque age witnessed a leap into a world of fantasy; it is hard to believe on entering the Neumünster in Würzburg or Johann Michael Fischer's abbey of Ottobeuren (1744–67), both of which might easily be fantastic stage sets, that the same epoch saw unprecedented achievements in science and in rationalist philosophy.

There is, however, one part of Europe where art does seem to be related to the inductive experimental methods which from the seventeenth century onwards supplanted the speculations of the Schoolmen. In the seventeenth century learned societies and academies were founded all over Europe whose aim was to explore this new mode of knowledge; one of them, instituted by Ferdinand II of Tuscany, was even called 'the academy of experiment': L'Accademia del Cimento. The aristocracy took up scientific research; it was the fashion to have *cabinets de physique*, physics laboratories in which to repeat well-known experiments and seek to create new ones. In the eighteenth century the 'experiment' became almost a parlour game. Science became an important source of subject-matter for engravers, and sometimes for painters too. There are many seventeenth-century portraits of celebrated Dutch doctors giving anatomy pl. 98 lessons; and an English eighteenth-century painter, Joseph Wright of Derby, took an *Experiment with an Air Pump* as the subject of one of his pictures. Many amateurs had physics laboratories in their homes, as well as collections of apparatus for the study of mathematics and natural pl. 101 history. Among those that have survived are the mineralogical collection of the monastery of pl. 390 Seitenstetten in Austria and the conchological collection of Clément Lafaille (in the Musée de La Rochelle), both dating from the eighteenth century. Amateurs often placed their mathematicals and physical instruments or botanical or zoological specimens in an elaborate and pl. 273 fanciful setting; the most astonishing of all was that of Joseph Bonnier de la Mosson (d. 1744) in Paris, which has fortunately been recorded in a series of drawings.

Most seventeenth-century painters seem to have constructed their pictures with the object of drawing the spectator's imagination into the far distance—either literally, by devices of perspective which carry the eye towards the horizon, or by the use of fantasy to offer an escape from the present. The disciples of Caravaggio, following their master's example, had brought the scene nearer to the spectator, even inventing the close-up; but this direct assault on the eye by the subject of the picture is calculated to cause surprise rather than to engage the attention. Only in Holland did painting remain a purely visual art based on careful observation and a sound optical education.

v Samuel van Hoogstraten (1627–78). Peepshow with views of the interior of a Dutch house ▶

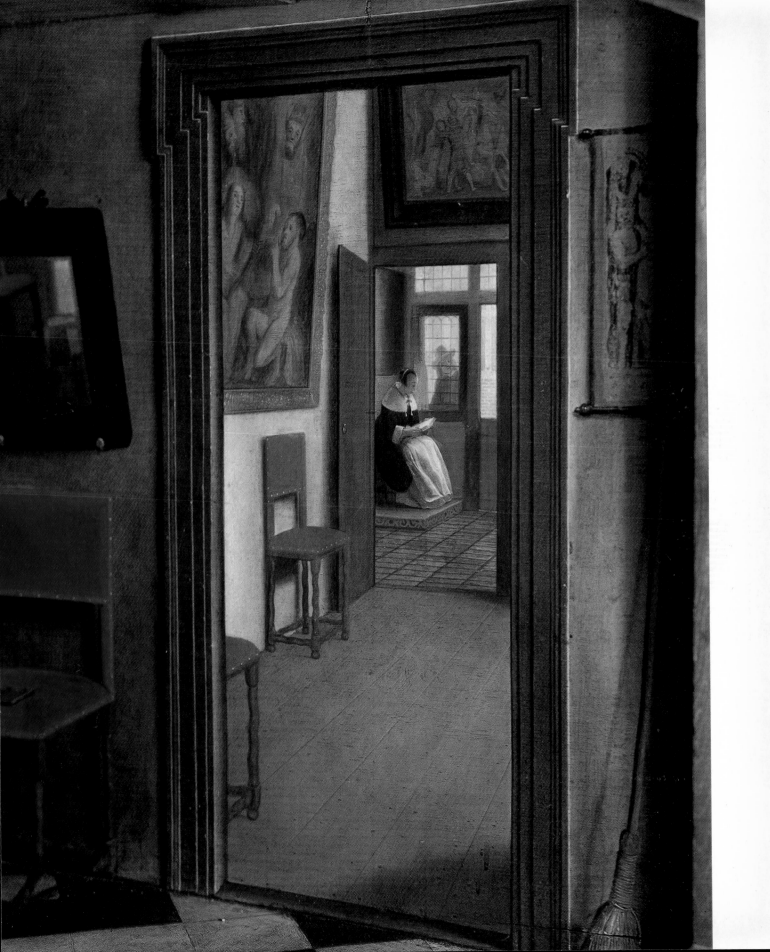

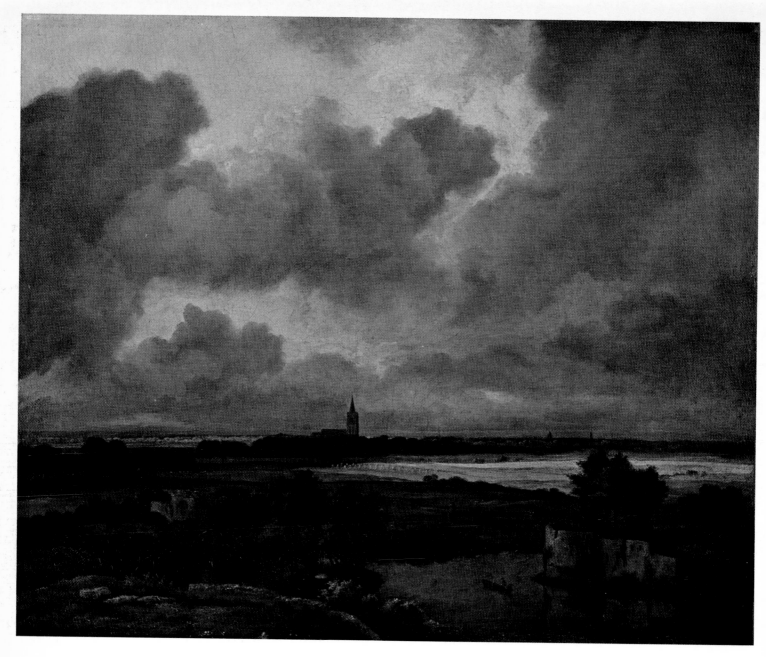

VI Jacob van Ruisdael (c. 1628–82). Extensive landscape with ruins

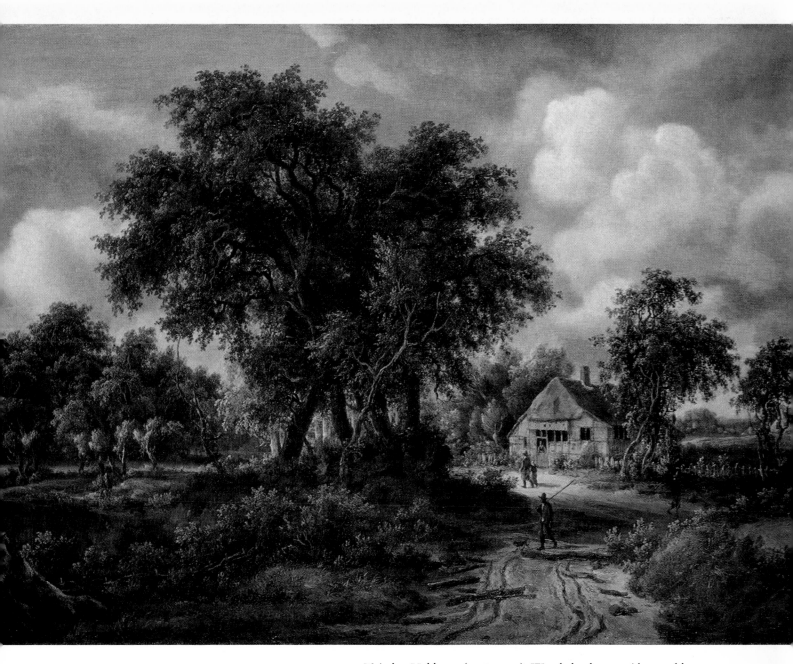

VII Meindert Hobbema (1638–1709). Woody landscape with a road by a cottage

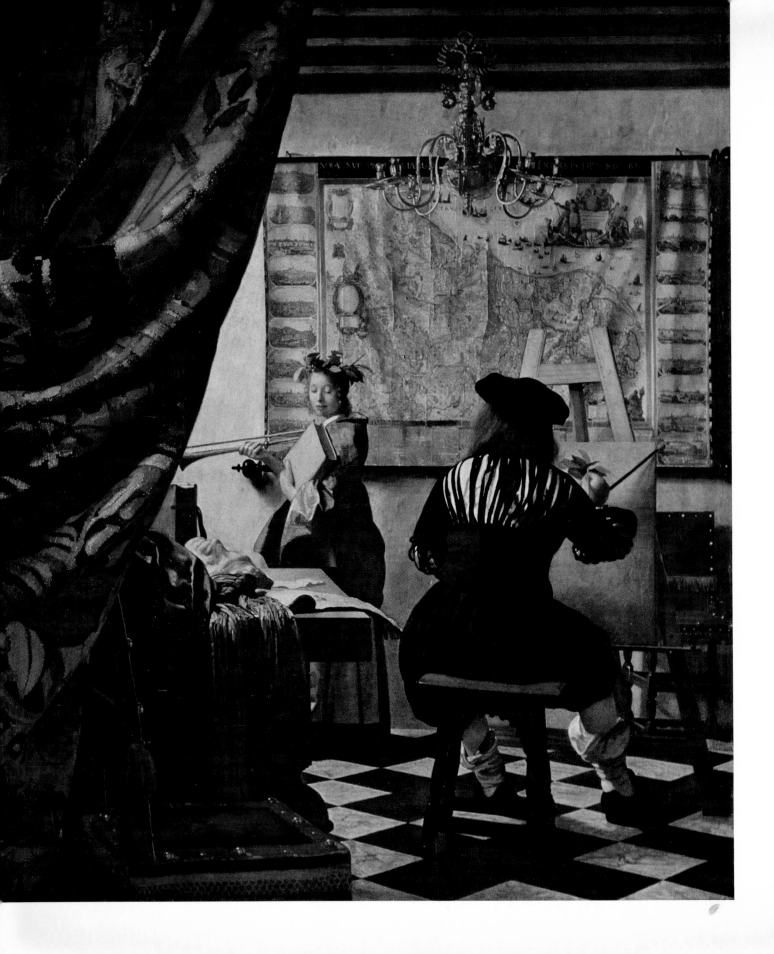

Painting had lost its 'optical' quality from the moment when the classicists of the Renaissance had been induced by a Neo-Platonic ideal to look beyond the image to the idea. In the fifteenth century, when the human intellect first embarked on the crucial transition from conceiving the universe in theological terms to perceiving it in empirical terms, artists in Flanders and Italy were passionately absorbed in the study of the world which had suddenly been revealed to them. The Italians, more intellectual in their approach, invented a guide for the eye, a machine for exploring space, to aid them in their conquest of infinity. This 'machine' was perspective, *costruzione legittima*. (Jan van Eyck, for his part, submitted more docilely to the results of direct experience.) The work of Leonardo da Vinci sums up the achievement of his predecessors; and it only remained for Raphael to sweep their learned intricacies aside with a stroke of the brush, while absorbing Leonardo's classical conclusion, expressed in the *Mona Lisa,* that a single form in itself can contain all the diversity of the world. Then came mannerism, in which reality and unreality alike were caught up in a whirlwind of inconclusive syllogisms and self-destructive analyses.

The value of any optical instrument, whether natural or artificial, lies not merely in the magnification it allows but in its *definition,* the power it confers of separating points which are merged into one by an optical illusion or by the effect of distance. Art historians puzzled by the mystery of Van Eyck do not seem to bear in mind that his genius must have been aided by a phenomenal visual equipment. This becomes all the more obvious if we reflect that he had no artificial aids other than spectacles, which were still very inefficient and awkward in his day. His exceptional optical powers of definition were at the service of an analytical genius which enabled him to apprehend the material substance of things, from the limpidity of the atmosphere to the hard density of stone, and to grasp the complexities of a technique capable of recreating for the spectator the visual magic felt by the painter as he contemplates the world.

This miraculous clarity of vision seems to have died with Van Eyck. It is as if painters became blind again, and found it simpler to look at Van Eyck, and convert him into formulas, than to look at nature. And although Van Eyck's capacity for observation reappears in Leonardo da Vinci, Dürer and Bruegel the Elder, it is never served by the same optical power. His conception of art as the mirror of truth disappeared with him, to reappear only in seventeenth-century Dutch painting, which like Van Eyck's is based on a pure visual act.

Seventeenth-century painters had at their disposal improved optical instruments that increased their keenness of vision. From the mid sixteenth century, combinations of lenses or mirrors were used to see distant objects; Galileo, who is credited with the invention of the telescope, did no more than improve it by increasing its magnification to a power (30 x) which made his astronomical discoveries possible. The magnifying glass and the microscope made their appearance almost simultaneously, and for a long time the magnifying glass was the more satisfactory of the two instruments. Antoni van Leeuwenhoeck (1632–1723) a bourgeois of Delft, had a secret process for the manufacture of magnifying glasses of exceptional quality; he made at least 419 of them. They enabled him to be the first to explore the world of the infinitely small (bacteria, protozoa, spermatozoa, blood corpuscles) and to study insects. The microscope was

89

◄ VIII Jan Vermeer (1632–75). The artist in his studio

more than a scientific instrument; in the eighteenth century it was used as a parlour toy, and
pl. 100 some were made that were real masterpieces of decorative craftsmanship.

Did artists make use of these devices? Should we subscribe to the theory of Erik Larsen who, in his study of Frans Post, holds that some painters looked upon the world through the wrong end of a telescope? In the composition of certain landscapes he detects the visual aberrations which would be produced by Galileo's telescope used in reverse. It must be noted that these instruments were perfected and came into common use in improved form only in the second half of the seventeenth century, after Dutch painting had reached its peak. But it is certain that there was great interest in optics, which Constantijn Huygens called 'the noblest part of mathematics'. I can more readily agree with Erik Larsen when he emphasizes the probable influence of the *camera obscura* (although as yet it produced only inverted images) through the magical aura with which it endows reality. One of these instruments inspired Huygens to exclaim: 'All painting is dead beside this, for this is life itself!' Which leaves no doubt as to his view of the purpose of the art of painting.

It was in this atmosphere that Descartes followed his *Discours de la Méthode* with a treatise on dioptrics. His purpose was to escape from the empiricism that had until then reigned in the sciences and to organize experience on the basis of a chain of truths, whose first principles he found within himself—thus breaking free of scholastic formalism, the faults of which he knew so well from the education he had received from the Jesuits of the Collège de La Flèche.

The great scientific advance of the seventeenth century consisted not only in discoveries, but also in the methodical organization of the instruments of knowledge, and the shift in emphasis from *a priori* mental constructs to experimental results. No other school of art has adopted the inductive method so wholeheartedly as the Dutch school. Confining their investigation to what was before their eyes, they aimed to make a methodical inventory of the immediate world about them. With this in view they divided painting into specialist genres, just as scientists pursuing an inquiry assign it to a number of specialist workers.

To achieve objectivity, Dutch artists had to free themselves first from mannerism, then from the baroque movement brought to their country by the Italianized artists of Utrecht, Theodor
pl. 109 van Baburen (d. 1623), Hendrick Ter Brugghen (1588–1629) and Gerard Honthorst (1590–
pl. 108 1656). Frans Hals too captures the baroque spirit; he gives life to the placid portraits of Mierevelt and Ravesteijn by infusing them with some of the ardour of his own temperament. The next generation abandoned the vein of Hals and turned its attention to an exploration of every detail of Dutch life. The studios of Haarlem elaborated methods of painting that were exploited by those of Amsterdam. Haarlem, city of painters, on the shores of its now-vanished lake, lends to its artistic products a poetic intensity which is lacking in Amsterdam, the city of merchants. Amsterdam realism is crisp; that of Haarlem is more sensitive. One need only
PLS VI, VII compare Jacob Ruisdael and Hobbema to appreciate the difference between the two. Rembrandt belongs to neither; although he lived in Amsterdam, he came from Leyden, the city of thinkers. The Dutch painters' preoccupation with the observation of their own country is rooted in a profound love for a land wrested from the sea. Holland is more a work of man than a product

of nature; it is not surprising that the nation which made it should have taken such delight in the contemplation of itself and its own handiwork.

Seventeenth-century artists developed a new genre which was practised by all the national schools, but nowhere with more intensity than in Holland. Only the observer who has overcome the anti-naturalistic prejudices of our time can savour the charm of the everyday objects painted by Willem Claesz. Heda and the flowers, so soon to fade, painted by Jan Davidsz. de Heem. *pls 104, 106* Their illusory permanence holds within itself the message of impermanence which emerges from too deep an analysis of the phenomenon of consciousness, an analysis in which both consciousness and reality are dissolved.

Certain Northern European artists were inspired by a true spirit of scientific enquiry, a tendency to enumerate the multiplicity of things, as when Jan 'Velvet' Bruegel, with a true Flemish sensuousness, assembles bouquets which include flowers of all the seasons of the year; other painters concentrate on insects and small animals, or displays of tulips representing all the varieties known to the age of 'tulipomania'. Others, like Baltasar van der Ast, the painter *pl. 103* of shells, and the German Abraham Mignon, seem to have been obsessed by the idea of the *pl. 102* microcosm, tirelessly examining a few square inches of ground which support all the flora and fauna of a miniature jungle, as if they felt that by penetrating the essence of a single object or a single creature man could capture the whole mystery of the world.

Seventeenth-century Dutch artists were not dull brutes, interested only in painting what lay before their eyes, as anti-naturalists have tended to believe. It would be surprising if they were; sight is the most intellectual of our senses, the one which leads by the shortest route to the mind. Many of these Dutch painters were highly skilled in the art of composition; in my *Gallery of Flowers* (1960) I tried to show how the evolution of the art of composing a bouquet can be traced from mannerism (Roelant Savery) to baroque (Jan Davidsz. de Heem), then to rococo *pls 105–6* (Jacob Walscapelle) and neoclassicism (Jan van Huysum). They were as much concerned as *pl. 107* the Italians with problems of the organization of space, but in their own style, which was realist. This concern was displayed most effectively in the painting of interiors. We frequently find in these painters the angled composition which is essentially baroque (J. M. Molenaer, *Judith Leyster at the virginals*), but their essential preoccupation, as I have attempted to show *pl. 110* in an article on 'the notion of "the interior" in Dutch art', is to suggest the space in its totality, including the wall turned towards the painter. For this they employed several methods: a curtain, an open window or door, a succession of rooms that can suggest a whole apartment (Emanuel de Witte). Finally they achieved a representation of the whole room, and even of *pl. 111* the whole house, by means of perspective devices or 'optical boxes' which made use of the PL. V mirage of the *camera obscura;* two examples of these boxes are in existence today. It was thus, on a minute scale, that the Dutch conceived the *trompe-l'œil* that was such a favourite device of the Italians, those grand manipulators of space. But the Dutch artist sees space in terms of the four walls of the room in which he lives. To a person of seafarers this is the centre of the world; often a map hanging on a wall evokes the presence of the universe. This tiny, well-defined domestic world is Vermeer's chosen symbol for the human condition.

We should perhaps remember, when tempted to lose patience with the endless tedious portraits of Vermeer's predecessors, that without a long and patient process of elaboration Dutch realism might never have produced the quintessence of Vermeer.

We can trace the development of the Dutch portrait over three generations of painters. At first Dutch sitters choose to appear collectively. Dirck Jacobsz. (1495?–1567) and Dirck Barentsz. (1534–94) show us rows of Civic Guards with professorial-looking caps, rather lackadaisically picking at smoked herrings to raise a thirst; Ravesteijn (1577?–1657) brings a certain relaxation to these stiff groups. Frans Hals gives them a life which they savour to the full. When Hals or one of his pupils paints a man on his own, the sitter's jovial mien often suggests that he has just stepped out of come convivial gathering.

And yet these same people became rigid burghers again in their everyday life; it was precisely because Rembrandt attempted to shake them out of their complacent censoriousness that they turned against him.

Vermeer's settings, as well as his people, are the outcome of many years of refinement and study of detail. A whole generation of painters had to analyse the structure of objects before Vermeer could come and express their inner life; others discovered all there was to know about interiors, so that he might compose with such accuracy the space enclosed within four walls, apportion its light and shade, and make it the repository of the elusive essence of being.

pl. 108

PL. VIII

Our Western civilization seems unable ever wholeheartedly to reject the classical spirit in art. In the seventeenth century, while the baroque movement was gaining impetus in Italy, the classical aesthetic which had been the glory of the Rome of Julius II and Leo X took root in Northern Europe and brought about what might well be called a second Renaissance.

Even in baroque Italy, classicism retained some adherents; these included the painters Andrea *pls 130-1* Sacchi, Sassoferrato, Albani and Domenichino—and Lanfranco, too, in some of his works. In architecture, even that superb dramatist and orator in stone, Bernini, occasionally comes very near to classicism. In admitting this we should first realize that bright colour is not enough to make a building baroque; otherwise time alone would have made the Parthenon the model of classicism, for it was once brightly coloured inside and out. The Galerie des Glaces at Versailles is called classical; but Sant'Andrea al Quirinale would be no less classical if Bernini had not embellished the magnificent architectural rhythm of his great portico, designed to encompass the whole space of the church, with the baroque rhetoric of the large, gesticulating stucco figures on the cornice. In his rotunda of L'Ariccia, a form with all the intellectual purity of the Renaissance, the rhythm of the angel-borne garlands round the base of the dome serves to mark off a finite space in a way which is the very essence of classicism. All this can be set against Bernini's more purely baroque gestures, such as the fountain in the Piazza Navona, the Scala Regia (a sham staircase) in the Vatican, the colonnade before St Peter's, or the façade of the *pls 138-9* Palazzo Barberini.

Pietro di Cortona, too, the most baroque of all Roman painters, designed the elegant classical dome of San Carlo al Corso.

All these Roman baroque artists were, in fact, convinced that they were recreating the art of antiquity, for which they had the same reverence as the artists of the previous century. (It is true that the antique sculpture they most admired was the *Laocoön*!) The fact that most of the ancient works of art found in Rome dated from late antiquity led to a misunderstanding which favoured the rise of the baroque.

Inigo Jones, who had visited Rome in 1603, made a Grand Tour of the Continent, including Italy, in the company of the Earl of Arundel in 1613–14, and brought back a heavily annotated copy of Palladio's *I Quattro Libri* and a desire to bring classicism to England. The source of his inspiration gave English classicism a form which deserves special study as a 'mode' of classical art.

The province of Holland, the obvious leader of the United Provinces, was the first of them to adopt classicism. Early in the century, Hendrick de Keyser refined Vredeman de Vries's brand of mannerism by stripping down the ornamentation while retaining the structure, partic-

pl. 112 ularly the vertical thrust of the tiered frontages (Zuiderkerk, completed 1624, and Westerkerk, 1620, in Amsterdam). The classical reform was a result of the meeting between two men, Constantijn Huygens, humanist, friend of Descartes, and secretary to Stadholder Frederick Henry, and Jacob van Campen, an architect. The hallmarks of Dutch classicism, its dominant horizontal lines, brick façades adorned with colossal stone pilasters, and a coping emphasized by a triangular pediment, appeared first in The Hague: the house of Constantijn Huygens

pl. 208 (1633), the Sebastiansdoelen (1636), and the Mauritshuis, the palace of John Maurice of Nassau, completed in 1643. The major fruit of the collaboration between Van Campen and Huygens was the Raadhuis (town hall) of Amsterdam, created after the Treaties of Westphalia to celebrate the benefits of peace and civic order. It is on the scale of the Roman *palazzi,* and is classical in style, with its superimposed orders and the *tempietto* dominating its roof. The Van Campen style later grew in majesty; Amsterdam, which is one of the finest museums of archi-

pl. 113 tecture in Europe, provides many examples such as the Admiraliteitshof (1666) in which the Van Campen idiom is enriched by a light decoration which in France might almost be described as 'Louis XVI'.

From Holland the classical style spread after 1650 to the other United Provinces and even beyond. Prince John Maurice of Nassau, friend of the Rhenish princes, helped to introduce it to the provinces of the lower Rhine. It even reached the Baltic; in 1637 a Frenchman, Jacques de la Vallée, who in 1634 had been summoned by the stadholder to be his chief architect and who had introduced the French *château* to the Netherlands, carried the style to Sweden.

In 1653, another Dutchman, Joost Vingboons, built (though admittedly in a somewhat

pl. 114 more baroque idiom) the Riddarhuset (House of the Nobles) in Stockholm.

The style of Versailles was brought to Holland by a Huguenot, Daniel Marot, who was driven into exile by the revocation of the Edict of Nantes in 1685; and this too helped to turn Dutch architects towards the baroque. This is very evident in the Royal Library built to Marot's designs in the Lang Veerhout, the Hague, 1734–64. The same architect embellished the great

PL. IX house of Het Loo with a staircase copied from the famous Escalier des Ambassadeurs at Ver-sailles. The United Provinces eventually adopted the rococo style of exterior decoration, but confined it to a central motif of exquisite elegance, standing out in finely-chiselled relief against a field of rose-coloured brick.

Baroque was never entirely unknown in Holland; seventeenth-century Dutch sculpture, which consists almost entirely of memorials to the dead, is full of the baroque spirit. Since the country produced few sculptors, Huygens and Van Campen, when creating the vast enterprise of the Raadhuis, Amsterdam, had to call on an Antwerp sculptor, Artus Quellinus. In his own country, the Spanish southern Netherlands, Quellinus was a baroque artist; but under the combined influence of the architect and the humanist his flexible talent swung towards clas-sicism. Though the pediments have a vigour that retains a flavour of the baroque, certain bas

reliefs such as the friezes of the mantelpiece of the Burgomasters' Room representing the *Triumph* *pls 115–6*
of Fabius Maximus or the friezes of frolicking children above the fireplace of the Council Room,
or again the *Israelites gathering manna* (comparable in movement to a bacchanale) in the Court
of the Magistrates, recall Poussin and the finest of the Renaissance creations inspired by the
antique, such as the Sala degli Stucchi or the Sala di Cesare in the Palazzo del Tè, Mantua.

Spain in the seventeenth and eighteenth centuries, a country in decline, sought in the baroque
a solace for her fever. Castille is a heaven-dominated country in which men's minds turn
towards fantasy; in the fifteenth century Castille had produced Alonso Berruguete and in the
seventeenth century Gregorio Fernández. Andalusia is a milder region, closer to reality, and a
favourable setting for classicism; the only two major seventeenth-century Spanish artists who
remained untouched by the baroque were Andalusians. Francisco de Zurbarán was a mystical
realist; while Martinez Montañés created some of the most profound of all images of divinity *pl. 132*
and sainthood. Several times in the history of art, classicism, which gives form to the Idea, has
shown itself to be a favoured medium for the expression of divine reality.

The altarpiece, a form which is central to the history of Spanish art, remained firmly classical
until the second half of the seventeenth century. Gregorio Fernández of Villadolid designs his *pl. 133*
altarpieces in a classical spirit, and yet carves his religious images with all the expressive fervour
of a baroque artist.

The France of Henry IV, emerging from a long period of civil wars with many ruins to
restore, was a vast building-site. For the sake of speed, most building was done in brick, but the
stone structures that were built might have made one expect that France was going to go over
to the baroque (Hôtel de Ville, La Rochelle, Hôtel de Vogüé, Dijon). This tendency persisted *pl. 117*
into the reign of Louis XIII, and was visible even later in interior décors in which gilded
panelling, paintings and stucco work combine to produce an effect of superabundance (Hôtel
Lauzun, Paris, 1650–8, Château de Vaux-le-Vicomte). Early in the reign of Louis XIV two *pl. 118*, PL. XII
architects, Le Vau and Le Mercier, in spite of their efforts towards classicism, were unable
entirely to suppress a natural tendency to the baroque. In Le Vau this found expression in an
abundance of ornament (Cour de Marbre, Versailles), and above all in a tension in the propor- *pl. 119*
tions which betrays an inner conflict (Château de Vaux-le-Vicomte, Hôtel Lambert de Thorigny,
Château de Saint-Fargeau (1657). Le Mercier, for his part, purifies his style in the Chapelle de
la Sorbonne (1629); but he also gave the ornamentalist Michel Anguier free rein to embellish
the vaults of the church of Val-de-Grâce.

The triumph of classicism over the baroque in seventeenth-century French architecture was
largely the work of three great architects, François Mansart (1598–1666), Jules Hardouin-Man-
sart (1646–1708), his great-nephew, and Jacques-Ange Gabriel (1698–1782). According to M.
Albert Laprade, we should add to these François d'Orbay (1634–97), a draughtsman of
genius, who worked under Le Vau and Jules Hardouin-Mansart.

The crisis through which French architecture was passing was both revealed and basically
resolved on the occasion of the international competition held by Louis XIV in 1663 for the
completion of the palace of the Louvre. Not surprisingly, the Italian competitors Rainaldi,

pl. 10　Pietro da Cortona, Candiani and Bernini submitted baroque designs; the French too (Cottart, Marot, Le Vau, Le Mercier, Le Brun, and even François Mansart) were still more or less inspired by a certain baroque emotionalism; only the plan of Léonor Houdin contained a foretaste of what was actually carried out. The fact that the king had asked for plans from Rome indicates how high was the prestige of Italian baroque in France at this time. It even seemed to Louis that only Bernini could be worthy of him, and he received him in 1665 with the highest honours. However Bernini's own self-importance, and his bombastic design for the Louvre, helped to make up the king's mind; he decided after all to seek a solution in the resources of his own country. In 1667 the task of drawing up a final plan was entrusted to a committee. Guided by the good sense of his minister Colbert, Louis XIV inclined the committee towards a *pls 11, 122*　classical solution, thus virtually determining the whole development of French architecture for generations to come. Thanks to Louis XIV, classical France found its destiny.

pl. 346　Then came the mighty enterprise of Versailles, in which three men, a decorator, Le Brun, an architect, Jules Hardouin-Mansart, and a landscape gardener, Le Nostre, created the first major architectural complex in Europe to be truly royal. Versailles proves that the royal idea can be expressed without grandiloquence; its greatest strength lies in harmony. While the baroque expresses an aspiration towards a higher state, classicism, with its controlled forms and fixed modular system of proportions, gives the aptest expression to the great seventeenth-century ideal of self-mastery, and as it were epitomizes the idea of kingship itself.

Europe was awestruck; even the smallest German principalities imitated Versailles. But the imitation was not based on real understanding or sympathy; eighteenth-century baroque Europe took Versailles as its model just as Bernini had taken the antique.

The interior decoration at Versailles made much use of colour to convey the splendour of royalty; but here too the rhythm and order of classicism are evident. Partitioned, ransacked by later kings, dismembered by the Revolution and stripped of its furnishings in the nineteenth century, the Versailles of Louis XIV is recognizable only in the Galerie des Glaces, the Grand Trianon and the design of the gardens.

pl. 120　And so France turned her back on Rome. In the Grand Trianon, Jules Hardouin-Mansart achieves a harmony of proportion comparable with that of Greek architecture; Jacques-Ange *pl. 121*　Gabriel created a true counterpart in the Petit Trianon. We need only compare the dome of *pls 123-4*　the Val-de-Grâce by François Mansart with the dome of the Invalides by his great-nephew to gauge the measure of this achievement. The colonnade of the Louvre is the French Parthenon; the Petit Trianon is the French Erechtheion.

All that was left for the eighteenth century was to refine these principles and bring them down to the scale of private life, creating infinite variations on the themes of town mansion and country house (*hôtel* and *château*) laid down in the seventeenth century. In this period, however, there was a certain revival of baroque architecture, of which Boffrand, who later had great success in eastern France and in Germany, was the chief exponent. In the field of interior decoration, France contributed to the development of the rococo style, employed with more restraint than in the German-speaking countries.

IX Louis Le Vau (1612–70) and Charles Le Brun (1619–90). Escalier des Ambassadeurs, Versailles, model ▶

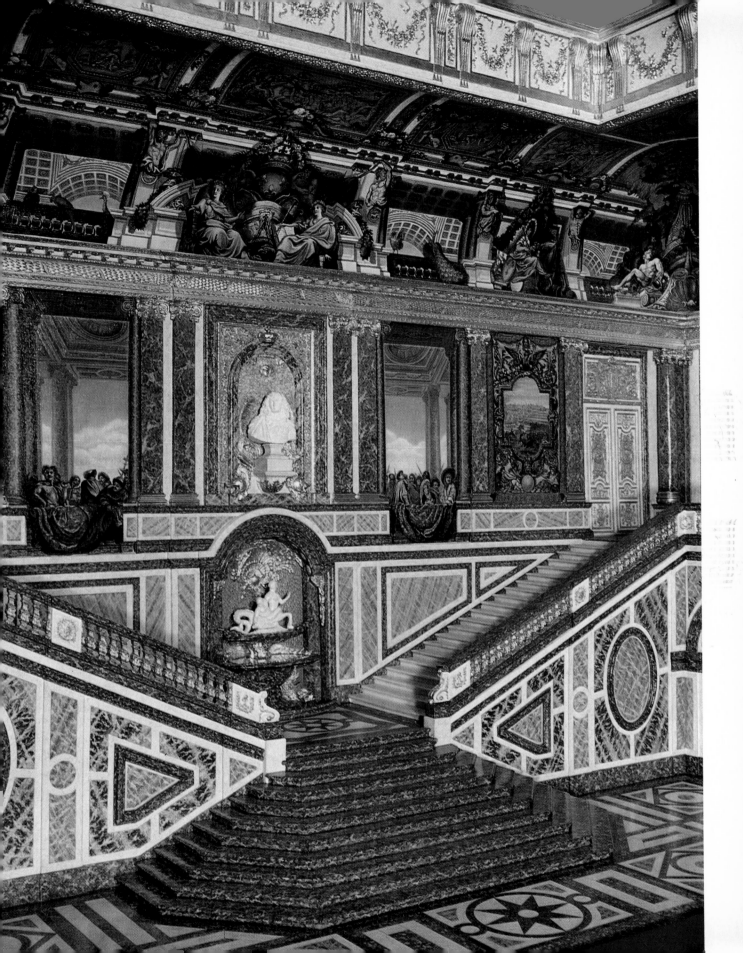

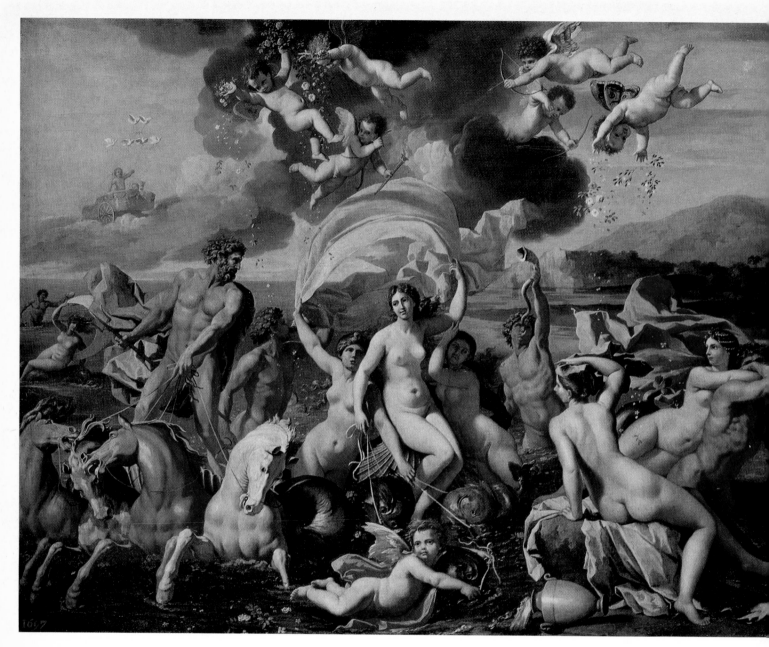

x Nicolas Poussin (1594–1665). Neptune and Amphitrite

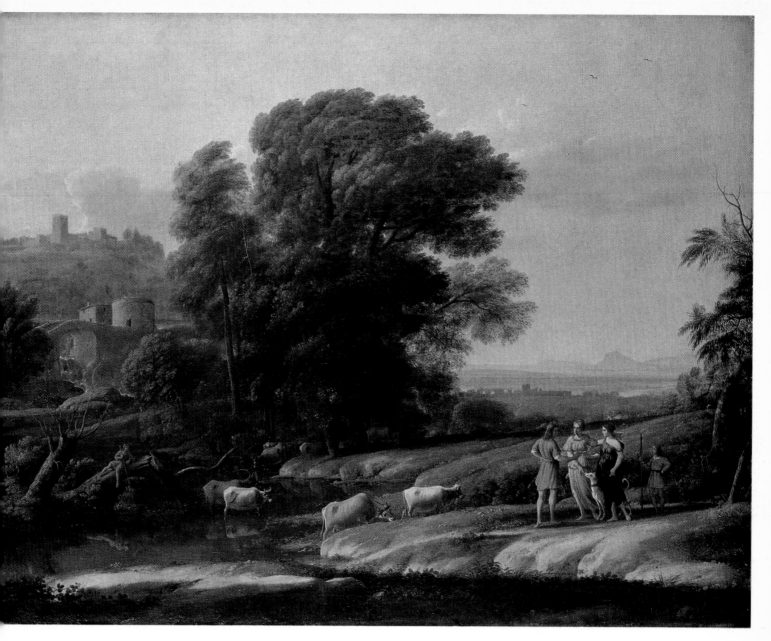

XI Claude Lorrain (1600–82). Landscape: Cephalus and Procris reunited by Diana

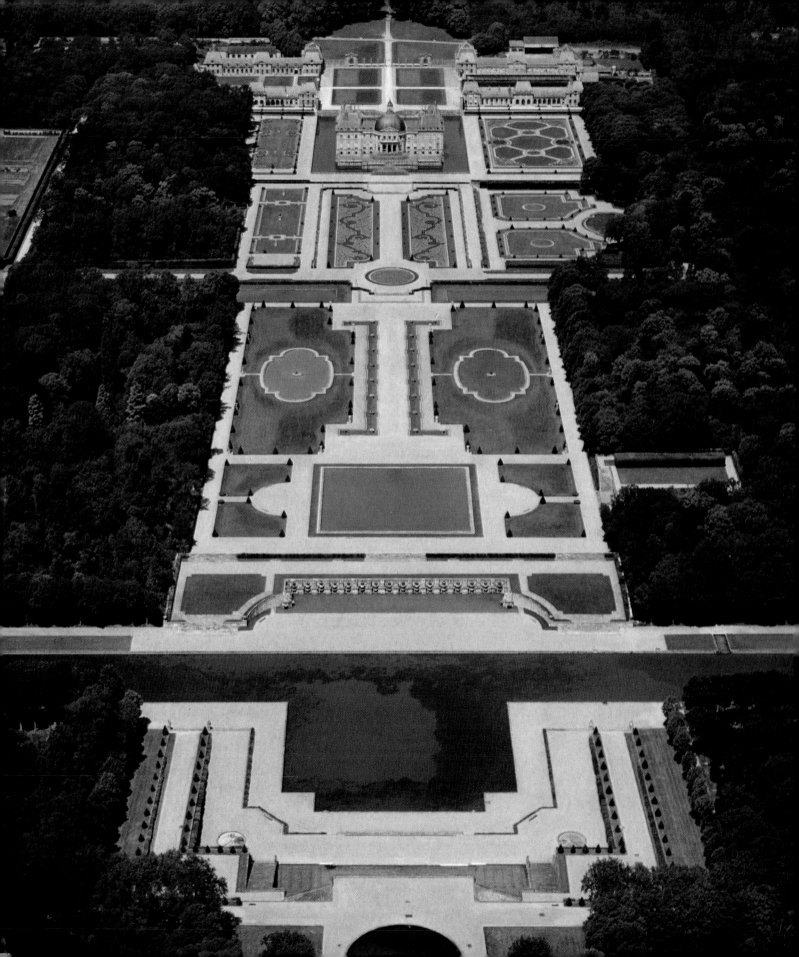

Sculpture did not follow the same pattern of development. The classical tendencies which were to culminate in the work of François Girardon (1628–1714) were already apparent in the reign of Louis XIII. Lapses into the baroque idiom are apparent in the work of Michel Anguier (*Holy Family* in Saint-Roch), in funerary sculpture in general (always a pretext for eloquence) and in the portrait bust, which conforms with the spirit of the age in expressing the life of the individual through action. The one whole-heartedly baroque sculptor, Pierre Puget (1620–94), is the exception which proves the rule; by training he was more of a Genoese than a Frenchman. In Girardon's *Apollo attended by nymphs* in the Grotte d'Apollon at Versailles, the problem of classical idealism is solved in a manner reminiscent of Pheidias.

pl. 125

pl. 149

pl. 126

Eighteenth-century French sculpture is divided between a disciplined form of baroque (Jean-Baptiste Pigalle, 1714–85) and an acuteness of psychological observation which liberated portraiture from the pomp of the seventeenth century (Jean-Antoine Houdon, *Voltaire*). Caffiéri indulges his baroque imagination; while Pajou devotes himself to the service of feminine elegance in a delicate *galant* style which is fined down still more by his successors, Clodion and Falconet. Such is the strength of tradition in French sculpture that this elegance and sense of femininity often recall the style of Fontainebleau (Houdon, *Diana*). Feminine influence did not, as we might have expected, favour the rococo, but served rather to restrain its excesses.

pl. 15

While seventeenth-century French architects hesitantly followed the path of classicism, painters were pursuing it deliberately, notwithstanding the effect produced by the arrival of Simon Vouet from Italy in 1627. The classical tendency was reinforced by the influence of the religious teachings of Bérulle and the doctrines of Jansenism, which turned French religious painters (Le Sueur, Philippe de Champaigne, Georges de La Tour) against the ecstatic expressions of piety which were in favour in Rome. Georges de La Tour expresses the inner struggles of the soul not by heavy emotional effects but by darkness and poignant silence. Philippe de Champaigne penetrates the very soul of his sitters, disguising nothing and yet respecting their innermost secrets, maintaining the balance between reality and appearances which is lost in the portraiture of the age of Louis XIV. The same restraint appears in the genre paintings of the brothers Le Nain.

pls 38, 127–8

A conscious decision led the two painters whose names have become the very symbols of classicism, Poussin and Claude Lorrain, to leave France and settle in Rome. Today we find it hard to understand how they can have been at home in an artistic milieu that appears so alien. But the contrasts which are obvious to us were not so apparent then. Poussin and Claude were revered in Rome as the artists who succeeded in coming nearest to the antique; and Claude, as a painter of landscapes, was an exponent of a genre which was recognized as a speciality of Northern European artists. Poussin and Claude lived not so much in the Rome of their day as in an imaginary Rome, finding in the many relics of antiquity which still abounded in the Eternal City a congenial setting for the development of their art. They were both, in the true sense of the word, historical painters. They apprehended the present through the medium of the past, and for them Rome was truly Rome only in its evocation of the ancient Romans. The dimension of imagination, which in baroque art led to pure fantasy, led these classical artists to

PLS X, XI

◀ XII Louis Le Vau (1612–70) and André Le Nostre (1613–1700). Château de Vaux-le-Vicomte, 1660

explore the world of the past: like their contemporaries, they had their dreams, and they nourished them on the *Metamorphoses* of Ovid and the romances of Tasso. Claude turned to these books for enchantment, Poussin for philosophical symbols. Both accepted imposed themes only with great reluctance; and neither ever willingly conformed to a decorative scheme. They thought of a picture as an object in itself, the fruit of personal speculation. By escaping from their own age they sought and achieved a timeless quality which in Poussin's case was enhanced by the fact that he drew the laws of his art from Raphael and Titian, and thus indirectly from the antique. This is in keeping with the Platonic theory that there is a certain constancy in forms, regarded as crude instruments which express for mankind's benefit the 'ideas' which are the essential reality contained in all things.

PL. XIV

Under Louis XIV, while architecture became classical, painting moved towards the baroque. The teaching of Le Brun imposed on religious and secular art a style that had the gestures but not the conviction of the baroque. Rigaud created an image of royalty and of the courtier so perfect that it was imitated all over Europe. In the eighteenth century French painters entirely abandoned classicism (to which a large proportion of French architects remained loyal) and returned to it only with neoclassicism. Thereafter the classical tradition was not finally rejected until the victory of impressionism; Delacroix, for example, regarded himself as a classicist. Even today in France a strong anti-baroque prejudice survives, notably in the vandalism of many parish priests. Yet history shows that although France in the seventeenth and eighteenth centuries produced the finest manifestations of the classical spirit the modern world has known, the baroque was a constant temptation. It was the tension between classical and baroque that enriched French art and endowed it with its profound and individual humanity. The existence of alternatives deepens the understanding; a talent which finds expression too easily may find a personality and a style, but many rich possibilities are lost. Eighteenth-century Germany is a case in point: in the style which we know as rococo, German artists found their true path altogether too easily and too quickly.

The baroque style originated in Rome between the pontificates of Sixtus V (1585–90) and Paul V (1605–21). The Church had survived the crisis she had undergone in the sixteenth century; she had renounced the dream, cherished by the Renaissance Popes, of unifying the Italian peninsula under the hegemony of the Holy See; but she had also checked the spread of heresy, and the Popes celebrated this triumph by giving the Eternal City an appearance worthy of the capital of the Catholic world.

A few works dating from about the year 1600 show the easy transition from mannerism to baroque. In the Pauline Chapel in Santa Maria Maggiore, built between 1605 and 1611 to *pl. 134* contain the tombs of Paul V and his predecessor Clement VIII, Flaminio Ponzio follows the lines of the Sixtine Chapel on the other side of the nave, built for Sixtus V by Domenico Fontana; but the slight alterations in the design tending towards stricter architectural discipline, combined with richer sculptural decoration, reveal the tendency of the work towards the baroque.

A comparison between the façade of Santa Susanna (1597–1603), by Carlo Maderno, and *pl. 136* that of Giacomo della Porta's Chiesa del Gesù on which it is based, illuminates the transition *pl. 135* from Counter-Reformation severity to baroque magnificence. Giacomo della Porta's façade, with its meagre pilasters, suffers from a kind of constraint; it is still no more than a large decorated wall, broken by a few bays which are out of scale with the building as a whole (a characteristically mannerist feature). Maderno's façade, with its interplay of columns and jutting pilasters, is a composition of volumes in light and space; it is a lyrical work, expressing a feeling of freedom, but always subject to a rhythm that imposes an overall discipline.

During the same period, a few artists were to deliver painting from the torments of mannerism. The Carracci brought an end to the scrappiness, the insubstantiality and the compositional vagueness which typify the art of their immediate predecessors; all the painters of the seventeenth century learned from them how to organize the figures in a picture according to one unifying principle based on a single action. The Carracci brought the painter back to a rational study of the masters, but also to a study of nature and principally of the human body; they restored its robustness, and did not hesitate to seek models among the common people. In his frescoes on the roof of the Gallery of Hercules in the Palazzo Farnese, Annibale Carracci recaptures the *pl. 153* sense of monumental composition achieved by Michelangelo in the Sistine Chapel; he uses the same methods, drawing his rhythm from the power of the human body, usually nude. Illustrating

for a cardinal the loves of the gods of Olympus, Annibale opened up a rich source of images on which artists all over the world were to draw for years to come.

pl. 154

Even more than the Carracci, Caravaggio dedicates his art to the human body. In the Contarelli Chapel in San Luigi dei Francesi (*Scenes from the life of St Matthew, c.*1600) and in Santa Maria del Popolo (*Crucifixion of St Peter* and *Conversion of St Paul,* 1600–1), his figures, with their powerful physique inspired by the porters and stevedores of the Tiber, are shown in the throes of a drama of life and death which has been reduced to a simple trial of strength; their world is without God or gods, seemingly abandoned even by Nature, plunged in the darkness of the Creation or the Apocalypse.

Before 1610, the artists of Rome showed the world of painting two paths to follow: that of illustrative and decorative painting, integrated into a social setting, and that of dramatic painting, fruit of the solitary anguish of genius. It was the unique achievement of Peter Paul Rubens, who lived in Italy between 1600 and 1608, to synthesize these two tendencies.

pl. 140

The pontificate of Urban VIII (1623–44) inaugurated an era of magnificence for Rome, an era on which Bernini lavished the inexhaustible riches of his genius. The Pope's major achievement was the remodelling of St Peter's, already provided with a nave by Carlo Maderno on the orders of Paul V in 1605. In 1629 Urban VIII entrusted Bernini with the decoration of the interior, which he conceived as a veneer of marble, stucco and gold. He animated it with gigantic statues and church furnishings of bronze, the tombs of two Popes, the Throne of St Peter (1656–65) and the Baldachin, the 85-foot high canopy over the high altar, subsequently imitated all over the world. It incorporates 'Salomonic' or 'barley-sugar' columns, modelled on those from Constantine's old St Peter's which had been preserved and re-used in the new church. Their spiral form expresses an ascending impulse better than straight shafts could ever do.

pls 137–8

In the course of his long life (1598–1680) Bernini set his stamp on Rome in a way which influenced the entire artistic development of the city until the day when it became the capital of the Kingdom of Italy. For him the task of architecture was to express grandeur and magnificence; but he remained loyal to the principle of monumental stability which was the legacy of Michelangelo and the Roman Empire, expressing weight by the use of solid entablatures and rigid supports, and enriching the style only by an increase in the number of elements, as in the square before St Peter's, surrounded by colonnades with four rows of columns. A comparison between Bernini's façade of the Palazzo Barberini and the court of the Palazzo Farnese, as designed by Giuliano da Sangallo with three rows of arcades, shows how Bernini enriches and complicates a traditional theme which is itself inherited from the antique (the Colosseum), notably by the perspective treatment of the upper arcades. Though he loves to handle colossal dimensions, he is

pl. 141, fig. 8
pl. 142, fig. 9

capable of creating a noble intimacy in a little church like Sant' Andrea al Quirinale, which in the Via XX. Settembre acts as a foil to Francesco Borromini's San Carlo alle Quattro Fontane. In contrast to Bernini, who is a man of the theatre, Borromini is a poet, fascinated by new modes of expression in preference to established traditions; thus he does not hesitate to modify the orders as laid down by Vignola, to which Bernini remains loyal. While Bernini gives a harmonious development to the façade, deepens the perspective and composes the building in terms of masses,

Borromini seeks for contrasts of angles, diagonal movements, the sliding, rebounding effects of curves and counter-curves, spiral movements, the spatial contrasts created by complex planes; in a word, he treats space in torsion, as a symbolic form. Borromini, a mystic, with a melancholic temperament (he eventually commited suicide), worked almost exclusively for the religious orders. Angels are among the *leitmotive* of his ornamental style. While Bernini's art is architectonic, Borromini's is lyrical; he has a distaste for colours, preferring the pure tones of white stucco. The exquisite San Carlo alle Quattro Fontane—which would fit comfortably into one pier of St Peter's—is an ardent cell, a celebration of the impulse which leads the soul out of the earthly shadows into the light. In Sant' Ivo alla Sapienza he suspends over the church a dome in the form of an open rose, crowned by a pagoda.

For Bernini, Borromini and the architects of their circle, such as Pietro da Cortona, Girolamo and Carlo Rainaldi, and Martino Longhi, scope for invention lay not only in the elevation and the décor, but in the plan, which ceased to be subordinated to functional considerations and became a subject for pure formal speculation.

The stability Bernini imposed on his architectural works is absent from his sculptured figures. All his statues show characters caught in the instability of an impetuous movement, carried away by passion or ecstasy. Two groups fully illustrate this quality: the *Ecstasy of St Teresa,* PL. XIII, *pl. 40* a much misunderstood work which has been seen by some as containing overtones of profane love, and the *Apollo and Daphne,* in which the artist has caught in marble that instant of meta- *pl. 147* morphosis that attracted so many baroque artists. Frozen in the cry that is the last expression of her humanity, Daphne, her eyes already blank, passes from one kingdom into another.

Other sculptors of Bernini's circle, such as Alessandro Algardi and the Fleming François Duquesnoy, showed themselves to be more attracted by the noble gestures of classicism. In Piacenza, Francesco Mocchi devoted seventeen years of his life to creating the two equestrian *pl. 372* statues in bronze of Alessandro and Ranuccio Farnese, in which he expresses all the fire of the heroic temperament in the nervous step of a pacing horse.

The painters of seventeenth-century Rome, most of them products of the Bolognese school of the Carracci—Guido Reni, Albani, Carlo Dolci, Lanfranco, Guercino, Domenichino *pls 130–1* —concentrated their energies on decorative painting, leaving easel painting to the foreigners Poussin and Claude Lorrain, who realized the classical ideal; while certain Northern painters, the *bamboccianti,* brought to Rome genre painting and the love of ruins.

Church exteriors (except for the façade) were usually sober; all the resources of the arts of painting, sculpture and ornamental modelling were devoted to transforming the interiors into worlds peopled with statues which seem engaged in a contest of sacred eloquence. The compart- mented décor of ceilings such as that of St Peter's was replaced by *trompe-l'œil* paintings of structures which, continuing that of the church, open out to the sky, revealing a paradise inhabited by cloudborne saints. The most skilful of these *trompe-l'œil* painters was a Jesuit, Andrea Pozzo; his masterpiece is the ceiling of Sant' Ignazio, Rome, where the whole universe is assembled in PL. IV, *pl. 316* the guise of saints and allegorical figures to celebrate the glory of the founder of the Society of Jesus. The powerful, rounded arches, the majestic entablatures and Corinthian pilasters symbolize

by their horizontal emphasis the earthly life which the Christian aspires to leave for the paradise revealed to him in the open ceiling. But this terrestrial life is not a vale of tears, it is a palace.

The influence of Caravaggio was profound, not only in Rome (Gentileschi, Borgiani, Manfredi) but in the Kingdom of Naples, where he stayed for some time. Battistello in Naples and Pietro Novelli in Sicily were the best assimilators of the severe quality of his art; while it was transformed by the Spaniard Pedro Ribera into a rhetoric of martyrdom and asceticism. Florence lingered in her dreams of formal perfection. As in the preceding age, the political divisions of Italy favoured the development of other provincial schools of painting, all tending towards a certain romanticism. They will be considered in another chapter.

In architecture the provinces, after a certain delay, produced their own distinctive variations on the principles elaborated in Rome. Venice (as in Baldassare Longhena's La Salute) was faithful to her traditions of decorative opulence; Naples, Sicily and Apulia (Lecce) displayed an exuberance which brought their art close to Andalusian baroque, an influence which reached them as a product of Spanish rule. In Naples, and even more in Sicily, interior decoration consists not of veneers of stucco or marble panels, but of marquetries of rare marbles which lend the building the richness of a work of jewellery (as in the décor of the Lady Chapel, Monreale). In the eighteenth century, Naples, once again the capital of a kingdom, was decked out with churches, monasteries and palaces. Ferdinando Sanfelice invented the most ingenious variations on the theme of the staircase; Ferdinando Fuga and Luigi Vanvitelli served the megalomaniac Bourbon King Charles VII. Following the impetus given by Rome in the previous century, the city produced great decorative painters: Solimene, Mura, Giaquinto.

The most inspired and far-reaching contribution of provincial Italy to the development of architecture was made by Guarino Guarini, who in seventeenth-century Turin pioneered the interplay of curves and intersections which was to be characteristic of the rococo architecture of the following century. Guarini treats interior space like a musical theme, instinct with vibrations, echoes and resonances. In Turin, in the eighteenth century, Filippo Juvarra returned to a more *pl. 220* static Berninesque baroque; sometimes, as in the church of La Superga (1715–27), he anticipates the coldness of neoclassicism.

Just as Bernini dominated Italian art, Rubens after his return from Italy came to dominate the artistic life of Flanders. The phenomenal vitality of this giant among baroque painters finds its *PL. XVI* expression in compositions (*Rape of the daughters of Leucippus*) which are sequences of oblique and spiral movements. In his vast studio in Antwerp Rubens worked for the whole of Europe, supplying the princes and prelates of the baroque age with paintings in which they recognized themselves. His late second marriage to a girl of sixteen, Hélène Fourment, brought a new note of personal feeling into his work; his portraits of his wife evoke (sometimes almost *pl. 158* indiscreetly) the sensuality and tenderness of his love. His landscapes, open to infinite horizons, seem to breathe in unison with the soul of the universe.

pl. 160 Meanwhile, his Flemish contemporaries became more and more specialized, each painter methodically exploiting one aspect of reality: Snyders and Fyt animals, David Teniers and

Adriaen Brouwer country life, Jan (Velvet) Bruegel landscape, Daniel Seghers and Bruegel flowers. Van Dyck was the only Flemish artist to reap the benefit of the teachings of Rubens, coloured with a marked Venetian influence (*Amarilli and Mirtillo*); the elegance of the court *pl. 159* of Charles I of England was congenial to his sensitive nature, and he brought to English painting a tradition which was maintained until the end of the eighteenth century.

Sculpture in Flanders followed the example of Bernini, though architecture still remained mannerist; not until the latter part of the seventeenth century do we find an architectural equivalent for the baroque style of Rubens. In 1657 work was begun on the Jesuit church of Saint-Michel in Louvain, in which the sculptured décor, using as a *leitmotiv* the charming and lively theme of *putti* disporting themselves in the 'sacred vine', is truly integrated with the architecture. The same synthesis is achieved in the earliest houses of the Grand' Place, Brussels, dating from the 1690s. *pl. 366*

After Holland, France was the country which most firmly resisted the baroque. If the original décor of Versailles were intact, it would undoubtedly appear to us more baroque than it does now that it has been reduced to a simplicity that we consider classical. Mansart and Le Brun adopted a décor in the Italian style, but tempered by a rhythm which, by blending all the elements into a harmonious whole, tones down the effect of ostentation; this is a true characteristic of classicism. And yet the whole concept of the Galerie des Glaces, in which the decor is repeated by its reflection in the mirrors, and the dark inside wall is filled with light, incorporates an essentially baroque principle which the Italians and Germans were later to use to obtain magical effects. What should we say if we could see sparkling in those mirrors the splendid silver furniture which Louis XIV ordered from the Gobelins in 1660, and which he had to melt down in 1689 to raise money for the War of the League of Augsburg? It yielded no less than twenty tons of silver.

After the school of Fontainebleau, France had no more real decorative painters; Marie de Médicis, Henry IV's widow, had to call in a Flemish artist (Rubens), and Anne of Austria, Louis XIII's widow, an Italian (Romanelli), to obtain paintings of truly monumental effect. Le Brun's teachings had the merit of producing painters capable of decorating ceilings on a large scale. He put his own precepts into practice in the Galerie des Glaces, but the results are no more than creditable; no French painter, heir to a monumental tradition in sculpture, has ever been completely successful as a decorator, being unable to conceive a picture otherwise than as surface. Even less is the French artist capable of *trompe-l'oeil* on curved surfaces. For his achievement (a relatively undistinguished one) in decorating the dome of the Val-de-Grâce, Mignard was hailed as a prodigy and was even the subject of a poem by Molière. In his easel painting Le Brun alternates between the classical mode (*Holy Family*, Louvre), a moderate baroque (*Adoration of the Shepherds*, Louvre) and an exaggerated baroque in which he puts into practice his personal theories of expression (*Magdalen*, Louvre). The artist who benefited most from the teachings of Le Brun was Rigaud, who gave to baroque Europe its perfect image of PL. XIV the courtier. By his figures' attitude as much as by the movement of draperies, wig, and accessories, he makes each individual a model of the station in life which he 'excels': military leader,

minister, dignitary of the Church, monarch or courtier. All his subjects seem to use profession or status as a kind of mask. Nevertheless Rigaud in no way tones down each character's individual features; on the contrary, it is a baroque tenet that lines of experience in a face are a proof of strength of character. Mignard, on the other hand, sets out to make each of his court ladies conform to the ideal beauty she thought herself to possess. In the reigns of Louis XIV and Louis XV the fashion spread for portraits in costume, making the courtier into a demi-god; ladies appear as Muses, Vestals, Dianas, Hebes or Minervas, with their children as Cupids.

The formalism of Le Brun was eclipsed by the baroque vigour of Rigaud, the hot-blooded Catalan. Away from the formality of the court, there was a spontaneous baroque movement in the South of France; in Toulouse, for example, the draughtsman La Fage, the painters Jean-Pierre and Antoine Rivalz, and the Provençal painters of battle scenes Joseph and Charles Parrocel, were more akin to the seventeenth-century Italians than to their French contemporaries.

pl. 149 Pierre Puget, too, owes to his Provençal origins the baroque instinct that he reveals in certain works of architecture and above all in his sculpture, which seems possessed by a cult of physical strength; but a work like his *Milo of Crotona* is exceptional in French sculpture; French artists more often prefer to interpret power in terms of the dominance of reason. Generally speaking, the line of demarcation between baroque and classical in seventeenth-century French sculpture corresponds to the division between sacred and profane themes. Court sculpture tends towards classicism; funerary or religious sculpture answers more the need for 'expression'. The portrait *pls 19–20* busts of Coysevox, however, like the paintings of Rigaud, depict character in the heat of action, whether the subject be painter or minister (*The Great Condé*, Louvre).

The teaching of Le Brun brought into being a whole school of baroque decorators, both painters and sculptors, which was to persist throughout the eighteenth century, existing parallel to *galant* and rococo art (Charles de La Fosse, Lemoine in painting; Lambert Sigisbert Adam, Michel-Ange Slodtz, Pierre Le Gros in sculpture).

Versailles was the baroque Olympus. Europe at once recognized its ideal, and Versailles influenced all the baroque and rococo art of the eighteenth century.

An over-simplified view would tend to regard England as entirely hostile to the baroque, faithful throughout the two baroque centuries to the classical and neoclassical principles laid down by Inigo Jones. The situation is in fact far more complex. Temperamentally inclined towards neoclassicism, English artists nevertheless carried on a constant flirtation with the baroque; all things considered, England gave more expression to this style than France.

About the year 1660 emerged a man who by force of circumstances was to achieve an importance in his own country equal to Bernini's in Rome. Sir Christopher Wren did in fact meet Bernini during a visit to France in 1665, at a time when the question of the building of the east wing of the Louvre had not yet been settled by the victory of classicism. The fire which destroyed London on 2–5 September 1666 enabled Wren to carry out a large number of architectural exercises on a scale worthy of a capital city. In the fifty-one parish churches he rebuilt, Wren

XIII Giovanni Lorenzo Bernini (1598–1680). Ecstasy of St Teresa, in Santa Maria della Vittoria, Rome ▶

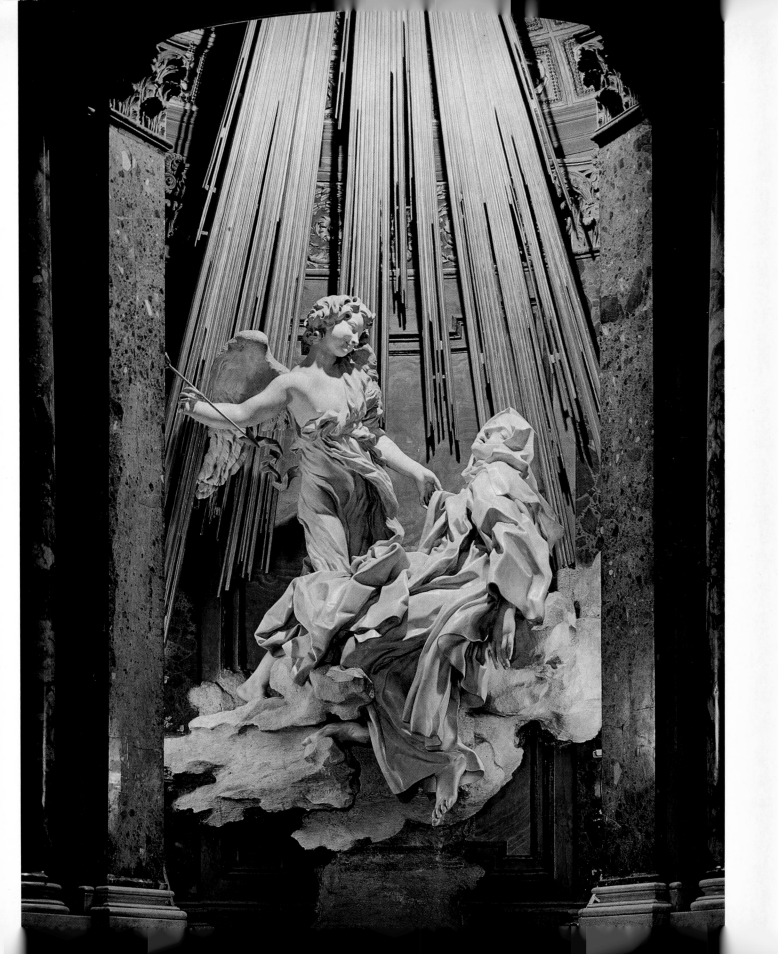

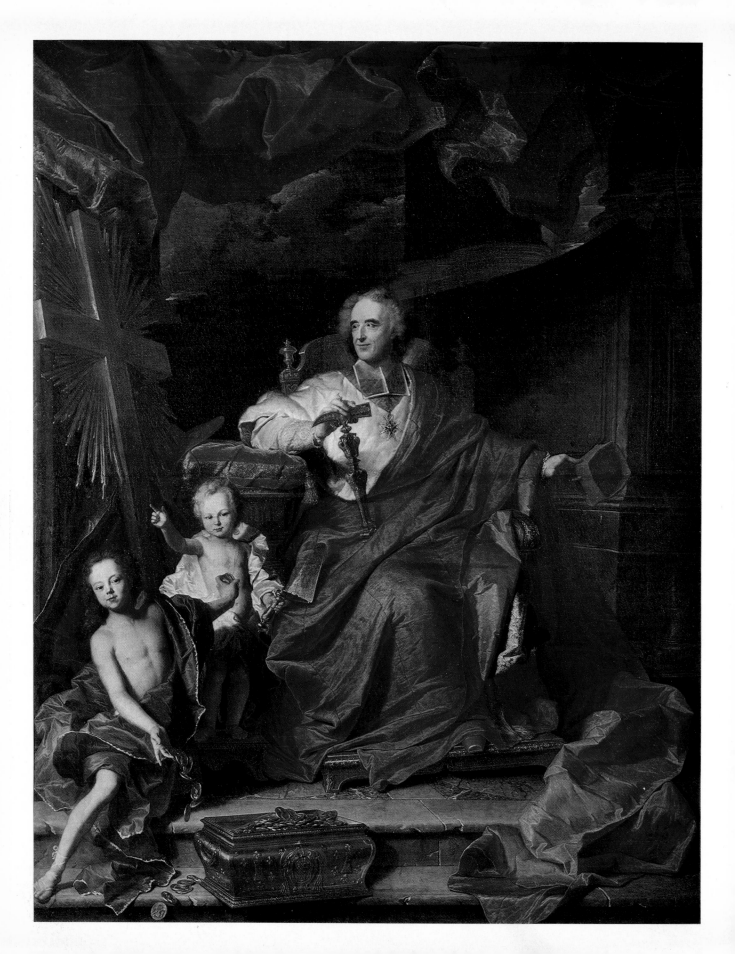

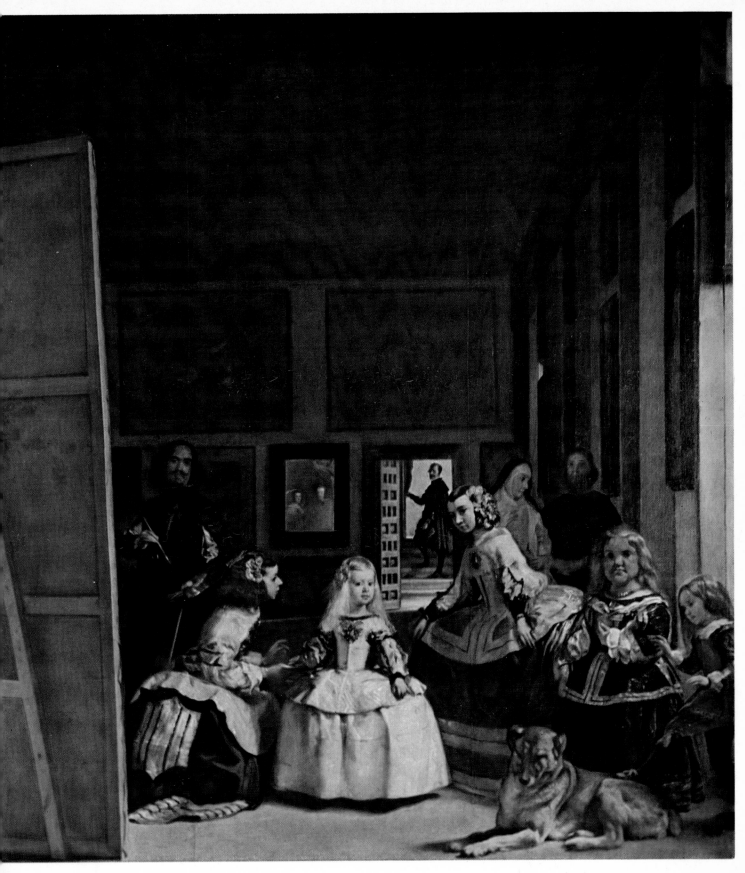

xv Hyacinthe Rigaud (1659–1743). Cardinal de Bouillon xv Diego Velázquez (1599–1660). Maids of honour

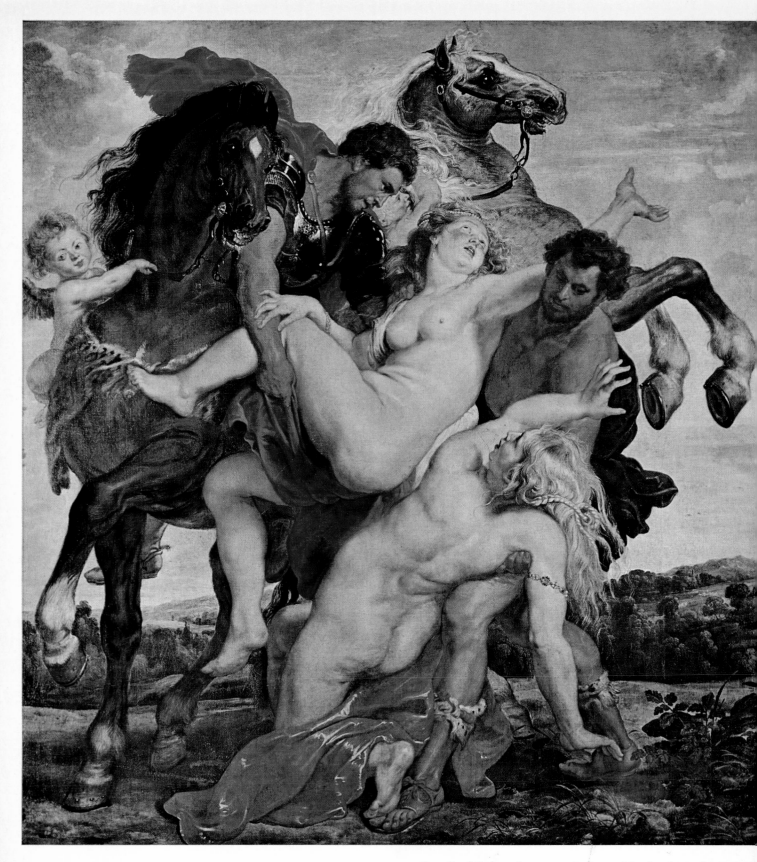

XVI Peter Paul Rubens (1577–1640). Rape of the daughters of Leucippu

showed the catholicity of his taste; the desire for variety is itself a baroque instinct, and by comparison with those of Inigo Jones his designs possess a certain dynamism, a tension between solids and voids. Other of his buildings, such as Chelsea Hospital (1682–92) and the rebuilt portions of Hampton Court, are in the classical idiom; but the majestic colonnades of Greenwich Hospital (1694 etc.) show some trace of inspiration from the square of St Peter's, Rome, by *pls 139, 383* Bernini. Although the Royal Commission on the rebuilding of St Paul's had rejected Wren's first design as too much inspired by St Peter's, it is in fact true that the vast London church holds the same position in the Anglican world as does St Peter's for Catholicism. Its formal analogies with the latter are undoubtedly due to the wishes of Wren, who throughout its construction, which extended from 1675 to 1709, continued to alter the plan approved by the Commission to bring it back to his own conceptions. His first idea, which was rejected, was for a central plan with incurved walls, surmounted by a Bramantesque dome; the Commission wanted a basilica in the form of a Latin cross, its centre surmounted by a tower. Wren succeeded in obtaining his dome, even keeping its primitive character of a rotunda by standing it on eight *fig. 13* piers set in a circle, after hesitating whether to base its design on Michelangelo's rhythms or those of the peristyle of Bramante. As for the decoration of St Paul's, with its somewhat pon- *pl. 175* derous magnificence, recalling its Roman models, it is much more akin to the baroque than to the classical ideal.

At the end of the seventeenth century the course of English art turned decisively toward the baroque under the influence of two architects, Nicholas Hawksmoor, who worked under Wren, and Sir John Vanbrugh. The concept of a palace with several courtyards of colossal size, derived from Versailles, inspired Vanbrugh to build the two most baroque structures *pls 179–80, fig. 18* in England, Castle Howard, begun in 1699 for the Earl of Carlisle, and Blenheim Palace, begun in 1705 for the Duke of Marlborough, to whom it was presented by a grateful nation as a reward for his victory at Blenheim. Vanbrugh had political differences with the Duchess, and was forced to stop work on Blenheim Palace, which was continued by Hawksmoor; in the end the two architects joined forces. The size of Vanbrugh's buildings, and the theme of glory which plays so important a part in the conception of Blenheim, give evidence of a desire for ostentation. Vanbrugh achieves his effects by the disposition of masses, by contrasts of proportion and by a general display of grandeur; all this is occasionally reminiscent of the grandiose eclectic architecture of the second half of the nineteenth century.

In 1715 began the Palladian reaction which brought English architecture back to the path of neoclassicism. It should not be thought, however, that this path was followed blindly by everyone. James Gibbs, a Scots Catholic and a Tory, who had been schooled in the studio of Carlo Fontana (a disciple of Bernini), remained outside it; the examples he gives in his *Book of Architecture* in 1728 are evidence of his eclecticism and of his liking for 'modern' French and Italian architecture. His Radcliffe Camera, Oxford, though built in 1737–49, is distinctly baroque; so, too, is St Mary-le-Strand (1714–17) in London. The famous London church of St Martin-in-the-Fields (1721–6), baroque in its interior, displays in the design of its exterior *pl. 182* a noble classical harmony inspired more by French and Italian rhythms than by the antique.

pl. 177

James Gibbs conceives his interiors in an entirely baroque style (as at Orleans House, Twickenham), as does the Venetian-born Giacomo Leoni (Clandon Park, Surrey, 1733). This was in fact the rule throughout the seventeenth and eighteenth centuries; though architecture alternated between baroque and classicism, the decorative arts remained resolutely baroque. Inigo Jones himself took his inspiration for theatrical sets from Italian baroque scenography; and towards the end of his life he designed the Double Cube Room at Wilton House (about 1649), which is inspired by the baroque décors then fashionable in France. It has close affinities with the interiors of the Château de Cheverny. William Kent, Lord Burlington's associate in the Palladian movement, also conceived his interiors in the baroque style. In fact, the purist reforms of Palladianism scarcely affected the decorative arts; it is a shock, on entering some sober Palladian mansion, to discover a baroque, Gothic or rococo décor, or even an array of *chinoiserie*.

pl. 266, fig. 3

pl. 178

The Palladian era witnessed the flowering of an indigenous English furniture style, inspired by rococo, Gothic and *chinoiserie,* and made famous by Thomas Chippendale in his celebrated collection *The Gentleman and Cabinet Maker's Director* (1754). Until then the style of the decorative arts in England had been derived from France and Italy. The great woodcarver Grinling Gibbons, who created the choir-stalls of St Paul's to an overripe baroque design by Wren, used the motif of coiled acanthus leaves then current throughout Europe. At the Restoration Charles II summoned a Neapolitan painter, Antonio Verrio; in the Heaven Room of Burghley House (1694–7) Verrio painted allegorical figures soaring in front of a background of sham architecture. A Frenchman, Louis Laguerre, was called in for the decorative painting at Chatsworth. In the time of Queen Anne, taste veered between the French (Charles de La Fosse, Jacques Rousseau, Baptiste Monnoyer) and the Venetians (Gian Antonio Pellegrini and the two Ricci, Sebastiano and his nephew Marco). Stucco-workers from Italy also came to decorate English houses at this time (Octagon Room at Orleans House, Twickenham, 1720, by Artori and Bugatti). The Queen Anne period did, however, produce the only great English decorative painter, Sir James Thornhill, a master of *trompe-l'oeil* who fills the walls and ceiling of the Painted Hall of Greenwich Hospital with an multitude of figures who seem about to invade the space of the room.

PL. XXIV

In easel painting, England long remained faithful to the Flemish school. Sir Peter Lely, a Fleming, painted the court of Charles II, just as Van Dyck had painted that of Charles I. These and other Netherlandish baroque influences had a decisive influence on the development of English painting. Hogarth owes much to Rubens and to the Dutch baroque artist Frans Hals. Though the mannered elegance of Gainsborough approaches the *galant* art of the French, Sir Joshua Reynolds' deep involvement with his great predecessors, particularly Rubens and Rembrandt, links him closely with seventeenth-century baroque (*Lord Heathfield,* National Gallery); in his large compositions he submits to the prevailing classical style.

pl. 157

Thus English artists were not entirely strangers to the baroque. Nevertheless their view of the baroque was a somewhat formalistic one, retaining the magnificence and the triumphal character, but missing the poetry and the imaginative impulse which carried the artists of the Italian and German baroque into the realms of fantasy.

Spain, declining and finally defeated, found an escape from reality in a baroque dream-world. While the sixteenth century had seen a flowering of royal art, the art of baroque Spain was almost entirely religious in inspiration. The revival of court art by the Bourbons was the signal for the decline of the Spanish baroque.

In the seventeenth century in Seville, the sculptor Martinez Montañés and the painter Zurba- *pls 132-3* rán expressed the heights of religious feeling in a purely classical style; meanwhile, however, the Castilian Gregorio Fernández, heir to a tradition established in the previous century by Alonso Berruguete, had already begun to turn devotional art towards mystical expressionism. His baroque statues are often set in classical altarpieces, many of them designed by the artist himself, which illustrate how far architecture lagged behind the figurative arts. The Seville school of painting tended finally toward the baroque, of which Bartolomé Estebán Murillo *pl. 156* (1618-82) was to be one of the principal exponents in Europe. The theme of the Immaculate Conception, which he chooses frequently in response to the Marian fervour of the Andalusians, is by its very nature impossible to treat realistically; it is essentially baroque. In many of his compositions, however, Murillo tempers the mobility of baroque forms with a sense of stability derived from classical Andalusian tradition. His contemporary and rival Juan de Valdes Leal, on the other hand, gives rein to his romantic fervour, endowing the theme of death with an *pl. 155* expressive violence which has been excelled by no other European painter. Diego Velázquez is *PL. XV* a product of the Seville school of realism, which he practised in his early period (as in the famous *Old woman cooking eggs*). In 1623, however, he was appointed first painter to the king, and on contact with the decadent court of Madrid he began to paint phantom figures, seldom linked *pl. 52* to one another by any action; they express the despairing sense of man's isolation which afflicts the Spanish soul. The form evaporates, to be replaced by a modulation of touches of colour, to which the supreme virtuosity of the brush lends a mysterious evocative quality. Velázquez explored the resources of his art more completely than any other painter who has ever lived. After Montañés and Fernández, Spanish art soon became fixed in an academic mould with the Granadan Pedro de Mena; to Alonso Cano, who produced little, we owe exquisite figures heralding the grace of the eighteenth century.

The development of architecture is linked to that of the altarpiece, which in the Iberian world *pl. 166* is the central feature of the church. This cliff-like structure with its coloured or gilded shapes and statues has a role similar to that of the church portals of the Middle Ages; the altarpiece above the high altar of a Spanish church is a kind of triumphal arch, giving access to the supernatural world. Early seventeenth-century altarpieces, still classical in design, stand out against bare walls. The first distinctly baroque altarpiece, inspired by Bernini's Baldachin in St Peter's, is the one made by Pineda and Roldán for La Caridad, Seville, in 1670. At *pl. 161* the end of the century, under the influence of José de Churriguera, altarpieces were endowed with a new element of monumental splendour, the Salomonic column. In Portugal, the altar- piece developed along similar lines; but something in the national temperament endows Por- tuguese altarpieces, such as that of São Bento, Oporto (1701), with an added element of structural *pl. 162* discipline.

115

In the course of the eighteenth century, both in Spain and in Portugal, the structure of the altarpiece became overlaid with a luxuriant growth of forms which proliferated as if impelled by some biological force. The doorway and altar of the Chapel of the Holy Sacrament in the church of San Salvador, Seville, by the Portuguese sculptor Caetano da Costa, carry the theme

pl. 163 of 'glory', so dear to Bernini and his Roman contemporaries, to its apotheosis. In Mexico—the province of New Spain—this decorative exuberance takes on the force of tropical vegetation; the baroque, held in check in Europe by the architects, seems on reaching the New World to have reverted to its wild state. Architectural discipline succumbed to the anarchic growth of

pl. 280 baroque ornament. The strangest of all the creations of Iberian Christianity is the *Transparente* behind the high altar of the cathedral of Toledo, by Narciso Tomé, a mass of thrusting vegetal forms, which I discuss in a later chapter under the heading 'Art Nouveau'. The idea of a transparent structure, through which an altar or a reliquary can be glimpsed rather than seen, has often fascinated Spanish architects, and the idea of the withdrawal of the sacred into a secret place finds expression in the invention of a specialized form, the *camarín,* situated above and behind the altar. The same theme of transparence reappears in Bavarian and Swabian

pls 198-9 rococo architecture, where it dematerializes forms (as in the church of Die Wies).
pl. 165 In the eighteenth century the luxuriant forms of the Spanish altarpiece began to influence architecture. Gradually the whole church became encrusted with a layer of stucco. Italian architects had used this material mainly on ceilings, where marble would have been too heavy; in Spain the absence of marble led to its use on the walls, while in Portugal gilt wood was used instead. Here the pattern established in seventeenth-century Spanish sculpture was neatly reversed. Andalusians—such as the Figueroa family—turned to the baroque while at Salamanca the Castilian Churriguera family remained faithful to the architectural principles of the Renaissance. Fernando de Casas y Novoa, at Compostela, and Pedro de Ribera, at Madrid, transposed into stone the wild exuberance of Spanish baroque stucco and wood carving.

The baroque permeated into Central Europe from Italy, by way of the Veneto, Ticino, Grisons, the Tyrol, Munich, Prague and Vienna. After the close of the sixteenth century Italian artists poured into Austria, Germany and Bohemia, and in spite of the activity of native artists, the migration continued until the eighteenth century. Vincenzo Scamozzi (1552–1616), who had received lessons from Palladio, was summoned to Salzburg by Bishop Wolf Dietrich in 1604. He designed a gigantic cathedral on the model of St Peter's, Rome; somewhat scaled down, this was built by Santino Solari and decorated by Italian painters and stucco-workers.

Until about 1680 the new style can be seen emerging very slowly from the native Gothic and mannerist traditions, both in the building of mansions and palaces and of churches. After many uncertainties, the influence of Il Gesù became a rival force to local styles of religious architecture; its notable adherents included the Vorarlberg school.

About 1660, basilicas in the true Roman style made their appearance; the Theatinerkirche, Munich, begun by the Italian Barelli in 1662, the Jesuitenkirche zu den Neun Chören der Engel, Vienna, begun in 1662 by a Ticinese architect, Carlo Carlone, the Universitätskirche,

Vienna (1701–3) by Andrea Pozzo (1703), the cathedral of Fulda by J. Dietzenhofer (1704–11), the Benedictine abbey of Melk by Jakob Prandtauer (1706), and the Benedictine abbey of *pls 171, 342* Weingarten in Swabia by Franz Beer (1716) all show a faithful adherence to the solemn Roman basilical pattern adopted by the Vorarlberg school. This development also affected the palace and the mansion, where massive Italian plans gradually made their appearance, disposed in a French style.

Stucco interiors employed borders of spiralling acanthus leaves, with mannerist cartouches made baroque by their exaggerated size and pronounced relief. A school of stucco-workers at Wessobrunn in Swabia soon rivalled that of Italy, sending its craftsmen all over Central Europe. Church furnishing in gilt wood soon abandoned the mannerist style which early in the seventeenth century had shown signs of developing into a premature rococo, and adopted a baroque manner characterized by the use of twisted Salomonic columns; a comparison between a pulpit designed about 1670, such as that of the Altmünster, Linz, and another dated twenty- *pl. 173* five years later, that of the Stiftskirche, Schlierbach, illustrates the progress of baroque influence, *pl. 174* displayed in fuller relief and luxuriant ornament.

The finest flowering of the baroque in Austria and Bohemia occurred about 1680; it coincided with the enhanced national consciousness which followed the victories over the Turks, and constitutes indeed a kind of manifesto of the Imperial ethos. Two architects of the Italian school brought about this development, Johann Bernhard Fischer von Erlach, who had lived in Italy between 1680 and 1685, and Lucas von Hildebrandt, who was born in Genoa in 1668, the offspring of an Imperial engineer officer and his Italian wife, and who had studied in Rome and been honoured by Prince Eugene of Savoy. In Bohemia and Austria these two artists built for emperor, princes, bishops and abbots, in a truly imperial style, triumphal mon- uments, churches, castles, palaces and monasteries. It is symptomatic that Fischer von Erlach gained the favour of Joseph I by winning a competition for triumphal arches to be built for the monarch's entry into Vienna in 1690, after his election as Holy Roman Emperor. Several of Fischer's official commissions have an imperial significance; the colossal plan (not executed) for the palace of Schönbrunn (1691–2), the Karlskirche in Vienna (1716) and the Hofbibliothek, *pls 169–70* also in Vienna (1723). We might also include the Pestsäule, a votive column erected in the Graben, Vienna, between 1682 and 1688, the pedestal of which was the work of Fischer von Erlach. Imperialist enthusiasm communicated itself to the Church. Ancient orders such as the Premonstrants, the Benedictines, the Augustinians and the Cistercians had their monasteries rebuilt on colossal plans inspired by that of the Escurial; the Emperor Charles VI, who for a few years had been king of Spain, acknowledges the debt in his magnificent palace-monastery of Klosterneuburg. The monastery became a kind of symbol of universality, a palace of theology, the sciences and the arts, including grouped around the church, imperial apartments (*Kaiser- zimmern*), an entertainment hall (*Marmorsaal*), a gigantic staircase (*Treppenhaus*), a decorated library which was a kind of temple of learning, princely apartments for the prelate (*Prelaturhof*), an art museum, a natural science collection, sometimes even an observatory (as at Krems- münster), and finally pleasure gardens which might contain luxurious pavilions (as at Melk).

In decoration, Fischer von Erlach applied to permanent buildings the same opulence which had marked his triumphal arches for Joseph I in 1690. With rather more restraint, Hildebrandt practised the same heavy magnificence. Sculptures crowded on to pilasters and cornices; in *pl. 379* secular architecture the motif of the Atlantean, derived from the figures of slaves created by Michelangelo for the tomb of Julius II, is used abundantly in lower rooms, staircases and balcony supports—an image of defeated strength which for the Austrians recalled the crushing of the Turks by the Western armies.

In the general conception of their buildings, particularly their churches, Fischer von Erlach and Hildebrandt derive more from Borromini and Guarini than from Bernini. The innovations of these architects, which were almost without influence in Italy, find their fulfilment in the baroque churches of Austria, with the characteristic intersecting lines of their elevations and plans. Here elastic forms lend vigour to the external mass, and quicken the internal space to vibrant life. Fischer von Erlach sets his domes not on a circle but on a tenser curve, the ellipse; *pl. 167* in the Ahnensaal (Hall of Ancestors) in Frain (Vranov) in Moravia (1690), he achieved for the first time that soaring spatial quality that he was to repeat endlessly in all his plans, notably in the Kollegienkirche in Salzburg (1694), the Hofbibliothek (now the Nationalbibliothek) and *pl. 169* the Karlskirche in Vienna. This church is a kind of epitome of Roman architecture; it has the peristyle of the Pantheon, the dome of Berettini's San Carlo al Corso, and the towers designed by Bernini for St Peter's. Trajan's Column appears not once but twice; there is a replica of it on either side of the west door. In Prague a member of a Bavarian family of architects, Kilian Ignaz Dientzenhofer, made use of projections, gliding diagonals and intersecting planes to create supple articulations, imperceptible transitions, which gave inspiration to the rococo of Swabia and Bavaria.

The heavy magnificence of Fischer's imperial baroque was purified by a provincial architect, Jakob Prandtauer, who used it to create harmonious effects; his masterpiece is the monastery of *pl. 171* Melk (church built between 1706 and 1726), magnificently sited on its promontory above the Danube. His son-in-law, Josef Munggenast, refines his style to the point of elegance (as in the *pl. 172* monastery of Altenburg) but is free of the preciosity of the rococo, a style almost unknown in Austria.

While Swabia and Bavaria, mingling French and Italian influences, were developing the rococo style, North Germany and Saxony adhered more to the solemnity of the baroque. In Dresden in 1709, Daniel Pöppelmann built for the opulent Augustus the Strong an open-air *pl. 349* setting for royal festivities, the Zwinger, which perpetuated the memory of a carrousel given in 1706 for the king of Denmark. In it he carries the exuberance of Fischer von Erlach a stage further, giving prominence to monstrous Atlanteans later imitated by Knobelsdorff in the palace of Sanssouci, near Berlin (1745–53).

In Berlin itself, in the late seventeenth century, Andreas Schlüter began the royal residence on the model of an Italian palace, and from 1693 to 1700, taking his inspiration from Girardon's *pl. 377* *Louis XIV*, erected a bronze equestrian statue, of the Great Elector, which is one of the finest in Europe.

In the German-speaking countries, mannerism in sculpture persisted until the latter half of the seventeenth century, its most notable representatives being Martin and Michael Zürn the elder. At the end of the century, however, numerous Italians came to work in Germany and Austria, bringing with them the Berninesque style. Among them were several members of the immense Carlone family. Among the earliest Berninesque sculptures are the extraordinary kneeling marble angels by Michael Zürn the younger which adorn the lateral altars of the monastery of *pl. 152* Kremsmünster (1685). They are represented in the posture of the bronze angels surrounding the altar of the Chapel of the Holy Sacrament in St Peter's, Rome, but their movement is that of the angels bearing the instruments of the Passion on the Ponte Sant' Angelo. The unearthly nature of these celestial beings has perhaps never been so well suggested as in these figures, still palpitating with the motion of their flight from beyond the skies.

In eighteenth-century Austria the ample style of Bernini continued to flourish. In Vienna the sculptor Georg Rafael Donner tempered the spirit of Italian baroque with something of the nobility of Girardon's bronzes in the gardens of Versailles. In Donner's high altar for the *pl. 151* cathedral of Pressburg (Bratislava), Bernini's motif of adoring angels is elegant, but somewhat cold, and far from the expressive intensity of the angels of Michael Zürn. Donner has all the perfection of a court artist; the provincial Zürn is an inspired poet.

Even before Peter the Great, Russia was not entirely isolated, and the great currents of European art penetrated as far as Moscow. The elements of the baroque were implanted there about 1680, at about the same time as in Central Europe, and in spite of strenuous opposition from the conservative clergy. Moscow was gradually surrounded with large fortified monasteries. At *pls 185-6* Rostov, Yaroslav and Dubrovitsy, the characteristic pyramidal Russian church became baroque. Here as in Latin America, the transplantation of the baroque produced strange and exotic fruits. In the iconostases of the new baroque churches sculpture in gilt wood took the place of icons, and the use of Salomonic columns enhanced their resemblance to the Spanish and Portuguese altarpieces. As in Spain, the style of the interior decoration was eventually transposed on to the fabric of the building itself.

The pace of Westernization quickened in the time of Peter the Great. After giving St Petersburg an appearance resembling that of Amsterdam, he visited Paris and Versailles in 1717 and called in the Frenchman Leblond to give the city an overall plan, which the latter did on the model of Versailles. Leblond also designed the palace of Peterhof, 'Versailles by the sea'. Peter *pl. 347* the Great's daughter Elizabeth called in Bartolommeo Rastrelli, son of an Italian architect living in Paris, who built the Winter Palace, the great monastery of Smolny, and the immense palace of Tsarskoye Selo (now Pushkin); ornamented with a rich decoration of stucco and *pl. 184* gilded wood, this is one of the most remarkable examples of the baroque in Europe. Under Catherine the Great, however, Russia turned towards classicism, largely under the influence of the St Petersburg Académie des Beaux-Arts, in which French ideas predominated.

Poland adopted the baroque (as at the Franciscan monastery at Krosno) with an enthusiasm *pl. 187* that was all the greater since in a Catholic country there was none of the ecclesiastical opposition which was encountered in Russia. It was from Poland that the baroque reached Russia.

6 Rococo

pl. 119

Scarcely had Louis XIV enjoyed the splendours of his grand apartment at Versailles, faced with marble and adorned with subjects from mythology, when he felt the necessity to have built around the Cour de Marbre an 'interior apartment' where he could live rather more privately. The plan of this was decided in 1684. Its interior decoration, though still sumptuous, is less solemn than its outer facing of marble in the Italian style, being composed of woodwork *à la française,* lacquered and gilded. In the latter part of his reign the Sun King felt increasingly oppressed by the vastness of the palace he had created, and escaped to the more intimate atmosphere of Marly or the Trianon, setting the precedent for a new style, in which the mansion was substituted for the palace.

pl. 188

Inside the great town houses (*hôtels*) that were built in Paris in the first two decades of the eighteenth century, the architectonic rhythm of orders and entablatures gradually disappeared, to be replaced by a system of arches of equal height encompassing doors, windows and mirrors. The tympanums above the lintels of doors were often occupied by a decorative painting set off by an elaborate carved frame; the panels inside the arches were now decorated only with ornamental sculpture in high relief, continued in stucco on a low ceiling which was seldom adorned with paintings. Cumbrous and unwanted, the great masterpieces of the previous century or of the Renaissance were put away in a special gallery or even relegated to the lumber-room. The salon of the Hôtel du Petit-Luxembourg in Paris (1710) is a typical example of this style. The new mode of ornamentation was the result of a movement which developed at the end of the seventeenth century through the influence of artists such as Pierre Lepautre; a fine illustration of it is provided by the sculptured stone trophies decorating the piers of the chapel at Versailles, in which Robert de Cotte has sought elegance rather than grandeur.

A whole succession of Paris mansions, many of which are still in existence today, give us a picture of the progress of the rococo tendency towards profusion of forms and sinuosity of line; examples are Vassé's panelling for the Hôtel de Toulouse (1718) and Boffrand's designs for the salon of the Hôtel d'Assy (1719). Designers specializing in ornamentation, such as Oppenord, Nicolas Pineau and later Meissonier, helped to influence taste in the direction of rocaille ornament, and one of them, François Cuvilliés, later made his fortune in Germany. At La Malgrange, near Nancy (1710), Boffrand, imitating the oval salon at Marly (1699), exemplifies the transition.

pls 189, 191

The Salon de la Princesse in the Hôtel de Soubise, Paris, by Boffrand, (1738–40) and the great Spiegelsaal (hall of mirrors) in the Amalienburg pavilion of the Nymphenburg palace

near Munich by Cuvilliés (1734–9) are similar in conception. Both are oval rooms, ornamented with large mirrors, and where the walls meet the ceiling the surfaces are out of true, to soften the transition from one plane to another. The reflections in the mirrors break up a confined space into facets, and the pronounced outline of the rocaille completes the disruption of the architectural lines. But a comparison between the two rooms reveals interesting differences, as well as similarities—differences which explain why French art historians have refused to agree with the American writer Fiske Kimball that the rococo originated in France at the end of the reign of Louis XIV. The sculptured decoration of the Hôtel de Soubise is still purely ornamental, and therefore abstract; at the Amalienburg the imagination of Cuvilliés breaks out into a host of fanciful creations which recall the grotesques of the Renaissance. The room in Paris is a society salon; the pavilion in the heart of the Nymphenburg park belongs to the world of fairy-tale. Most important of all, the decorator of the Hôtel de Soubise has been faithful to the principle of symmetry, whereas in the Amalienburg Cuvilliés experiments with an asymmetrical system of ornamentation which the stucco artists of Swabia and Franconia were to carry to an extreme.

The spirit of a people is revealed in its rhythmical instinct, and during the same period there was a similar divergence between France and Germany in the field of music. Rameau's work is a progression of chords, relying for its effect on the laws of harmony, whereas Bach derives his finest effects from counterpoint. We could perhaps see reflected in this pattern of answering voices the German mind itself, hesitating between opposites and resolving them in a complex synthesis. French thought proceeds by the dialectic of cause and effect, German thought by the dialectic of thesis and antithesis; Descartes laid down the principles of the former, whereas the latter, even in Hegel, has its roots in medieval scholasticism.

The immoderate use of rocaille, and even more the asymmetrical distribution of ornament, are the defining characteristics of true rococo. We might therefore describe the style of those European schools that rejected the rococo as *barocchetto,* the name sometimes given by the Italians to their art of the eighteenth century. For Italy in this period, in architecture at least, remained essentially baroque; in Rome, rocaille decoration such as that of the Palazzo del Grillo or the church of Santa Maddalena is rare, and even in Piedmont Juvarra conceived the great central room of the hunting-lodge of Stupinigi in elegant baroque terms. In Turin, however, the minor arts came under rococo influence; here the taste was for woodwork *à la française,* but heavily ornamented with rocaille in the German fashion (decoration of the Palazzo Reale). The crafts- *pl. 192* men of Venice could give graceful curves to asymmetrical ornaments in stucco, on mirror frames, or on painted furniture; and yet the rocaille artist Brustolon overloads his chairs with figures in a heavy baroque style. The ceilings of Giovanni Battista Tiepolo express the rococo spirit in paint- *pl. 195* ing; abandoning the perspectivist use of architecture, Tiepolo cuts his clouds into rocaille- *pl. 326* like patterns, with figures astride them, carried round in an endless spiralling space. Guardi is *pl. 193,* PL. XVIII undoubtedly the most rococo of painters; his forms explode in convulsive touches of the brush, and his compositions are fragmented by zigzags.

Such are the riches of Italian art that it is responsible for many formal inventions which it did *pl. 194* not itself exploit. The pioneer of asymmetrical rhythms was a stucco artist from Palermo, Giacomo

Serpotta, who created for his native town exquisite chapels in which all the gestures and attitudes of the figures are balanced contrapuntally. He began to decorate the first, that of San Lorenzo, in 1699, and continued to practise his art until his death in 1732. Though his ornamentation remains baroque, his figures are the first to show the active, fugal rococo style which later found its finest expression in Germany. The salon eloquence of Serpotta becomes a kind of expressionist frenzy in the Cappella di Sangro in the church of San Severo, Naples, the work of Francesco Queirolo, Giuseppe Sammartino and Antonio Corradini, who can make even marble transparent. Naples, where painters adorned ceilings with soaring visions worthy of Tiepolo, can show examples of rocaille, if not of rococo; the finest rocaille décor in the city, that of the church of Santa Chiara, was destroyed in the Second World War.

The French eighteenth-century decorative style, which almost never made use of asymmetry, could very appropriately be termed *barocchetto*. France did, however, produce some genuinely
pl. 190 rococo furniture; about the year 1730 four designers, Lajoue, Meissonnier, Cuvilliés and Mondon, produced collections of ornaments in an asymmetrical style, from which goldsmiths in particular derived inspiration. The working of precious metals is especially suited to spiral forms, curved profiles, swellings, dislocated surfaces, and irregular projections. It was in fact in a pamphlet ostensibly addressed to the goldsmiths of France (his *Supplication aux Orfèvres*, 1754) that Nicolas Cochin made his protest against the rococo. Faience makers imitated the metalworkers' forms; but porcelain manufacture reached France too late to be influenced by the rococo. Painting was divided among various tendencies: a poetic strain derived from Watteau, which in Lancret and Pater is refined into rococo grace; a tendency towards realism and intimacy (Chardin); an official baroque current following the teachings of Le Brun (François Lemoine, the Coypels and the Van Loos); and finally a style whose qualities were definitely rococo, that of Boucher and Fragonard. The talent of French artists made painting a reflection of the tastes of society, a society which loved to contemplate itself; the art of the seventeenth century, deeply concerned with problems of form, had been a mirror reflecting every visible object. More than ever, mankind enjoyed the contemplation of its own image in painting, sometimes stiff and formal, sometimes more natural in style, but always compelling. Women, whether queens or favourites, aristocrats or bourgeoises, dominate the whole epoch. The feminine grace of Quentin de la Tour's subjects tempers his severe style with a touch of elegance; by the end of the eighteenth century it was even accepted that women might be painted by women.

In Spain, rococo decoration found expression almost nowhere but in the royal apartments of the Palacio Real in Madrid. Religious art—such as that of the Churrigueras in Salamanca or of the Figueroas in Seville—elaborated upon the baroque. The one exception is the rocaille stucco decoration of the sacristy of the Cartuxa of Granada. Chiefly in Latin America, changes in rocaille style were occasionally made to the ornamental woodwork of altars, where it was well suited to use in combination with mirrors.

Portugal, as usual contrary to Spain, was with Germany the most strongly rococo country of all Europe. Rocaille is already coming into flower in the library of the University of Coimbra (1720–3), where the decoration of the woodwork, gilded and lacquered in the Chinese style, is

still symmetrical in character; but in the dissolution of forms it was painters who preceded
sculptors (as in the cartouche in Nossa Senhora da Luz, Rio de Minhos, Borba, dated 1714). *pl. 202*
The transition from baroque to rococo in church woodcarving occurred about the year 1740.
The second John V style made use of all the possibilities of rocaille; the decorators of Lisbon and
Oporto fashioned it like goldsmiths, while in the north, at Braga and elsewhere, rocaille in wood *pl. 204*
and stone takes on a swollen, inflated, visceral quality, almost like a revival of the Manueline style
of the reign of Manuel I (1495–1521). But it was Brazil that produced the finest true rococo (i.e.
asymmetrical rocaille) decoration, between 1770 and 1800. In the state of Minas Gerais, Antonio
Francisco Lisbõa, a half-caste known as O Aleijadinho (the little cripple), created decorations *pl. 203*
in wood and stone which have, though on a more restricted scale, all the soaring lyrical quality
of Swabian church interiors.

Austria in the eighteenth century, unlike Germany, remained faithful to the baroque. This
eighteenth-century baroque is refined and harmonious; the forms are never excessively fragmen-
tary, while the ornament is symmetrically disposed. To take an example, the polished baroque
of the church and library of the Benedictine monastery of Altenburg (architect Josef Munggen- *pls 172, 197, 324*
ast, painter Paul Troger, decorator Franz Josef Holzinger) communicates a sense of peace and
wellbeing, very different from the swooning ecstasy of the churches of Swabia. One exception,
that of the interiors of the imperial palace of Schönbrunn, proves the rule that here as in Spain
rococo was a style reserved for court use. The other exception, the church at Wilhering, can be
explained by Bavarian influence.

England, the land of paradoxes, succumbed to the charms of the rococo in interior decoration
and furniture in the very heyday of Palladian architecture. Rococo triumphed about the year
1750. Here more than in Portugal, Chinese influence was decisive in determining its develop-
ment, showing itself in the serpentine curves of the 'English' garden and the furniture of the
Chippendale family. Thomas Chippendale, who published in 1754 a famous collection of
models entitled *The Gentleman and Cabinet Maker's Director,* uses markedly asymmetrical features *pls 205, 266, fig. 3*
in the design of his mirrors. The conflict between classical and rococo inspired Sir Edmund
Verney to build a severe Palladian mansion, Claydon House, whose interior reveals Palladian *pl. 206*
doors, a rocaille salon, an extravagant Chinese room, and a wrought-iron staircase so delicate
that one can almost hear the wind rustling in the ears of corn that adorn its balustrade. The art
of the goldsmith was flourishing; goldsmiths employed a variety of styles, some of them sober
and almost functional. In the work of Charles Kandler (about 1730) rocaille returned to the Art *pl. 271*
Nouveau fluidity characteristic of Dutch work a century before.

It was in Germany that baroque fantasy attained its greatest splendour. Protestant and Catholic
Germany plunged joyfully into a magic world of art. French art historians are inclined to attribute
far too much importance to Italian and French influences in Germany; in fact, external influence
weighed no more heavily upon the originality of the German rococo than did antiquity upon the
genius of the Italian Renaissance. The political divisions of Germany favoured this movement,
for every landed prince wished to have his own Versailles. In the Catholic areas, Franconia,
Bavaria, Swabia and the Rhineland, the house of God rivalled that of the prince. In the Lutheran

areas, Saxony, Prussia and Bayreuth, artistic creativity was focused on the monarch. The ambivalent nature of the régime of Saxony, a Protestant country two of whose Electors were converted to Catholicism, is aptly expressed by the two churches of Dresden, the Catholic *pl. 333, fig. 15* church of the court and the Lutheran Frauenkirche—one of the finest sacred buildings of the Western world, destroyed, alas, in the last war. In certain districts human and divine laws were united in the person of a single ruler, wielder of both temporal and spiritual power—the prince-bishop. Towns were covered with palaces and churches, for the princes built on a grand scale. Perhaps the largest residence is that of Ludwigsburg, built by the dukes of Württem-*pls 195–6* berg, and one of the most magnificent is that of Würzburg, built by the powerful Schönborn family which also built the imposing residence of the prince-bishops of Bamberg at Pommers-felden. None, however, rivals the splendour of the many residences of Frederick the Great of Prussia, the palaces of Berlin (now destroyed) and Charlottenburg, the Stadtschloss and Neues Palais at Potsdam, and the palace of Sanssouci.

Catholic faith was concentrated around the monasteries (*Stifte*) and the pilgrimage churches (*Wallfahrtskirchen*), situated in rural surroundings which enhanced the richness of their architecture and decoration. As in Austria, the ancient orders (Benedictines, Premonstrants, Cistercians, Augustinians) had their old Gothic buildings reconstructed, providing the last and perhaps most poetic expression of an ancient ideal, that of the 'City of God' dreamt of by St Augustine.

German rococo achieved the fusion of all the arts that is the central principle of all baroque art. At the time of the Renaissance, the sculptor and painter filled in the 'spaces' left for them by the architect; they conceived their works as creations in themselves, and gave little consideration to the setting in which they would appear. The lack of unity in mannerism is partly due to the conflicting demands of sculptor, painter, and ornamentalist and the disappearance of the dominant role of the architect. In Italian baroque the architect once more takes control; in St Peter's, Rome, and in Sant'Andrea al Quirinale, Bernini conceives architecture, decoration and sculpture as a whole, and Borromini does the same in San Carlo alle Quattro Fontane and San Giovanni in Laterano. The decoration of Louis XIV's first Versailles, the Versailles of the 'Grand Apartment', was the result of close collaboration between an architect, Mansart, and a decorative painter, Le Brun. But in German rococo the architect no longer does more than prepare for the decorator, painter and sculptor a space in which they can deploy their art; the decoration, in fact, is what makes the building. In the Residenz at Würzburg, the visitor's slow ascent to the full *pl. 362* length of the grand staircase is intended by the architect, Balthasar Neumann, to make it possible to take in gradually the ceiling painting by Tiepolo glorifying Bishop Schönborn. On occasion, *pl. 199* two brothers entered into partnership, uniting in themselves all the arts, as did Kosmas Damian and Ägid Quirin Asam in Bavaria, or Dominikus and Johann Baptist Zimmermann, the *pl. 198* creators of those twin jewels, the pilgrimage churches of Steinhausen and Die Wies.

The unifying principle of the baroque was architectonic, that of German rococo was musical. Although the exteriors retain their monumental majesty, in the interiors all the elements which since Greek and Roman times had served to emphasize the architectural structure were now made *124* to serve the decorator. Capitals are like precious necklaces around piers that are shafts of glittering

light, or columns delicately painted in imitation of marbles that never existed; cornices undulate and spill outwards to mask the transition between walls and ceiling; ceilings open to reveal the heavens. At Steinhausen, a round dance of pillars leads the eye upward to the *Paradise* painted by Dominikus Zimmermann, and at Ottobeuren skilful tricks of perspective centre the whole church on the *trompe-l'oeil* of the dome above the crossing, on which is a painting of Pen- *pl. 329* tecost. At Rohr (by the Asam brothers) the nave is like the proscenium of a theatre from which *pl. 199* the spectator contemplates the Assumption of the Virgin Mary. The light colours of the stuccos, pale rose, sky-blue, pastel blue, violet, amaranth, straw-colour, orchid, pure white or milk-white, all touched with gold and sometimes with silver, help to give the building a completely ethereal quality. The artful use of transparent screens (as in the choir of Die Wies) floods the church with *pl. 198* light; in German rococo, light, the supreme Christian symbol of Divinity, is used to the very fullest extent. At Die Wies the whole church seems to float in the air, and the pillars appear to be drawn towards the ceiling rather than to support it.

Thus the great age of Western art was to draw to its close in a symphonic style in which every- thing is linked in a musical unity. Since every architectural relationship is broken, this unity is like that of melodic compositions whose rhythm is based less on tempo and structure than on accen- tuation, that is on dynamic contrasts. Chromatic qualities are provided by ornaments—*acciac- cature*—which enrich the melodic line, lightening rather than burdening it. For the miraculous fact is that the result of all this added matter is only to etherealize solid substance; irregularities are blended into a fundamental unity by their convergence upon a harmonic centre. Nothing is in excess, because everything is necessary. We should be wary of analysis, which could simply reduce unity to chaos; every gesture is a response to the call of another, every turn of ornament, which appears to fly off into the absurd, is answered elsewhere by another, its antithesis and its justification. This art destroys once and for all the old laws of geometrical perspective conceived by Ghiberti and Alberti. The Italian decorators of the seventeenth century still observed perspec- tive, using insidious devices of acceleration, deceleration or distortion. In Sant' Ignazio, Rome, *pl. 316* Pozzo still thinks in terms of perspectival depth, but a depth converted from the horizontal to the vertical; the distant horizon is replaced by the heights of the Empyrean. German rococo church decorators, on the other hand, eliminate depth entirely and handle space in vibrating waves which, intersecting one another at a thousand points, produce a rich harmony, a dissolution of space into light and music. Here a dream of Christian artists dating from the most ancient times has been realized; the solid matter of which the church is necessarily built becomes transcenden- tal; it is transformed into pure spirit.

Between its first appearance in 1715 and its disappearance in 1770, rococo architecture contains a whole evolution—an evolution difficult to define, so rich are the personalities who created it. The Benedictine church of Weltenburg in Bavaria, built by the Asam brothers between 1716 and 1723, still has some baroque features—the ornamentation applied flat to the wall, the stage perspective leading the spectator's eye horizontally towards the scenography of the *transparente* on the high altar, where St George slays the dragon. In the Augustinian church of Rohr (1717–23) *pl. 199* by the same architects, we are still in the world of the theatre, but here the *Assumption* at the far

125

end of the church leads the eye upwards towards the heavens, where the angels welcome Mary. In one of their last works, the 'Asamkirche' adjoining their palace in Munich (1733–5), the Asam brothers broke the bonds of horizontal depth and suspended the image of the Trinity in the loftiest part of the church. The purest harmony was achieved by the brothers Zimmermann, who at Steinhausen (1728–31) and Die Wies (1746–59) create a vision of Paradise suspended upon a ring of arches. Here again the eye is drawn up towards the highest point.

In the period from 1745 to 1760 there are moments when the rococo exceeds itself. In the church of Birnau near Lake Constance, decorated by the stucco artist Joseph Anton Feichtmayr (between 1748 and 1758), the movement, rising from *crescendo* to *crescendo,* becomes frenzied; ornaments and figures are convulsed in a sort of nervous spasm which recalls Berruguete, and we sense a recoil from matter, like that of an ascetic who mortifies the flesh in order to *pls 200–1* achieve a state of pure contemplation. In the Benedictine abbey church of Zwiefalten, decorated by Johann Michael Feichtmayr, the asymmetrical irregular ornamentation dislocates space, destroying the architectural rhythm. Perhaps the rococo might be said to have passed through a mannerist phase of its own.

It was in religious art, rather than in the palaces of kings and princes, that German rococo found its truest expression. Church architecture, with its imposed unity of plan, lent itself much better to rococo treatment than did the palace, which is inevitably divided into a number of sections of different sizes. When they did work for royal patrons, rococo designers understandably paid special attention to the design of staircases, which afforded space for their imagination to soar, and sought to minimize the cramping effect of comparatively small rooms by using mirrors; this was done in certain rooms (now destroyed) in Louis XIV's second Versailles. The dignity of royal power also demanded that decoration should be seen to be overdone to some extent; Cuvilliés' *Reichzimmern* in the Residenz in Munich, and the state apartments of Würzburg and Tsarskoye Selo, are examples of this. At Charlottenburg and Potsdam, on the other hand, the light and graceful rococo of Johann August Nahl belongs with the elegance of the salon and the intimacy of chamber music.

The vast single space provided by a church offered an ideal setting for plastic experimentation. God is One; he must be honoured in unity. A display of opulence is not enough—matter must *pl. 340* be subordinated to spirit. A complex of buildings like the monastery of Ottobeuren (1710–64) is undoubtedly the supreme expression of the baroque. The church, begun in 1746, is no less than 290 feet in length; it combines the cruciform symbol, the processional theme of the basilica and the unitary concept of the central plan. Choir stalls, stucco ornament and paintings are executed with a perfection that makes every detail a jewel. The whole building, radiant with light, centres on the dome, with its glorification of the universality of the church in the symbol of Pentecost, the day on which the light of Truth spread out upon the world. A joy like that of Whitsun—the moment of the year when spring approaches the majesty of ripeness without losing its youthful ardour—fills this church in the heart of the Swabian orchards, where worshippers come in crowds to kneel before an old Roman crucifix radiant in the centre of the church like the very source of its being.

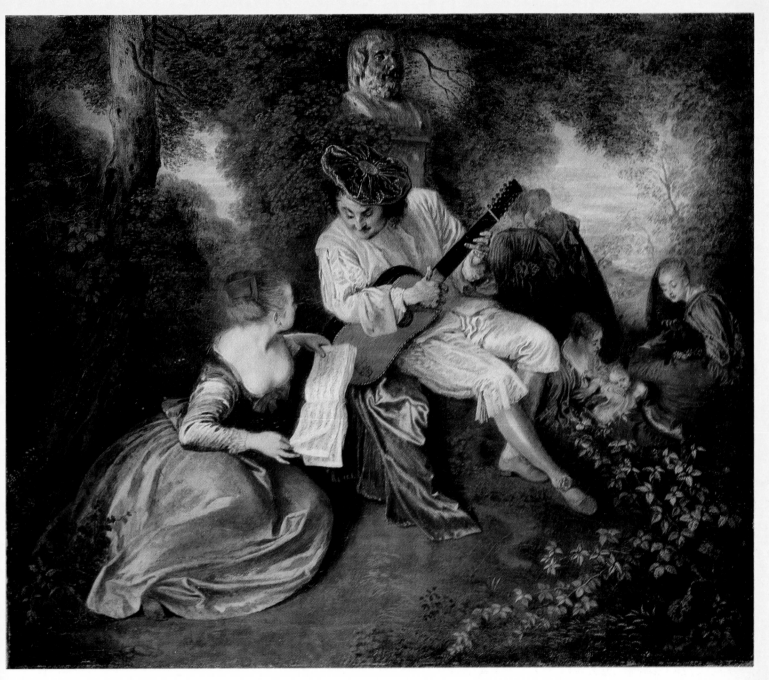

XVII Antoine Watteau (1684–1721). The gamut of love

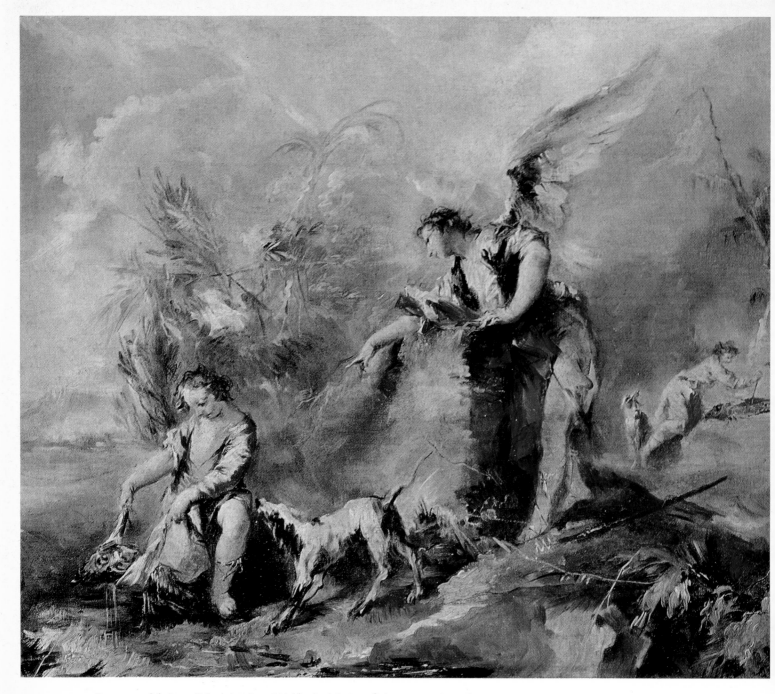

XVIII Francesco de' Guardi (1712–93) and Antonio de' Guardi (1698–1760). Tobias and the Angel, on organ loft of Angelo Raffaele, Venice

XIX Johann Michael Fischer (*c.* 1691–1766). Ottobeuren, Swabia, 1744–67

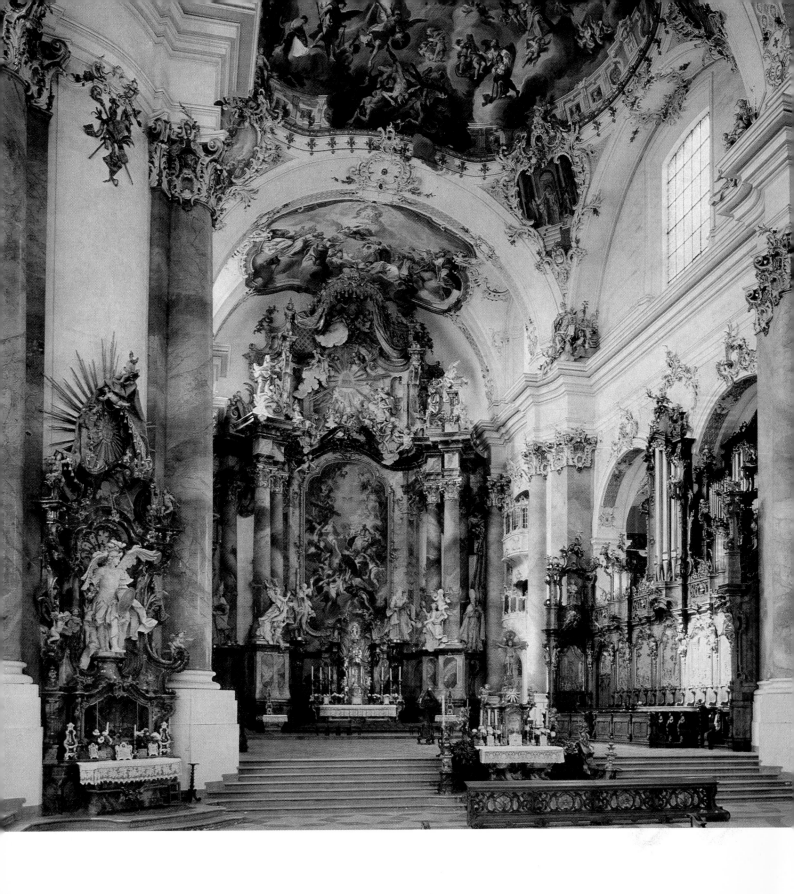

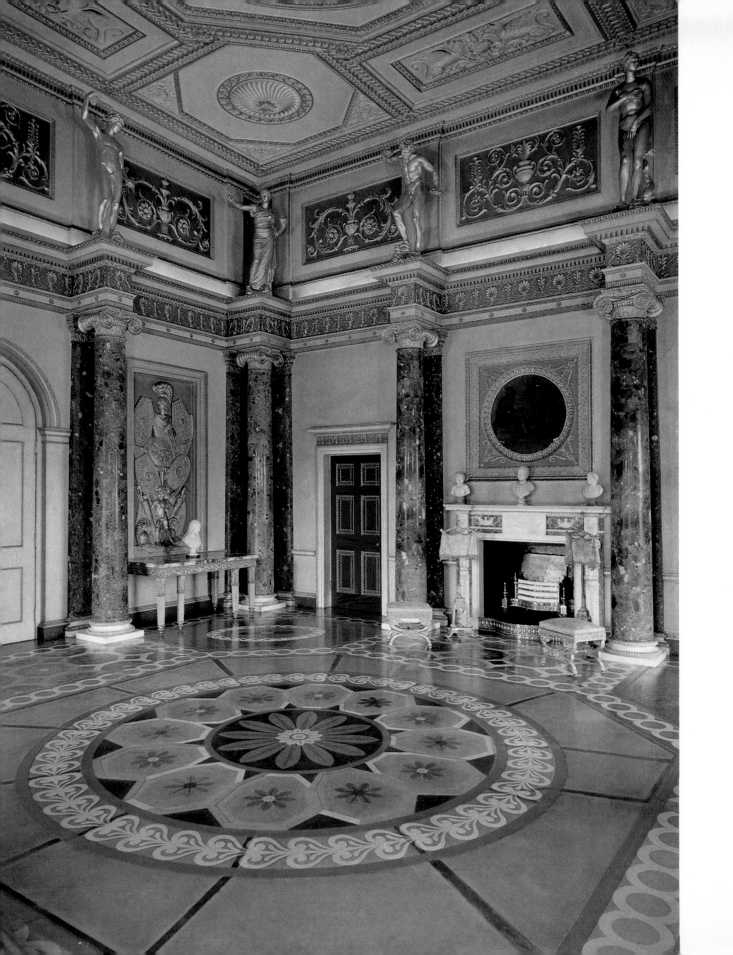

Like the baroque, classicism is a free interpretation of principles developed by antiquity and the Renaissance. Neoclassicism differs from classicism by virtue of its strict observance of rules. This neoclassical, purist aesthetic, elaborated in England, brought an end to the baroque age throughout Europe.

Some critics have found it surprising that Inigo Jones should have thought in Palladian, and hence neoclassical, terms at a time when the baroque was flourishing in Italy. This anomaly is easier to explain if we see the architecture of Inigo Jones as England's discovery of the Renaissance. In architecture, at least, the Tudor styles had been little more than renewed forms of Gothic, while the decorative arts had quickly succumbed to mannerism. Inigo Jones derived his principles of the purity of style not from Rome and Vignola, but from Venice and Palladio. Queen's House, Greenwich, with its six-pillared loggia, its flat roof, its rusticated ground floor *pl. 207* and graceful proportions, is a Palladian villa transported from Vicenza to the banks of the Thames.

Although during the Restoration period the influence of Christopher Wren inclined many architects towards baroque forms of expression, the neoclassical tendency by no means disappeared. It was even reinforced by Dutch influence, Holland having gone over completely to classicism after 1630, under the leadership of Jacob van Campen and Pieter Post. The English architect Hugh May, who spent the years of Charles II's exile in Holland in the company of Buckingham, brought to England the practice of building in brick with a stone ornament upon the central motif, a method which became widespread largely because of the need to rebuild London in an economic manner after the Great Fire of 1666. It became the standard mode of building for town houses of the day, and remained so until stone returned to fashion in the Victorian era; it lends the older quarters of London and other English towns their distinctive, rather Puritan charm. Hugh May's imitation of the Dutch style was often literal, as can be seen by a comparison between the Sebastiansdoelen by Van 's Gravesande in The *pl. 208* Hague (1636) and May's Eltham Lodge, Kent (*c.* 1664). This mode of building survived *pl. 210* despite the popularity of the baroque styles of Wren, Vanbrugh and Hawksmoor (which were in a certain sense Court styles); it is evidence of the underlying strength of Puritanism in England, and its kinship with that of Holland.

The Duke of Marlborough, for whom Blenheim Palace was built, was a Tory; and the Palladian movement, which began in 1713, was in the nature of a Whig reaction. Its leaders

◀ xx Robert Adam (1728–92). Interior of Syon House, 1760–9

were, in fact, members of the Whig aristocracy, Lord Burlington and the Earl of Pembroke, humanists with an enthusiasm for architecture.

Palladianism was founded on strict observance of the precepts of three great masters, Vitruvius, Palladio and Inigo Jones. They were declared in the *Vitruvius Britannicus* (published between 1715 and 1725 by the architect Colen Campbell), which brings together various models, proposes new ones, condemns the licence of the baroque school, and formulates a national classical doctrine. In 1715 there appeared a book on Palladio by the Venetian-born Giacomo Leoni, who in 1726 made a translation of Alberti's *De Architectura,* while Lord Burlington himself published several works during the same period. All these works unleashed a flood of studies, theories, manuals and reviews on architecture; England throughout the eighteenth century remained something of a laboratory of the art of building.

In taking inspiration from Palladio, English architects were adopting as their guide one of the greatest of all classical architects. Recent critics have attempted to see Palladio as a mannerist, perhaps attributing too much importance to the Basilica in Vicenza, which is one of his early works. Palladio was a man steeped in antique culture; in his villas he goes beyond Roman interpretations of Greek architecture to achieve an intuitive recreation of the Greek canons of proportion. Perhaps the atmosphere of Venice, still full of the Hellenistic spirit, prepared him better for the rediscovery of Greek art than the Roman background that inspired Vignola. The simple idea of the villa, the country residence, freeing him from the grandiose conceptions of urban palaces public or private, helped him to achieve a purity of style which renounces all seeking after effect and creates beauty by a simple harmony of numbers, a marriage of calm surfaces and the rhythm of the classical orders. Among these his intuitive preference was for the Doric and Ionic, the two orders used by the classical Greeks; Roman architects preferred the Corinthian and Composite, the orders which might be called imperial.

The passion for Palladio in England went as far as direct plagiarism; the Earl of Pembroke, who had inherited Wilton House, built by Inigo Jones, had a Palladian bridge built in the park by Roger Morris (1736). This was copied at Prior Park, at Stowe and later at Tsarkoye Selo in Russia. The Villa Rotonda, Vicenza, inspired an imitation by Colen Campbell at *pls 209, 211* Mereworth in Kent (1723), followed immediately by another, Chiswick House by Lord Burlington (1725); this 'type' was repeated in all the English-speaking countries, and on the continent of Europe, up to the first half of the nineteenth century. Lord Burlington was himself an architect and his followers included a number of professional architects, William Kent, Colen Campbell, Giacomo Leoni, Henry Flitcroft and William Adam; Roger Morris later broke away from the group to join that of the Earl of Pembroke.

William Kent was the architect most closely associated with Lord Burlington, who was responsible for persuading him to turn from painting to architecture. Kent's most representative *pl. 217* work is Holkham Hall, Norfolk, which owes much to Burlington's influence. The design of the exterior, as well as the hall, conforms to the Palladian style, but in the interior Kent, who in 1727 (at the instigation of Lord Burlington) had published *The Designs of Inigo Jones,* returns to Jones's noble, grandiose, weighty style. Kent was the first to see the role of the architect as

extending to the entire decoration of the interior, including the design of the furniture. In his interiors he practises what has been called 'the English grand style', based on that of Versailles and revitalized by the spirit of the Italian Renaissance.

The most complete application of Palladian doctrines was the rebuilding of Bath, the West Country watering-place which developed rapidly after the year 1727 under the influence of Nash. John Wood I and his son John Wood II turned the town into a kind of English Vicenza; John Wood I created the Circus, a kind of circular forum which resembles the Colosseum turned inside-out, and John Wood II invented the semi-elliptical street-plan known as the *pl. 367* crescent, which has been much used all over England.

The second generation of Palladians (Robert Taylor and James Paine in London, John Carr in York) was associated with the Adam style, and Palladian doctrines spread to Scotland, to Ireland and eventually to North America. American architects took as their models architectural pattern books from England, often converting the combination of brick and stone into one of brick and wood, which gives their buildings a particularly light, graceful quality as in the Royal House and Synagogue at Newport, Rhode Island. After Independence, Thomas *pl. 223* Jefferson, who had been to France, made use of French models in addition to English; his State Capitol at Richmond, Virginia, is one of the purest of Palladian temples. Charles Bulfinch *pl. 213* was more inclined to follow the Adam style. The United States remained true to neoclassicism much longer than England; there it has taken on the role of a national style.

Between 1754 and 1758 Robert Adam, the eldest of the four brothers of this name, made a long visit to Southern France and Italy in search of inspiration, during which he met the French architect Clérisseau and the Italian Piranesi; he brought back with him a new style, directly inspired by the antique, which he imposed both on exterior design and interior decoration, achieving at last that harmony between the outer shell of a building and its contents which German artists had achieved in the rococo. The Adam style is less classical than the Palladian, *PL. XX* for it is inspired by the late Roman Empire, recreating under the cloudy skies of England the graces of a Hellenism derived from Pompeii and Herculaneum; it becomes more purely Grecian in character when inspired by the figures on vases unearthed from the tombs of Tuscany and Latium, then thought to be Etruscan, but in reality Greek; an example is the Etruscan Room of Heveningham Hall by James Wyatt.

The Adam movement had its rivals. The second half of the eighteenth century witnessed a late upsurge of rococo, which brought with it a passion for *chinoiserie* and Gothick; it was at this time that Chippendale introduced his rococo furniture, which had considerable success abroad, in New England, in Portugal, and even in Italy. This furniture was enriched with fine materials and exotic woods, notably mahogany, made available by the lifting of tariffs on products from British colonies in the West Indies.

The eclecticism of architecture and interior decoration in late eighteenth-century England is due partly to the absence of a Court capable of giving the lead in matters of artistic style as the French court did. The English constitution evolved rapidly in the direction of parliamentary rule, and the first Hanoverian kings, although they gave their name to the Georgian era, could

never command the status of sovereign of the arts that belonged to absolute monarchs; in any case their somewhat colourless personalities did not fit them for the role of Maecenas.

In the second half of the eighteenth century the reaction against the rococo spread all over Europe, except in the German-speaking countries. This reaction was encouraged by a revival of antique influence inspired by archaeological discoveries in Pompeii, Herculaneum and Etruria, and later in Magna Graecia and Sicily, just as in the Renaissance the discovery of antiquity had enabled the Florentines to free themselves from the Gothic. But had not the baroque itself claimed to be inspired by the antique? For Western civilization, the antique appears as the equal of Nature, by turns its adversary and its ally: a fundamental principle from which can derive the most contradictory forms.

In the second half of the eighteenth century European architecture moved in the direction of classical unity, and thus one type of palace design appeared in widely separated areas; this *pl. 10* was the palace on two floors, with rustication on the ground floor and on the next floor a colossal order of columns or pilasters, a revival of the palace designs of Raphael and Bramante. It was introduced by Juvarra in his design for the Palacio Real in Madrid in 1738, and Vanvitelli used it at Caserta in 1769 for the king of Naples. Jacques-Ange Gabriel uses a similar formula *pl. 224* in the Place de la Bourse in Bordeaux (1731–55) and the Place de la Concorde in Paris, derived from the colonnade of the Louvre (1753–65); he also proposed it for the rebuilding of the palace of Versailles, only a fraction of which was carried out (the Aile des Reservoirs). It was also used by Rinaldi in the Marble Palace in St Petersburg (1768–72).

Under antique influence, the increasing use of the load-carrying column and the development of the peristyle began to give European architecture a certain monotony. In 1733 Servandoni, an Italian stage designer who had settled in Paris, used these features as the basis for his design of the façade of Saint-Sulpice, and Soufflot followed the same style for the façade and dome, *pl. 218* inspired by St Paul's, of the church of Sainte-Geneviève (now the Panthéon) designed in 1757. Under Louis XVI several architects, notably Ledoux, took their inspiration from the Greek architecture of the south of Italy. About 1755 rocaille in France tends to disappear, panelling follows an architectural pattern like that of the seventeenth century, and in furniture curves are succeeded by straight lines.

Eighteenth-century Italy was almost entirely unaffected by the rococo (the Cantoria of La Maddalena, Rome 1736, is an exception). In Rome, works like the façade of San Giovanni in Laterano, the fountain of Trevi by Nicolo Salvi, and the façade of Santa Maria Maggiore by Ferdinando Fuga, bear witness to the loyalty of the Eternal City to the Berninesque baroque. Sculpture, too, was still inspired by Bernini's principles; incidentally, the finest collection of eighteenth-century Italian works in this style is that of the palace-monastery of Mafra in Portugal. In Italy the reaction against the baroque began in the provinces; in Catania, Vaccarini attempted to restrain the anarchy of the Sicilian baroque, and in Naples Vanvitelli imposed a strict archi- *pl. 331* tectural discipline on the grandiose projects elaborated for Charles VII. Earlier, Juvarra had *pl. 220* reduced the structural complications of Guarini to a simpler Berninesque architectural scheme, which in the Superga, Turin (designed in 1715) is distinctly neoclassical in character. The

regions where the art of Palladio had flourished, Treviso, Venice and Vicenza, were naturally prepared for its rebirth; here humanists such as Count Algarotti, Count Pompei, the architect and theorist Millizia and the Venetian architect Lodoli preached a return to Palladio. As early as the beginning of the eighteenth century Andrea Tirali modelled the façade of San Vitale, Venice, on the façade of Sant' Andrea della Vigna; in the *pronaos* or recessed portico of the Chiesa dei Tolentini his style was markedly more antique. The Venetian church of San Simeone *pl. 215* Piccolo, built in 1718–38 by Giovanni Antonio Scalfarotto, was inspired by the Pantheon in Rome.

The neoclassical movement did not reach Rome until the second half of the eighteenth century. Then, under the influence of the German historian Winckelmann, there arose a mania for the antique. The Villa Albani, built between 1743 and 1763 by Carlo Marchionni to *pl. 225* house Cardinal Albani's collections of antiques (of which Winckelmann was curator) is still baroque in feeling, though the *Caffè-haus* is to some extent Palladian. In Rome, neoclassicism and its attendant enthusiasm for the antique inspired the painting of Pannini before it found expression in architecture. Rome now became once more what it had been in the early seventeenth century, a meeting-place for artists of all nations. Frenchman such as Vien, Subleyras, Clérisseau and David, Italians such as Benfiale and Pompeo Batoni, Germans such as Anton von Maron, *pl. 227* Anton Rafael Mengs, Angelika Kauffmann, Wilhelm Tischbein, 'Anglo-Saxons' such as *pl. 228* the Scotsman Gavin Hamilton and the American Benjamin West, reacted violently against *pl. 229* the baroque style, which had borne its last fruit in the art of Tiepolo. They revived historical painting, with a didactic or Neo-Platonist tendency, drawing inspiration from the antique, Raphael and the school of Bologna, and brought a stiffly dignified style to their portraits. In terms of pictorial technique, the change was expressed particularly by a deliberately cold, impersonal touch, contrasting with the virtuosity of baroque painting, which uses brushwork as a medium of expression. Only David retained the sensitive technique of the eighteenth *pl. 231* century, tempered but not chilled by neoclassical serenity.

The neoclassical school drew its inspiration from two sources; a 'Hellenistic' tendency derived from Pompeii and Greece, which was the natural sequel to the *galant* and effeminate art of the eighteenth century (typified by Vien's *Vendor of Loves*, 1763) and a more virile 'Roman' *pl. 230* tendency. This heroic manner was to have as its manifesto David's *Oath of the Horatii*, painted in Rome in 1784; it became the style of the Napoleonic period, and Prud'hon was one of its first exponents. The two genres were also practised in sculpture, which under Hellenistic influence showed a great fondness for childhood themes (Clodion) and sought a somewhat mannered elegance (Pigalle's *Mercury fastening his sandal*, Houdon's *Diana*). In his early works, which still belong to the eighteenth century, the Italian Canova practised both styles (*Portrait of Paolina Borghese* and *Monument of Pope Clement XIII*).

In the 1780s neoclassicism triumphed throughout Europe. In Spain it superseded a still flourishing baroque through the efforts of the Academía de San Fernando; the way had been prepared by the French influence which was present at the Bourbon court. In order to stamp out the persistent native baroque style, a royal decree of 1777 made the approval of the Academía

de San Fernando obligatory for any new secular building. Ventura Rodriguez, trained by court architects, set an example in his own work and paved the way for the art of Juan de Villanueva.

German rococo was even more tenacious than Spanish baroque; here the Frenchmen Nicolas Pigage, Simon-Louis du Ry and Ixnard tempered the exuberance of their predecessors. Prussian rationalism provided a favourable environment for the growth of neoclassicism, as practised *pl. 226* by Knobelsdorff (Opernhaus, Berlin) and Carl Gotthard Langhans (Brandenburg Gate, Berlin 1789–94).

The swing towards neoclassicism in Russia occurred during the reign of Catherine the Great, who followed all the latest trends from Western Europe, and was such an enthusiast for the art of Rome that she ordered Clérisseau to design her an antique palace and museum, and wished to have Raphael's Vatican frescoes copied for her palace (only those of the Loggia were in fact reproduced). Neoclassicism was introduced by the Frenchman Vallin de la Mothe (who taught architecture at the academy founded in 1758 by the Empress Elizabeth) and by Velten, a German. Cameron, of Scots descent but born and trained in Rome, decorated the famous agate rooms at Tsarskoye Selo in the style of Adam, Flaxman and Wedgwood.

King Stanislas Augustus Poniatowski, who had lived for several years in Paris and had been deeply affected by French influence, introduced the neoclassical style into Poland. He had the interior of the royal palace at Warsaw redecorated in the new manner by Domenico Merlini, *pl. 219* architect of several other royal residences, the most elegant of which is Lazienki, a graceful Palladian palace by the Vistula. The painter Simon Czechowicz, a pupil of Carlo Maratta in Rome, reflects the art of Benedetto Luti and Pompeo Batoni.

The purest creation of the Palladian revival in Central Europe is the palace of Kačina near Prague, a grandiose Venetian villa built in the late eighteenth and early nineteenth centuries; its incurving peristyles recall those designed by Palladio for the Villa Trissino at Meledo.

This essentially reactionary tendency, at a moment when the modern world was being born, *pl. 231* is inevitably puzzling. Surely nature, which was the object of the rising sciences, should also have furnished inspiration to the arts? A masterpiece by David, painted in France four years before *The Oath of the Horatii,* illustrates how, if the return to antique models had not taken place, a renewal of the art of historical painting might, without breaking with the baroque tradition, have opened the way to realism and romanticism. The figures of the plague victims, in the votive painting *St Rock interceding with the Virgin Mary,* foreshadows Géricault and Gros, while that of the Virgin reminds one of Ingres. But David was rarely to find his way back to this realist vein; it reappears in revolutionary works such as *Marat murdered.*

European civilization embraced neoclassicism as an escape from a loss of artistic self-confidence attendant on the rise of technology and science. The nineteenth century was thus embarked on a false course and long prevented from heeding its own profound impulse towards nature. Landscapes were painted in a manner which had been learned from copying statues. Only the energy of a Géricault, a Constable, a Delacroix or a Courbet could break the fetters which the eighteenth century had had wrought for the nineteenth, and which until the rise of impressionism continued to hamper the work of most painters and sculptors.

GOTHIC

The completion of the cathedrals

Classical France, in spite of its theoretical contempt for Gothic, continued to employ this style for the restoration or completion of medieval buildings. During the seventeenth century, new Gothic churches were actually being built in some French provinces. Strangely enough, it was Louis XIV himself, the creator of Versailles, who vetoed the building of a 'modern' façade for Orleans cathedral and insisted on a design in keeping with the original Gothic of the rest of the fabric.

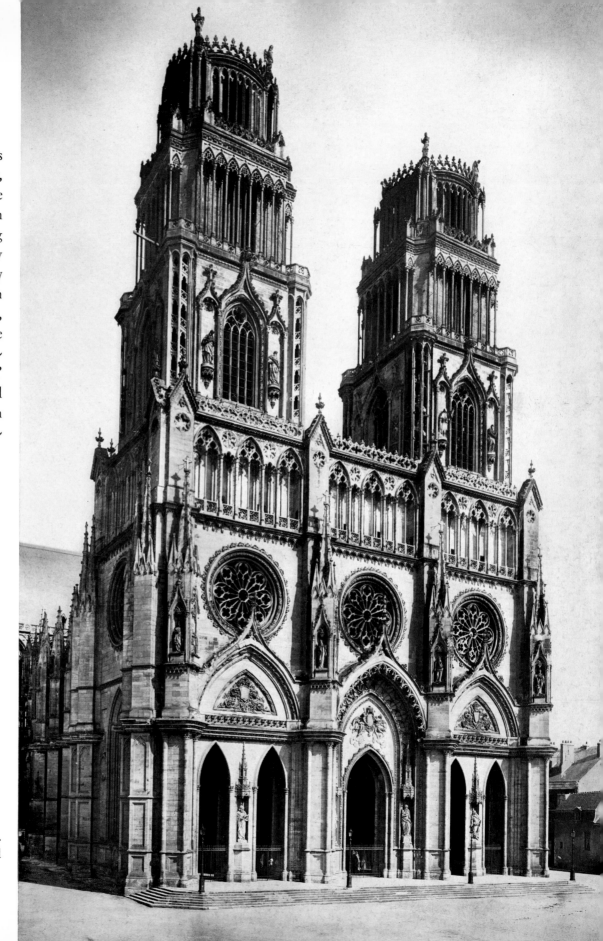

55 Jacques Gabriel (1667–1742). Façade, Orleans cathedral

Milan cathedral: the unfinished giant

From the sixteenth century onwards the need to add a façade to Milan cathedral inspired to a succession of projects, most of them Gothic. The one that was finally executed after the competition of 1886 is based on a project dating from 1653.

Survival and revival

In Great Britain, Gothic has a permanent quality; it has never ceased to be used, notably for religious and educational establishments. Meanwhile in Bohemia, at the beginning of the eighteenth century, an architect of Italian origin, Johann Santin Aichel, drew upon Gothic inspiration in a number of his baroque church buildings.

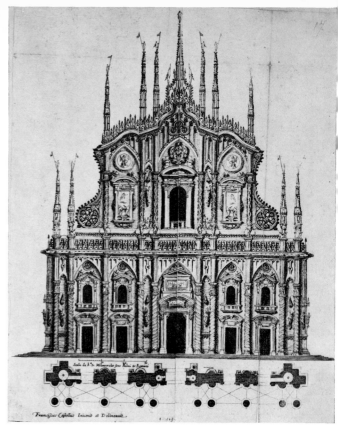

56 Francesco Castelli (*fl.* 1648–88). Project for façade of Milan cathedral, 1648

59 Nicholas Hawksmoor (1661–1736). All Souls College, Oxford, 1734

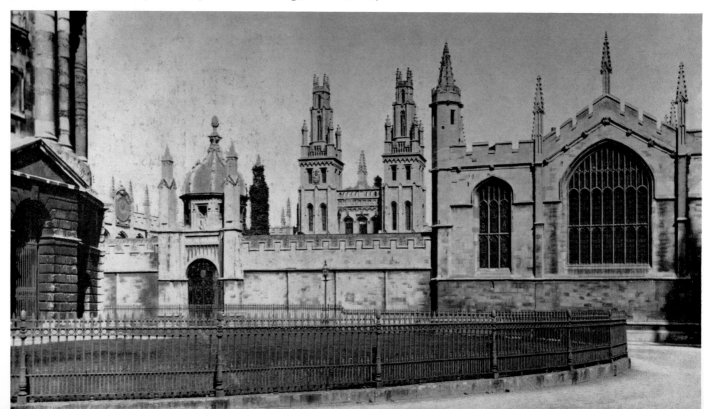

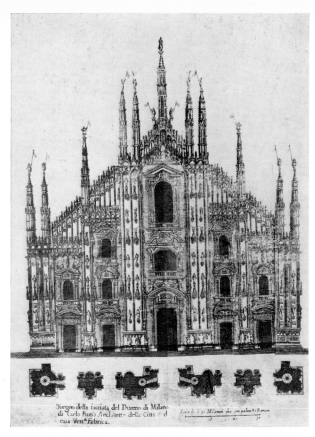

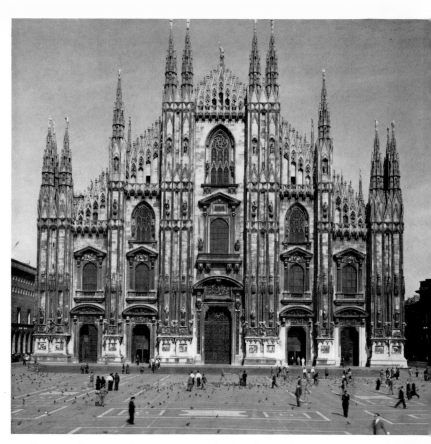

57 Carlo Buzzi (d. 1658). Project for façade of Milan cathedral, 1653

58 Giuseppe Brentano (1862–89). Façade of Milan cathedral, 1888

60 Christopher Wren (1632–1723). Tom Tower, Christ Church, Oxford, 1681–82

61 Johann Santin Aichel (1667–1723). Monastery church of Kladrau (Kladruby), 1712–26

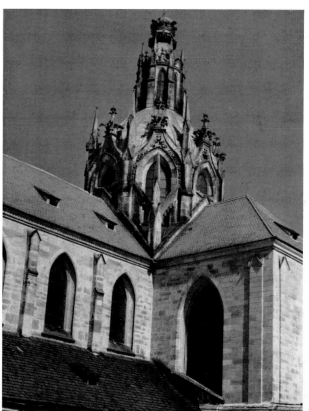

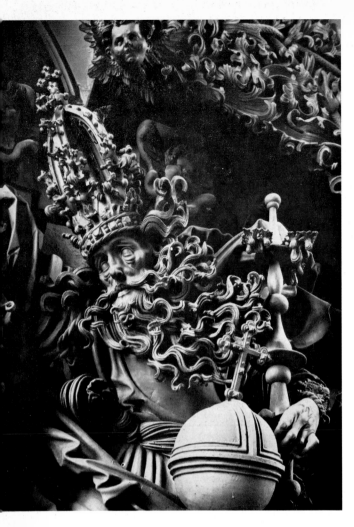

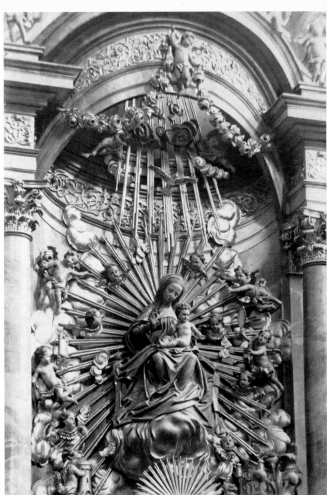

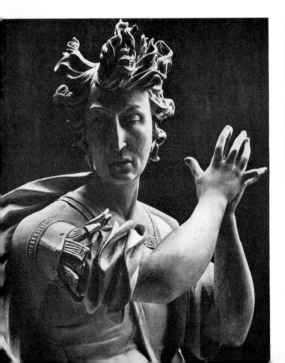

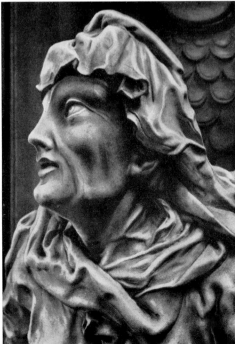

Gothic in the age of rococo

In Central Europe in the eighteenth century, there was a vigorous resurgence of the Gothic which manifested itself in several forms. In the complexity of their draperies and the violence of their attitudes, rococo sculptures are directly inspired by the tormented forms of German late Gothic. Sometimes, too, a baroque spectacle is 'staged' in a Gothic setting, as at Zwettl or Salem; sometimes a great Gothic statue is set 'in glory' in a baroque setting as was Michael Pacher's *Virgin and Child* in Salzburg before a misplaced zeal for stylistic unity led to the removal of the sumptuous setting (shown here) in which pious hands had enshrined the masterpiece.

62 Anon. Head of God the Father, in Münster, Breisach, sixteenth century

63 Michael Pacher (*c.* 1435–98). Virgin and child, in Franziskanerkirche, Salzburg

64 Thomas Weissfeld (1671–1722). St Hubert, in Zisterzienserkirche, Kamenz, Silesia

65 Franz Joseph Ignaz Holzinger (*c.* 1690–1775). St Anne (detail), in church of Metten, Austria

66 Josef Munggenast (d. 1741). Décor in choir of Stiftskirche, Zwettl, Austria, 1722–35

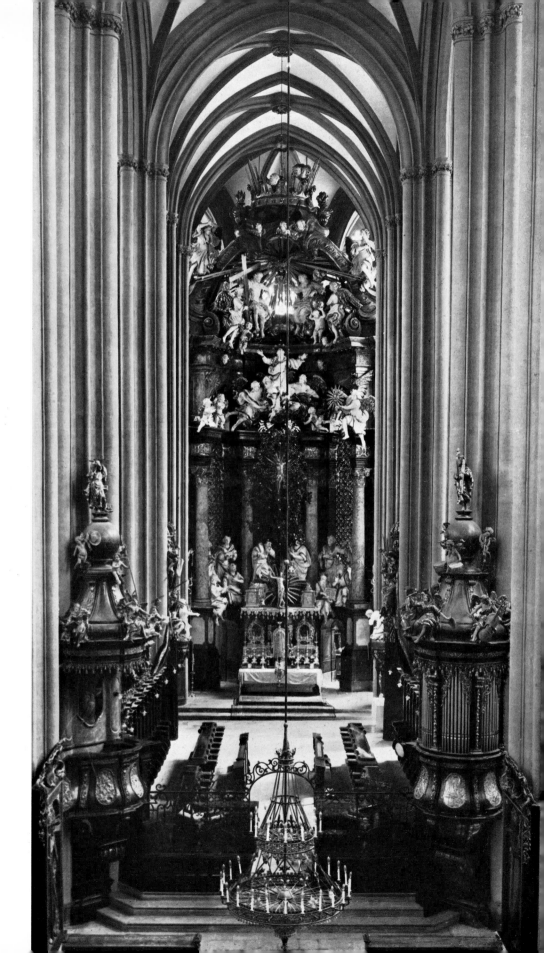

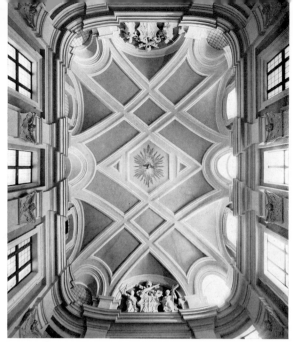

67 Windows in the Prefettura, Lecce, sixteenth century

68 Francesco Borromini (1599–1667). Vault, in chapel of Collegio di Propaganda Fide, Rome, 1649–66

Gothic inspiration in Italy

Italy, which had rejected the Gothic, did not always disdain to draw inspiration from it. Borromini and Guarini took delight in rib vaulting; at Lecce the accolade motif of the Gothic flamboyant style surmounts classical doors and windows.

Holland, too, in spite of its leaning towards classicism in design, retained certain Gothic echoes in decorative art.

The Gothick

In Great Britain in the eighteenth century, while the Palladian movement set the seal on the triumph of neoclassicism over the baroque, a fashion for Gothic decoration swept the country houses. This eighteenth-century neo-Gothic is often called 'Gothick' to distinguish it from medieval Gothic and its later antiquarian revivals.

69 Janus Lutma (c. 1584–1669). Choir screen of St Catharinakerk, Amsterdam, 1650

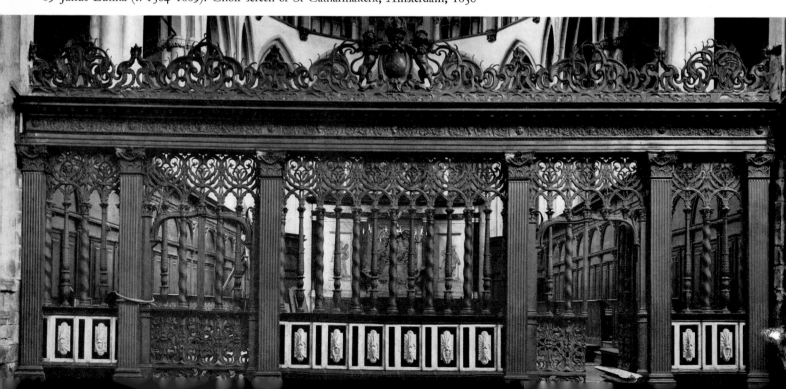

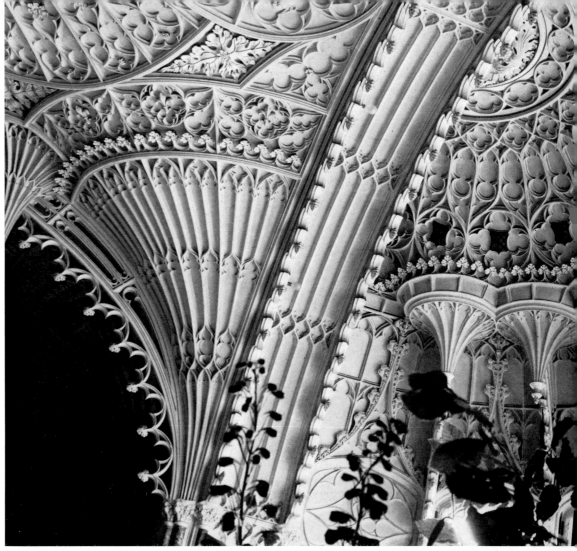

70 François-Joseph Bellanger (1744–
1818). Design for pavilion, Bagatelle,
France

71 Stucco tracery of window,
Arbury Hall, Warwickshire,
eighteenth century

72 John Chute (1701–76). Library
of Strawberry Hill, begun 1766

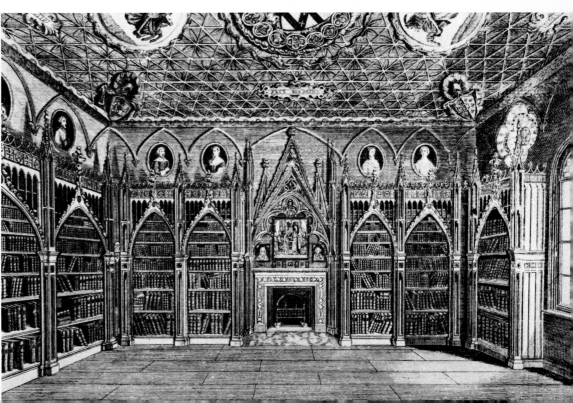

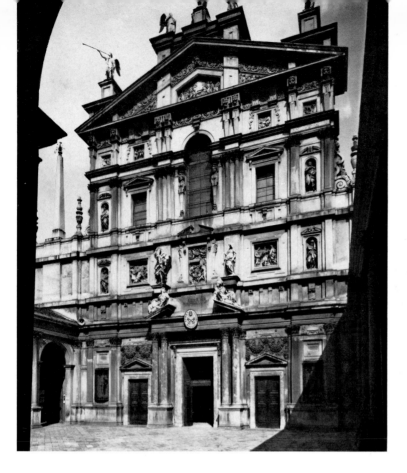

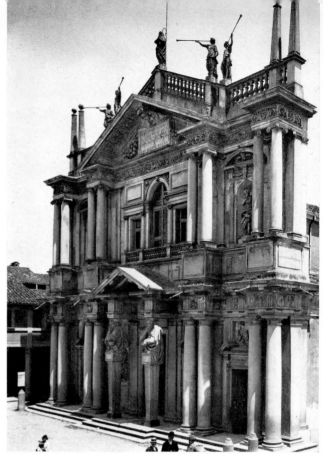

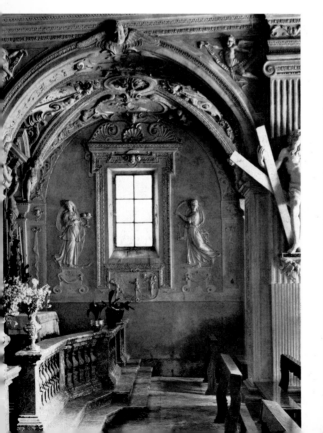

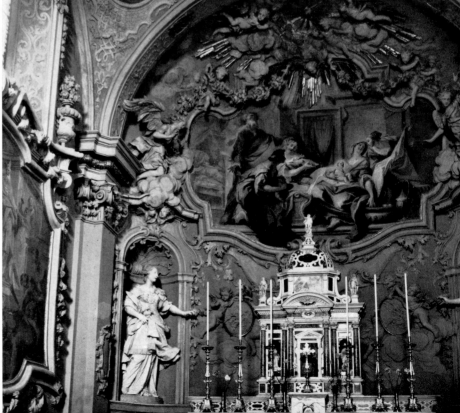

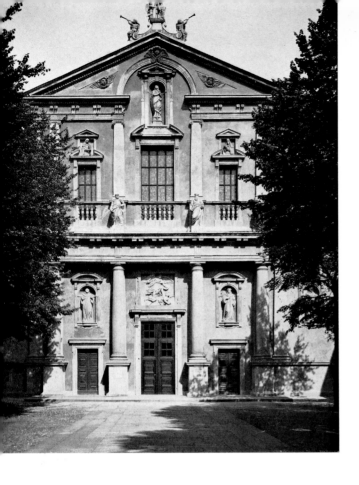

MANNERISM

Northern Italy

In the second half of the sixteenth century, Milan was an active centre of mannerist architecture, and the movement lasted into the next century. Three church façades (*pls 73–5*) progress from mannerist multiplicity to baroque unity. In the field of stucco decoration, mannerism lasted even longer (*pls 76–7*). In Lombardy it was not until the eighteenth century that churches became wholeheartedly baroque. Genoese architecture in the seventeenth century was equally steeped in the mannerist spirit.

73 Galeazzo Alessi (1512–72). Santa Maria presso San Celso, Milan, *c.* 1565–70

74 Vincenzo Seregno (*c.* 1510–94). Madonna dei Miracoli, Saronno, 1556–66

75 Sant'Angelo, Milan

76 Domenico Frisone (*fl.* 1622) and Giovanni Battista Barberini (d. 1666). Stucco décor in San Lorenzo, Laino d'Intelvi, Lombardy

77 Diego Carlone (1674–1750) and Carlo Carlone (1686–1775). Décor in Santa Maria, Scaria, Intelvi, Lombardy

78 Giacomo della Porta (1537–1602). Santissima Annunziata, Genoa, 1587

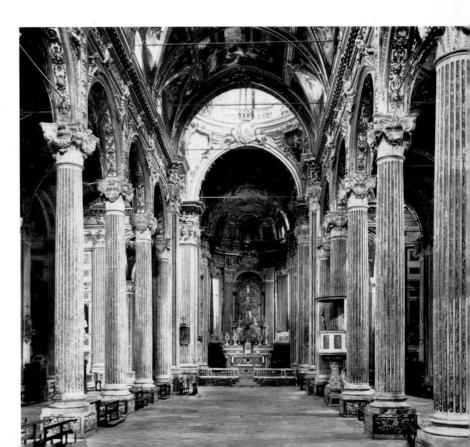

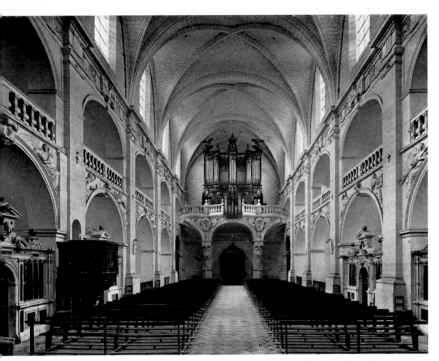

79 Etienne Martellange (1569–1641). Chapel of Collège de La Flèche, France, 1612

Mannerism lingers

In European architecture as a whole, the baroque was never fully assimilated until fifty years after its birth, even longer in certain regions. In France, England, the Low Countries, Spain and Germany, the mannerist spirit lingered throughout the first half of the seventeenth century. Mannerist structure is characterized by a tendency to compartmentalize surfaces in syncopated rhythms, a persistence of Renaissance decorative motifs, and a tendency to juxtapose themes which differ in scale. A comparison between two German church façades, one built in 1690 and the other in 1711, which share the same basic schema, is a perfect illustration of the transition from mannerism to baroque (*pls 84–5*).

80 Lieven de Key (1560–1627). Vleishal (meat hall), Haarlem, 1602

81 Canterbury Quadrangle, St John's College, Oxford, 1631–36

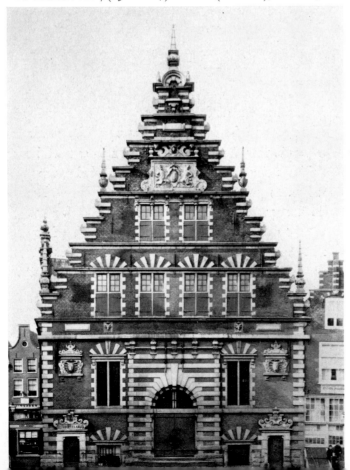

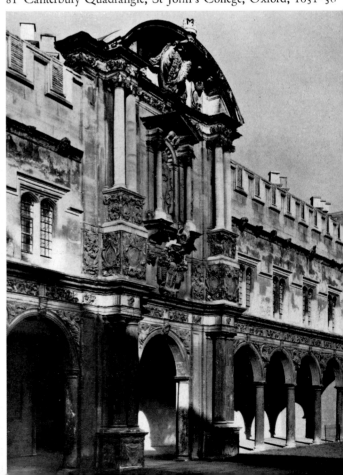

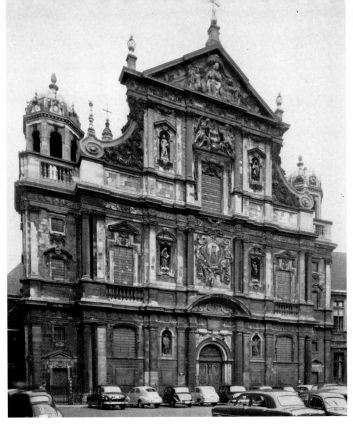

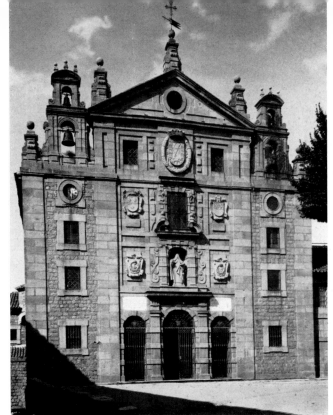

82 François Aguillon (1566–1617) and Peter Huyssens (1577–1637). Saint-Charles-Borromée, Antwerp, 1615–21

83 Santa Teresa, Avila, 1631–54

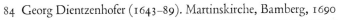

84 Georg Dientzenhofer (1643–89). Martinskirche, Bamberg, 1690

85 Valentino Pezani (d. 1716). Neumünster, Würzburg, 1711

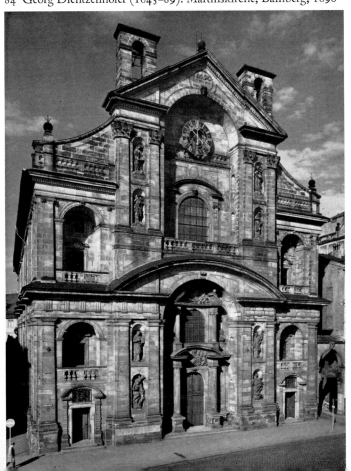

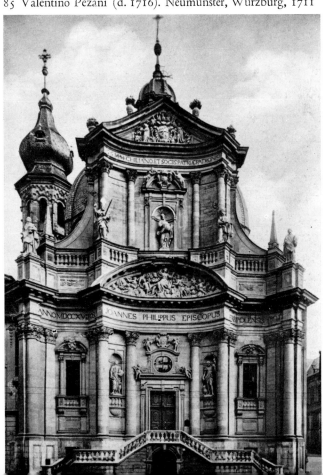

86 Lukas Kilian (1579–1637). Grotesques

87 Wendel Dietterlin (c. 1550–99). Design for doorway

Mannerist fantasy

In Germany the mannerist style of decoration flowered in the first thirty years of the seventeenth century under the influence of a revival of Gothic formal elements. Engravers indulged in flights of imagination which were imitated by decorative artists. A comparison between a doorway in the castle of Bückeburg and an engraving from a work by Dietterlin clearly reveals the true source of the complexities of German mannerist ornamentation.

88 Johann Smieschek (fl. 1618). Ornament

89 Doorway of gold room, Schloss Bückeburg, c. 1620

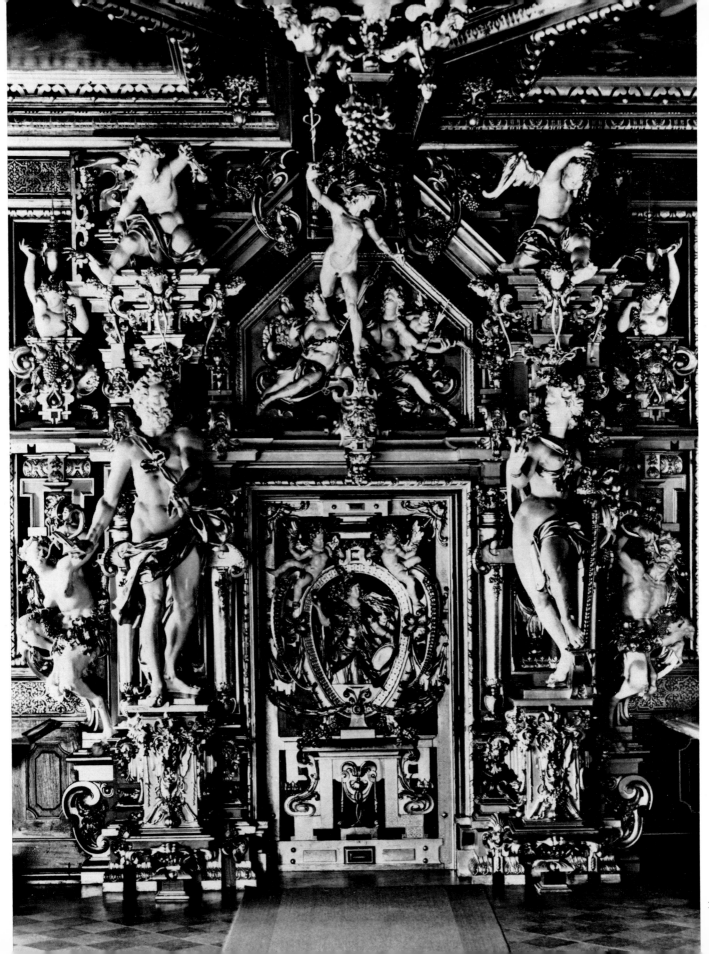

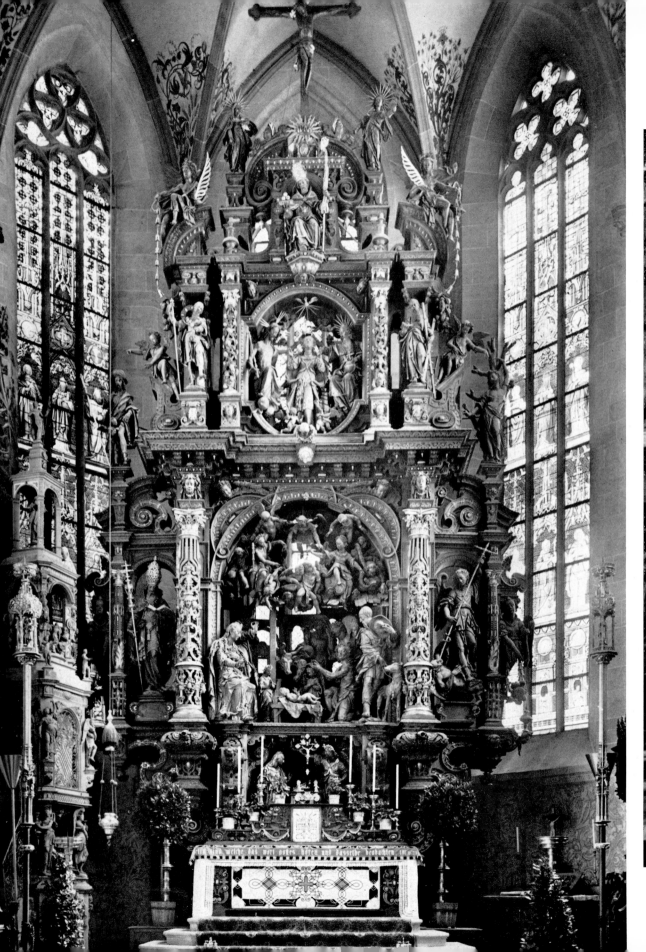

Mannerism in the north

The beginning of the seventeenth century was a remarkably productive period in German sculpture. The decoration on Jörg Zürn's Überlingen altar anticipates the convolutions of the so-called *Ohrmuschelstil*.

At the beginning of the century, the chapel of Frederiksborg is a characteristic product of the essentially anti-architectonic nature of mannerism; laden with marble, silver, alabaster and rare woods, it is jewellery rather than architecture.

90–1 Jörg Zürn (*c.* 1583–*c.* 1630). High altar of Münster, Überlingen, *c.* 1613, and Column, detail of *pl. 90*

92 Hans Steenwinkel (*c.* 1545–1601) and others. Slotskirke, Frederiksborg near Copenhagen, 1600–20

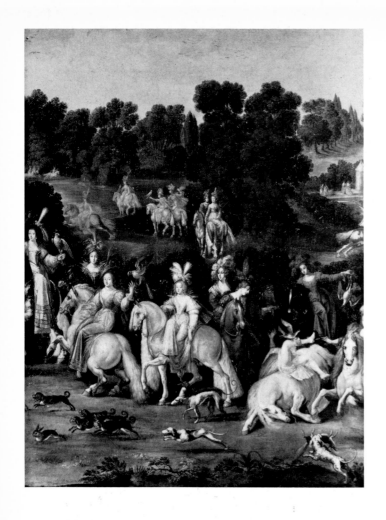

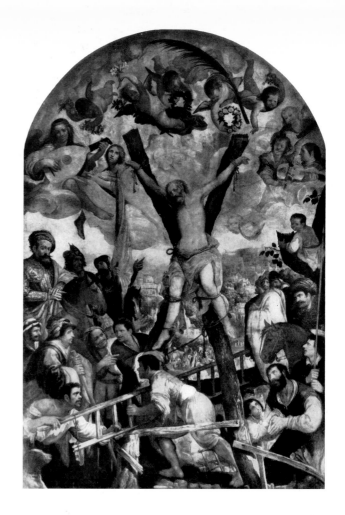

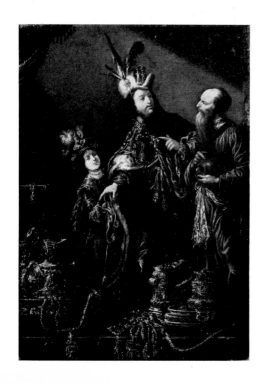

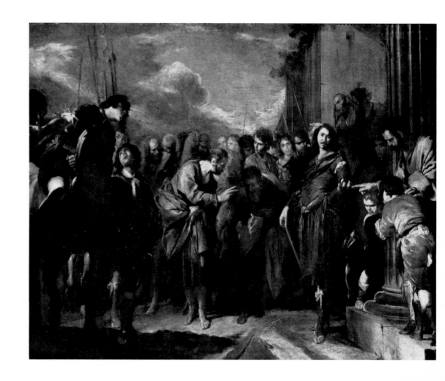

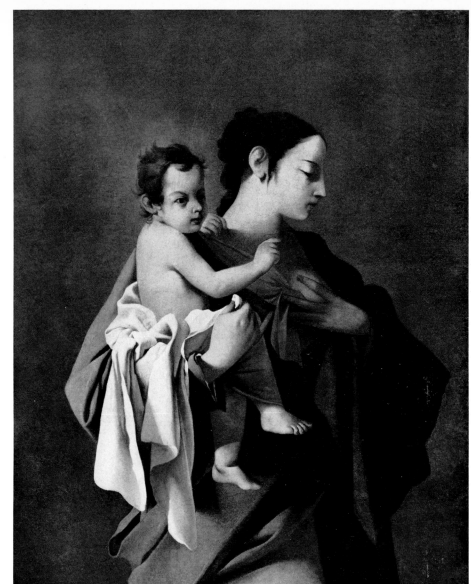

93 Claude Deruet (1588–1660). Hunting scene (detail)

94 Juan de las Roelas (*c.* 1560–1625). Crucifixion of St Andrew

95 Claude Vignon (1593–1670). Croesus displaying his treasure to Solon

96 Bernardo Cavallino (1622–54). St Peter and the centurion

97 Jean Tassel (1608–67). Virgin and Child

Mannerist painting

All over Europe, certain schools of painting remained faithful to the mannerism of the previous century. Spanish painting before Velázquez is mannerist. Magnasco in Genoa and Cavallino in Naples retained certain features of the late sixteenth century *(cf. pl. 224)*. In Lorraine, which was still German-oriented, mannerism flourished (Lallemand, Vignon, Deruet, Varin). French painting, too, was mannerist until Simon Vouet returned from Rome in 1627.

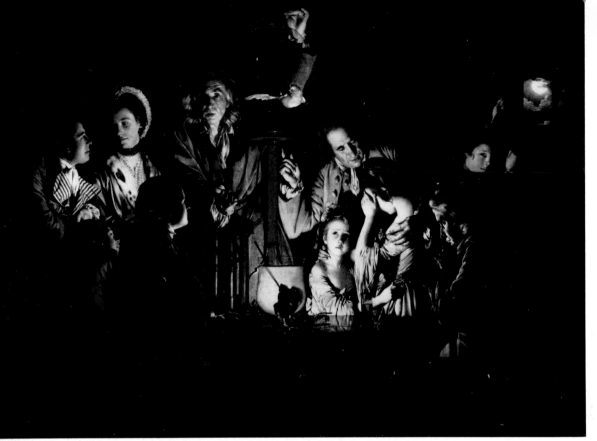

98 Joseph Wright of Derby (1734–97). Experiment with an air pump

99 Domenico Santini (*fl.* 1672–1684). Armillary Sphere according to the planetary system of Heracleides of Pontus

100 A. Magny. Microscope, eighteenth century

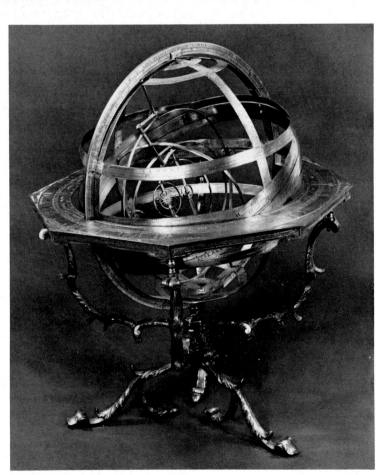

REALISM

The age of experiment

The seventeenth and eighteenth centuries witnessed the rise of the exact sciences; experimentation at last took precedence over the theoretical speculation which had retarded the advance of knowledge in the preceding centuries. The passion for scientific enquiry spread beyond the narrow circle of specialists, and in the eighteenth century it even became a drawing-room entertainment. The microscope, symbol of the enormous progress which had been made in the realm of visual observation, was treated as an ornamental object; meanwhile amateurs were assembling collections of objects of scientific interest. (See also *pls 273, 390*.)

101 Cabinet of natural history, Seitenstetten, Austria, 1760–69

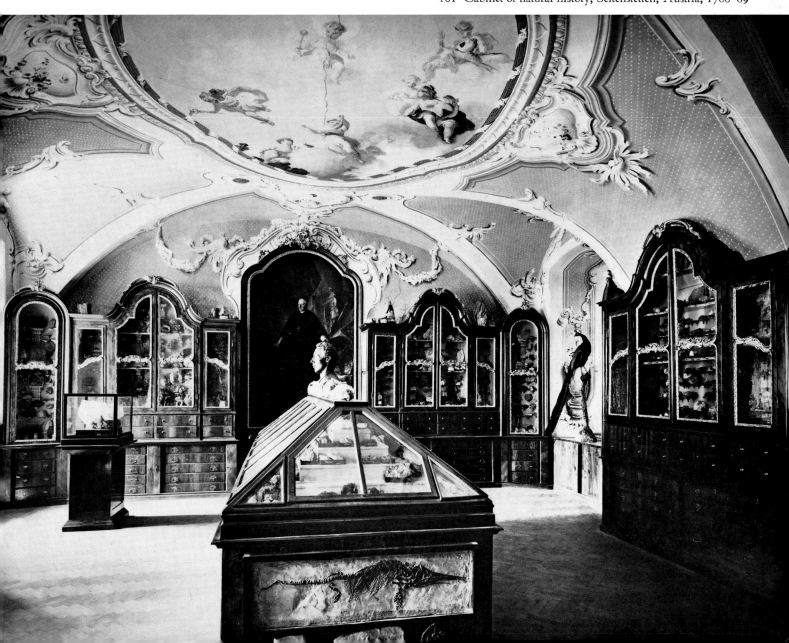

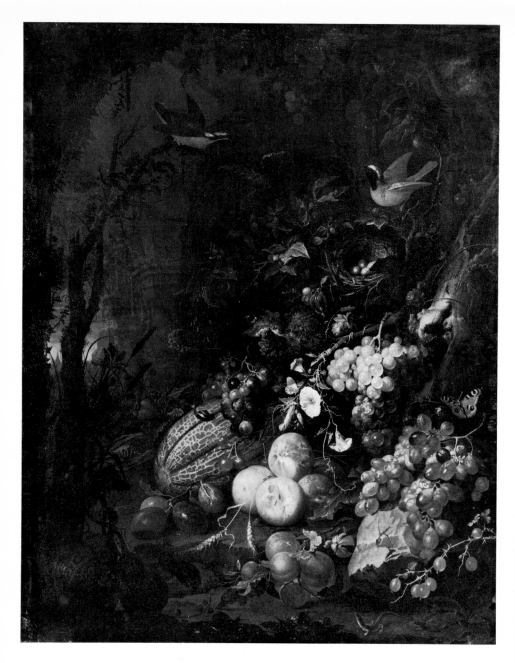

102 Abraham Mignon (1640–79). Flowers, fruit, birds and insects

103 Balthasar van der Ast (*c.* 1590–*c.* 1656). Still-life with shells (detail)

104 Willem Claesz. Heda (1594–1682). Still-life

105 Roelant Savery (1576–1639). Flower piece

Optical realism

It was in Holland that the great advances which had been made in visual observation found their reflection in painting. The still-lifes of the Dutch school were inventories of natural or artificial elements reproduced with scientific exactitude: plants, flowers, fruit, shells, small animals, birds, insects, objects of use.

106 Jan Davidsz. de Heem (1606–83). Flower piece

107 Jan van Huysum (1682–1749). Flower piece

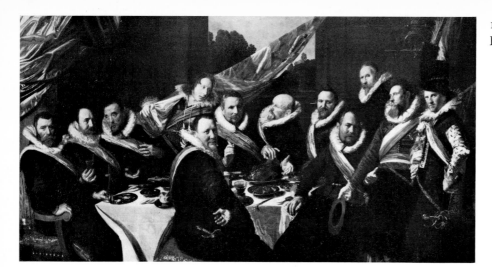

108 Frans Hals (1580–1666).
Banquet of the guard of St George

110 Jan Miense Molenaer (c. 1610–68). Judith Leyster at the virginal

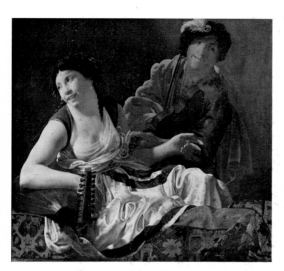

109 Hendrick Ter Brugghen (1585–1629).
Musician and courtesan

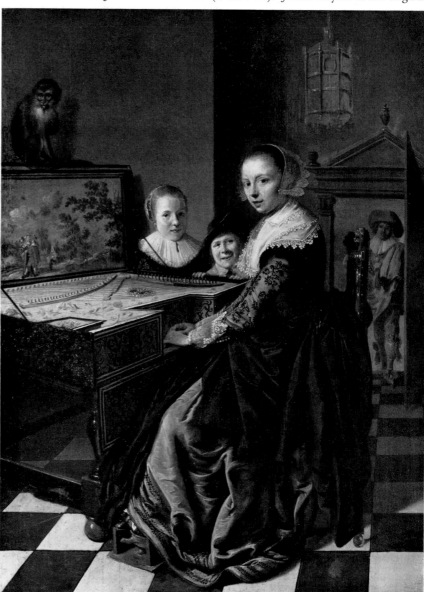

The world of everyday

The figures in Italian paintings always seem
to have stepped off a stage; by contrast, the
realism of the Dutch leads them to represent
man as he is in his most spontaneous
impulses, even, on occasion, in the unbridled
expression of his instincts.

Inner space The anti-realist prejudices of our own period have blinded us to the true intentions of the Dutch realists and the subtleties of their artistic experimentation. They were passionately absorbed in the problems of spatial composition; what interested them was the restricted space of an interior. They went so far as to paint the insides of 'optical boxes', peepshows which reproduced the magic of the *camera obscura* (see PL. V). On a minute scale, their paintings reveal a great subtlety in the spatial definition of the few square feet within which a human being lives and breathes amid objects ordered according to use. All this artistic virtuosity paved the way for Vermeer.

111 Emanuel de Witte (1617–92). Woman at the clavichord

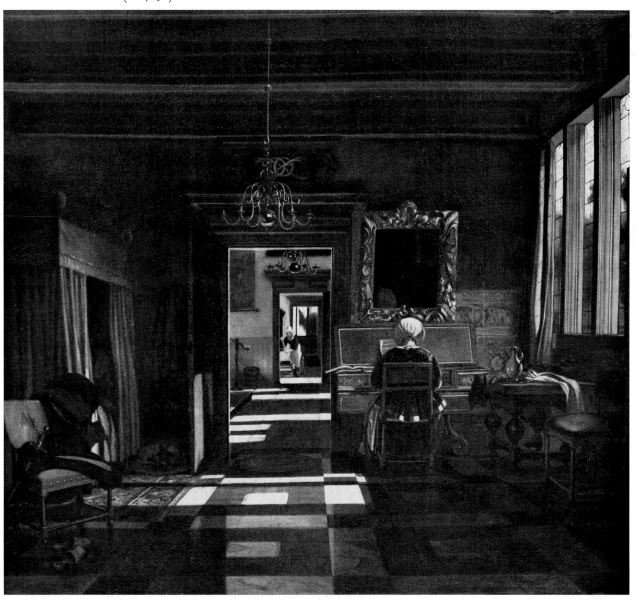

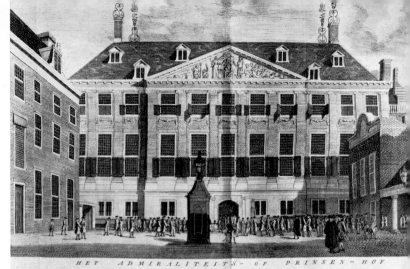

113 Admiraliteitshof, Amsterdam, 1661

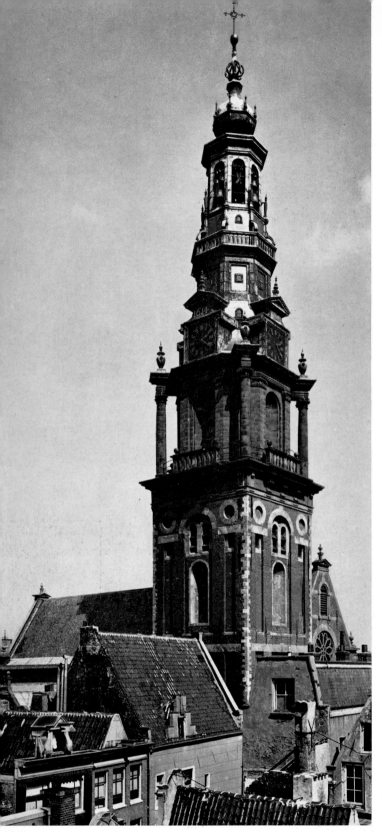

112 Hendrick de Keyser (1565–1621). Zuiderkerk, Amsterdam, 1603–14

CLASSICISM

Holland: the classical moment

The suddenness of the conversion from mannerism to classicism in Holland around 1630 is a reminder of the affinities between Dutch realist positivism and the classical emphasis on reason in art.

The steeple of the Zuiderkerk is still mannerist; but a very few years later Dutch architecture underwent a classical revolution which was unique in Europe. Pieter Post and Jacob van Campen were the guiding spirits of this revolution, which had considerable repercussions in Scandinavia and in Great Britain. Classicism spread to sculpture; the Antwerp sculptor Quellinus, called in to work on the Amsterdam town hall, laid aside his native baroque and conformed to the classical rhythms implicit in the architectural and thematic context of the commission.

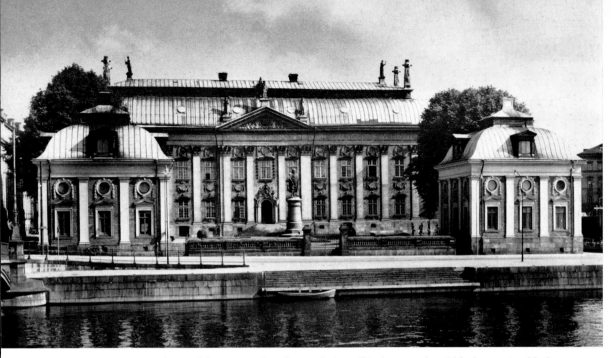

114 Joost Vingboons (*fl.* *c.*1650–70) and Jean de la Vallée (1620–96). Riddarhuset, Stockholm, *c.* 1650

115–6 Artus Quellinus (1609–68). Triumph of Fabius Maximus and Israelites gathering manna, in Raadhuis (former town hall, now royal palace), Amsterdam

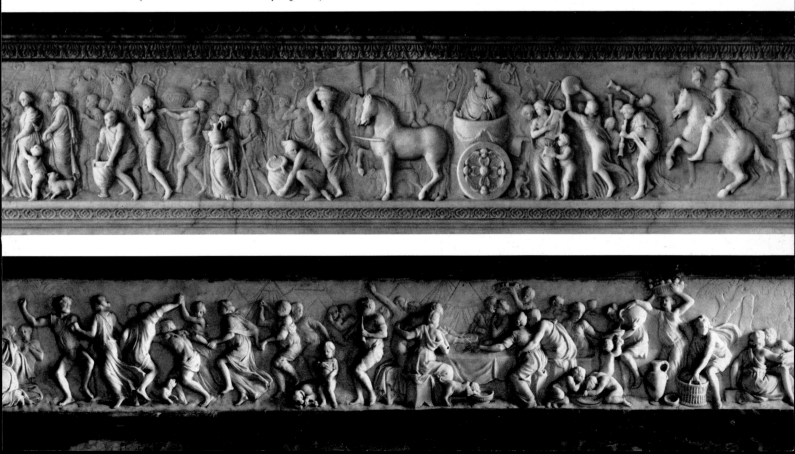

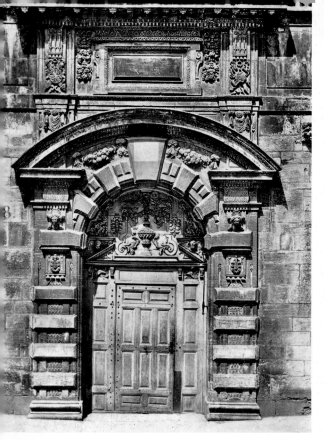

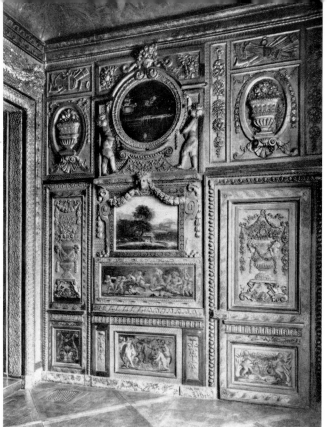

117 Doorway, Hôtel de Vogüé, Dijon, c. 1610

118 Bedroom on second floor, Hôtel Lauzun, Paris, 1650–58

From the beginning of the seventeenth century to the end of the eighteenth, French art underwent a gradual process of refinement in the direction of classicism. The buildings of the reign of Louis XIII are still mannerist or baroque. The old Château de Versailles, even as modernized by Le Vau, retains something of its baroque proportions. The colonnade of the Louvre is the architectural manifesto of French classicism, which was to evolve, in the course of the eighteenth century, in the direction of refined elegance.

France:
the progress
of classicism

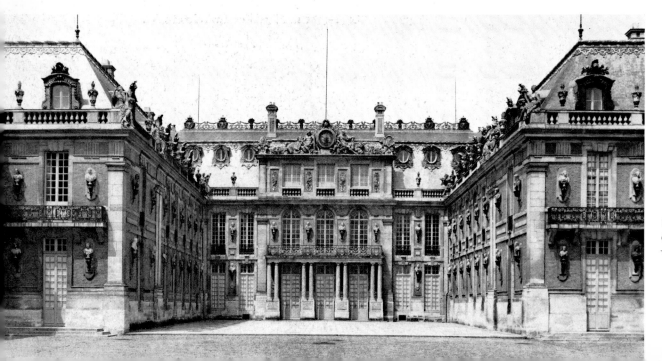

119 Louis Le Vau (1613–
Cour de Marbre,
Versailles, begun 1661

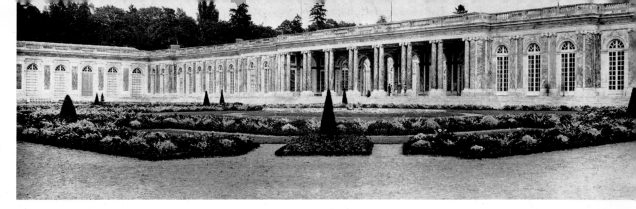

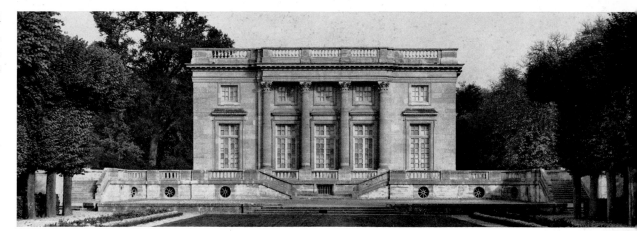

120 Jules Hardouin-Mansart
(1646–1708). Garden façade,
Grand Trianon, Versailles,
1687

121 Jacques-Ange Gabriel
(1698–1782). Garden façade,
Petit Trianon, Versailles,
1762–6

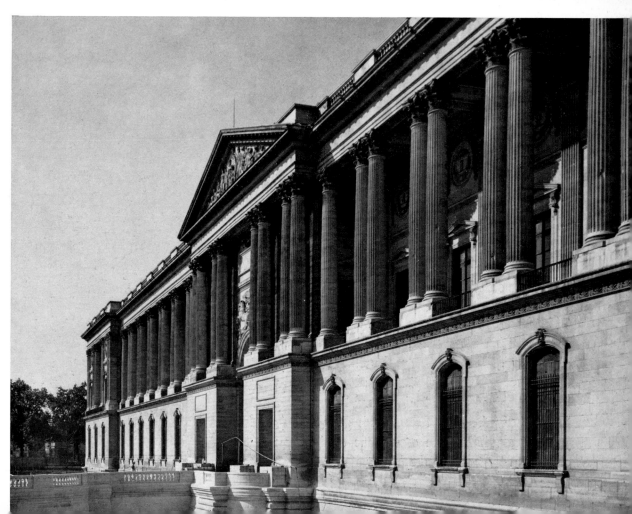

122 Colonnade, east façade,
Louvre, Paris, 1667–70

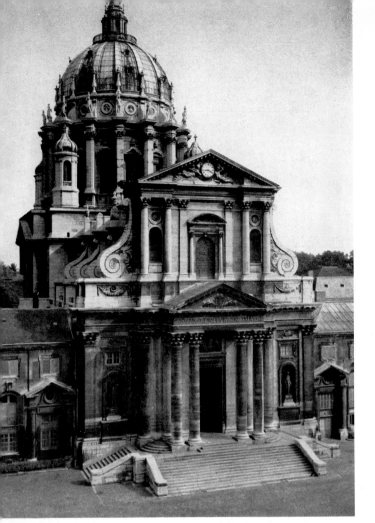

123 François Mansart (1598–1666). Val-de-Grâce, Paris, 1645–65

124 Jules Hardouin-Mansart (1646–1708). Saint-Louis-des-Invalides, Paris 1693–1706

The Mansarts

The Mansart family made a major contribution to the elaboration of the principles of French classical architecture. François Mansart, handling the theme of the domed church in the Roman manner, is still a little constrained by his Italian exemplars. Starting from exactly the same formula, his great-nephew Jules Hardouin-Mansart creates one of the most classical monuments in the history of architecture.

Humanism and classicism

The nature of French humanism, as it was manifested in the first part of the seventeenth century under the influence of the Berullian and Jansenist schools of spiritual thought, inclined French culture as a whole towards the calm and serene expressive forms characteristic of classicism. This is particularly evident in painting, whatever the nature of the subject. In sculpture, Girardon and his colleagues at Versailles instinctively recaptured, beyond the Renaissance and ancient Rome, the pure cadences of fifth-century Greek art. Baroque 'aberrations', such as Anguier's *Holy family,* are rare.

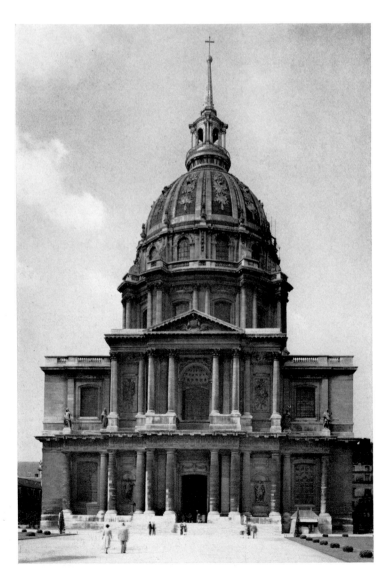

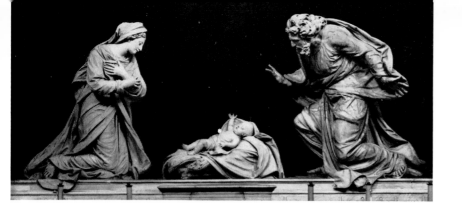

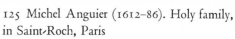

125 Michel Anguier (1612–86). Holy family,
in Saint-Roch, Paris
126 François Girardon (1628–1715) and Thomas
Regnaudin (1622–1760). Apollo attended by nymphs,
in Grotte d'Apollon, Versailles, 1666–75
127 Philippe de Champaigne (1602–74). Mère
Catherine-Agnès Arnauld and Soeur Catherine de
Sainte-Suzanne (detail)
128 Eustache Le Sueur (1617–55). The Muses
Clio, Euterpe and Thalia
129 Louis Le Nain (c. 1593–1648) and Mathieu
Le Nain (c. 1607–77). Venus at Vulcan's forge

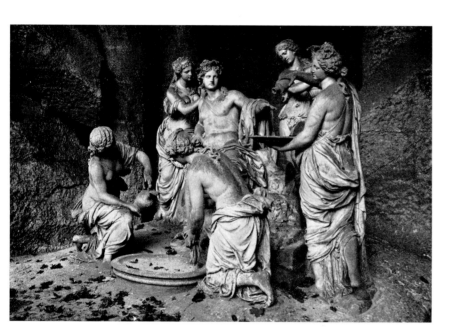

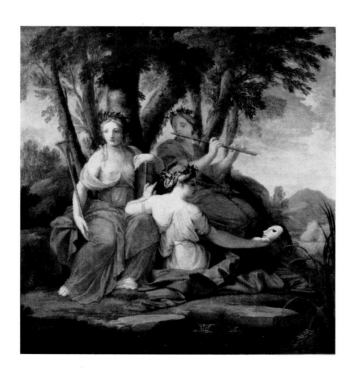

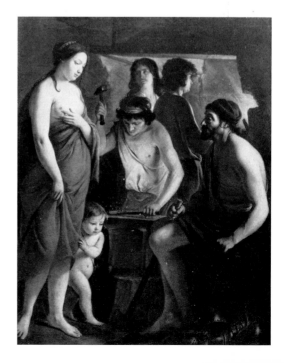

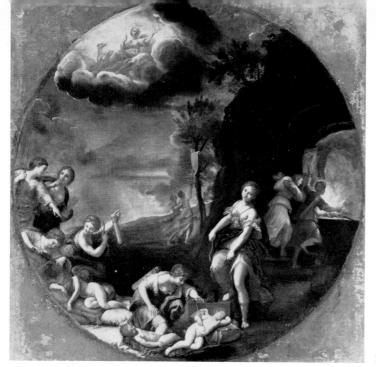

Roman classicism

The Roman milieu in which the classicists Poussin and Claude (PLS X, XI) lived was not wholly out of sympathy with their ideas. Not only did the baroque artists share their preoccupation with antique and allegorical subject matter, but two Italian painters, in particular, were entirely classical in their approach.

130 Francesco Albani (1578–1660). Triumph of Diana

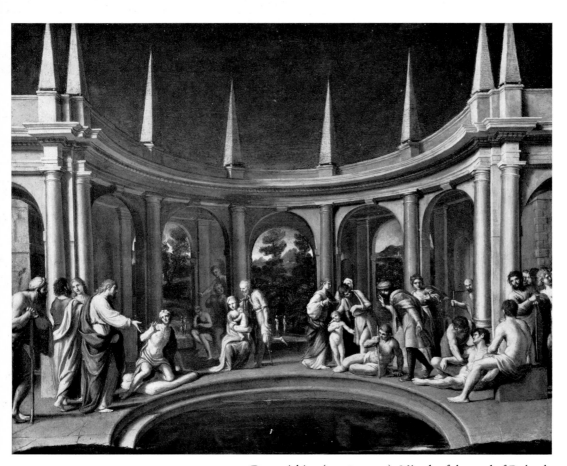

131 Domenichino (c. 1581–1641). Miracle of the pool of Bethesda

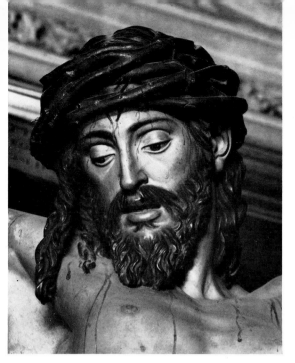

132 Juan Martinez Montañés (1568–1649). Christ of Clemency (detail), in sacristy of Seville cathedral, 1606

Mysticism and classicism

Spain, like Germany, has a fundamental affinity for the baroque; in the seventeenth century, however, religious influences fostered a form of classicism. Early in the century, the designers of Spanish altarpieces transcended the mannerist crisis of the end of the sixteenth century and followed the classical example of Herrera's Escurial altarpiece. In Seville, Zurbarán and Montañés attained classical harmony through their sense of the gravity of the inner life, and sublimity through their conception of the divine.

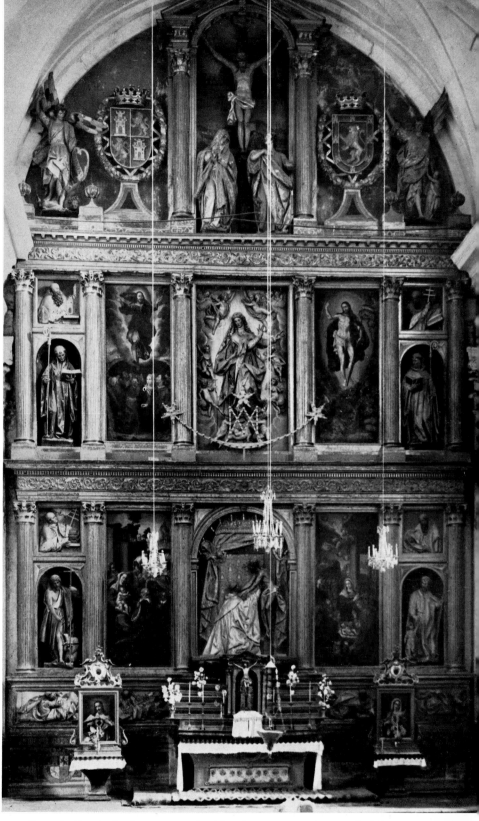

133 Gregorio Fernández (c. 1576–1636). Altarpiece, Las Huelgas, Valladolid, 1618

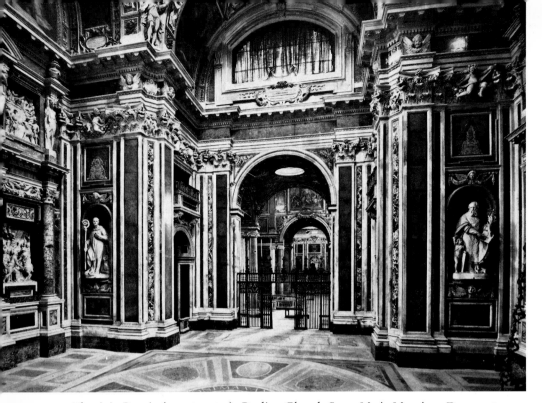

It was in Rome, in the early years of the seventeenth century, that the baroque style of architecture took shape. The clumsiness of the integration of the sculpture into the architectural scheme of the Pauline Chapel of Santa Maria Maggiore is a last reflection of mannerism. In the façade of Santa Susanna, Maderno succeeds in uniting the component parts in a monumental rhythm; in his mannerist model, Il Gesù, the same elements are ill coordinated and unrhythmical.

The architect of the Palazzo Barberini has taken a theme used by Sangallo and Michelangelo in the Palazzo Farnese, that of the façade with superimposed orders and integrated arcades, inspired by the Colosseum, and reinterpreted it.

134 Flaminio Ponzio (c. 1560–1613). Pauline Chapel, Santa Maria Maggiore, Rome, 1605–11

135 Giacomo della Porta (c. 1537–1602). Il Gesù, Rome, 1584

136 Carlo Maderno (1556–1629). Santa Susanna, Rome, 1603

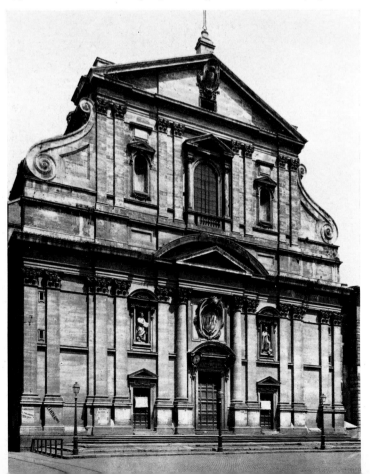

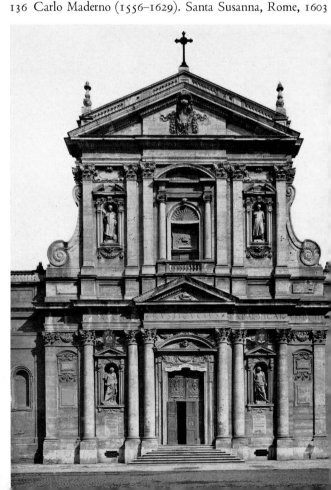

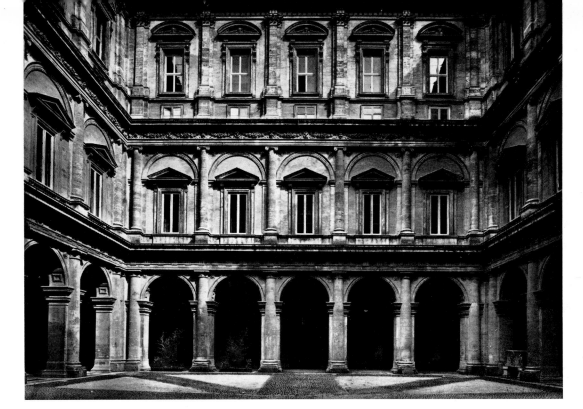

137 Antonio da Sangallo the younger (1483–1546). Palazzo Farnese, Rome

138 Giovanni Lorenzo Bernini (1598–1680). Palazzo Barberini, Rome

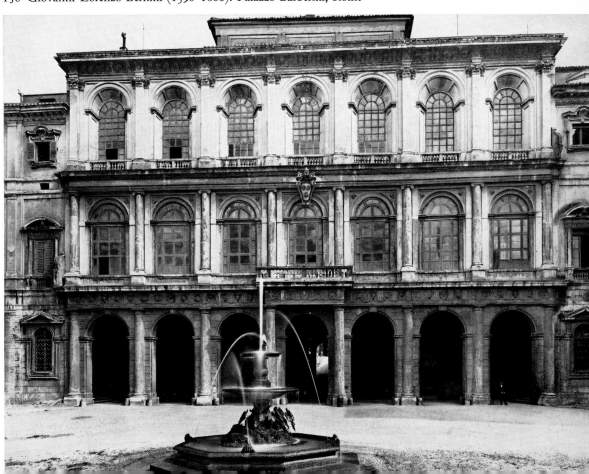

Bernini's Rome From the election of Urban VIII in 1623, Bernini became an artistic dictator, imprinting on the city of the Popes a new style instinct with magnificence. He was inspired by the concept of the spiritual power which, in default of the temporal power which was now a lost cause, the Popes set out to impose on the world. This style is a re-creation of that of imperial Rome, whose successors the Popes might claim to be.

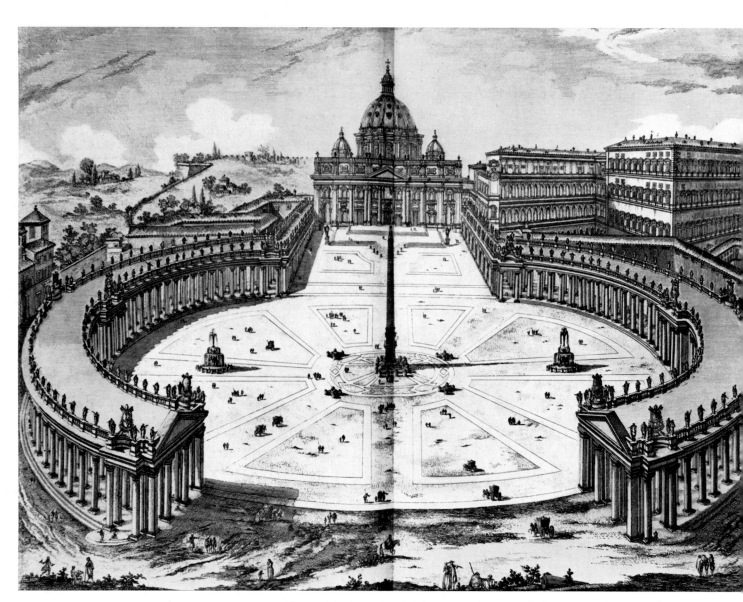

139 Giovanni Lorenzo Bernini (1598–1680). Square before St Peter's, Rome, begun 1656

140 Giovanni Lorenzo Bernini. Baldachin, in St Peter's, Rome, 1633

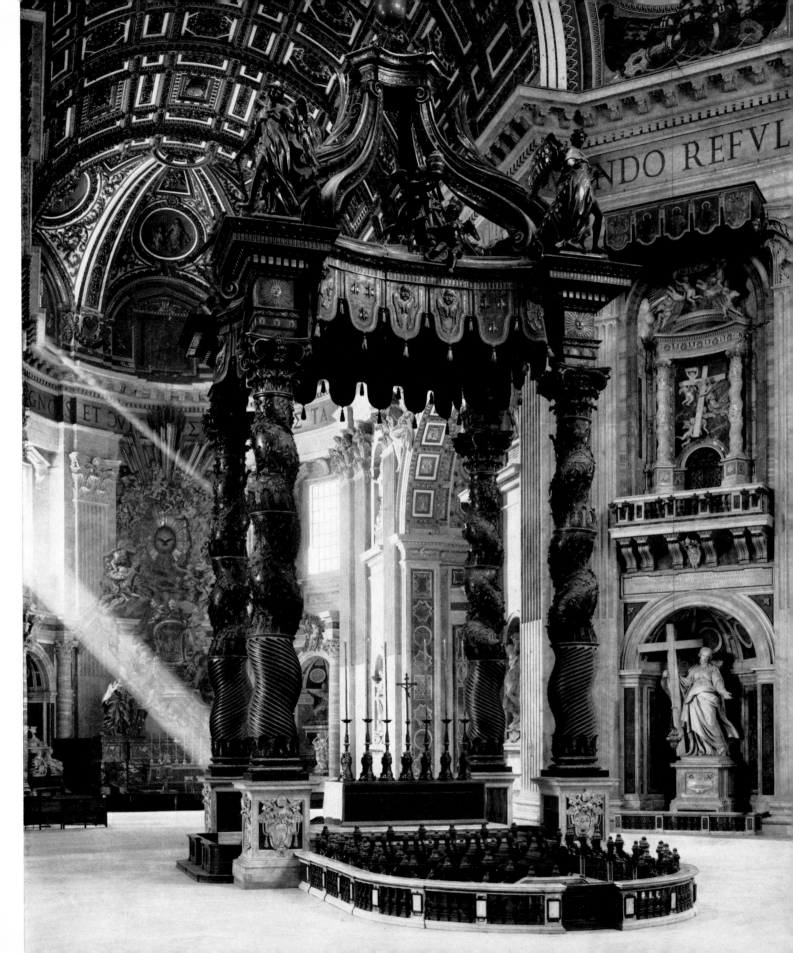

Rome: two versions of baroque

Roman baroque is polarized about two utterly dissimilar artists: Bernini and Borromini. In his conception of architecture, Bernini is the heir of Michelangelo, asserting the stability of the architectural form through the interplay of verticals and horizontals. His effects are essentially sculptural or plastic. Borromini, on the hand, a much more inventive intellect, treats architecture as a symbolic expression of spiritual life. Borromini's San Carlo is an incitement to the soul to soar towards the light; Bernini's Sant' Andrea is a setting for the pomp of the liturgy.

141 Giovanni Lorenzo Bernini (1598–1680). Sant'Andrea al Quirinale, Rome, 1658

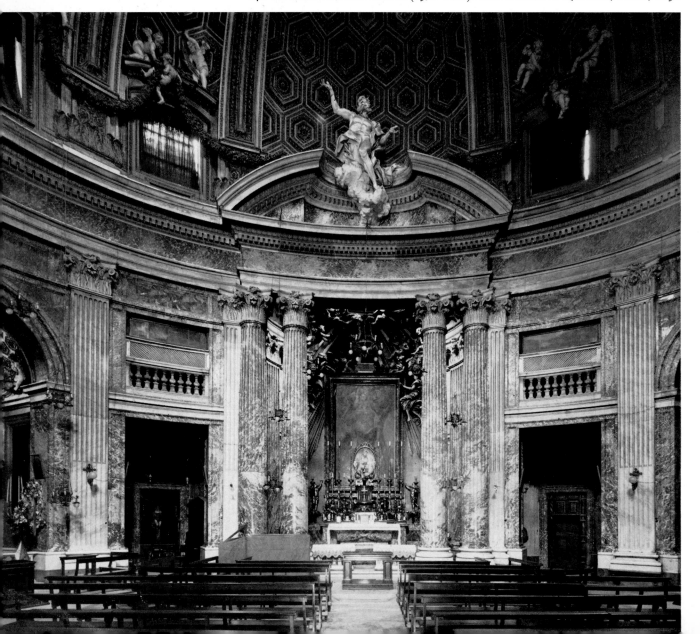

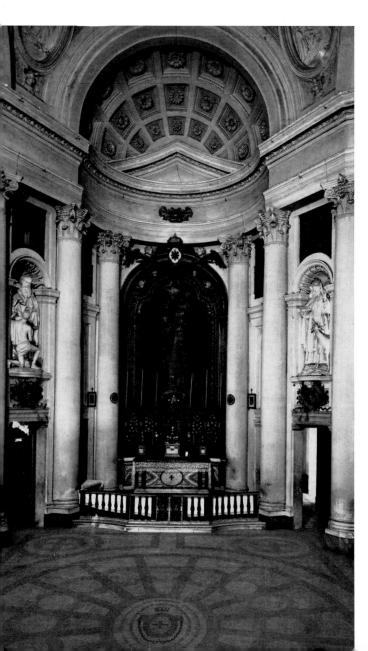

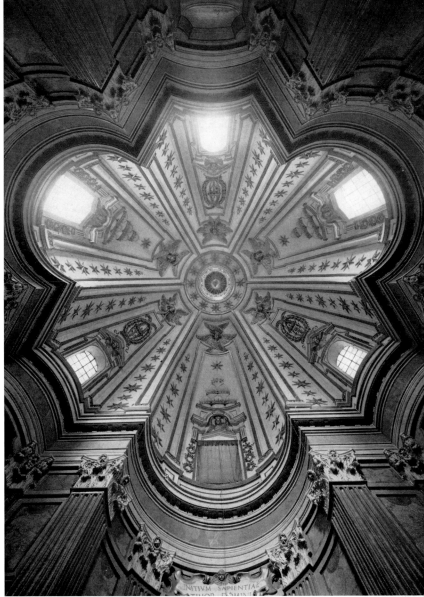

142 Francesco Borromini (1599–1667). Dome of Sant'Ivo alla Sapienza, Rome, 1660

143 Francesco Borromini (1599–1667). San Carlo alle Quattro Fontane, Rome, 1638–40

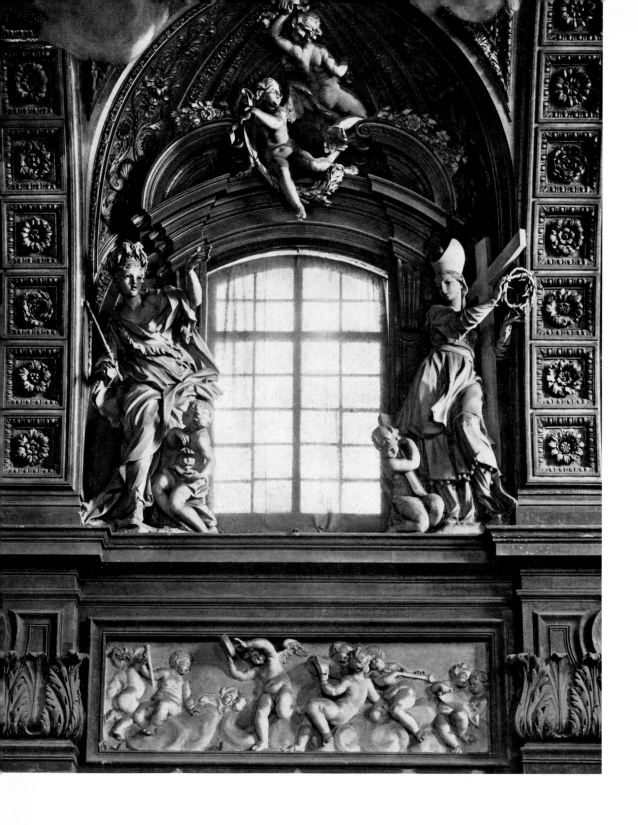

Décor à l'italienne

All techniques were suitable, and all materials valid, for the decorative craftsmen of Italy. All the possible varieties of marble are used not only for facing but, in the south of the country, to produce delicate marquetry which revives the fanciful decorative motifs of the Renaissance, the *grotteschi*. More rapidly worked, stucco was a rival to marble; while gilded wood was used more

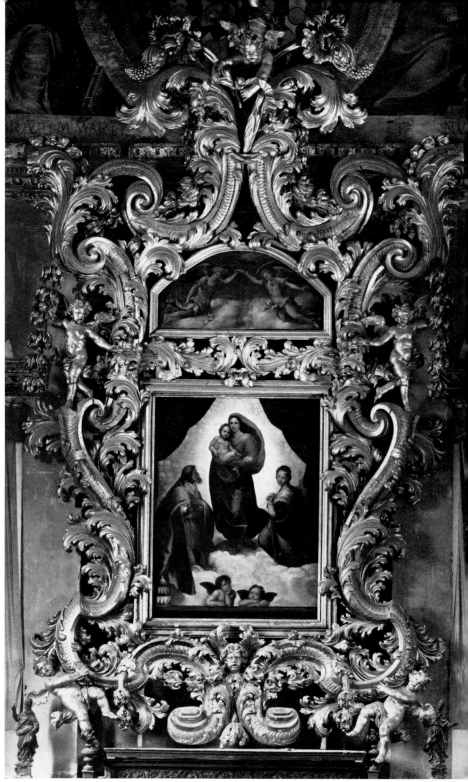

144 Antonio Raggi (1624–86). Stucco décor on left of nave, Il Gesù, Rome, 1668–83

145 Altar of Lady Chapel, Monreale

146 Frame made for Raphael's *Sistine Madonna* (*pl. 286*), now containing eighteenth-century copy, San Sisto, Piacenza, 1698

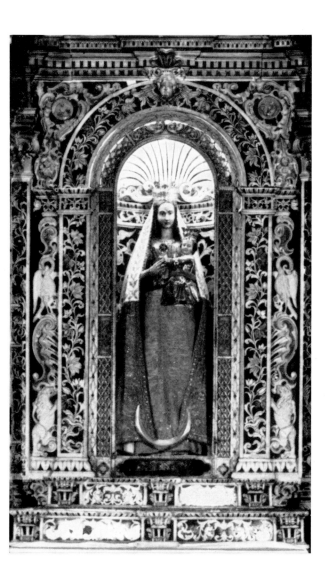

rarely, especially in religious buildings. A popular technique was to set in a sumptuous baroque décor the masterpieces of the previous age (see also *pls 63, 66*); sometimes a marble 'mount' of this kind was contrived for an entire church, such as Santa Maria Maggiore in Rome or the church of Santiago de Compostela in Spain.

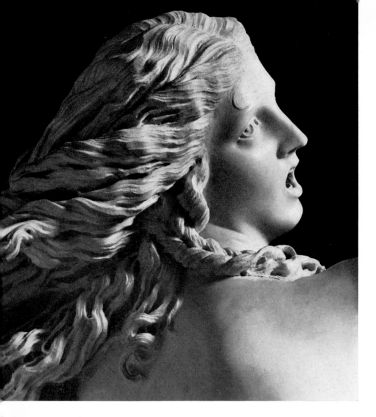

The transcendental impulse

Concentrating all their vital energy in a single supreme effort, the figures in baroque painting and sculpture seem eager to fragment their own personalities, to project the human soul beyond the corporeal husk in which it lies captive. This violent transcendental impulse manifests itself under the stress of death, joy, pain or mystical aspiration. The angels themselves, celestial beings though they are, tremble with the same fever.

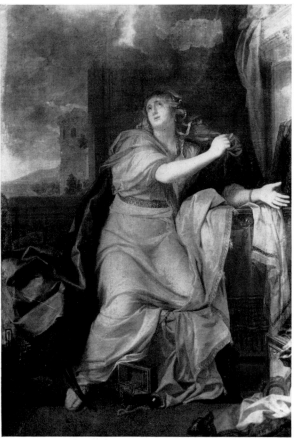

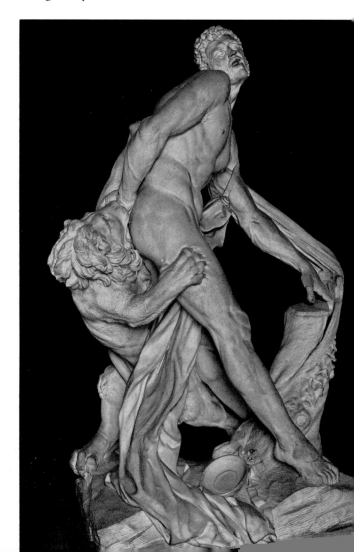

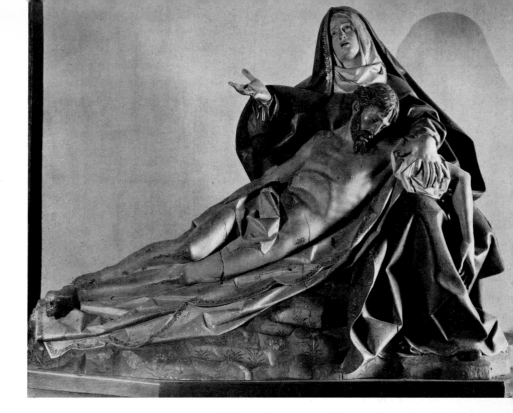

147 Giovanni Lorenzo Bernini (1598–1680).
Apollo and Daphne (detail: Daphne)

148 Charles Le Brun (1619–1690). St Mary Magdalen

149 Pierre Puget (1620–94). Milo of Crotona

150 Gregorio Fernández (c. 1576–1636). Pietà

151 Rafael Donner (1639–1741). Angel,
formerly in Pressburg (Bratislava) cathedral

152 Michael Zürn the younger (b. c. 1625).
Angel, Kremsmünster, Austria

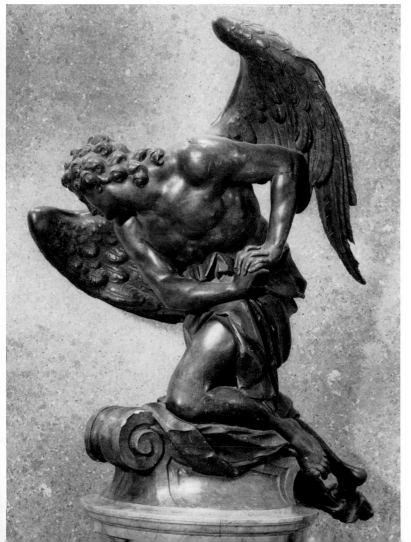

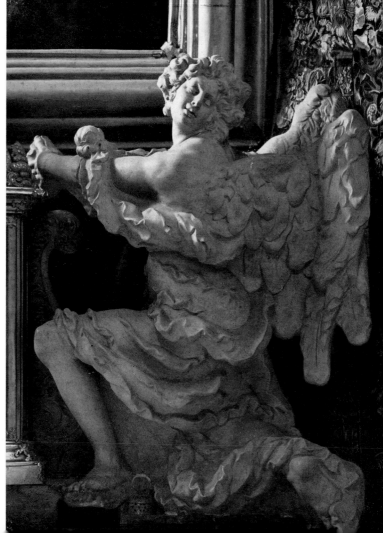

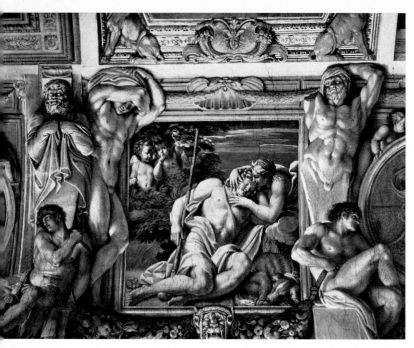

153 Annibale Carracci (1560–1609). Diana and Endymion, in Gallery of Hercules, Palazzo Farnese, Rome

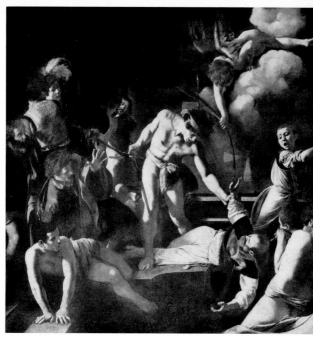

154 Michelangelo Merisi da Caravaggio (c. 1560–1609). Martyrdom of St Matthew

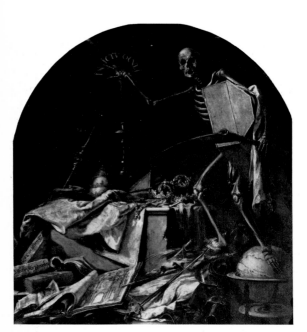

155 Juan de Valdes Leal (1622–90). Triumph of death

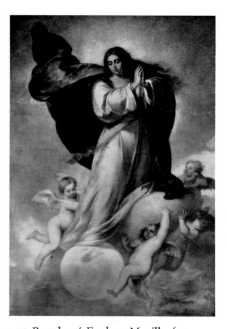

156 Bartolomé Esteban Murillo (1617–1682). Immaculate Conception

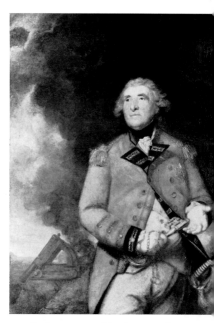

157 Joshua Reynolds (1723–92). Lord Heathfield

The kingdom of painting

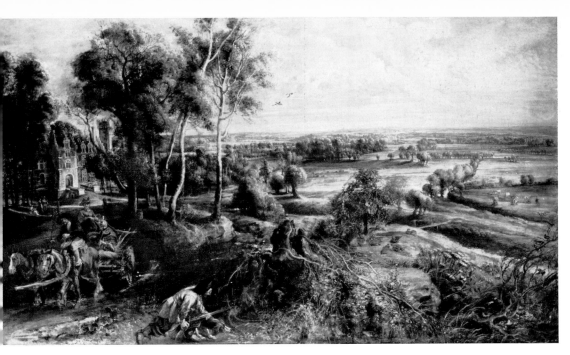

158 Peter Paul Rubens (1577–1640). House and park at Steen

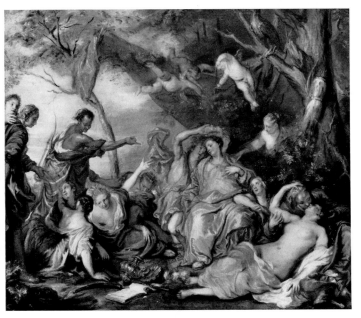

159 Anthony van Dyck (1599–1641). Amarilli and Mirtillo

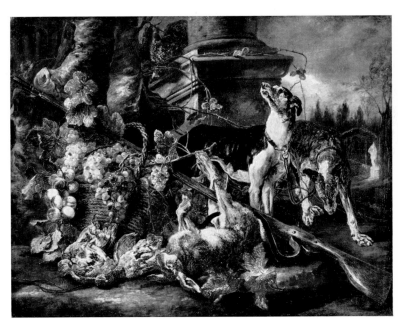

160 Jan Fyt (1611–61). Game, fruit and attributes of the hunt

Baroque artists explored to the point of exhaustion the expressive possibilities of the art of painting: sensuality and sanctity, the profane and the sacred, joy and pain, cruelty and love. Their work encompasses the realms of the imagination as well as the earthly kingdom whose every aspect they examined with such fervour.

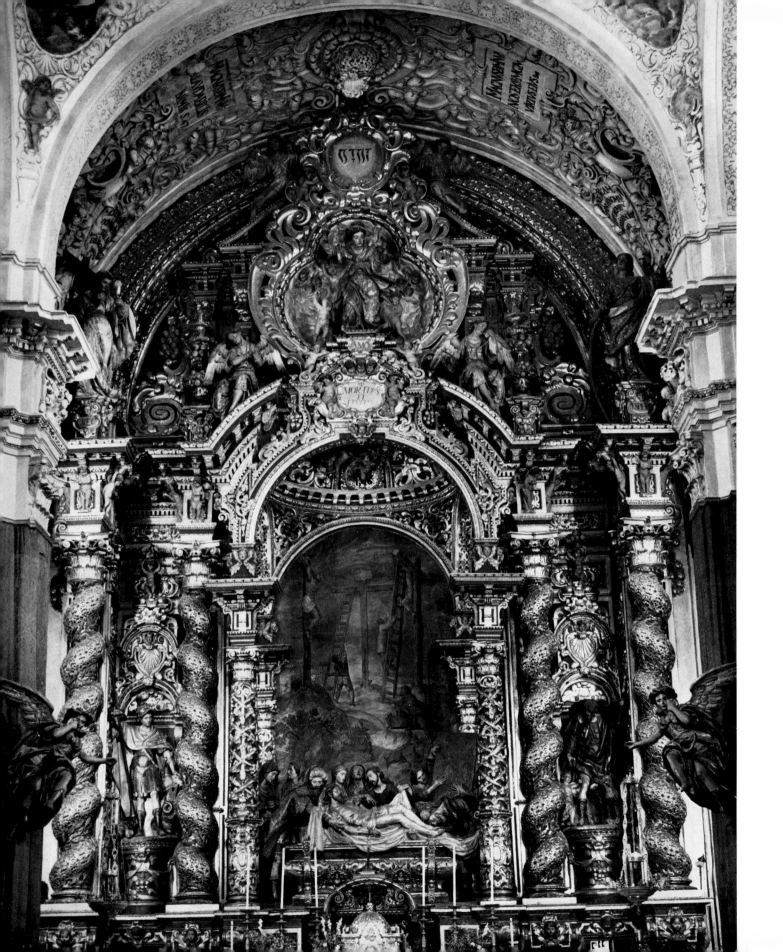

The altarpiece

Gilt and polychrome woodwork is the chosen medium of expression of the church decorators of the immense Iberian world. In Spain, in Portugal and in all the countries of Latin America, thousands of altarpieces were carved with passion by sculptors many of whom, in the New World, were *mestizos*, Negroes or Indians. The altarpiece, laden with images and symbols, plays in the baroque church the role which in medieval cathedrals belongs to the doorway. Portugal, at one moment in its artistic history, and the Spain of José Churriguera, subordinated this sculptural form to a monumental rhythm; but the Iberian altarpiece soon reverted to the luxuriant complexity which is its hallmark.

161 Bernardo Simón de Pineda
(*fl.* 1640–89) and
Pedro Roldán (1624–1700).
Altarpiece, La Caridad, Seville

162 Altarpiece, São Bento, Oporto, 1701

163 Altarpiece, Santa Clara, Queretaro, Mexico, eighteenth century

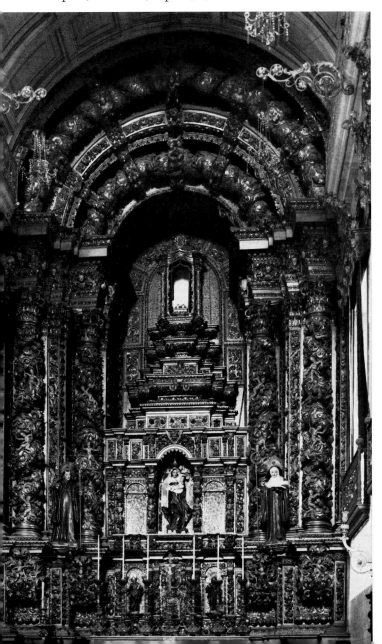

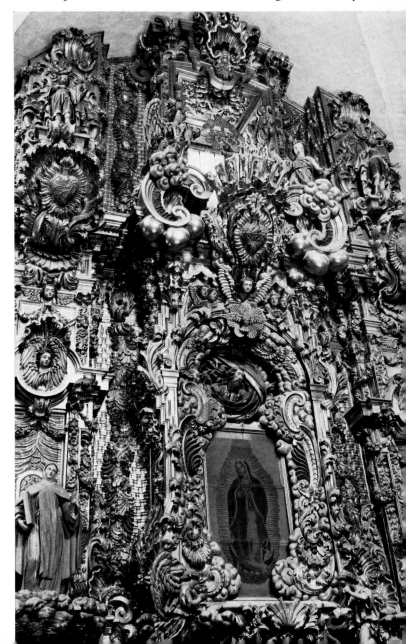

Return of the Manueline style

Stucco and wood are particularly well suited to the formal exuberance of Iberian baroque, which seems to be the product of a process of continuous creation. In the eighteenth century this proliferation of forms spread to stonework. The massed, tangled forms are often animated by a tumescence which recalls living tissue. Like those of the fifteenth-century Portuguese Manueline style, these forms constitute a reference to the crude products of nature.

166 Pedro and Miguel de Borja. Dome of sacristy, Santa Maria la Blanca, Seville, c. 1652–57

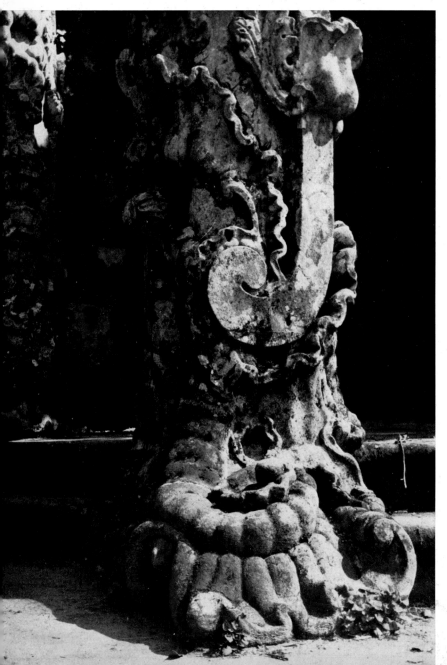

164 Detail of fountain, Bom Jesus do Monte, Braga, Portugal, eighteenth century

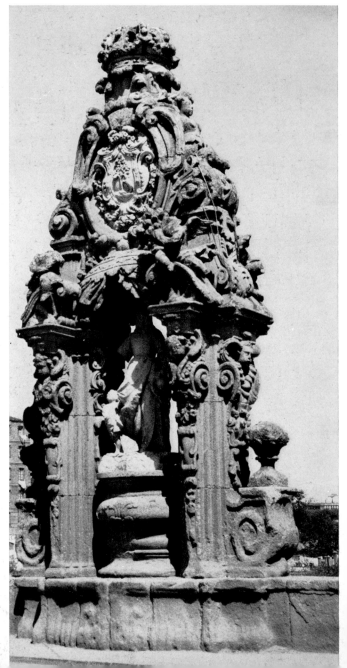

165 Oratory on Puente de Toledo, Madrid, eighteenth century

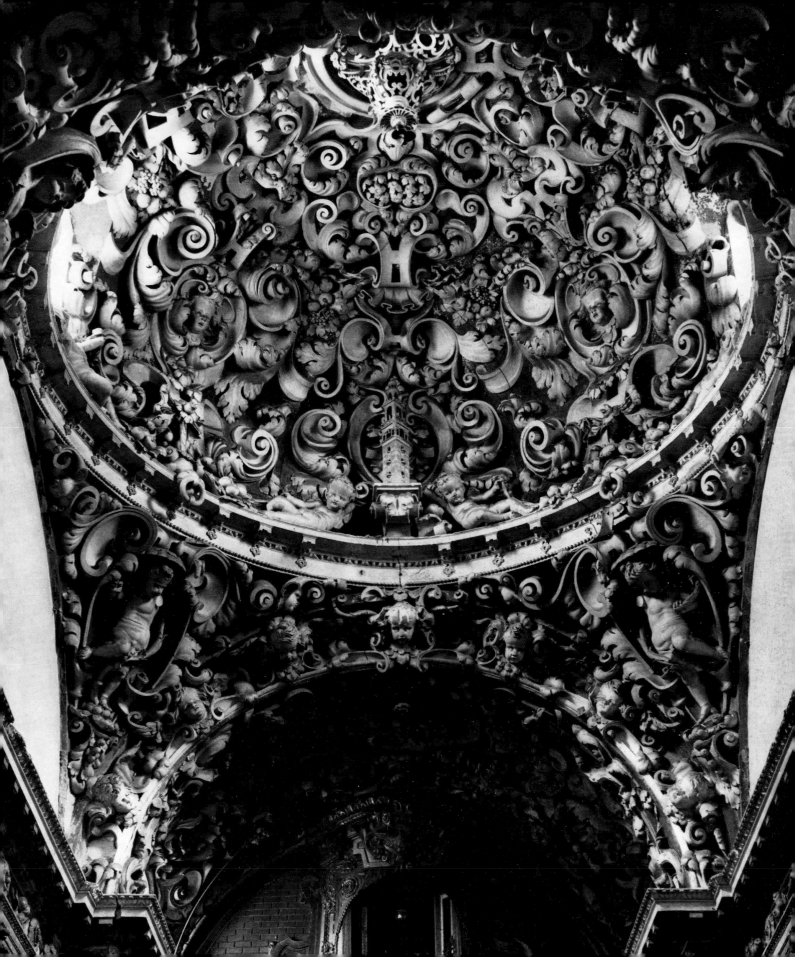

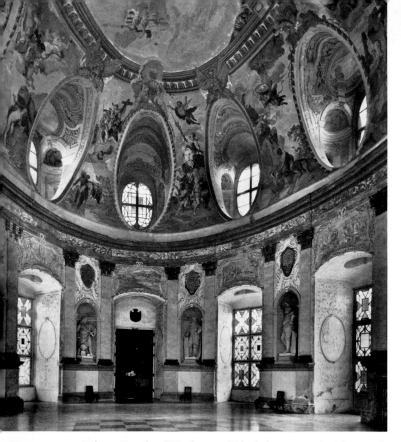

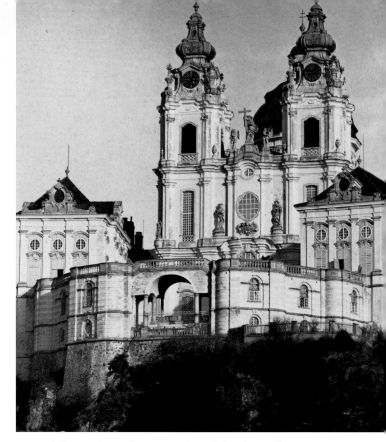

167 Johann Bernhard Fischer von Erlach (1656–1723). Ahnensaal, Schloss Frain (Vranov), Bohemia, 1690

168 Jakob Prandtauer (1660–1726). Stiftskirche, Melk, Austria, 1706–26

The baroque in Austria

It was from Vienna and Prague that the baroque spread over Central Europe. In pursuit of a policy of magnificence inspired by the victories of the Hapsburg monarchy over the Turks, Charles VI set out to endow Vienna with the splendour appropriate to the place of residence of the emperor. The first generation of baroque artists in Vienna, the Italians Antonio and Carlo Carnevale, Carlo Antonio Carlone, Andrea Pozzo and Donato Felice Allio, and the Austrians Johann Fischer von Erlach and Lucas von Hildebrandt, drew their inspiration directly from Italian baroque. The next generation, dominated by the genius of Prandtauer, freed the Viennese baroque style of some of its heaviness; this second-generation baroque is represented particularly in the numerous monasteries which were rebuilt in the early eighteenth century.

169–170 Johann Bernhard Fischer von Erlach (1656–1723). Karlskirche, Vienna, 1716–25 and Hofburg (Nationalbibliothek), Vienna, begun 1722

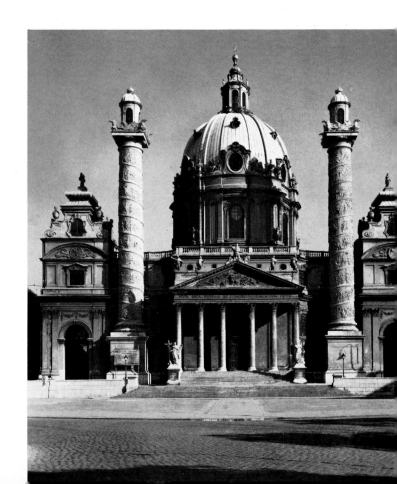

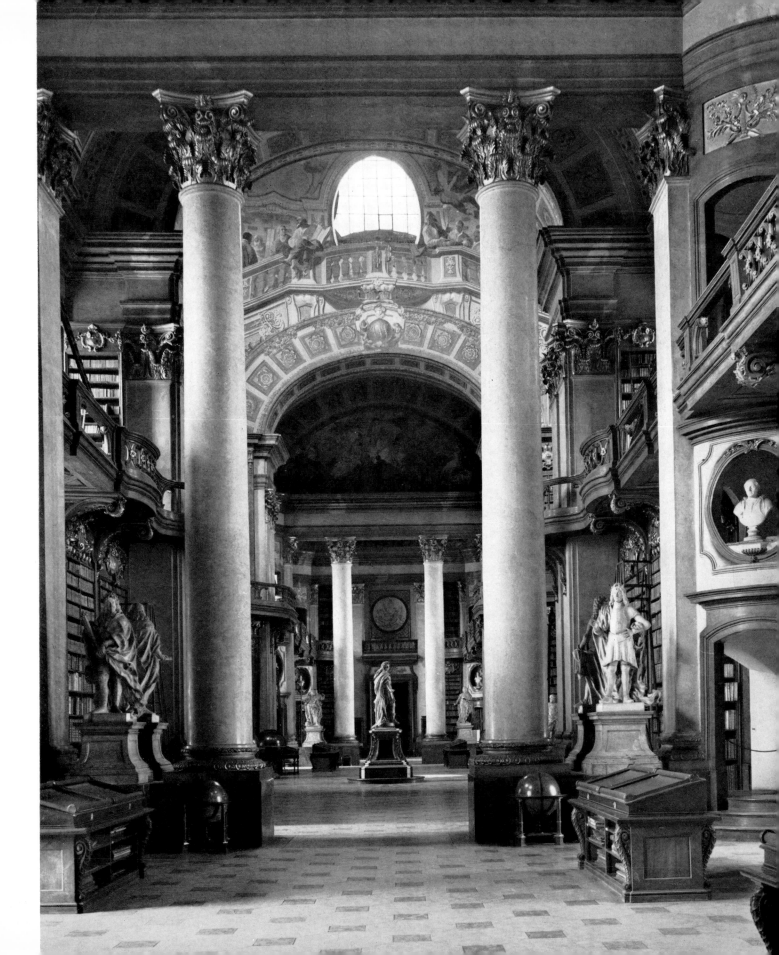

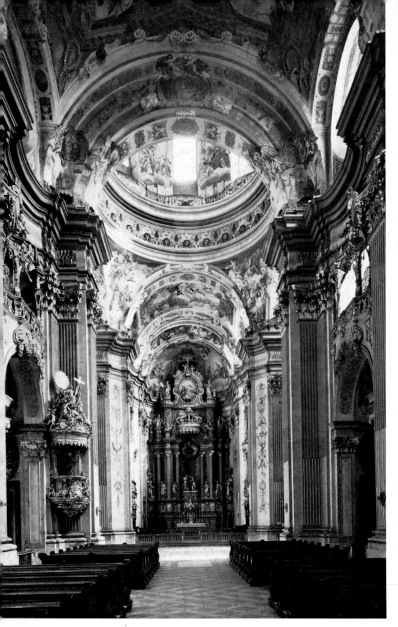

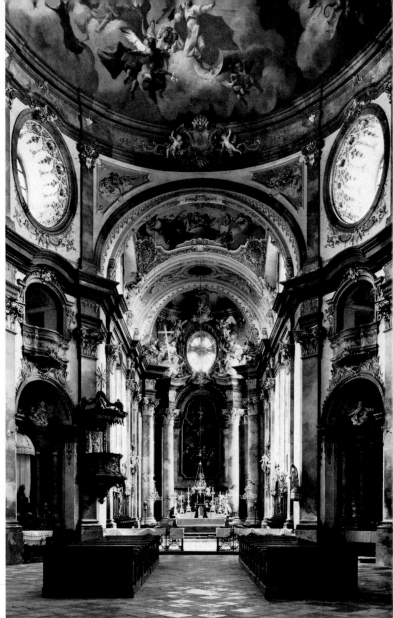

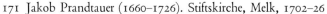

171 Jakob Prandtauer (1660–1726). Stiftskirche, Melk, 1702–26 172 Josef Munggenast (d. 1741). Stiftskirche, Altenburg, begun 1731

Towards elegance From seeking effects of magnificence, Austrian architects turned to a preoccupation with elegance. The Roman plan inspired by Il Gesù (Melk) gave way to subtler patterns based on the oval and the central plan (Altenburg). Unlike Southern Germany, however, Austria seldom turned to the rococo, at least in religious buildings.

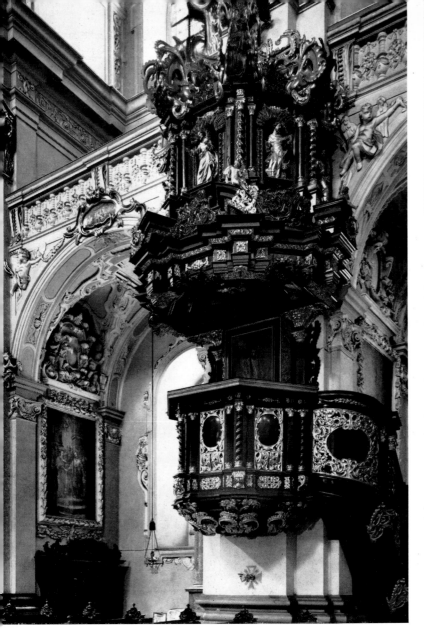

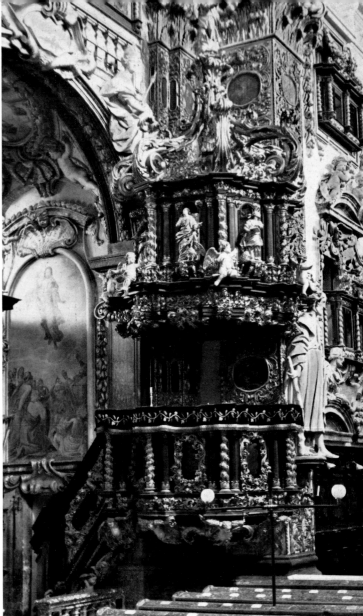

173 Pulpit, Altmünster, Linz, Austria, *c.* 1670 174 Pulpit, Stiftskirche, Schlierbach, Austria, 1690

Towards complexity

Twenty years separate these two pulpits, which share the same overall pattern; they exemplify the evolution of the baroque in the direction of increased complexity, as if in response to a fatal necessity inherent in the evolution of forms.

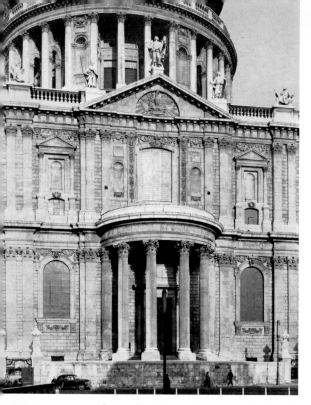

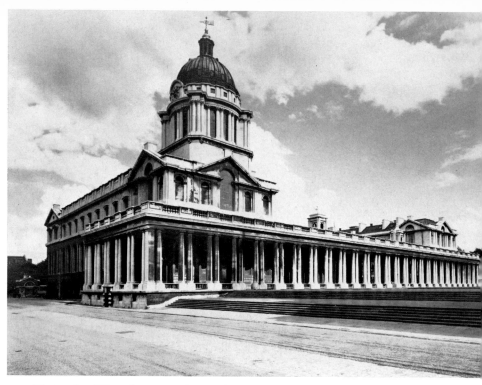

175 Christopher Wren (1632–1723). Façade of transept, St Paul's, London, 1675–1710

176 Christopher Wren (1623–1723). Royal Hospital (Royal Naval College), Greenwich, 1694

English baroque In the course of the seventeenth and eighteenth centuries, English architects followed simultaneously a number of contradictory paths before finally opting for neoclassicism. Wren, presented by the Great Fire of 1666 with the chance to lead in the remodelling of a whole

177 Inigo Jones (1573–1652). Double Cube Room, Wilton House, Wiltshire, 1649

178 Grinling Gibbons (1648–1720). Staircase from Cassiobury Park, Hertfordshire, 1677–80

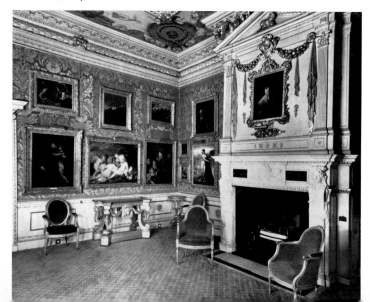

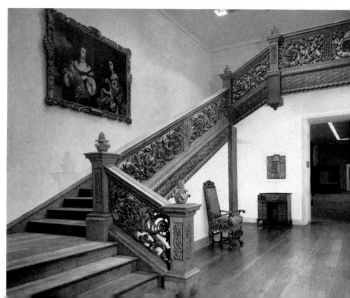

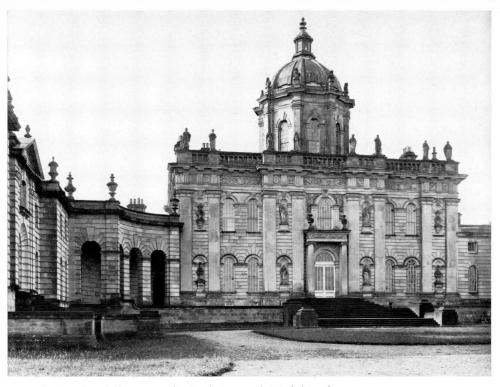

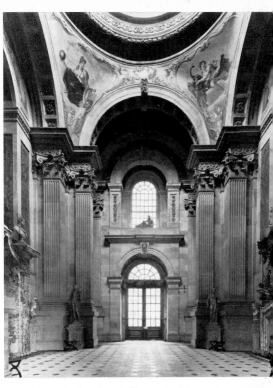

179 John Vanbrugh (1664–1726). Castle Howard, Yorkshire, begun 1699

180 John Vanbrugh. Hall, Castle Howard

city, played a role analogous to that of Bernini in Rome. At the beginning of the eighteenth century, under the influence of Vanbrugh and Hawksmoor, architects seemed about to follow in the footsteps of Bernini and Borromini; but the Palladian reaction was to be decisive.

181 Christopher Wren (1632–1723). St Mary-le-Bow, London, 1706

182 James Gibbs (1682–1745). St Martin-in-the-Fields, London, 1721–26

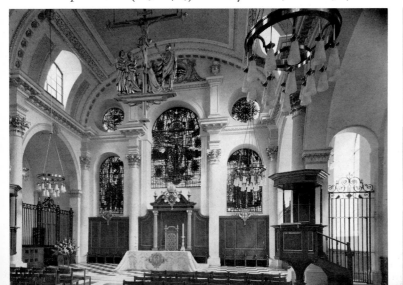

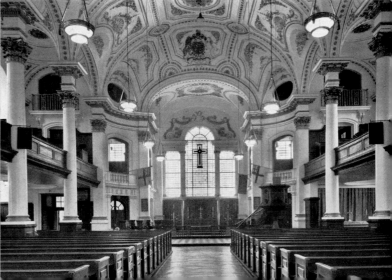

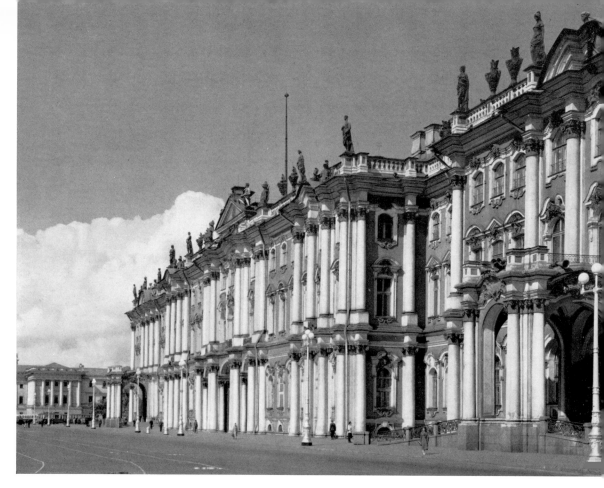

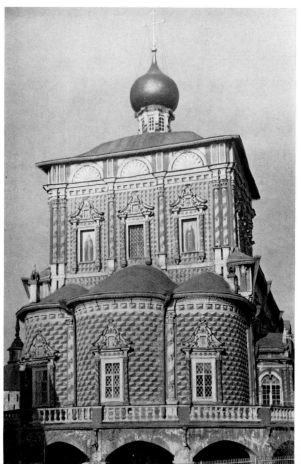

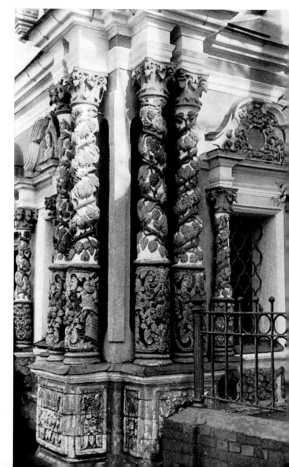

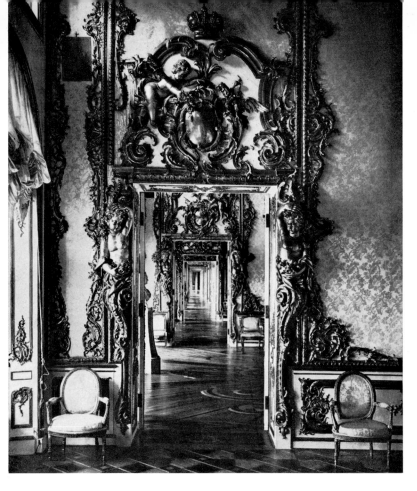

Slav baroque

The expansive force of the baroque carried it into Eastern Europe before the end of the seventeenth century. Baroque ornament, both interior and exterior, appeared in Russia about 1670. In Poland, a Catholic country, the infiltration had taken place even earlier, as can be seen from the mid-seventeenth-century Franciscan church at Krosno. It was after Peter the Great had opened Russia to Western European influences that the court of St Petersburg followed the other great courts of Europe in adopting a 'policy of building'.

183 Bartolommeo Rastrelli (*c.* 1700–1771). Winter Palace, St Petersburg (Leningrad), 1754–68

184 Doorways of state apartments, Tsarskoye Selo (Pushkin)

185 Monastery refectory, Zagorsk, near Moscow, 1686–92

186 Columns, Chapel of the Miraculous Fountain, Zagorsk, near Moscow, 1686–92

187 Dome, Franciscan church, Krosno, Poland, 1647–50

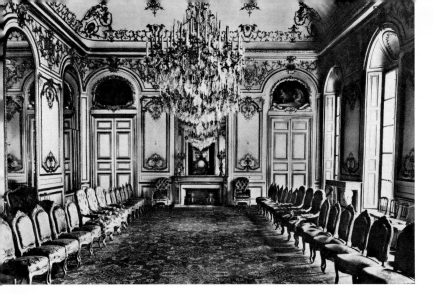

188 Grand Salon, Hôtel du Petit-Luxembourg, Paris 1710

The rococo style, characterized by the use of rocaille and the asymmetrical arrangement of ornament, is the result of a transformation which took place among the decorative artists who were active at the end of the reign of Louis XIV. This new fashion was applied to the woodwork of the great town houses that were built in Paris between about 1710 and 1720. About 1730 it spread from France through Germany, as is shown by a comparison between two very similar works, one by the Frenchman Boffrand and the other by a Walloon who had worked in Paris, François de Cuvilliés.

189 Germain Boffrand (1667–1754). Oval salon, Hôtel de Soubise, Paris, 1738–40

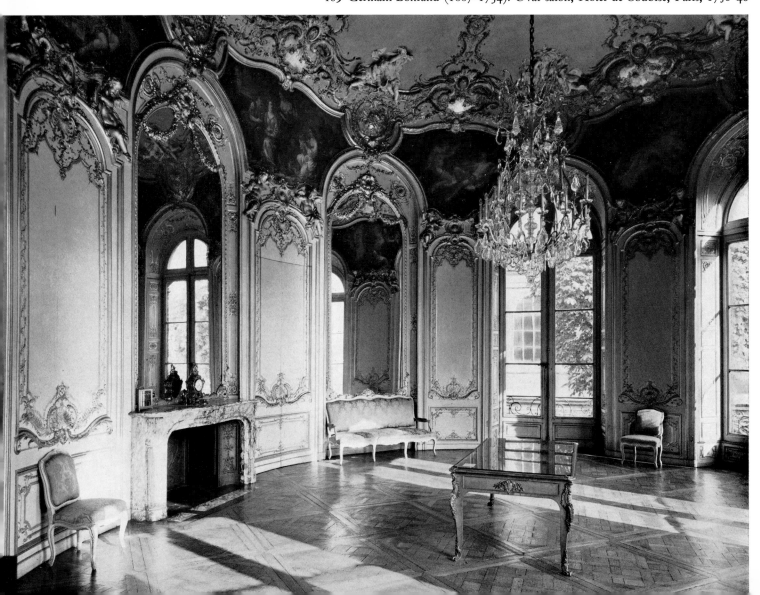

ROCOCO

The birth of rococo

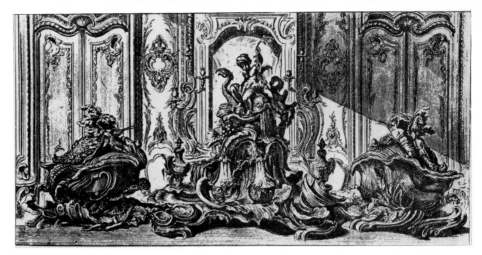

190 Juste-Aurèle Meissonier (c. 1693–1750). Design for centre-piece, Paris, 1734

191 François de Cuvilliés (1695–1768). Spiegelsaal, Amalienburg, Nymphenburg, Munich, 1734–39

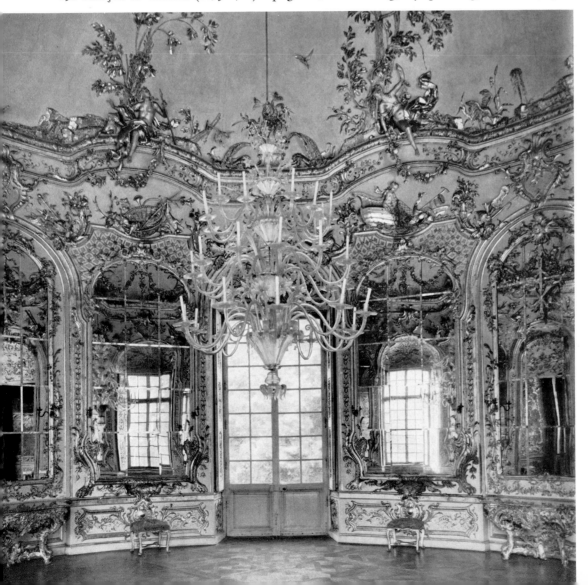

Barocchetto

Rococo, in the narrow sense of the word, never reached Italy. Although it had been anticipated by Borromini, Guarini and Serpotta, the Italian genius is hostile to its characteristic intricate, asymmetrical curves. The style practised in Italy in the eighteenth century is an elegant, fined-down baroque which art historians have christened *barocchetto*. Nevertheless, in painting, the fragmented style of the Venetian Guardi is in perfect conformity with the rococo spirit.

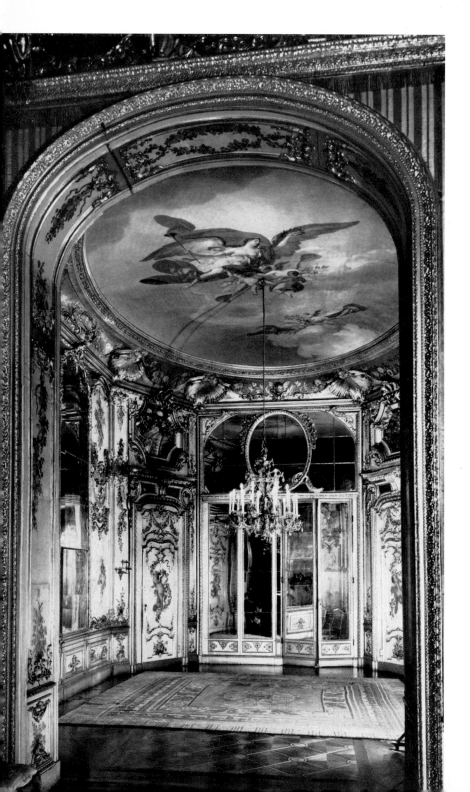

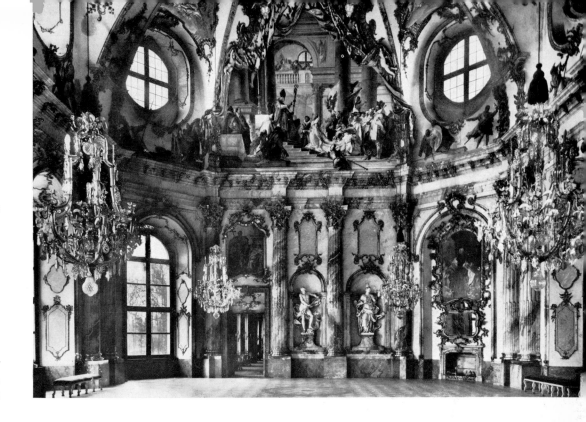

192 Alcove in breakfast room, Palazzo Reale, Turin, eighteenth century

193 Francesco de' Guardi (1712–93). Wedding of Tobiolo (detail)

194 Giacomo Serpotta (1656–1732). Humility, with *putti,* in San Lorenzo, Palermo, 1704

195 Lucas von Hildebrandt (1668–1745). Kaisersaal, Residenz, Würzburg, with frescoes by Tiepolo, 1752

196 Wolfgang van der Auvera (1708–56). Décor of Spiegelsaal, Residenz, Würzburg

The mirage

In Germany the profuse ornamentation of the rococo transformed residences and Catholic places of worship into fairy palaces. Often, in the rooms of princely dwellings, fantasy becomes mirage through the use of mirrors incorporated in the stucco and woodwork; by multiplying the images of people and things, these mirrors fragment and dissolve reality.

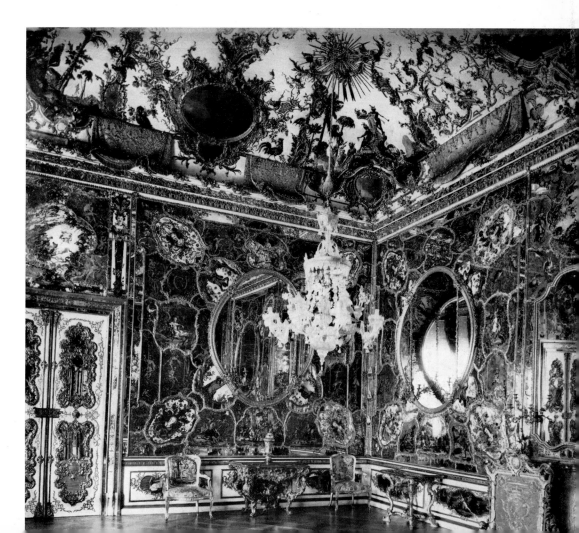

The symphonic style

The German rococo engenders an intimate fusion of all the arts: painting, sculpture, architecture—and theatre, for these rococo buildings are theatres built to be brought to life by the events staged within them. The competition between architecture and the other arts, which resolves itself into unity only at certain moments in history, culminates in the German rococo in a miraculous har-

197 Josef Munggenast (d. 1741). Décor, Prelatur, Altenburg, Austria

198 Johann Baptist Zimmermann (1680–1758) and Dominikus Zimmermann (1685–1766). Die Wies, Bavaria, 1754

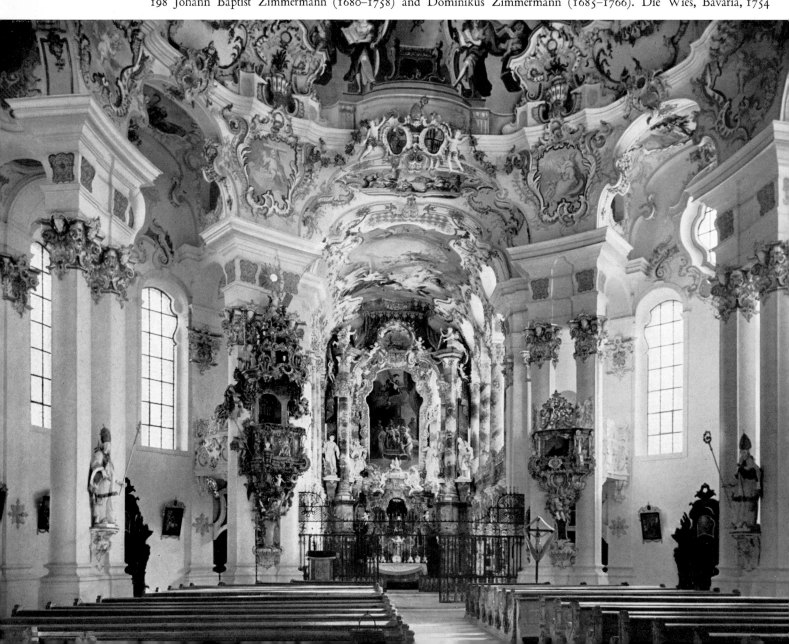

mony in which the ornamental irregularities, the mime and gesticulation, the infinitesimal subtleties of rococo organization unite in a fundamental unity through the convergence of the whole upon a harmonic centre. A comparison between décors of the seventeenth and eighteenth centuries shows how in the latter the ornament is translated into an almost musical harmony.

199 Ägid Quirin Asam (1692–1750). High altar, Rohr, Bavaria, 1717–23

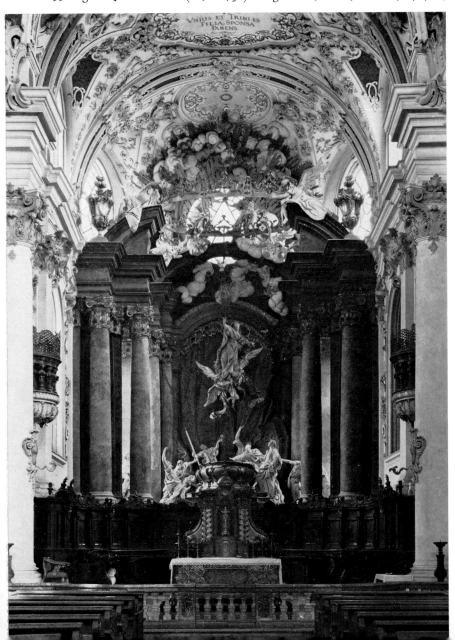

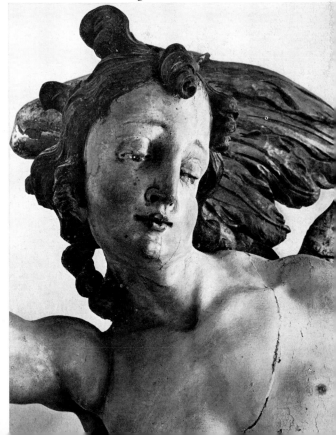

200 Johann Michael Feichtmayr II (c. 1709–72). Stucco, Zwiefalten, Bavaria

201 Joseph Anton Feuchtmayer (1696–1770). Head of angel from church of Frauenberg, Baden

Rococo in Portugal and Brazil

Spain remained almost totally impervious to the rococo, except in a few royal residences built under foreign influence; the eighteenth century witnessed the finest flowering of Spanish baroque. Portuguese art, on the other hand, which is closer to that of Germany than to any other in Europe, evolved early on (*c.* 1730) in the direction of the rococo, which reached Brazil thirty years later, just at the moment when Portugal was about to turn to neoclassicism. The most refined products of this rococo tradition are the work of a Brazilian artist of genius, Antonio Francisco Lisbõa, known as O Aleijadinho.

202 Cartouche with Virgin and Child, Nossa Senhora da Luz, Rio de Minhos, Borba, Portugal, 1714

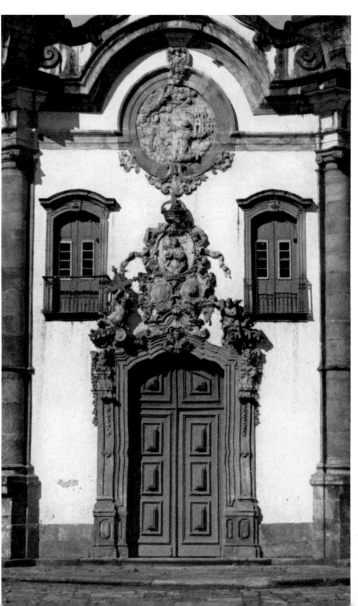

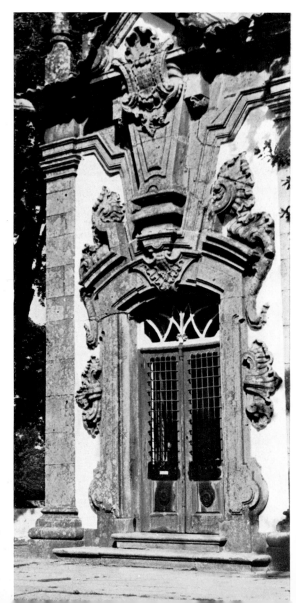

Rococo in England

England, land of paradox, witnessed the development of a rococo style of furniture and inner decoration at the very moment, around 1750, when architecture was dominated by the neoclassical reaction; it is not uncommon to find pure Palladian structures enclosing rococo interiors inspired, in their sinuous inflections, by Chinese art.

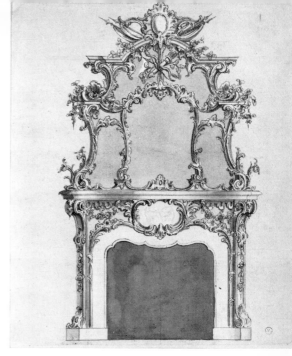

205 Thomas Chippendale (*c.* 1709–79). Design for fireplace, London, 1754

203 O Aleijadinho (1738–1814). Doorway, São Francisco de Assis, Ouro Preto, Brazil, 1766 and 1774

204 Doorway of chapel, Terrace of the Evangelists, Bom Jesus do Monte, Braga, Portugal, 1767

206 Stucco in North Hall, Claydon House, Buckinghamshire, *c.* 1775

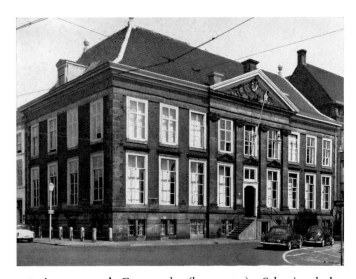

207 Inigo Jones (1573–1652). Queen's House, Greenwich, 1616–35

NEOCLASSICISM

Jones and Palladio

The neoclassical instinct was carried to English art by Inigo Jones: in the full flood of the baroque, he inspired a sober architectural style, using brick and stone in combination, which drew further inspiration from Dutch classicism (Van Campen). At the beginning of the eighteenth century, the revival of Palladianism was linked to the Whig party in politics. The effort to return to the rules produced a flood of theoretical treatises on architecture, unparalleled anywhere in Europe.

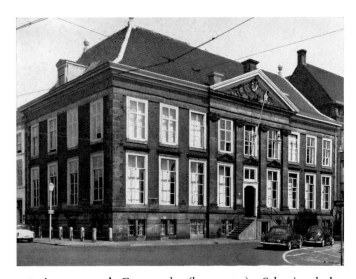

208 Arent van 's Gravesande (b. c. 1600). Sebastiansdoelen (Gemeentemuseum), The Hague, 1636

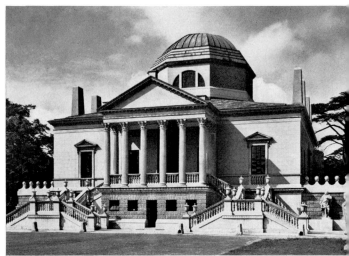

209 Richard, Earl of Burlington (1695–1753). Chiswick House, Middlesex, 1725

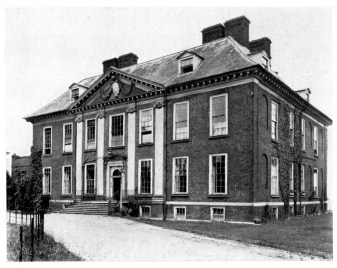

210 Hugh May (1622–84). Eltham Lodge, Kent, 1664

211 Colen Campbell (d. 1729). Mereworth Castle, Kent, 1723

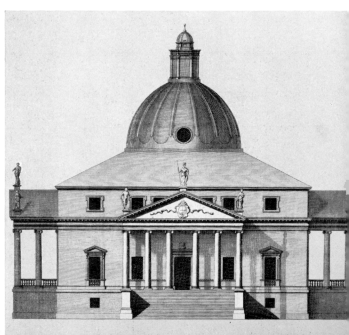

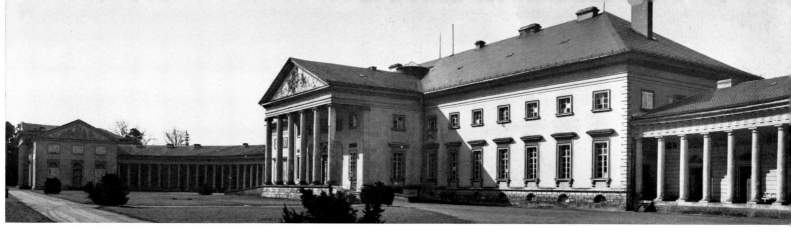

212 Christian Friedrich Schuricht (1753–1832). Kačina, near Prague, 1802

The spread of neoclassicism

Under the combined influences of English architectural theory and the reaction against the baroque aesthetic which took place in Italy (notably in the Veneto, where stand the masterpieces of Palladio), neoclassicism spread all over Europe and to the North American colonies, where it took on the function of a national style.

213 Thomas Jefferson (1743–1826). Capitol, Richmond, Virginia, begun 1785

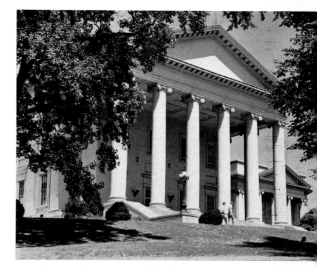

214 Filippo Juvarra (c. 1676–1736). Basilica di Superga, Turin, 1717–31

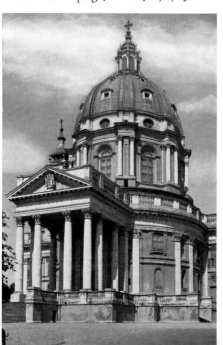

215 G. A. Scalfarotto (c. 1700–64). San Simeone Piccolo, Venice, 1738

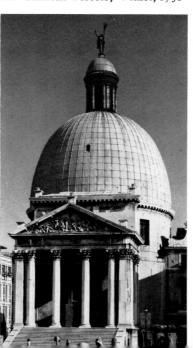

216 Jacques-Germain Soufflot (1713–80). Sainte-Geneviève (Panthéon), Paris, begun 1757

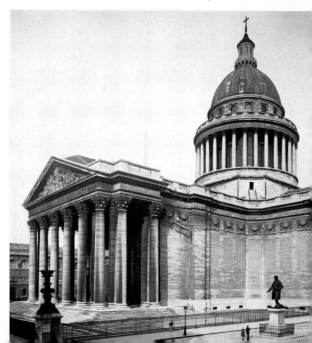

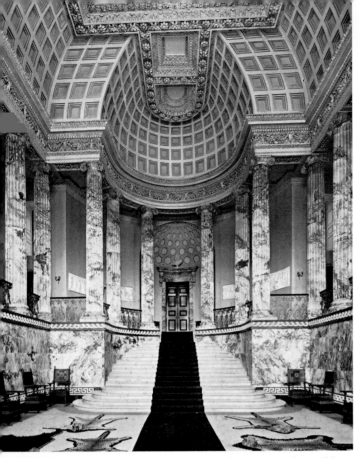

217 William Kent (c. 1685–1748). Great Hall, Holkham Hall, Norfolk, begun 1734

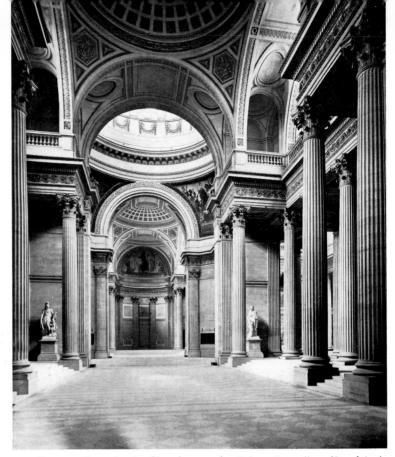

218 Jacques-Germain Soufflot (1713–80). Sainte-Geneviève (Panthéon), Paris, begun 1757

The orders return

Neoclassicism is founded on a return to the antique architectural system based on the horizontal architrave relieved by columns. The strict application of the canons of proportion inherent in the orders as defined by Vitruvius produces a certain monotony in the neoclassical buildings of Europe which contrasts with the national variety fostered by the baroque. In ornament, the sinuous line gave place to the straight line, and Graeco-Roman formulas replaced rocaille.

219 Domenico Merlini (1731–97). Rotunda, Lazienki, Warsaw, 1784–93

220 Filippo Juvarra (c. 1676–1736). Basilica di Superga, Turin, 1717–31

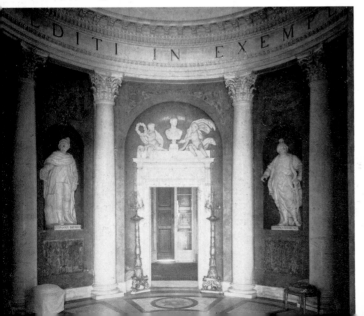

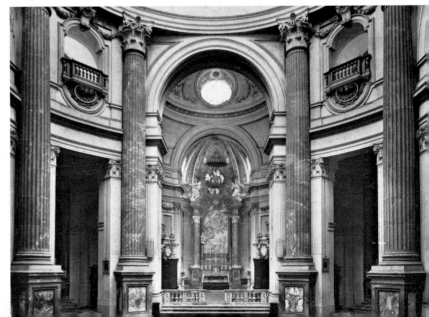

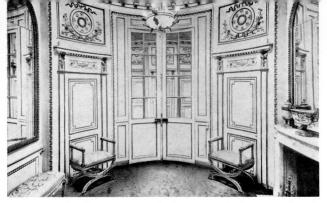

221 Round salon on ground floor, Hôtel de Fersen, Paris

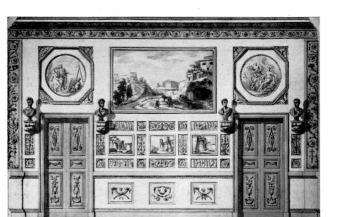

222 Charles-Louis Clérisseau (1722–1820). Project for a museum, St Petersburg, c. 1780

223 Peter Harrison (1716–75). Synagogue, Newport, Rhode Island, 1762–63

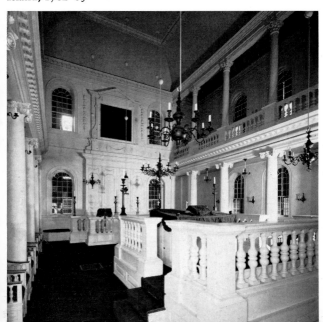

224 Carlo Marchionni (1702–86). Villa Albani, Rome, 1746–63

225 Jacques-Ange Gabriel (1698–1782). Hotel de la Marine, Place Louis-XV (Place de la Concorde), Paris, 1754

226 Carl Gotthard Langhans (1732–1808). Brandenburg Gate, Berlin, 1789–94

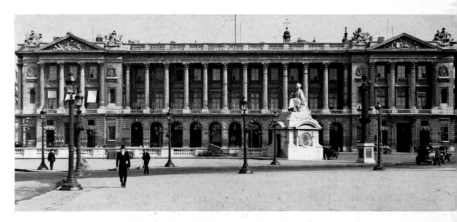

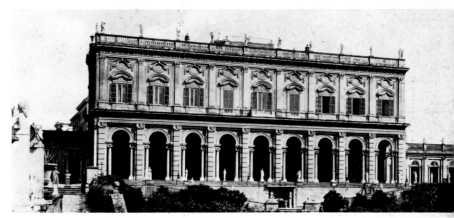

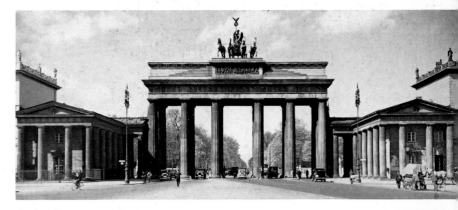

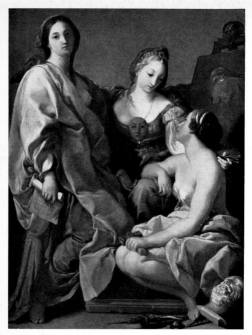

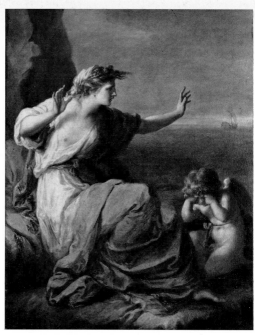

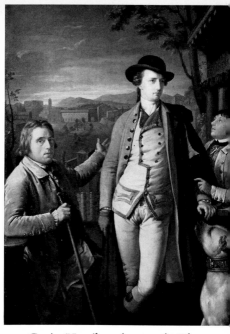

227 Pompeo Batoni (1708–87). Architecture, Sculpture and Painting

228 Angelika Kauffmann (1741–1807). Ariadne deserted by Bacchus

229 Gavin Hamilton (1723–98). The Eighth Duke of Hamilton

The neoclassical reaction in painting

The neoclassical style, essentially an invention of the architects and the decorators, took time to spread to painting. It was introduced by British and French painters, and soon spread all over Europe, stimulated by the discovery of the ancient paintings of Herculaneum. Rome, where the high priest of the movement, Winckelmann, lived, and where British, American, French and German artists were at work, was the birthplace of neoclassical painting.

230 Joseph Vien (1716–1809). Vendor of Loves

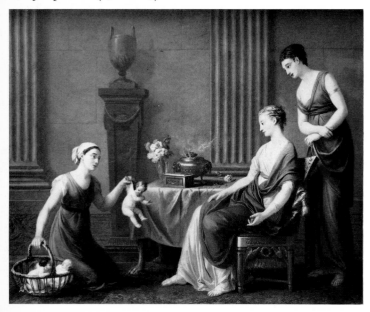

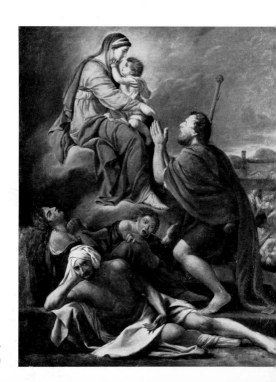

231 Jacques-Louis David (1748–1825). St Rock interceding with the Virgin Mary (detail)

III MODES

1 Romanticism

Baroque is not romanticism, but contains it. What, then, is romanticism? In the arts of expression it is, according to the best authors, a predominance of sensibility and imagination over reason. If this is all, romanticism might even be merely one variety of the eternal baroque, *Barocchus romanticus,* as Eugenio d'Ors termed it. For baroque and romantic art have certain symptoms in common: the restless longing for escape into the past (antiquity in the case of the baroque, the Middle Ages in the case of romanticism) and for escape to distant places (exoticism in all its forms). But romanticism is more than this; though it is often said that its nineteenth-century manifestation was an unrestrained outburst of individual feeling, it has perhaps not been sufficiently emphasized that this exalted state involved an alienation of the self from the human and natural world, the immensity of which was then becoming known. The individual, a prey to the *mal du siècle,* was conscious of his isolation in the midst of an indifferent universe. Conflict with society became the basis of a whole ethic, each man cut off from communication with his fellows; the consequences were nostalgia, pessimism, neurasthenia, *weltschmerz,* tearfulness, and a self-destructive impulse which for some romantics led to early death, suicide, or madness.

The wasting sickness, the vague yearnings, which Jean-Jacques Rousseau made fashionable, were not unknown to the men of the seventeenth century. Seventeenth-century attitudes to music illustrate this quite clearly; the plaintive lute became a favourite instrument in Italy and later in France. Its effects on the human psyche were thought to be so pernicious that preachers and moralists joined in condemning it. The Catholic moralist René François, for instance, declared that all on hearing it were 'bereft of their senses', and the Protestant Samuel Bernard said that those who were much given to playing the lute were no more than 'fantastical dreamers'. The lute was thought to have unfortunate effects on young ladies; according to Tallement des Réaux, Mlle de Champré was led astray at the age of thirteen by her lute instructor, and M. de Montbazon at the age of eighty allowed himself to become enamoured of a girl who could play the instrument well. Painting is full of representations of both male and female lute-players. The most striking picture is undoubtedly that in which Caravaggio shows a figure, about whose sex there is some dispute, accompanying himself (or herself) on the lute and singing a *canzona d'amore,* the words and music of which can be read from his or her manuscript book. It is the madrigal *Voi sapete ch'io vi amo,* composed by Archedelt in 1539. The accompanying still-life (apparently an allusion to the five senses), and the profound melancholy on the face of the musician, make the picture into a kind of *Vanitas.* A more touching example is the delightful

picture in Washington, once attributed to Caravaggio but now known to be the work of *pl. 232* Orazio Gentileschi, in which a girl, whose half-unlaced bodice suggests that she has dressed in haste, is playing a lute, which she cradles amorously against her cheek.

Melancholy casts its shadow over many faces in seventeenth-century painting; it is not inspired by love alone; it may have the nature of a philosophical meditation on the vanity of human knowledge. Such is *Melancholy* by Domenico Feti, who undoubtedly had in mind, as he painted it, the famous engraving by Dürer. A poignant sense of the transitoriness of life, a concern over man's ultimate end, have been expressed by every school of painting, but especially by the Dutch school in the genre of allegorical picture known as the *Vanitas* in which symbols of fragility, particularly flowers, are grouped around various emblems of the illusory goods of this world.

Alongside the artists who lived content and in accord with their time lived a different breed of men, who turned away from the prevailing harmony to plumb the depths of individual loneliness and anxiety. The first of these was Caravaggio, whose giant figures are surrounded by a heavy darkness which no ray of spiritual light will ever pierce. Maurizio Calvesi has related this pessimistic attitude to the heretical philosophy of Giordano Bruno, who was burnt by the Inquisition in Rome in 1600. The fierce controversies over the efficacy of Grace aroused anxieties over personal salvation; even the Christian who did not feel abandoned by God came to feel crushed by the sheer fact of his omnipotence; this is the anguish of which Blaise Pascal has become the symbol.

And yet there is a light to be seen in the darkness, the light of the candle that shines in Honthorst's *St Joseph the Carpenter* in Montecompatri (1617) or his *Christ before the High Priest* in the *pl. 233* National Gallery, London (1617); this wavering flame is the light of faith in the soul of the sinner. It illuminates the catacombs where the mystical figures of Georges de la Tour keep their vigil, gazing inward into the depths of the soul, and watching for a light so faint that it can only be perceived in utter darkness. In the paintings of Honthorst, a Dutch Catholic, the light is a spiritual radiance not of this world, whose source is the Divine (the two *Holy Families* in the Uffizi, 1620). It has been suggested that Honthorst derived the idea of light as a spiritual entity from his native northern traditions; but this is to forget the dazzling angel who sets free Raphael's *St Peter* in the Vatican, or the radiant child in Correggio's *Night,* or the amazing *Nativities* of Cambiaso. The same light belongs to Rembrandt.

Rembrandt's life might be the very pattern of the romantic artist, first pursuing pleasure, then turning to the other extreme of solitude and asceticism, openly at war with a bourgeois society incapable of understanding him. However, his optimistic conception of the world sets him apart from romanticism; it is derived from the very heart of Christian belief, from the Being who was both God and man and united in himself the perfection of the two natures. The more Rembrandt suffered, the more his heart overflowed with the evidences of Divine love; in the last years of his life, absolutely alone, having lost both his son and his faithful companion, he left his testament of love in works such as the *Jewish bride* in the Rijksmuseum or the *Return of the Prodigal* in the Hermitage. In these last two pictures it is the laying on of hands, a sacral

gesture, which expresses the total act of giving by which he who loves takes on himself the guardianship of the beloved. The fact that the tragedy of Rembrandt's life turned him towards love and not towards aggressiveness and negation caused him to be fundamentally opposed to romanticism; he was a man of very different temper—a mystic.

If true romanticism is not to be found in the work of an isolated mystic such as Rembrandt, where in seventeenth-century art does it exist? The answer lies in provincial Italy, where numerous artists practised a romanticism which, at least in its application to the externals of painting, was more romantic than the romantic movement itself.

There was in Italy a kind of official baroque whose headquarters was in Rome, founded on the essential optimism of a city bathed in the glory of the Church. In painting Guido Reni is undoubtedly the most perfect example of this pious hedonism, based on a firm distinction between what is due to the flesh and what is due to the spirit. This attitude did not find acceptance in the provinces, where the *angst* of Caravaggio was a truer expression of prevailing religious feeling. While the Eternal City was basking in its eternity, the cities of the provinces, all to a greater or lesser degree fallen from their political greatness—and almost all under foreign rule— seemed instinctively aware of the germs of decadence in an artistic civilization which (except in Venice) was then in its last moment of glory. In Naples, Genoa, Milan and Bologna, painters relished dramatic episodes, battle scenes, mournful orgies, scenes of massacre or execution, sordid backyard quarrels, miracles, portraits of cripples, mountebanks, prostitutes, bandits, tramps, convicts, pirates, or sorcerers, and scenes of necromancy. A reflection of the wars which ravaged Europe haunted Callot, and set a fashion for battle scenes. Aniello Falcone, Salvator Rosa in Naples, Micco Spadaro in Florence, and in Rome a Frenchman, Jacques Courtois, known as Il Borgognone, became famous as specialists in this genre. In Naples the Spaniard José Ribera, on the pretext of some hagiographic or mythological subject, took pleasure in

pl. 234 depicting tortures or murders, themes which Artemisia Gentileschi carried to an extreme of sadism. In the late seventeenth century and early eighteenth century an artist obsessed by death, by crime and by the burlesque combined in his work all these pessimistic tendencies. This was

pl. 244 Alessandro Magnasco, who painted monasteries only in order to introduce sensational scenes of monastic debauchery; when he depicts an artistic festivity in a garden, he makes it a circus. In Naples in the seventeenth century two Lorrainese artists, known under the one name of

pl. 241 Monsù Desiderio, escaped into a world of fantasy; anticipating surrealism, they painted an absurd antiquity, full of part-Gothic, part-Renaissance edifices shattered by bombs or earth-quakes. These bizarre and apocalyptic works reveal a subconscious obsession with death.

All the figures in these paintings act out their drama against a background of night, not the pure, crystalline blackness of Caravaggio, but a soot-black, sticky, suffocating darkness like the smoke of a fire.

Where these artists go beyond romanticism as such is in the freedom of their means of expression. They are completely unhampered in their exploration of the art of painting itself—and the seventeenth century was the great age of this art. They did not suffer from the sense of constraint which inhibited the nineteenth-century romantics, who had the misfortune to inherit the

aesthetics, the beliefs and the technique of neoclassicism. At the dawn of romanticism, in a period whose beginnings come within the field of our study, certain artists such as Fuseli and *pl. 242* William Blake were in the paradoxical position of having to express their deepest emotions through an art formed on a study of antique statues. This inhibition prevented the development of romantic painting in the most romantic country of all, Germany. Only French painters— Géricault, Delacroix and Daumier—and English painters—Turner, Bonington, Constable— succeeded in reconciling their methods with their aspirations.

Perhaps the greatest technical virtuosi of seventeenth-century Italian painting were the Venetians, members of an artistic school whose existence has only recently become widely known. Vincenzo Maffei, from Vicenza, achieved nuances of colour worthy of Velázquez. Venice fostered the revolutionary instincts of Sebastiano Mazzoni, a Florentine exiled for his libertarian views, whose hallucinatory intensity anticipates that of Goya (*Portrait of a captain of halberdiers,* *pl. 236* Museo Civico, Padua). Venice had so deep a love affair with Caravaggian gloom that the joyous Tiepolo had as it were to cleanse the murky palette of his predecessor Piazzetta.

One feature of romanticism is a reaction against the aristocratic spirit, a tendency to seek rejuvenation in a plunge into the world of the common people. The Carracci at the end of the sixteenth century had introduced popular subjects to restore corporeal vigour to the puppet figures of mannerism. Caravaggio combined this motive with an instinctive revolt against authority. This tendency spread throughout Europe, but did not really take hold in Italy until the eighteenth century, in painters for whom debauchery and misery seemed to be the human ideal—the Neapolitans Giuseppe Bonito and Gaspare Traversi and the Lombard Giacomo *pl. 240* Ceruti. Their vulgar approach even came to affect mythological and historical subjects. Bernardo Strozzi made his *Three Fates* into ignoble toothless hags, Velázquez ridiculed the gods (as in his *pl. 235* *Mars*), and Ribera, Salvator Rosa and Luca Giordano turned the august philosophers of antiquity into bohemians in patched cloaks. Tormented by doubts, mankind mocks what it reveres the most.

Venice in the eighteenth century concluded the history of baroque art and Italian painting with a grand apotheosis; but not far away, one artist raised a protest against the prevailing hedonism. Vittore Ghislandi, known as Fra Galgario (he was a monk), observing the aristocracy *pl. 239* of his day as they posed for him, saw in these representatives of a declining civilization the marks of their approaching death. Goya was one day to do the same; but his early works belong to the agreeable art of the eighteenth century; his romantic protest was a reaction to his first contact with the rotten court of Ferdinand IV and his lustful queen, ruled by the favourite Godoy. But at this point we leave the baroque age and enter modern times.

Spain, being mystical, was never romantic. Valdes Leal alone might appear to be so, with his love of battles and scenes of violence. But his pictures in La Caridad in Seville could not be *pl. 155* called romantic; the same quality of macabre realism is present in Bernini's tombs of Urban VIII and Alexander VII, and is an essential part of the language of religious baroque.

A presentiment of the Apocalypse, a sense of living in an absurd universe, a world of madmen, haunted the sick mind of the eighteenth-century Prince Palagonia, who peopled his villa at

pl. 245, fig. 22 Bagheria, near Palermo, with monsters, midgets, dwarfs and hybrid or misshapen creatures, represented today by the line of grotesque statues on the top of the surrounding wall.

It was a strange circumstance that German artists, who in the nineteenth century never succeeded in breaking out of the iron grip of neoclassicism, were perfectly at ease in a romantic setting in the eighteenth century, enjoying all the freedom of method permitted by the baroque. All the eighteenth-century schools of painting in the German-speaking world derive from the spatial discoveries of the Italians, notably the Venetians; the Teutonic genius often added murky, sulphurous colours and a liking for the bizarre. The figures sometimes have an indefinable air of slightly raffish romanticism, even of buffoonery; the most picturesque examples are the odd,

PL. XXI loutish creatures painted by the Austrian Maulbertsch, who seems to owe more to Magnasco than to Tiepolo.

It is in keeping with the very nature of baroque art that artists affected romanticism as a picturesque burlesque amusement. An instinctive awareness of the tragedy which threatened civilization encountered a block on the threshold of consciousness; the repressed emotional insight was deflected into fantasy and manifested itself as a game, a pose. Baroque romanticism is not the romanticism of 1830 simply because in the nineteenth century the tragedy had entered the realm of consciousness.

The 'baroque romantics' were so little conscious of their romanticism that one of the most genuinely romantic of all, Salvator Rosa, sought to justify his art with theories which a classicist would not have disowned. Rosa was once a very famous painter, especially in Great Britain; his landscapes often served as inspiration for the English gardens of the eighteenth century. Today he is thought of as a minor figure, but it was he who introduced into Italian art the form of landscape which was then called 'picturesque' and which corresponds closely to the romantic feeling for nature expressed at the beginning of the sixteenth century by Roelant Savery. Steep and hostile coasts, deep gorges, savage defiles where lofty crags dwarf the wayfarer: Rosa's

pl. 243 landscapes are lit by a dramatic light, and often serve as a meeting-place for bandits or witches or as a background to the meditations of a hermit.

This genre appealed so much to the first romantic painters that in order to account for it they endowed Salvator Rosa with a complete, dramatic and largely imaginary life-story. The first elements of this they found in the work of Bernardo De Dominici, the writer of a collection of lives of the Neapolitan painters which appeared in 1742; and the subsequent accretions of legend culminated in the romanticized monograph of Lady Morgan (London 1824). The story goes that, having escaped from a monastery, the young man wrote erotic poetry, followed a band of brigands into Apulia and Calabria, and became a wandering player and composer. In 1647 he hastened to Naples to take part in Mas' Aniello's insurrection against the Spanish Viceroy. He ended his days in somewhat bourgeois domestic bliss. It is strange to see a modern writer, Ottilie G. Boetkes, in a book published in 1960, still giving credit to these fables which Ozzola had already utterly discredited as early as 1908.

The real facts are less picturesque but quite as symptomatic. Salvator Rosa seems to have been acutely aware of the predicament in which a man of genius may find himself, cut off from

XXI Franz Anton Maulbertsch (1724–96). Holy Family with St Anne, St Elizabeth, St John and St Joachim ▶

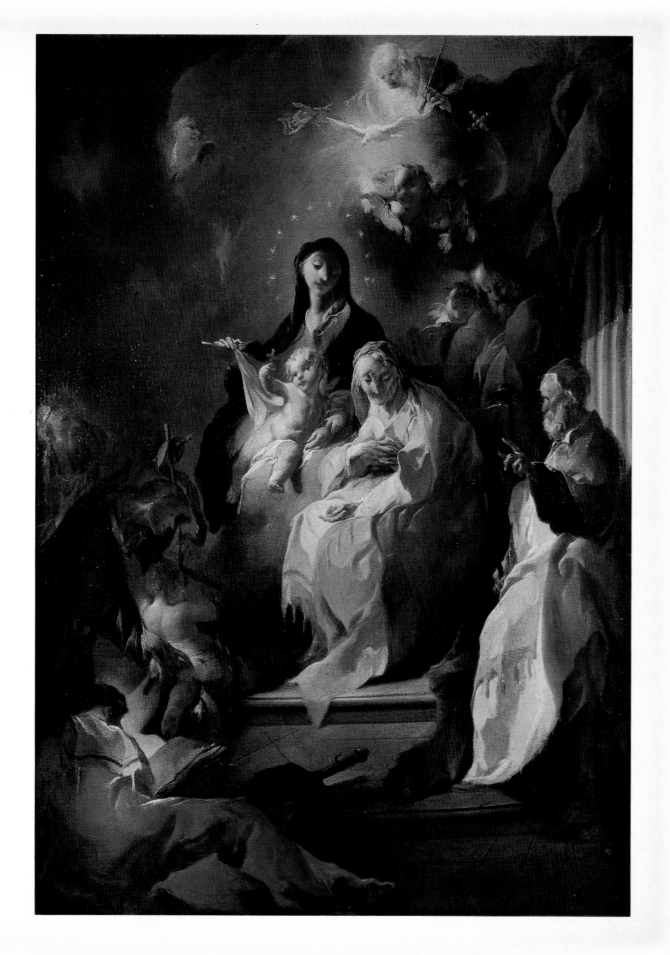

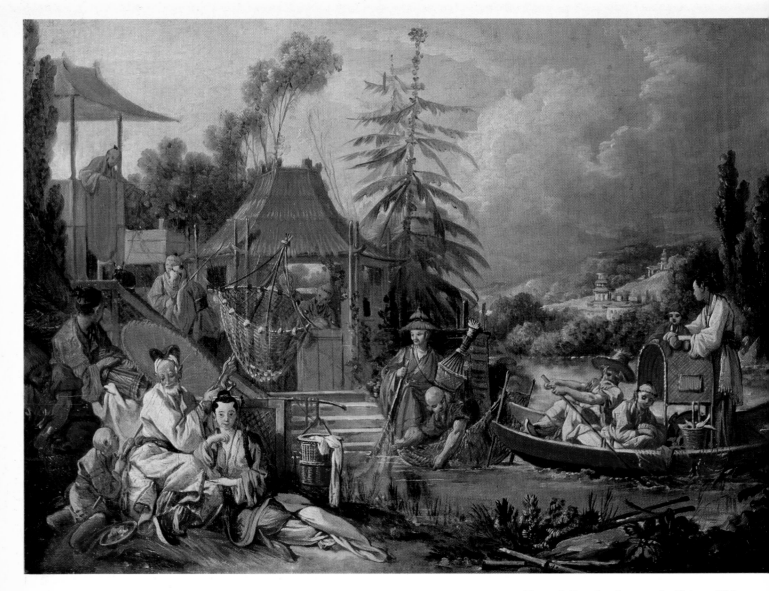

XXII François Boucher (1703–70). Chinese fishing scer

XXIII Porcelain room, Château de Rambouillet, Fran

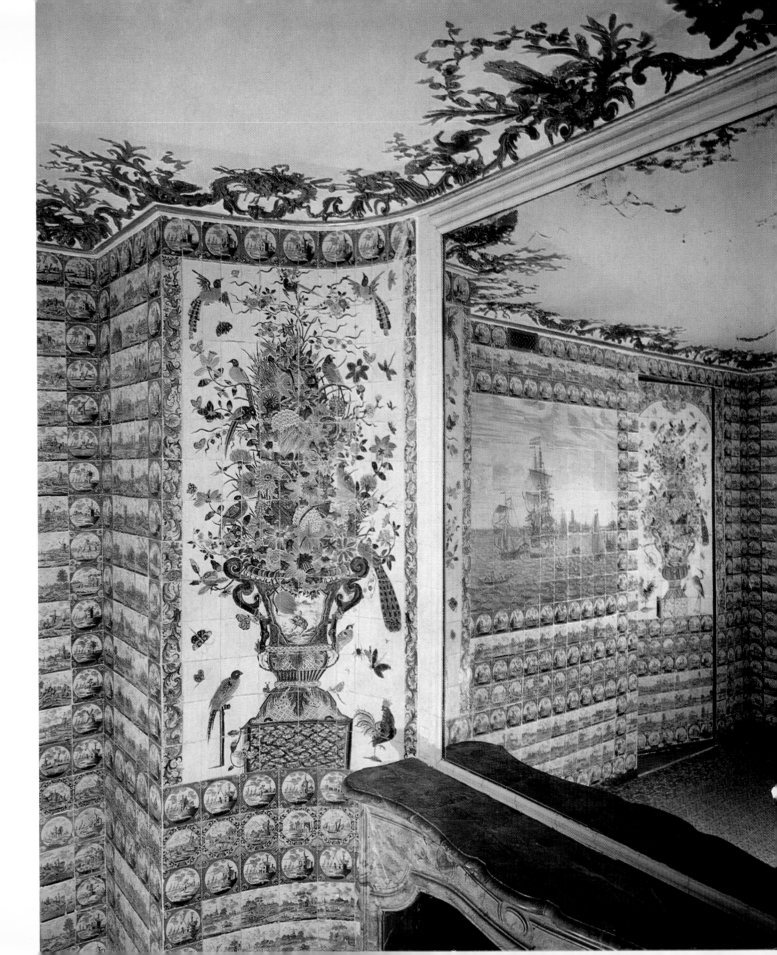

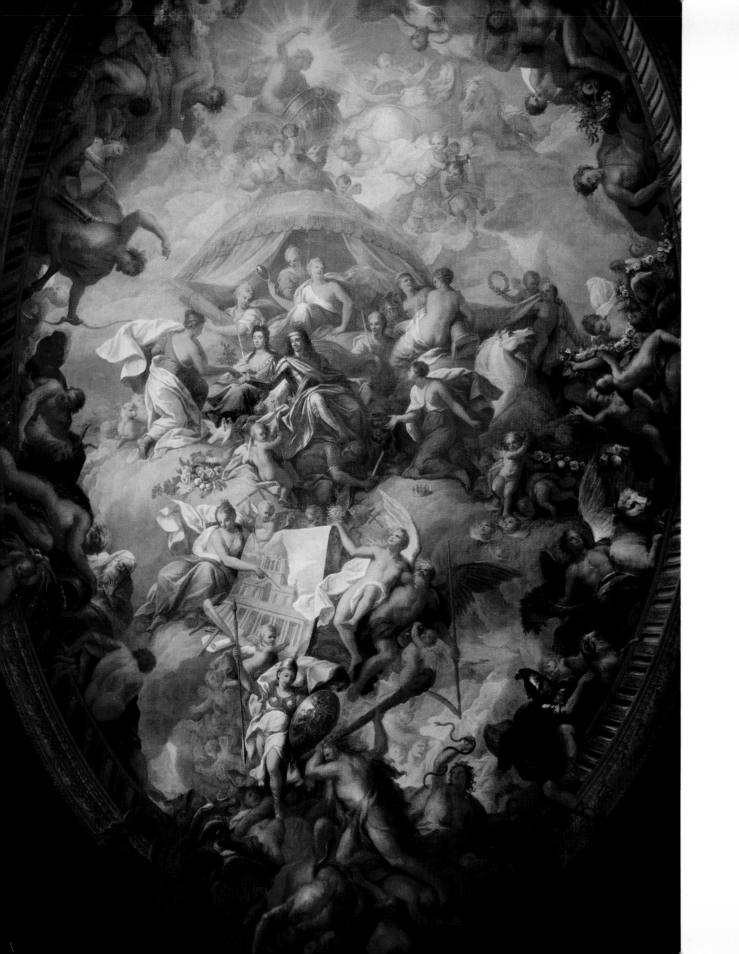

society and opposed to its precepts. All his life he adopted an attitude of fierce hostility towards a social milieu in which the artist was generally fêted. He satirized the Pope, the clergy and the aristocracy, and when (in 1641) he accepted the patronage of the grand duke of Tuscany, he was unable to retain it for more than a few years. This ardent Neapolitan returned to Rome where he again took up a free life, painting from his own inspiration without commissions, and maintaining the same attitude of revolt against authority.

This story contrasts with the princely lives led by Bernini, Lanfranco, Guido Reni and Rubens, the calm and laborious existence of Claude and the steady business career of Le Vau. And yet Guido Reni, having quit Rome for Bologna, was to end his days in the Bohemia of the gaming den and the bawdy house. Ruined by gambling, he worked as drudge for an obscure painter who tyrannized him. As for Poussin, the court of the king of France was even more unbearable to him than that of Tuscany to Salvator Rosa. Poussin lived in Rome like a hermit surrounded by a very few friends. He too avoided having to paint on commission as much as possible. It seems as if some of the greatest painters, in this century when artists became the intimates of princes, actually felt the need to isolate themselves in order to express their own feelings more profoundly. Rembrandt renounced wealth and success, his own collection of works of art and his luxurious town house. He rejected the society which flattered him in order to meditate in solitude upon the mysteries of the human soul. A clause in Saskia's will had prevented him from remarrying, and because he lived with Hendrickje Stoffels unmarried he was ostracized by the Calvinist church session. He died in a state of total isolation, having lost both Hendrickje and his son Titus. Another artist who at the beginning of the century had set a precedent for this isolation was Caravaggio, first of the doomed artists. He embraced his destiny voluntarily, sinking into the abyss at the time when his own genius was opening up the path of certain fame.

◀ XXIV James Thornhill (1675–1734). Painted Hall, Royal Hospital (Royal Naval College), Greenwich

2 Exoticism

One cannot discuss exoticism in the art of the seventeenth and eighteenth centuries without raising a host of questions to which I can only allude in this study.

Two currents of ideas brought exoticism into favour; an immense curiosity about the world, which led men to study the 'singularities' of non-European countries, and a love of fantasy, which found satisfaction in the aura of magic attached to distant lands.

It must be admitted that the objective study of foreign countries, though it gave rise to innumerable books and book-illustrations, inspired almost nothing in the field of the major arts. The scientific mission which John Maurice of Nassau took on his expedition to Brazil in 1636–44 included two painters, Albert van der Eeckhout and Frans Post, to record the ethnography, folklore, fauna and flora of the country. Though the paintings of Van der Eeckhout, preserved in the National Museum of Copenhagen, are little more than anthropological documents, those of Post—now dispersed throughout the world—have a charm which was appreciated by his contemporaries; on his return from Brazil he developed them into a highly successful genre which has been rediscovered in our own day. The items in this pictorial record were given away or sold to several European princes. The most important collection, presented by John Maurice to Louis XIV, inspired a series of Gobelin tapestries known as the *Tenture des Indes,* which was in such demand all over Europe that it went into production on three separate occasions. It was first set up in low warp in 1687, and woven in high warp from the same cartoons from 1692 onwards; the cartoons became so worn that François Desportes had to renew them in 1737. All over Europe the pattern of the *Tenture des Indes* retained its popularity throughout the eighteenth century. A painted imitation of it by Johann Bergl (1763) is to be found in the Gartenpavillon (summerhouse) built by the clerics of the opulent abbey of Melk in Austria in 1747–8.

The influence of China upon eighteenth-century European art is well known, but less consideration has been given to that of Turkey, which was the earlier of the two. The Turks, who had proved formidable adversaries of Western European civilization both by land and sea, inevitably excited curiosity. The victory of Lepanto (1571) and the raising of the siege of Vienna (1683) contributed to the spreading of the motif of the chained slave, first used by Michelangelo on the tomb of Julius II. In the seventeenth century it appeared on the bases of royal statues, symbolizing both the powers of evil and the vanquished enemy, and sometimes fashioned in the likeness of a Turk. In the seventeenth century the Colonna family, one of

pl. 249

pl. 246

whose ancestors commanded the Papal forces at Lepanto (where he was second-in-command to Don John of Austria), ordered for the hall of their palace some extraordinary baroque console tables, supported by Atlantean figures of Turkish galley slaves. The later victories of the Austrian *pl. 248* empire over the Ottomans also left their mark on the arts; one of the most curious examples is the Turkish prisoner, paired with a Magyar, who forms one of the corners of the colossal 'bed *pl. 247* of Prince Eugene' in the imperial apartments in the monastery of Sankt Florian. Claude Ballin, a silversmith of the reign of Louis XIV, used it as a support for silver tables and gueridons, of which a record has been preserved by drawings in the Tessin collection in Stockholm. Venetian craftsmen sculpted many turbaned 'Moorish' slaves in wood, gilded and painted, but these were Negroes.

In the early seventeenth century exoticism in art was comparatively rare, appearing most notably in the magnificent portraits of Negroes painted by Rubens, Rembrandt and others. It is surprising that the produce of the Indies, then pouring into the ports of Holland, did not arouse more interest among Dutch painters; though Rembrandt copied Persian miniatures, he sought his exoticism principally in Judaism. An early example of *chinoiserie*, all the more unusual since it appears in architecture, is the spire composed of three Chinese dragons with *pl. 256* coiled tails which surmounts the Royal Exchange in Copenhagen, designed by King Christian IV himself.

Exoticism appeared in the minor arts before it seriously affected the major arts or the theatre; it originated in imitations of the various *objets d'art* which came into Europe in great numbers from China and Japan in the seventeenth and eighteenth centuries. Canton was the great port from which silks and other textiles, porcelain, Coromandel lacquerware, dolls, curios, 'magots', bronzes, printed wallpapers and paintings on glass were shipped to the West. Chinese fabrics were such a success in France that vain attempts were made in 1709, 1714, 1717, and 1721 to ban their importation by edict. There are still a few houses in Europe decorated with fragile Chinese wallpapers, such as the charming pavilion at Svindersvik, near Stockholm, built by a director of the Swedish East India Company. The importation of works of art, together with that of spices, was among the most profitable enterprises of the various East India Companies which multiplied in Europe after the founding of the Amsterdam Company in 1602. The greatest craze was for Chinese and Japanese porcelain, particularly for large vases, which were often given sumptuous mounts of golded bronze, or arranged in a room of their own with a rich setting of panelling; one of the finest of these, damaged in the Second World War, was that of the Schloss in Dresden, installed beneath a sixteenth-century painted ceiling. Often the reception rooms of royal residences were decorated with Chinese work set into rococo panelling; and many of these still survive in Germany and Austria. The palace of Schönbrunn in Vienna has several lacquer rooms, a porcelain room, and a room in which seventeenth-century Indo-Persian miniatures are set into the woodwork. Lacquer was also imported in the form of immense screens, or used to decorate furniture; but it is rare to *pl. 303* find genuine Chinese lacquerwork mounted on furniture. The technique was very soon imitated by European craftsmen.

Chinese porcelain had been imported (at first by Portugal) since the beginning of the sixteenth century, when the Chinese began to decorate pieces specially for the Western market. Not until the second half of the seventeenth century was the Chinese decorative style imitated by the faience manufacturers of Nevers, Rouen, and Saint-Cloud; the two last succeeded, by methods incorporating the use of soft paste, in coming very close to the marvellous substance worked by the Chinese since the T'ang dynasty. But it was chiefly the potters of Holland (the most famous of whom were those of Delft) who about the year 1700 produced the finest ceramic wall decorations, sometimes showing Persian influence or using the French *lambrequin* style introduced by Daniel Marot, either in blue monochrome or in several colours.

For many years it seemed as if the secret of the manufacture of porcelain itself would remain hidden from Europeans, as it had been for centuries. Finally in 1709 a student apothecary, Böttger, who had been working on the problem for Augustus the Strong of Saxony for some years, discovered that by using a very fine clay called kaolin he could reproduce the Chinese and Japanese porcelain ware of which his master was a keen collector. A factory was set up *pl. 262* at Meissen, near the royal castle of Albrechtsburg, in 1710, and its products were at first copies of Chinese patterns. Although Böttger was kept in the closest seclusion, a whole web of intrigue was soon afoot to steal the secret from Saxony, and it was not long before it was discovered. From this developed a European porcelain industry, which soon invented its own decorative patterns, but never entirely abandoned Chinese motifs; one of the factories which most imitated *pls 265, 259* the Chinese style was that of Chelsea in England. Sometimes whole rooms were covered with facings of porcelain adorned with Chinese figures in relief, derived more from Western theatrical conventions than from Chinese art as such. In 1737 the king of Naples, Charles VII of Bourbon, brother-in-law of the Elector of Saxony, established a porcelain works at Capodimonte which he commissioned to produce a porcelain room for his villa at Portici (the porcelain is *pl. 261* now in the Museo di Capodimonte in Naples). This factory was so dear to him that he took it with him to Buen Retiro, near Madrid, when he became king of Spain as Charles III. But he could not take his Portici room with him, and so he had another made by the same artists for the castle of Aranjuez (1759–63) and immediately afterwards another for the castle of Madrid.

By the early seventeenth century numerous Chinese lacquer boxes, caskets and screens were entering Europe. After 1660 attempts were made in France to imitate this material, produced in China by means of a special resin since the Han dynasty. Under Louis XIV the Gobelins *pl. 267* had a workshop making 'varnish in the Chinese fashion', and the brothers Martin, who achieved the best imitation with the varnish bearing their name, founded in 1748 the 'Manu-facture royale de Vernis façon de Chine'.

The open-patterned Chinese style, with its serpentine curves often following uneven rhythms, was admirably suited for combining with rocaille; the style itself had some influence on furniture, appearing in France as *Louis XV chinois,* and in England in certain forms used by Chippendale, *pl. 266* especially in mirrors. Chinese sinuosity undoubtedly contributed to the rise of rococo, as can *pl. 263* be seen in the ornamentation of panelling. Decoration *à la chinoise* also appeared on silverware, particularly, of course, tea services. It is less usual to find traces of it in architecture, except in the

design of gardens. However, it was from China that Portuguese architects borrowed that elegant upward curve at the corners of a roof which is characteristic of the reign of John V, and certain of the forms of their altarpieces. Borromini, on top of Sant' Ivo, Rome, imitates a Chinese pagoda.

In painting, and in the tapestry that derived from it, innumerable Turkish and Chinese motifs appear from Watteau to the rise of neoclassicism. In literature and the theatre, as in painting, China and the Islamic world were thought of as lands of enchantment, complete Utopias, allowing absolute liberty to the artist's imagination. Themes popular in *galant* painting included the harem and pastorals *à la chinoise;* these were most used by Lancret, Boucher, Huet, *PL. XXII* Fragonard, and Amédée van Loo. For the masquerades in vogue in the eighteenth century the Orient was of course an inexhaustible store of disguises, and women often had their portraits painted in their Oriental costumes. The Swiss painter Liotard (1702–89) lived for some years in Constantinople, and considered becoming a Muslim and taking a Turkish wife, but contented himself with adopting Turkish dress and growing a beard. Thus accoutred, he returned to Europe calling himself 'the Turkish painter', and had great success in Vienna and Paris with his pastel portraits, in which he often portrays the beauties of the day as ladies of the harem. *pl. 252*

The Oriental was also a source of inspiration in tapestry, used either fancifully as in the charming products of the Soho workshops in England, or more literally, as at Beauvais. One of the most famous series was *Turkish Costume,* in four pieces after Amédée van Loo, purporting *pl. 251* to show the life of the Sultan's harem—a scene more evocative of light opera than of the Bosphorus. It should be added that Biblical imagery was greatly enriched by Turkish elements, and the famous *Story of Esther* (after de Troy, seven pieces, 1737), apart from a few soldiers in something approaching Roman dress, appears to be taking place in a seraglio.

Chinese influence was decisive in transforming the English garden, between 1720 and 1730, from the regular French design of Le Nostre into a landscape garden using, or rather recreating, the irregularities of nature. William Temple, in his *Essay on the Gardens of Epicurus and the Art of Gardens* in the year 1685, introduced the barbarous word *sharawaggi* as a name for the Chinese gardens he described. The first gardens in this style were not, however, created until nearly forty years later. Imitation of Chinese forms involved such an abundance of serpentine curves that *pl. 257* their layout often looked something like a diagram of the human intestines. The Europeans made one essential error in adopting this style; the gardens of the Celestial Ones were made to be seen, not to be walked in.

This type of picturesque and philosophical garden quickly spread throughout Europe, for in that age there was almost instantaneous communication of all modes of thought and feeling. France, which once had some of the most famous of these gardens, possesses now (apart from the pastoral 'hamlet' of the Trianon at Versailles) only a few poor vestiges of them; one of the finest Chinese pavilions, built of rare wood, situated in the 'wilderness' in the gardens of Retz near Paris, is in the last stages of decay; a characteristic example of the vandalism of a Department of Historic Monuments which seems passionately hostile to all that is baroque. Fortunately the governments of Central and Northern Europe take better care of their baroque treasures.

pl. 268　　The strangest of all Chinese pavilions is the one in the park of Sanssouci near Berlin, built in 1763–4 for Frederick the Great. Under its palm-shaped portico, a whole population of life-size statues is engaged in consuming Chinese food and drinking tea. The imagination is a trifle oppressed by this superabundance of realism. Such evocations of things Chinese were sometimes combined with 'Moorish' elements; among the most original examples are the Turkish tent in

pls 253–4　　the park of Drottningholm near Stockholm, and the great mosque of Schwetzingen, a curious mixture of Gothic, Grecian and Turkish elements designed for the Elector Palatine by the French architect Nicolas de Pigage and built in 1778–95.

　　The Orient contributed a new repertory of forms to the 'grotesque' style, which had been abandoned after the decline of mannerism and revived at the end of the reign of Louis XIV by

pl. 250　　Claude Audran (1658–1734), lending warmth to the stiff decorative style of Le Brun. His pupils developed his style and added the ·Oriental influence: 'grotesque' was enriched by 'arabesque'. Exotic animals such as bears, lions, camels and monkeys (popular for their agility in the eighteenth century), plumed American Indians and sultans and sultanas all disport themselves alongside the severe gods and goddesses of antique mythology. All the themes of the baroque imagination, all the fantasies with which the men of the baroque age loved to enchant themselves, are brought together in these grotesques, an art in which artists had enjoyed freedom of invention since the fifteenth century. Prints, tapestries, painted decoration, even the tortoiseshell and brass inlays invented for furniture by André-Charles Boulle (*c.* 1642–1732) fostered these exquisite fantasies, with their delicate evocations of legend, mythology and fable.

　　Less subject to the tyranny of realism than the major arts, the minor arts were particularly well suited to reflect visions of the Orient. One of the strangest objects ever inspired by exoticism is the group begun in 1701 by Johann Melchior Dinglinger, jeweller to Augustus the Strong, representing 'the great Mogul Aurengzeb receiving gifts from notables on his birthday'. After methodical research into accounts by travellers and ambassadors, Dinglinger fashioned, on a base three feet square, a group of 169 figures in enamelled gold, lavishly studded with precious stones, diamonds and rubies. In his letter of presentation to Augustus the Strong dated 11 October 1711 he recalls that His Majesty, not content with imagining the splendours of the Orient, had wished to contemplate them with his own eyes. The Western vision of the East is here transposed into the medium of gold and precious stones. As he handled this royal plaything, Augustus must have thought himself another Aurengzeb.

3 Art Nouveau

The Renaissance had embarked on a dangerous course. To shake off Gothic naturalism, which had degenerated into formalism, the humanist artists of fifteenth-century Florence saw no way but to resort to another formula, that of the antique. While they were still obliged, by a slow investigation of exhumed texts and buried monuments, to re-create a vocabulary of forms, their exploration of the past was the equivalent of original discovery, acting as a stimulus to the creative instinct. But there was a danger that the instinct might become paralysed once the vocabulary was established. The antique heritage weighed heavily on the artistic imagination, and this led to the crisis of mannerism.

Nothing was fundamentally more alien to the baroque spirit than the classical system of rules, orders and modules, imposing clear-cut articulations where the artist instinctively seeks the indefinite transitions required for the expression of movement. At the end of the nineteenth century, a few artists, exasperated by what the French novelist J. K. Huysmans called 'bits and bobs of Roman and Greek', attempted a direct use of natural forms, transposed as such into *objets d'art,* furniture or even works of architecture; this was the short-lived international movement known in England as 'Art Nouveau', in France as *Modern' Style,* in Germany as *Jugendstil,* and in Italy as *Stile Liberty* or *Stile floreale.*

So rich is the baroque age in all the potentialities of Western civilization that it contains in itself premonitions of Art Nouveau. Early symptoms of it can be found in Italian mannerism, and principally in the work of goldsmiths and silversmiths. Without entirely rejecting formal articulation and segmented composition, these Florentine artists made use of the sinuosity of scrollwork, imparting to it an almost organic form. Jewellers went further when they used a crude form provided by nature, a baroque pearl, a nautilus or an ostrich egg, and set it in a tangled network of delicate tracery. The taste for deformity that appears in their work cannot be explained solely as a kind of repressed satanism, as has been suggested; it also springs from a desperate need for freedom of form. German artists went further in this direction than any other, making mannerism more mannered. A silver ewer by Wenzel Jamnitzer—on which a *pl. 268* chimaera and an eagle astride a snail (as large as himself) form the setting for a seashell—would have greatly appealed to the craftsmen of 1900. The fantastic distortions that Dietterlin imposes on the classical orders are his way of transgressing and violating them, by kneading, fragmenting and smothering in a dense growth of ornaments the accursed modules which he longs to destroy. In France in the early sixteenth century, Bernard Palissy created dishes laden with

flowers and swarming with lizards, frogs, snakes, crabs and seashells which were so much to the taste of the nineteenth-century *belle époque* that it turned out endless copies of them.

In this field, the most remarkable similarity to Art Nouveau appears in the work of Dutch goldsmiths and silversmiths in the first thirty years of the seventeenth century; here the inflation of form peculiar to the baroque masks the articulations and accentuates the similarity to the late nineteenth-century 'style of Nancy'. The direct link between these Dutch goldsmiths and German mannerism is provided by Paulus van Vianen (*c.* 1575–1613), the first of a famous line. He had actually worked at the court of Rudolph II in Prague, the last great centre of European mannerism, which attracted artists from many countries who later helped to establish a durable anti-classical tendency throughout Northern Europe. Paulus van Vianen, who also worked in Vienna and Italy, invented a whole series of viscous forms inspired by the convolutions of the German *Ohrmuschelstil,* the 'auricular style' in which alternating protuberances and *pl. 272, fig. 1* hollows give the impression of a bubbling liquid. Paulus' younger brother Adam (d. 1629) carried his brother's style to Holland, exaggerating it and adorning it with figures carved in the round. One of Adam's sons, Christian van Vianen, worked in the same style at the court of Charles I; in 1637 he renewed the gold plate of the Chapel Royal at Windsor, which was to be melted down again during the Civil War, and he also worked for Charles II after the Restoration. The Vianen style was carried throughout Europe by a collection of engravings published by Christian based on his own designs and those of his father.

An Amsterdam goldsmith, Janus Lutma, carried the Vianen style to its extreme; his swirling forms carry the resemblance between mannerism and Art Nouveau almost to the point of identity. The existence of this style in Holland is all the more surprising since at the same period Dutch architecture, under the influence of Hendrick de Keyser, was breaking away from mannerism; as early as 1630 Pieter Post and Van Campen were elaborating a pure classical style. Here is a perfect instance of the tension between contradictory elements that so enriches seventeenth-century European culture.

The affinity between this one tradition of baroque silverwork and the work of Art Nouveau craftsmen is not fortuitous; both styles have a special affinity with the goldsmith's and silversmith's art. At the end of the nineteenth century, it was the goldsmiths, far in advance of the sculptors and other decorative artists, who grasped the possibilities of natural forms, after Viollet-le-Duc and other theoreticians had called for their use to rescue the decorative arts from the abysmal decadence revealed by the great exhibitions of 1851 and 1855. Like the Gothic sculptors before them, the decorative artists of the late nineteenth century looked to the vegetable kingdom for the fountain of youth. The prosperity of the Second Empire in Paris had encouraged the development of work in precious metals. As early as 1855 Eugène Fontenay made a tiara in the shape of a wild bramble; in 1860 he turned his attention to the animal kingdom and made a succession of jade insects: a grasshopper, a beetle, a scarab. In the same year Oscar Massin made a tiara of flowers and ears of corn and oats; in 1878 Massin produced a three-dimensional tea-rose made up of diamonds totalling 150 carats. It was purchased for thirty thousand gold francs by Mme Boucicault, wife of the founder of the first large department store in Paris, the

Bon Marché. Plant forms, and their natural concomitants, the insects, amphibians and small reptiles, which had formed a direct link between the mannerist goldsmiths and the seventeenth-century flower painters, returned in the nineteenth century to adorn the arms, the throats, and the hair of ladies of fashion.

It is understandable that goldsmiths and jewellers were the first to turn to natural forms for inspiration both in the seventeenth and in the nineteenth centuries. The tyranny of architecture, which had dominated all other arts in the Gothic age, had extended to the goldsmith's craft, finally imposing monumental proportions on small portable objects utterly unsuited for them. The Renaissance had continued on the same path, changing only the formal vocabulary; the mannerists were the first to break the spell, seeking liberty in sinuous animal or vegetable forms which their imagination transformed into creations of fantasy.

Sometimes the frenetic baroque style used in the 'applied arts' arose from a feeling on the artists' part that they were incapable of assimilating the Graeco-Roman style which was *de rigueur* in architecture. This is the explanation for the baroque pulpits and confessionals of *pl. 276* Belgium, those extraordinary mountains of rocks, trees, palms, draperies and rioting figures.

Seventeenth-century Italy on the other hand, produced very little that recalls the forms of Art Nouveau; an exception is the work of certain late mannerist sculptors of Florence, such as Pietro Tacca, with his extraordinary fountains after the style of Buontalenti; Callot imitated them in some of his drawings. As for the baroque of Rome, its whole importance lies in the fact that it constitutes a new approach to the art of antiquity, curbing the aimless licence of mannerism. Bernini not only applied the Greek and Roman modules himself but commended them to his colleagues; though he sometimes gave reign to his fancy in free creations which could be said to bear some resemblance to Art Nouveau, such as the fountain of the Piazza Navona, Rome (1648–51). Its piled-up rocks, river gods, palm trees and animals were imitated elsewhere in Europe in the following century (for example at Córdoba). Borromini, for his *pl. 274*

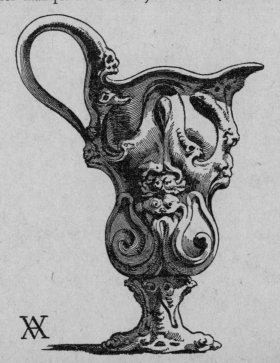

1 Adam van Vianen (*c.* 1569–1627). Design for ewer

223

part, often bends the rules to suit himself, but never ignores them. Guarini is more faithful still to the classical vocabulary, and thinks in terms of central plans in which he makes frequent use of secants, straight or curved.

The Art Nouveau mannerism of the Dutch goldsmiths and silversmiths was a spent force by 1670, when a classical tendency became apparent in the design of the more elaborate forms of silverware intended for formal occasions; silver for everyday use had remained simple all along. Dutch silver work was to take another baroque turn in the eighteenth century; but this time the style was to be rococo rather than mannerist. The mannerist tradition survived only in *pl. 269* England, where Nicolas Spirmont, Paul de Lamerie and Charles Kandler modelled exuberant silver objects laden with flowers, crustaceans, dolphins and other animals, *putti,* bunches of grapes, all mingled, as in the heyday of mannerism, with pagan gods and fantastic figures borrowed from the formal repertoire of 'grotesque' decoration. One of the most astonishing *pl. 271* examples of this inflated style is a wine-cooler made by Kandler in 1734 to a design by Georges Vertue, incorporating figures sculpted by Michael Rysbrack. This piece was eventually bought by Catherine the Great of Russia. By contrast with contemporary French rocaille work, the formal rhythm is lost in an accumulation of realistic forms directly transposed on to the object.

The decorative exuberance of Italian furniture design never entirely obliterates the basic ornamental structures, scroll, cartouche and rocaille, except in the work of certain Genoese and Venetian artists who abandon structural patterns entirely and make furniture out of accumulations of figures and naturalistic elements.

One of these was the famous craftsman Andrea Brustolon, who, about the year 1690, made for the palace of Pietro Venier in Venice forty extraordinary pieces of furniture on which a bacchanalian host of Atlanteans, satyrs, Negroes, allegorical figures, dragons, and naked human beings cling to bare trunks on which, strangely, roses blossom or palm trees grow; the orgasmic female bodies are the counterparts of those with which Art Nouveau sculptures, *objets d'art* and window cornices are so richly endowed.

pl. 280 A recent historian of Spanish baroque art, George Kubler, says rightly that the *Transparente* in Toledo Cathedral 'anticipates by six generations the characteristic forms of the Art Nouveau of 1900, as they appear in the inventions of Antoni Gaudí'. In this strange structure, which astounded and exhilarated contemporary observers, decorative and representational forms melt into each other; marble reverts to a fluid state, and the cornice descends to expire on the ground in soft undulations, dissolving like the nudes in Man Ray photographs. The columns framing the side of the monument which abuts on the back of the altar are enveloped in what looks like a sheath of bark or parchment, torn in places to reveal the classical fluting beneath. A work such as this, the *nec plus ultra* of Spanish baroque, is the antithesis of the rococo spirit as it is manifested in Bavaria or Swabia, or even in neighbouring Portugal. The rococo artist allows forms to proliferate, only to bring them together about a harmonic centre where they are resolved into one. The clamorous anarchy of the *Transparente* is a protest against rules and rhythms; it expresses an aspiration towards a metaphysical architecture achieved by a return to the elementary forms of matter, a world in which modules and orders are unknown and forms are linked by

free association. It is the most audacious architectural realization of the ideas of Wendel Dietterlin.

Andalusia in the eighteenth century witnessed the flowering of a pompous, almost Victorian, baroque style which can be seen at its most astonishing in the choir stalls and pulpits of the cathedral at Córdoba. In the Casa de Dos Aguas in Valencia, the sculptor Ignacio Vergara *pl. 281* made the most of his opportunity to adorn the gateway with a carved representation of the name of the noble owner (Marqués de Dos Aguas, 'Marquess of Two Waters') which might have been designed in 1900.

The spirit of Art Nouveau would have been very out of place in eighteenth-century France. Even the goldsmiths succumbed seldom and reluctantly to its charms. For a few years, however, there did exist in Paris just one example of this exuberant return to the forms of nature. By virtue of its very function, this particular exception proves the rule: nature was its *raison d'être*. A vigorous and vital nobleman, who was to die at forty-two, ruined by debauchery and natural science, Joseph Bonnier de la Mosson, had set up in his Paris house a 'cabinet' or museum of *pl. 273* mechanics, astronomy, pharmacy, physics, chemistry and natural history. This beautifully arranged collection became the wonder and the envy of all Europe; visitors, whom Bonnier took pleasure in receiving in person, crowded to see it. He housed his collection in magnificent showcases which we know only from drawings by Courtonne. Framed by carved serpents, the glass fronts of the zoology cases were surmounted by the heads of animals, carved in wood and surmounted by genuine horns. The shelves of the mechanics display were supported by palms.

The Art Nouveau spirit which had made its appearance among German goldsmiths of the sixteenth century returned to life in the art of eighteenth-century Germany. Curiously, its home *pl. 278* was not in Swabia or Bavaria, where the sophisticated art of the rococo was developing, but in the peripheral, more 'barbarous' regions such as Saxony. Here Permoser carved the monstrous Atlantean figures, in the Zwinger in Dresden, which so appealed to the artists of 1900 that they imitated them; this had also been done by Knobelsdorff in the eighteenth century, in another peripheral region, Prussia. Further east, in Silesia, the luxuriant vegetation of the choir-stalls of the monastery of Leubus eludes any definition in terms of the Graeco-Roman stylistic voca-bulary. Renaissance Germany had already produced examples of this purely vegetal style, which can be seen in the pulpit of the cathedral in Freiburg (1519), shaped like the calyx of a flower. In Franconia, Bayreuth shows some really remarkable expressions of the Art Nouveau spirit. Early in the eighteenth century, Margrave George William built himself a 'hermitage' out of *pl. 279* stones cut in the shape of enormous rocks. Later the Margravine Wilhelmina built the Felsen-garten theatre, in her park of Sanspareil, out of actual rocks. Even more extreme was the 'cedar *pl. 275* room' of the palace, built for the same Margravine, in which vegetation appears to swarm freely up the panelling; it might be signed Majorelle. Was this the destiny of the baroque? Not yet; instead there followed the rise of neoclassicism. The ultimate metamorphosis was delayed for more than a century.

These foreshadowings of Art Nouveau, though sporadic and widely separated in time and space, are evidence of a powerful instinct for freedom which, had it not fortunately been restrained by 'rules', would have sapped the vitality of the baroque and brought the age to a premature end.

4 Academies and Factories

The artistic civilization created by the Renaissance carried within it the seeds of academicism. The Renaissance took as its point of departure the principle of submission to the antique, which was considered to have attained absolute perfection—a perfection which could be approached only by a rediscovery of the 'rules' laid down by Vitruvius and expressed by the masters of sculpture. This feeling of admiration, which was in itself fertile in that it aroused in the artists of the fifteenth century the desire to emulate the achievements of the past, was followed after 1530 by an attitude of submission to the great masters of the Renaissance themselves, an attitude from which mannerism tried to escape by ways which led only to an impasse.

It was now that the academies were formed, in an attempt to resolve the mannerist dilemma through a return to the sources—antiquity and the masters. Academicism, which arose spontaneously out of associations of artists, prospered in the atmosphere of seventeenth-century court art; royal patrons sought to 'protect', to encourage, even to direct the organization of artistic production, being all too ready to remove it from the sphere of individual initiative and direct it towards the celebration of their own glory.

Academicism was also a product of art criticism. Artistic creation in the Middle Ages was a spontaneous, almost physiological process which did not involve a self-conscious use of aesthetic criteria. The discussion of aesthetics began in the sixteenth century. Almost the sole purpose of aesthetic thought was to recall artists to 'the rules' and to oppose any attempt at artistic revolution. Thus all the Italian aestheticians defended classicism despite visible evidence of the triumph of the baroque, and the only theorist to express disapproval (in veiled terms) was Poussin's friend Bellori.

The result was that the atmosphere surrounding education in art was entirely different from that of the Middle Ages. In medieval times art was learned by practice in the studio of a master, but after the seventeenth century it was learned in a school or academy where teaching was as much theoretical as practical.

The first academies to have an official character were the Accademia delle arti del disegno, founded in Florence in 1563 under the patronage of the grand duke, and the Accademia di San Luca in Rome; both sprang from ancient corporate associations, the latter having its remote origins in a kind of university of painters which met in the church of San Luca on the Esquiline. It was established as an academy of fine arts by a brief of Gregory XIII dated 15 October 1577, and consolidated by a Bull of Sixtus V in 1588. Its first statutes were drawn up in 1593 by Federico Zuccari, by whom it was formally opened in the same year. Courses were given to

which students were admitted by examination; and the academy as a corporate entity developed into a society of distinguished architects, painters and sculptors, presided over by one of them, who bore the coveted title of 'prince'.

Much more far-reaching was the influence of the academy founded by the Carracci in Bologna. This university town was a predestined home of academicism; 'Bologna teaches' (*Bononia docet*) was its motto. Before the school of the Carracci there had been other academies, including that of Domenico Tibaldi, where, says Malvasia, 'there was drawing from casts from the first hour of the day, and from life the first two hours of the night', and the school founded by a mediocre Flemish painter called Denis Calvaert. It was in 1585 that the three Carracci cousins opened their school, which was called the Accademia dei Desiderosi or degli Incamminati. A famous sonnet, based on a common turn of speech, has led to a misunderstanding of the true nature of this school, which gave extensive practical teaching. Theory was the responsibility of Agostino Carracci, who lectured on perspective, chiaroscuro and anatomy, the last-named with the aid of a doctor. The influence of the Carracci on seventeenth-century painting was considerable, even outside Italy; Rubens owed much to them. Theirs was the merit of having re-established the principles of composition abused by the mannerists, and (contrary to what has long been thought) of bringing painters back to a study of nature, both through their teaching and through their own example.

We may pass over a few attempts to found schools of a similar kind in Italy, such as the short-lived academy founded in Milan by Cardinal Federigo Borromeo, which in addition to its artistic aims endeavoured to further the ends of the Counter-Reformation; the most powerful academic organization in the seventeenth century was in France.

On 29 January 1648 a group of painters presented a petition to the king of France requesting him to grant recognition to their association. Later Louis XIV saw how he could turn the existence of this trade association to his own advantage, and on 14 May 1664 the Académie Royale de Peinture et de Sculpture had its statutes registered by Parliament. The academy's aims were pedagogical and aesthetic. Art was to be taught after the antique and from life, and the academicians also worked to establish theoretical principles, particularly through lectures on the work of the masters. The Académie de France in Rome, founded in March 1666, received students who had won the *Prix de Rome,* a prize awarded by the Académie de Peinture et de Sculpture to enable selected pupils to complete their training by a first-hand study of antiquity and the masters. In the eighteenth century the Ecole Royale des Elèves protégés coached architects, painters and sculptors for the *Prix de Rome.* In 1671 Colbert, realizing the advantages of the system, had created the Académie Royale d'Architecture, whose members were appointed not by election (as they were in the Académie Royale de Peinture et de Sculpture), but by royal nomination; the artists who belonged to it having the right to the title of *Architecte du Roi.* Down to the present day, these two institutions have upheld the principle of respect for antiquity and tradition.

The rest of Europe was not slow to follow the French academic system, which Le Brun, who bore the title of 'first painter to the king', had made into an instrument for controlling artistic

227

production in the service of the monarch, basing the work of the academy upon that of state-owned industrial enterprises such as the Gobelins. Academies modelled on those of Louis XIV became centres of French influence all over Europe; examples were those of Dresden (founded in 1697 by Augustus II), Vienna (founded by Charles VI in 1726), Parma and St Petersburg. The last-named, first conceived by Peter the Great, was established by Elizabeth in 1758 and organized by Catherine the Great in 1764; most of the teaching posts were occupied by French professors.

In the second half of the eighteenth century the academies became great centres for the spread of neoclassicism. The Royal Academy of London was recognized by George III on 17 December 1768; its first President was Reynolds, who delivered fifteen important lectures there. But the most active of the academies in this field was that of San Fernando in Madrid; originating in a group of Spanish artists formed in Rome in 1680, it was established under royal decrees dated 1744 and 1749, and given powers of rigid dictatorship over Spanish artistic life, powers which included the approval of all plans for new buildings. By this means the academy succeeded in bringing a halt to the baroque, then in full flower in Spain, and replacing it by an undistinguished neoclassical style.

pl. 288 Governmental control of artistic production went hand in hand with the establishment of state-owned industries, and here too, France led the way. Under Le Brun the Gobelins factory (the *Manufacture royale des Meubles de la Couronne*), formally established in 1667, became a centre of production for tapestries, series of which were eventually sent out to every corner of Europe, and also for royal furniture.

As tapestries were one of the essential elements in the decoration of the *châteaux* of the time, all the courts of Europe ordered them from the Gobelins; several of them sought, however, to free themselves from this obligation by founding their own national factories. But it was not always easy to procure the necessary workers; for the interested countries practised a strict protectionism. When Bourbon Spain lost the Spanish Netherlands under the Treaty of Utrecht, it also lost the workshops which had provided the country with tapestries since the Middle Ages. In order not to be dependent upon the Gobelins, Philip V's minister Alberoni founded the Santa Barbara factory in Madrid. In 1720 he summoned one Jacob Vandergoten from Antwerp, but the Austrian government of the former Spanish Netherlands objected to his departure and he was imprisoned for nine months. Vandergoten was finally able to leave the country, but without the tools of his trade. All his other possessions were also confiscated.

The policy of most monarchs was to encourage existing private industries, which when they enjoyed exemption from taxation could bear the title of 'royal'. But porcelain was an exception. There was in the eighteenth century a kind of 'porcelain mania', and many sovereigns were keen to possess an official factory. The lead was given by the Meissen works, where since 1710 Augustus the Strong had been exploiting Böttger's discovery of the manufacturing process. Saxon workers from Meissen took the secret with them to Vienna in 1717, and it was from *pl. 290* Vienna that it was divulged to the rest of Europe. The movement spread rapidly, and official factories were set up in Vienna (1744), Ludwigsburg (1758), Munich (Nymphenburg, 1747),

Berlin (1763) and in many other capitals. Porcelain figurines, first made at Meissen by J. J. Kändler and given their most graceful form by the Italian F. A. Bustelli of the Nymphenburg porcelain works, became a popular genre. Ceramics became a passion of the aristocracy, and there was competition between members of the nobility to 'protect' a porcelain or even a faience factory. In Spain the famous Alcora factory was founded by the Conde de Aranda, and in Florence the Marchese Ginori set up the factory of Doccia. In France, the art of porcelain is associated primarily with the name of Madame de Pompadour. The factory of Vincennes,

pl. 289

pl. 292
pl. 291
pls 293, 295, 297

2 Daniel Marot (1663–1752). Project for picture room

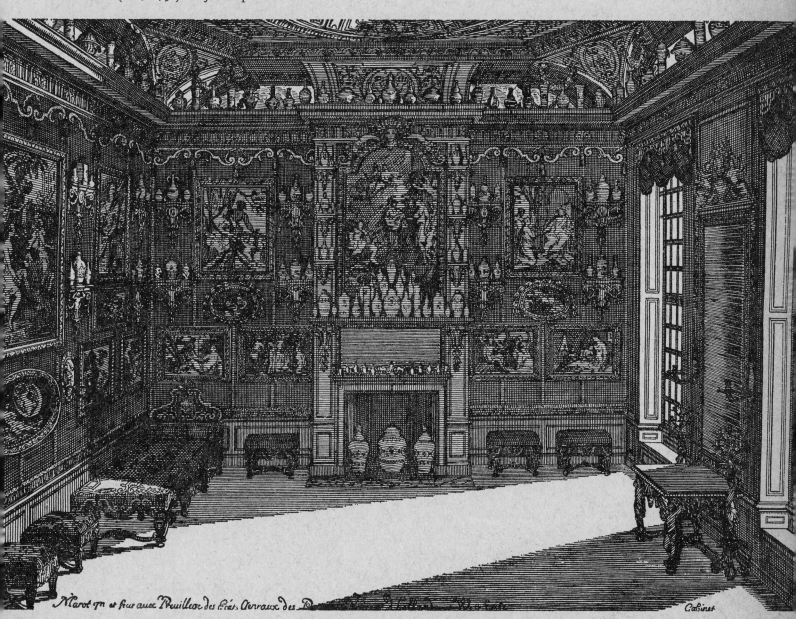

founded between 1738 and 1741 as a limited-liability company, was granted wide franchises by the crown; Madame de Pompadour awakened Louis XV's interest in it, and in 1756 it was transferred to specially-built premises at Sèvres. In 1760 it became a royal factory. Augustus the Strong and Augustus III of Saxony were so passionately fond of porcelain, both eastern and western, that they used it to decorate a whole palace, Pöppelmann's Japanisches Palais in Dresden. Duke Charles Eugene of Württemberg, founder of a porcelain factory at Ludwigsburg, declared that porcelain was 'an indispensable attribute of glory and dignity'. Chancellor Eberhard Dietrich Pfaff, keeper of the collection of the Landgrave of Hesse-Darmstadt and director of the porcelain factory of Kelsterbach, celebrated thus the virtues of his office: 'The gracious orders of his Most Serene Highness have placed me in the delicate and noble domain of fine porcelain, and by a miraculous destiny and the care of the Almighty it has been vouchsafed to me to be a true connoisseur of these treasures.' A refined age, when a man's nobility could reside not in the exercise of arms, but in a porcelain figurine!

In the manufacture of porcelain, Germany never lost its lead over the other European nations. When this technique came into general use all over Europe, the rococo, with its repertoire of forms eminently suited to the minor arts, was already in decline. On the other hand, in Holland, France and elsewhere, faience enjoyed a splendour unknown in Germany, where it remained a popular art. As its French name (derived from its Italian birthplace, Faenza) clearly shows, *pl. 299* faience took its origin from the majolica ware of Italy; this parentage is plainly revealed in the seventeenth-century ware of Nevers. That of Holland was very similar, until Oriental, and especially Chinese, influences gradually modified the style of the tableware; meanwhile the Dutch ceramic wall tiles which were in demand all over Europe maintained a style of images which had its origin in the Renaissance. At the end of the seventeenth century, the colour blue began to dominate Dutch ceramics more and more; the same applies to the Portuguese *azulejos,* the wall tiles originally manufactured in Seville, which both in palaces and cathedrals were often used to cover entire walls.

In France, at the end of the seventeenth century, a royal edict forbade the use of silver plate, and there sprang up a luxury faience industry. Louis XIV set his subjects a good example by melting down his own plate and going over to faience. To please their clientele, craftsmen intro- *pl. 300* duced an enormous variety into their output. The Rouen factory created a series of sumptuous services, in the Louis XIV style, which was continued and elaborated throughout the eighteenth century. While the factories of eastern France imitated German porcelain, those of Marseilles and Moustiers vied with one another in ingenuity and inventive resource. After the so-called Clérissy period in French faience, in which there developed the blue pattern of grotesques which became known as *à la Berain,* the Marseilles painter-craftsman Olérys introduced, from Alcora in Spain, *pl. 298* the polychrome technique. At Moustiers he used it to produce pieces of a delicacy and technical freedom unsurpassed anywhere. His only real rivals were Robert and the Widow Perrin, both of whom worked at Marseilles. The decline of faience manufacture coincided with the spread of porcelain; and anart on which immense talent and creative ingenuity had been expended was reduced to the level of a popular craft.

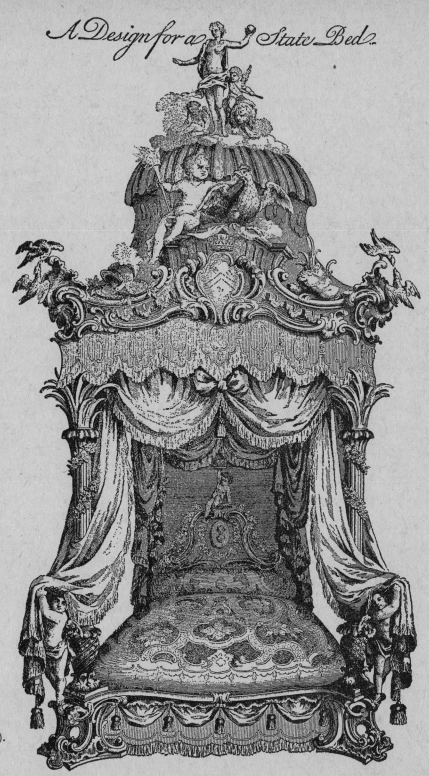

A Design for a State Bed.

3 Thomas Chippendale (*c.* 1709–79).
Design for a state bed

We have seen that official intervention in the field of the arts (strongly supported by the enormous royal demand for luxury articles) took the form of academies and factories; but these two institutions had directly opposite effects.

The encouragement given to industry stimulated the creative powers of the craftsmen of this period, and there was an admirable development of the minor arts. Originality in those forms of art adapted to daily life had been stifled since the Middle Ages by the dominance of architectural principles which compelled artists to conceive objects within a rigid framework of monumental forms. These forms, whether Gothic or classical, were always at variance with the nature of a portable object. The baroque at last brought freedom from this restraint; and the rococo style lent itself more completely than any other to the exercise of creative genius in the 'minor arts'. Meanwhile, new refinements in the art of living obliged craftsmen to invent new forms and new styles of ornamentation. It was the court of Louis XIV that gave the original stimulus to this boom in the arts of luxury, and the eighteenth century became, with the Carolingian and mannerist periods, one of the greatest ages of the minor arts in the history of Western Europe.

The academies, on the other hand, contributed to the maintaining of an alien aesthetic, based on the Florentine Neo-Platonism of the late fifteenth century adapted to a greater or lesser degree to the climate of the day. According to this aesthetic, perfection in art resided in the idea underlying the form, a form whose purity had to be maintained against the vagaries of fashion and style. To take only one example, after Raphael had created a definitive image *pls 282, 286* corresponding to the 'idea' of the Madonna, the type of his *Virgins* was perpetuated in an unbroken succession down to the nineteenth century. The perpetuation of this type was an act both of *pl. 283* piety and of aesthetic convenience. Immediately after Raphael, the mannerist Bachiacca made *pl. 284* profitable use of it; and the art of Sassoferrato in the following century consisted almost entirely of variations on the Raphael Madonna. We find her again—toned down to suit the taste of the *pl. 285* day but nevertheless still herself—in Pompeo Batoni in the following century. In the nineteenth *pl. 287* century Ingres restored her in all her purity. It was the Pre-Raphaelites in England and in France (Bouguereau) who were to break with this convention—not in order to innovate but to return to an older and, they believed, purer tradition.

The sterilizing effect of this sort of 'academic' tradition has often been emphasized. Nowhere did it gain a stronger hold than in France, where it helped to keep alive almost into our own times an art emptied of content. On the other hand, academicism can have a beneficial effect. The idea of progress lies at the very heart of Western civilization; if it were not subject to discipline it would too quickly exhaust its possibilities and die. Baroque vitalism needed a restraining force; this was provided by academicism which was in a sense its antithesis, just as the baroque itself was born at the end of the sixteenth century from a synthesis of mannerism and academicism. The dialectic of the interdependence of opposites is an essential principle of life; within ourselves the sympathetic nervous system, which stimulates, could not function without the parasympathetic nervous system which acts as a brake.

We do not exhaust the creative riches of the baroque age by enumerating its artistic styles. There remain two important features of Western culture in this period which stand outside stylistic evolution: the extraordinary tenacity of 'primitive' forms in popular art, and the tendency of styles transplanted into an alien environment to regress towards the primitive.

Whether classical or baroque, whether inspired by Gothic art or by mannerism, the forms elaborated in court and church art throughout the seventeenth and eighteenth centuries belonged to 'learned cultures'; they could not, as such, be assimilated by popular culture, or by communities whose culture had for some reason remained close to the primitive. By making art a mode of intellectual speculation, the Renaissance created a schism between artistic creation and popular feeling. The latter, withdrawn into itself, was henceforward to find expression in forms which show a remarkable consistency through time and space. These forms are not always crude; in the field of the decorative arts, notably textiles, popular artists have often shown great refinement in their use of ornamental rhythms and variations of colour. It was, of course, in the regions that were furthest away from the great centres of ideas, such as the Scandinavian and Slav countries, *pl. 306* that this rustic art flourished most strongly. But the conditions of life often favoured the continuance and development of local cultures even close to the great centres. Thus the French province of Brittany, very backward economically, and with a population cut off from the rest of the community by a language barrier, seems to have been unaffected by the evolution taking place elsewhere in France. In the seventeenth century Breton sculptors continued to carve crucifixions in a tradition which went back to the end of the fifteenth century.

The isolation of mountain communities was all the more favourable to the development of popular culture, in that the peasants had time to devote to art during the long winters, when they were virtually cut off from the outside world. One of the most curious examples of this coexistence of sophisticated and primitive artistic cultures is provided by the thirteen mountain communes just north of Verona whose people speak a German dialect. Their ancestors, people of Bavarian stock, came here from the region of Vicenza in the thirteenth century. In the sixteenth, seventeenth and eighteenth centuries they set up at crossroads little shrines, some of which were dedicated to the Virgin and to the saints who had power to avert the plague, and some of which depicted the Crucifixion. Attempts have been made to interpret the very primitive figures in these shrines as a survival of traditions from the Veneto; but this would be incompatible with what we know of the origins of these communities. In the age of Veronese and in that of

pl. 304 Bernini, their crude bas-reliefs retain an eternally primitive quality which makes it possible to compare them with the famous seventh- and eighth-century altars of Cividale and Ferentillo. Here the decisive factor in the survival of primitive forms has clearly been linguistic isolation.

Still more intriguing than the survival of the primitive is the phenomenon of 'regression'; and this is by no means restricted to the realm of popular art. Briefly, when an artistic civilization borrows a new form of art from another civilization, it can usually assimilate it only by taking it back to an earlier stage of its development. Thus, on coming into contact with Greek art, Etruscan art of the fifth century BC adopted the archaic Greek style of the *sixth* century; meanwhile, Athens was developing the classicism which the Etruscans adopted only in the fourth century. In the fourteenth-century Gothic art of Italy, the art of Andrea Pisano recalls that of the sculptors who worked in the French cathedrals of the thirteenth. All the countries which adopted the Renaissance performed this stylistic regression in order to assimilate it; France in the first half of the sixteenth century practised the Italian style of the fifteenth, and the situation was the same in Spain, as is apparent in the art of sculptors such as Diego de Silos or Alonso Berruguete. Who would think to see Berruguete's works, profoundly inspired by Donatello, that he was a pupil of Michelangelo? Donatello, in fact, was the true master of European sculpture in general during this first half of the sixteenth century, at a time when the all-powerful Michelangelo ruled in Italy.

The regression effect is all the stronger when the two cultures concerned are remote from each other in space. In the same Renaissance period the example of Mexico, which has the oldest Spanish-American buildings apart from those of Santo Domingo, is particularly significant. The great Franciscan and Augustinian monasteries which were set up in the second half of the sixteenth century are in a 'plateresque' style similar to that used in Spain; but the monochrome frescoes which adorned them, and which are being found in ever-increasing numbers under their coating of whitewash, perpetuated the style of painting in use in Italy a hundred years earlier. Sometimes regression seems to stem from the desire of a people who are the victims of evolution to cling desperately to the past as it slips away from them. Raynaldo dos Santos has shown that the Portuguese art of the Manueline period, early in the sixteenth century, reverted to Romanesque forms, curved mouldings supplanting the angular mouldings of Gothic. The attraction of Romanesque art was so strong in the Portuguese collective mind that in the full flood of the baroque age, at the end of the eighteenth century, there appeared a type of gilded wooden altar with arches ornamented in a way which exactly parallels the ornamentation of Romanesque doorways.

In some countries a nationalist reaction against international fashions in art caused the Romanesque to be reborn at the very moment when its ideas might seem most incompatible with the dominant stylistic trend. Mr Z. Swiechowski has studied the deliberate imitations of Romanesque architecture which appeared in Poland at the close of the Middle Ages: twin-towered church façades, cubic capitals, bases ornamented with claws in the angles, tressed ornaments, all totally unexpected in a fifteenth-century context.

Portugal possesses some of the finest examples of baroque and rococo decorative art; but the buildings which house them conform to the classical traditions of the Renaissance, while superb painted wooden statues stand aloof and impassive amid the exuberant baroque rhetoric of the *pl. 309* surrounding décor. Some of these Portuguese sculptures, so utterly unlike contemporary work in Swabia, Bavaria and Italy, retain a Gothic air; others have a chaste and melancholy reserve which recalls the long-obsolete Spanish style of Martinez Montañés. Since the fifteenth century, regression has been a recurrent phenomenon in the sculpture of Portugal; this nation which set out to conquer the world has always remained strangely introverted and self-absorbed.

The regression principle would seem to apply in the baroque age even in parts of Europe where contemporary outside influences were particularly strong, such as the Alpine passes. Around Lake Constance, three great artists led the way in the evolution of Baroque sculpture— *pls 90–1, 308* Jörg Zürn, the creator of the altar of Überlingen (d. 1637), Christoph Daniel Schenk (1635– 1691) and Joseph Anton Feichtmayr (1696–1770). Impelled by the mannerism of the 1600s, Jörg Zürn created a native baroque already tending towards the rococo, thus preparing the way for the next stage of development represented by Feichtmayr. Between the two, the evo-lutionary curve was interrupted by Schenk; his break with the style of Zürn was a consequence of the traumatic effect produced on him by his contact with Roman baroque. Schenk was rarely successful, however, in making this new form his own (*The Doubting of St Thomas,* in the cathedral at Constance), and usually 'regressed', using late and even early Gothic forms. What he was unable to assimilate was the glorification of physical strength which is charac-teristic of true baroque sculpture; a form so alien to his temperament brought out in him all the ascetic tendencies of Gothic, hence the leanness of his figures, which totally negates the signifi-cance of their opulent baroque prototypes.

The isolation of the countries of Latin America from the sources of their culture made them *pl. 310* ideal ground for artistic regression towards the primitive. The social climate of these regions was closer to the Middle Ages than to the baroque age, and the use of native labour must also have contributed towards the regression of artistic styles. This phenomenon can be studied in Latin America in all its forms. The commonest, and the least specific, is the simplification characteristic of a popular art practised by craftsmen of average ability. But the creative instinct inspired the more gifted artists to interpret the styles they received from Europe in terms of earlier, indigenous forms. This phenomenon was studied twenty years ago by an Argentinian art historian, Angel Guido, who dubbed Latin American art *el arte mestizo;* it is possible however, that he tended to exaggerate the scope of the contribution made by native civilizations. Generally what Mexican, Peruvian and Brazilian artists did was to reinvent, quite independ-ently, the pre-classical and pre-baroque styles of the European art which they imitated. Latin American painters and sculptors have produced their own versions of the Gothic and Renais-sance styles, and even the Carolingian and Byzantine.

The assimilation of European styles is at its most complete in architecture; forms imported by Spanish, Italian and Portuguese architects have been faithfully copied. As to the figurative arts, the European models that reached New Spain came from the workshops of Seville which

produced inferior work for overseas markets almost on an industrial scale; both Montañés and Zurbarán were involved in this. These prototypes were supplemented by engravings exported in large quantities by the publishers of Antwerp. In painting Mexico was the only country to maintain a school of painting of its own, modelled on that of Seville. Elsewhere painters interpreted European models in more or less primitive terms. The two most original schools in South America were those of Cuzco in Peru and Quito in Ecuador, comparatively isolated centres which developed a hieratic style and a rigid iconology which recall Byzantine painting, and particularly the post-Byzantine art of fourteenth-century Venice as represented by Paolo della Francesca, Lorenzo Veneziano, Caterino and Donato. These fourteenth-century Italian masters share with those of Cuzco and Quito a love of floral decorations in gold leaf, applied to draperies without any attempt to reproduce their folds. Brazil at the end of the seventeenth century witnessed the rise of a style of ceiling panel painting which for want of published reproductions has remained almost unknown to the public. The finest examples of this are on the ceiling of the Capela Dourada at Recife and the Conceição at Olinda; they vividly recall the Sienese primitives of the fifteenth century. The relationship between the artists of the Capela Dourada and the 'advanced' styles of their European contemporaries is analogous to that which existed between the fifteenth-century Sienese, primitive survivals, and the progressive art of the Florentines; the result is a naive style which conceals a deep-seated ossification.

Brazil, unlike Peru and Mexico, was practically virgin territory from the artistic point of view; no advanced civilizations existed there before the Europeans came, and its art therefore demonstrates the process of regression in a particularly clear form. In my book on O Aleijadinho, I studied its implications in the world of sculpture, and showed how the regression process in Brazil interacted with the regressive patterns inherent in Portuguese art. An altarpiece from a remote corner of Brazil looks like a Carolingian ivory carving; a bas-relief calls to mind the Romanesque; a Madonna recalls a Burgundian Madonna of the fifteenth century; a carved head might be Gallo-Roman. Even the stylization of Chinese art is present in this extraordinary gallery of sculptural styles; the jaguars of Embú might easily have been carved by a T'ang artist. The ruins of the Jesuit mission of São Miguel have yielded numbers of seventeenth-century sculptures which include Romanesque fonts, a Romanesque Virgin, a Virgin with the 'Rheims smile', a head as proud as Donatello's St George, and an apostle in the manner of Berruguete.

pl. 305

pl. 307

pls 311–14, fig. 4

The introverted and regressive art of Brazil finds its most characteristic exponent in a mulatto artist, the son of a Portuguese architect and a Negro slave, whose distressing physical deformity earned him the name O Aleijadinho, 'the little cripple'. In his work as an architect and decorator, this astonishing artist adopted the Portuguese rococo style, with an added refinement of his own which sometimes recalls German rococo. But as a sculptor he came progressively closer to the Gothic ideal. At a time when the armies of Napoleon were overrunning Europe, O Aleijadinho re-created, on the terrace of the sanctuary of Congonhas do Campo, the vehemently protesting prophets of Claus Sluter's *Well of Moses*. His 'primitive' nature reacted to the dynamism of baroque art with an expressionist violence which parallels that of the last phase of Gothic sculpture.

pl. 315

The ambivalent position of O Aleijadinho, whose architecture is progressive and whose sculpture regressive, is a proof, if one were needed, that stylistic regression can be a creative force and can produce an artist of genius. The central flaw of our culture is its total commitment to the idea of evolution and progress, the continual search for new forms which cuts mankind off from the source of strength which lies in the forms of a more 'primitive' age.

4 Font, São Miguel, Rio Grande do Sul, Brazil, eighteenth century

6 Trompe-l'oeil

pls 104, 316, PL. IV What greater contrast could there be than a still-life by Willem Claesz. Heda and a ceiling by Andrea Pozzo? And yet between these two forms there is a link. Heda's still-life and Pozzo's apotheosis of St Ignatius are part of the same process of deception. One deceives us as to the real, the other as to the fictional; Heda would have us believe that this pitcher, this ham, these oysters and this gold cup are really present, not merely in semblance; Pozzo suggests to us as true the phantasmagoria that is seen through the open ceiling of the church. Vision and reality, fantasy and observed fact, become interchangeable.

The aesthetic tradition of the painting-as-mirror, created by Van Eyck, had degenerated rapidly even in the fifteenth century; but it flowed on like a subterranean river and burst forth again in the Dutch painting of the seventeenth century. Calvinist influence undoubtedly contributed to this revival. To explain it by the purely material fact of the disappearance of the church and the monarchy as patrons of the arts, and their replacement by a matter-of-fact bourgeois clientele, is to take a superficial view; although the absence of a mythology, whether religious or monarchical, in the United Provinces did favour the adherence of the artist to the straightforward truth of appearances.

One contributory cause of the revival of *trompe-l'oeil* was undoubtedly theological. Calvinism took an austerer and more pessimistic view of the meaning of human life than Catholicism, but did not regard the possession of worldly goods with the same scorn that the Catholics— outwardly at least—professed. The result was that the Calvinist painter adopted a relatively humble attitude towards inanimate nature. He used all his art to reproduce as faithfully as possible the world around him, and particularly the objects of everyday use. There is one category of still-lifes in which *trompe-l'oeil* takes on a more subtle meaning; this is the *Vanitas*, a reminder of the vanity of the things of this world, a genre practised especially by painters working in Leyden, the great centre of Calvinist theology. Here everything deceives us, for this appearance of solid reality which confronts us is only the cloak of the ephemeral. There is *pl. 318* a further subtlety; in one of his paintings David Bailly has presented as attributes of 'vanity' the emblems of his own art. Is art then no more than an artifice? In a *Vanitas* everything is false; not only are the objects attributes of vanity, they are in themselves no more than painted simulacra. Could the eye be more meaningfully deceived?

The imitative realism of Dutch seventeenth-century art was peculiar to it, and ended when it ended. It has nothing in common with the naturalism of the nineteenth century. Between

the two there is as much difference as between the philosophical positions of science in the seventeenth century and in the nineteenth. Impelled by determinism and materialism, the nineteenth-century scientist sought to discover the objective nature of things. The painter of the same period, whether romantic, realist or impressionist, also sought to perceive the reality behind appearances. The Dutch painter of the seventeenth century is far removed from this analytical attitude; he takes appearances as they are, without seeking to interpret them. His approach may be compared to that of the scholars of his time, Gassendi, Hobbes, Mersenne, Pascal, Huygens and Robertval, who, rejecting Platonism and Aristotelianism alike, succeeded in laying the foundations of modern scientific method. For them, however, science was concerned only with phenomena; its object was not to know the nature, or the principles, that underlie them.

The *Vanitas* attracted Italian artists only occasionally. They confessed the vanity of the things of this world in perhaps a more categorical fashion: by refusing to paint them. This attitude bears witness to the persistence in our civilization of Neo-Platonism, which dismissed the material world into a kind of non-existence, assigning truth only to the ideal. While the artists of Holland endeavoured to reproduce the appearances of this world, the Italians painted the appearance of a super-world—Olympus or Paradise, but most often Paradise, for with the exception of Tiepolo it was the revelation of the Christian heaven that most inspired decorators.

The artifices of ceiling painting derive from that passion for perspective which haunted the Florentine artists of the fifteenth century, its great virtuoso being Mantegna. But perspective for them was a means of exploring the earthly world; the baroque painters turned it upwards towards God. The first to think of painting figures seen from below, *sottinsù,* and standing out against the sky, was Mantegna himself; in the Camera dei Sposi (Mantua) he shows women gossiping behind the balustrade of a lunette opening on to the sky, with cupids frolicking around it. The classical regard shown by Raphael for the beauty of the human body prevents him from showing it foreshortened—that is, from disfiguring it—even when he paints a ceiling (as in the Loggia of the Villa Farnese, Rome). Michelangelo hoists his giant figures on to the feigned architecture of the ceiling of the Sistine Chapel, but, still respecting the integrity of the body, he foreshortens them only to an angle of vision of forty-five degrees; even the scenes painted on the crown of the roof are done for the most part as if they were seen at right angles on a vertical wall, and applied as such to the curved surface. The first who dared to paint figures *sottinsù,* soaring in the heavens, was Correggio, in the domes of San Giovanni Evangelista (1520–23) and the cathedral (1526–30) in Parma. We can appreciate the boldness of Correggio's innovation when we realize that when he was beginning the dome of San Giovanni, the dying Raphael had just abandoned the ceilings of the Loggia of the Villa Farnese. In 1534 Gaudenzio Ferrari filled the dome of Santa Maria in Saronno with a hundred and forty figures of angels, *pl. 321* but he evaded spatial problems by pressing the figures against one another in concentric circles.

The mannerists were particularly concerned with the problem of opening ceilings or the vaults of naves. They made use of the devices of perspective, aided by a feigned architecture which continued that of the church and opened on to the sky like that of the *cortile* of a palace.

Their attempts are still very clumsy, and their foreshortening, usually reduced to forty-five degrees, is imperfect; the perspective of the false architecture does not follow the real perspective of the church or palace, due also to the fact that these artists worked on ceilings which were not really high enough to create an illusion. There are examples of this in San Paolo Converso in Milan, by Antonio Campi (1560), the Palazzo Poggi, Bologna, by Pellegrino Tibaldi (*c.* 1554), the Libreria San Marco, Venice, by Stefano and Cristoforo Rosa (1559–60), and the Palazzo Lancelotti in Rome, by Agostino Tassi (1607–23).

pl. 153

Ceiling decoration was one of the great themes of seventeenth-century Roman painting. Generally speaking, artists abandoned the architectural perspective effects sought by the mannerists, relying for their *trompe-l'oeil* on the foreshortening of figures, painted either in natural colours or occasionally in imitation of monochrome sculpture, with which, moreover, they were often combined. In the Palazzo Farnese (1595–1602) the Carracci followed Michelangelo in decorating a ceiling with nude male figures (*ignudi*) painted in monochrome; this compartmented ceiling is still Renaissance in spirit. In the first half of the seventeenth century, figures apparently hovering in the air made their appearance on the ceilings of the churches of Rome. Domenichino and Lanfranco compete with one another, the latter, the more baroque, being the easy winner;

pl. 322

his dome of the San Gennaro chapel in the cathedral at Naples (1641), representing the *Glory of the Blessed,* is, however, not far removed from the *Choirs of Angels* painted by Gaudenzio Ferrari at Saronno a century earlier. Lanfranco's frieze in the Sala Regia of the Palazzo del Quirinale (1611–17) is still mannerist in spirit, though here, it is true, he was working under the direction of the mannerist Agostino Tassi. Domenichino's best works are the decoration of the pendentives of the domes of Sant' Andrea della Valle (1624–8) and of San Carlo ai Catinari (1630), in Rome. They set the style for the future; but they are still inspired by the pendentives of Correggio's dome in San Giovanni, Parma (1520–23); they are still figures hung on the curved wall, like those on the ceiling of the Sistine Chapel.

The virtuosi of the flying figure in the seventeenth century were Pietro da Cortona (1596–1669), whose most famous works are the ceiling of the great hall of the Palazzo Barberini and the

pl. 323

ceilings of Santa Maria in Vallicella, in Rome, and Giovanni Battista Gaulli (1639–1709), who glorified the Holy Name of Jesus on the roof of the church of Il Gesù. Both make their figures pour in torrents over the concave surfaces; they press together in such numbers that they occupy the entire space, which takes on a plastic quality. Such was the prestige of the human body in post-Renaissance Italy that every concept, even space, was expressed in corporeal terms.

The artist who gave ceiling painting its true spatial value was the Jesuit Andrea Pozzo (1642–1709). He succeeded in joining in an indissoluble unity the real space (that of the church) and the fictitious space (that of the ceiling). Taking inspiration from methods used in the design of scenery for the theatre, which had made magnificent progress in Italy in the seventeenth century, Pozzo returned to the method with which the mannerists had tentatively experimented, the use of architectural *trompe-l'oeil* to create the illusion of a celestial space peopled by angels

pl. 316, PL. IV

and saints. The immensity of the vault of Sant' Ignazio, Rome (1691–4) enabled Pozzo to achieve a masterpiece of theatrical illusion. The sham architecture, continuing the real, causes

the heaven in which Ignatius of Loyola soars in glory to seem infinitely distant. Gazing up into this remote, celestial space, a real image of the 'Most High', a historian might recall that at the same period telescopes in private or official observatories all over Europe were trained on the heavens (Paris 1672, Greenwich 1675). Pozzo achieved an even more masterly *trompe-l'oeil* elsewhere in Sant' Ignazio by painting on a canvas stretched over the crossing of the church a sham dome to take the place of the one that had not been built. This masterpiece of artifice, ruined by a fire, has now undergone restoration. He revealed the secrets of his art in a treatise on perspective (*Perspectiva pictorum et architectorum,* 2 volumes, 1693 and 1700). The perspective he employs is no longer Alberti's simple *costruzione legittima;* it is a much more complex science, combining the *perspectiva artificialis* of the fifteenth and sixteenth centuries with the *perspectiva naturalis* of the Greeks, who calculated foreshortening by angles.

The wonderful ceiling of Sant' Ignazio is still a centred perspective, conceived in relation to a stationary spectator placed in the centre of the nave, where a disc of white marble marks the apex of the cone of vision. The next great advance in the technique of ceiling painting came in the eighteenth century, when artists used all their skill to suggest, in a small real space, an infinite imaginary space, multiplying axes, making use of oblique trajectories and spiral move-ments, and accelerating the recession in depth, no longer by the method of feigned architecture but by the use of figures alone—figures gifted now with the secret of levitation. Scenic designers had shown the way in the late seventeenth and early eighteenth centuries by fragmenting stage perspective. Fernando Galli Bibiena (1657–1743), Francisco Galli Bibiena (1659–1739), and Filippo Juvarra (1685–1735), who worked as a producer at the Ottoboni theatre, were no longer content to combine vistas centred on the backcloth. Their stage sets often show palaces in the form of a rotunda, giving a sense of rotary movement; diverging staircases cleave through the stage space; sets are placed at an angle, and vistas are seen in oblique perspective.

The new techniques of multiple perspective in ceiling painting were developed in Venice. In the only ceiling he painted, in SS. Giovanni e Paolo, Venice (1725), Piazzetta transposes to the vertical the axial disruption which characterizes the composition of his altar paintings; the viewpoint is not central but oblique. Tiepolo accentuated this obliquity in an early work by including a monumental staircase (*Institution of the Rosary* in the Gesuati, Venice, 1737–9). This is an exception, however, for Tiepolo later renounced the method of Pozzo, which was based on the use of imaginary architecture. Is not our surprise all the greater to see the vision through an apparent breach in the ceiling? To create the impression of distance Tiepolo places figures in close-up on the rim of the opening, to emphasize by their size and physical density the recession into infinity of a nebulous world where other figures float, insubstantial and seemingly created out of light. Like Piazzetta he uses multiple axes, but they are harmonized in a symphonic balance within their convoluted frame. Sometimes the opening reveals to us in mid-heaven a nebula spiralling away into the infinite, carrying with it the unreal figures held in its whorls (this is the case in Tiepolo's staircase in Würzburg and in his *Apotheosis of Aeneas* in the Palacio Real in Madrid, 1764–6). Sometimes, chiefly in his last period, the most distant figures seem to disintegrate into the emptiness of space (Palazzo Canossa, Verona, 1761, *Homage to*

pl. 325

241

pl. 326 *Spain* in the Palacio Real, Madrid, 1762), while the circling movement of the figures in the foreground accentuates this distinction between the two worlds, the world that is still close to us and the world of the beyond. To emphasize that the close-up figures, who seem seized with dizziness on the edge of the opening, belong to our own sphere, the artist sometimes makes them spill over into the space which is ours (as in the Palazzo Rezzonico, Venice, *c.*1758), or adds to the composition some real object, like the iron chain by which a stucco dwarf is holding a monkey—also in stucco—on the ceiling of the Palazzo Clerici, Milan. This device was not new; it had been used by the mannerists, sometimes with even greater virtuosity. In San Paolo Converso, Milan, for example, placards bearing Latin *sententiae* appear to be hanging straight down from the ceiling and are in fact painted on its surface; it takes a moment for the eye to perceive the deception. The Greeks were practising *trompe-l'oeil* in the fifth century BC; the trappings of the horses on the frieze of the Parthenon were made of bronze, and the horses and their riders were painted in natural colours.

The Teutonic soul embraced ceiling painting as a means of expressing its yearning for the infinite. Apart from the influence that Roman and Venetian decoration may have had on German artists who came to Italy to complete their training, the impetus was given at home by the Italians who come north to work as architects and decorators. The Roman style, with its architectural features, was introduced into Austria by Pozzo himself, who worked in Vienna between 1702 and 1709, notably on the decoration of the Jesuit Universitätskirche. Later, Lombards or Venetians—Carlo Carlone, Jacopo Amigoni, Giuseppe Appiani—and one Bartholomäus Altomonte whose father had changed his name from Hohenberg—introduced the Venetian style. The art of Tiepolo was widely known in Germany even before he created the wonderful ensemble of the Residenz in Würzburg (1750–3). To all these influences was added that of Rembrandt, with his love of chiaroscuro and dramatic lighting effects.

All these modes of expression of space were explored to the very limit by a host of artists.
pl. 327 Architectural perspective particularly attracted Kosmas Damian Asam, who in the dome of the choir of the Klosterkirche, Weingarten, closely imitates two domes by Pozzo, that of the mission church of Mondovi (1676), and the false dome in Sant' Ignazio, Rome, with columns supported by enormous consoles seen *sottinsù* (1690). We find ceilings with a unitary zenithal perspective (Bergmüller in the Augustinian church of Diessen, Johannes Zick in the palace of Bruchsal); in the delightful ceiling of the church of Steinhausen painted by Johann Baptist Zimmermann (1731), all the figures of the earthly realm (the Four Parts of the World) painted on the edge of the opening, make an assault in perspective on the heavens, in which shines the name of Jehovah, adored by the Virgin and angels. Other artists transposed the dancing rings of blessed souls from the circular domes of the Italians (such as Saronno) to oval baroque ceilings; Kepler's principle of the revolution of the planets in elliptical orbits—which as Erwin Panofsky has shown, Galileo himself rejected more from aesthetic considerations than scientific conviction—was henceforward to become part of the European imagination. The elliptical
pl. 324 shape is well suited to the portrayal of the Apocalypse on the oval ceiling of the church of Altenburg in Austria, painted by Paul Troger (1733); the ellipse of the dome of the Prunksaal

in the Hofbibliothek, Vienna, painted by Daniel Gran (1730) expresses the ever-widening scope of human knowledge.

The system most generally used is oblique perspective, the centre of interest being the part of the dome that is furthest from the eye, and which is seen first by the spectator coming from the entrance. In some cases, as he walks the length of a nave, different domes present a succession of oblique perspectives. In Ottobeuren his eye is struck as soon as he enters the church by the *Pentecost* painted by Johann Jakob Zeiller over the crossing in 1763. As the spectator moves forward, the scene unfolds before his eyes; and the artist has adjusted the perspective so that each new section of the dome that comes into view is designed to be seen from a point of view a little further down the aisle. Here space is dynamic, conceived for a spectator who is mobile; we have come a long way from the marble disc placed in the centre of the nave of Sant' Ignazio to mark the apex of the cone of vision. The spectator, distracted by the multiple points of perspective, experiences a sensation of dizziness.

pl. 329

The unity of architecture and vision, disturbed by the Venetian convention of the open ceiling, is re-established by the continuity of style between the rocaille decoration and the painting itself. The border of the ceiling is so intricately shaped that it is, so to speak, interlocked with the painting; stucco decoration and painted decoration interpenetrate (Altomonte at Wilhering, Zimmermann at Steinhausen). Sometimes the rocaille unfurls in waves into the space of the ceiling itself (Franz Spiegler at Zwiefalten); in the dining-room of the palace of Brühl, painted by Carlo Carlone, a luxuriant growth of rocaille mingles closely with the figures.

Towards the end of its evolution, and particularly in Germany, baroque ceiling painting turns from the theme of apotheosis to that of cosmic drama. Oblique views show fragile edifices toppling into an abyss (Bergmüller in the nave of Zwiefalten); jagged clouds unfurl like waves, and space explodes in a multiplicity of axes. Matthäus Günther in the Pfarrkirche at Goetzens places the vision off-centre in the oval dome, so that it appears to be revolving. In the Pfarrkirche, at Wilten (1754) the artist represents the *Triumph of Judith* in a chaos of forms suggesting an earthquake. Figures modelled in chiaroscuro sometimes evoke a storm at night, in which the blackness is relieved only by a few faint gleams. The Austrian Maulbertsch (1724–96), with his scenes of eddying, smoky darkness shot through with flashes of reddish light, creates on his ceilings the insane world of Magnasco; his paintings are apt expressions of the end of a civilization. The Teutonic genius, which had received from Italy a vision of beatitude, transformed it into a glimpse of the mouth of hell.

pl. 330

pl. 328

PL. XXI

The domain of illusionism extended beyond the ceilings to the walls of the palace. While in the eighteenth century the French sought for the intimate, restful quality of panelling with abstract decoration, the Venetians, followed by the Germans, peopled their walls with a host of painted figures. Italians are so gregarious that in the closed world of home they are afraid of being alone; the walls of eighteenth-century rooms, as a precaution, are often painted with the figures of visitors about to open the door—a motif borrowed by Veronese from antique decoration. In the Villa Lechi at Mortirone, near Brescia (1745), the walls of the grand ballroom are

pl. 320 adorned with fantastic *trompe-l'oeil* edifices. On one wall a man and a woman, accompanied by a dog, can be seen descending a large oblique staircase; the illusion is perfect, and this might be a theatre rather than a dwelling. The master of the house, on days when he was not receiving, could converse with these dream figures. *Trompe-l'oeil* paintings were used extensively to make the house into a palace of illusion. Nor was rationalist France exempt from this spirit of fantasy. Jean-François Nicéron (1613–46), a Paris-born monk of the Order of Minims who was an enthusiast for perspective and anamorphoses, describes the Château d'Essonnes, belonging to Hesselin, counsellor and *surintendant des plaisirs du roi,* as an enchanted palace. Nicéron took Queen Christina of Sweden on a guided tour. As one entered, the walls disappeared, and one saw a succession of immense halls, grottoes, clouds bearing a blazing town or a chariot of Fame; a series of doors to various apartments, the first of which was guarded by two porters, whom one thought to be merely painted, but who detached themselves from the wall and danced; automata, transformation scenes, anamorphoses, optical illusions based on systems of accelerated perspective, all made the house into an unstable, absurd, fairylike world.

German decorators obtained similar results with distorting mirrors, which fragment the image. The drawings of Leonardo, himself a contriver of illusions, include an octagonal room lined with mirrors. Any trick is possible between object and reflection; the palace of Rosenborg in Copenhagen still contains a small mirror room in which the marquetry floor is reproduced on the ceiling, and an oval mirror set into the centre of the floor in turn reflects the reproduction.

There is another form of *trompe-l'oeil* which consists in using things in the opposite sense to that for which they were intended, transforming rigidity into movement, or making marble and *pl. 140* bronze tremble. The bronze valances of Bernini's Baldachin in St Peter's are fluttering in an imaginary wind. Bernini loved to juggle with heavy masses; having to design a fountain for the *pl. 317* Piazza Minerva in Rome, he amused himself by sketching the vain efforts of an athlete to hoist an obelisk on to a rock. Thus the paradigm of eternity, the gnomon which by its shadow marks the passing of the hours, has become the symbol of instability; nothing less than an elephant will do to shoulder the unstable burden of time.

232 Orazio Gentileschi (*c.* 1565–1639). Lute player

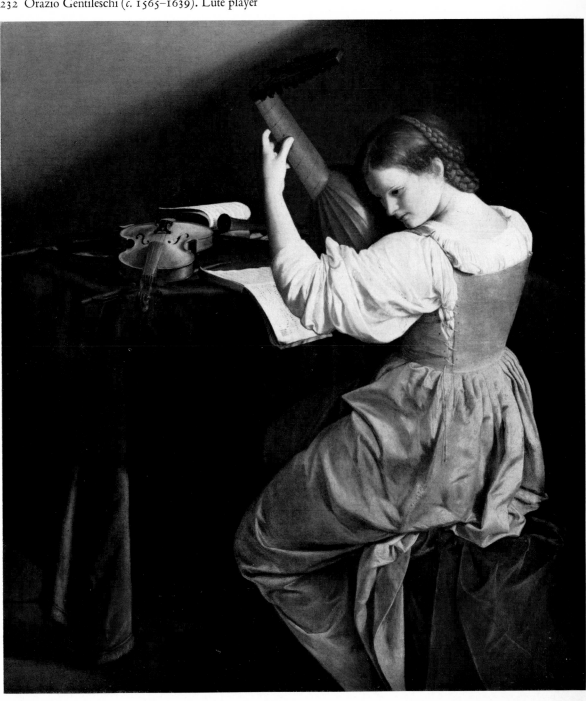

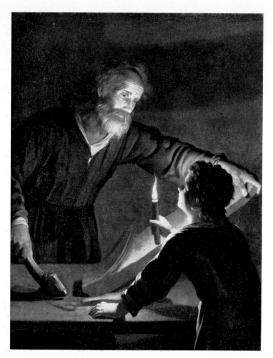

233 Gerard Honthorst (1590–1656). St Joseph the Carpenter

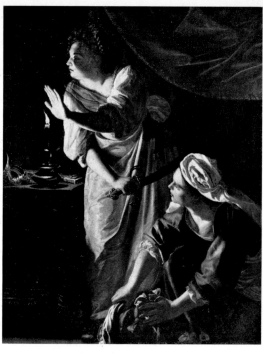

234 Artemisia Gentileschi (1597–1651). Judith and Holofernes

Italian romanticism

Melancholy, a profound sense of solitude weighing on the soul, *angst* expressed in elusive, flickering chiaroscuro, a sadistic taste for drama, pain, even cruelty, a preference for low company, caricatures of a decadent aristocracy: all these manifestations of eternal romanticism are present in Italian baroque painting. Far more

235 Bernardo Strozzi (1581–1644). Three Fates

236 Sebastiano Mazzoni (d. *c.* 1683). Portrait of a captain of halberdiers

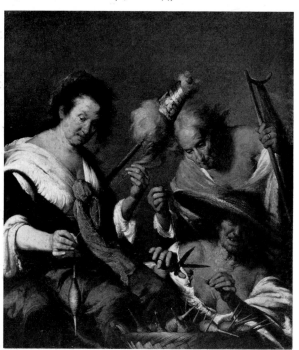

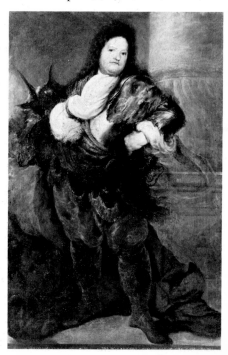

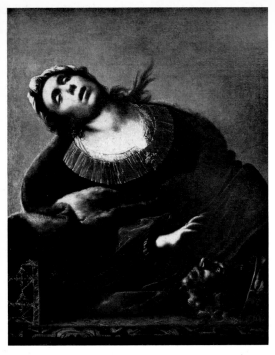

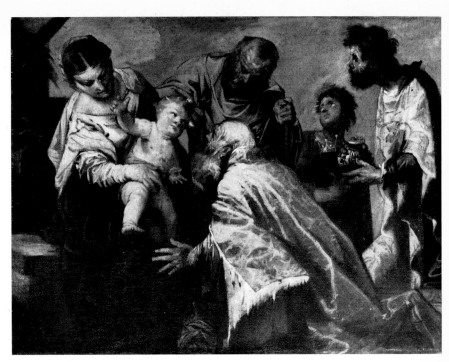

237 Francesco del Cairo (1598–1674). Herodias

238 Francesco Maffei (*c.* 1620–60). Adoration of the Magi

than the romantics of the nineteenth century, constrained as these were by the aesthetic and the technique of neoclassicism, the seventeenth- and eighteenth-century romantics were free to draw on all the inexhaustible technical resources of the art of painting.

239 Vittore Ghislandi (1655–1743). Portrait of Isabella Camozzi de'Gherardi

240 Gaspare Traversi (1732–69). Brawl

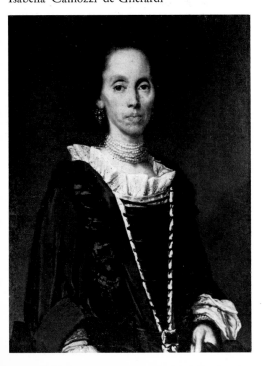

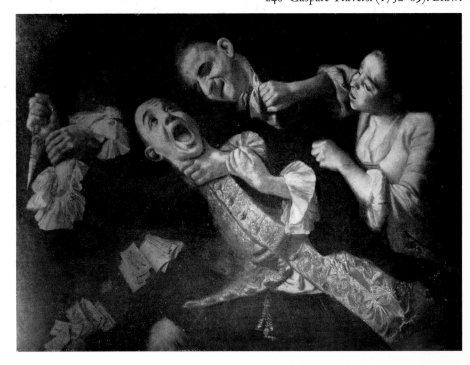

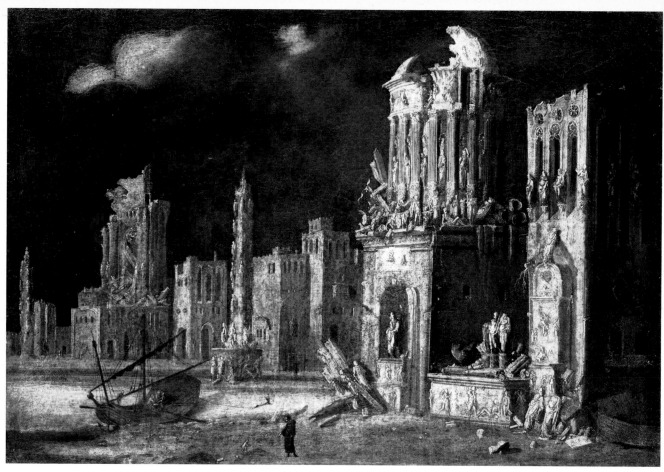

241 'Monsù Desiderio'. Fantastic ruins with a vision of St Augustine

Apocalyptic visions

The profound malaise which underlies the assertive hedonism of the baroque age inspired certain artists with the vision of an apocalyptic universe peopled with monsters, witches, madmen and freaks, where buildings topple, and where the light of day succumbs to the triumphant onslaught of darkness. This form of expression, fostered by the freedom of baroque painting technique, loses all its suggestive power in the neoclassical brushwork of the Swiss Fuseli.

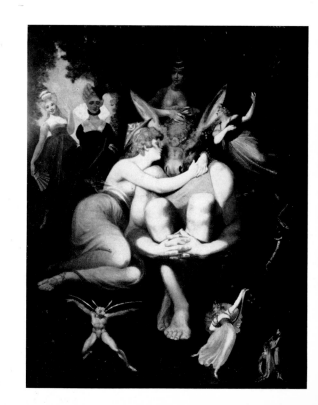

242 Henry Fuseli (1741–1825).
Titania and Bottom

244 Alessandro Magnasco (1667–1749). Woman and soldiers at table

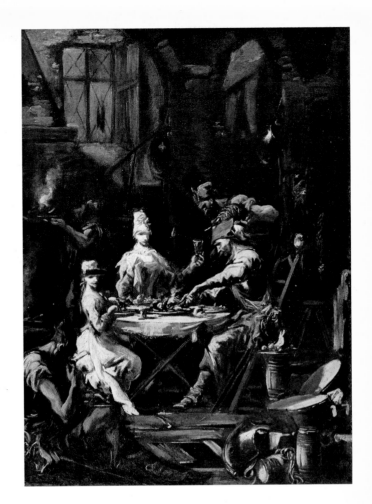

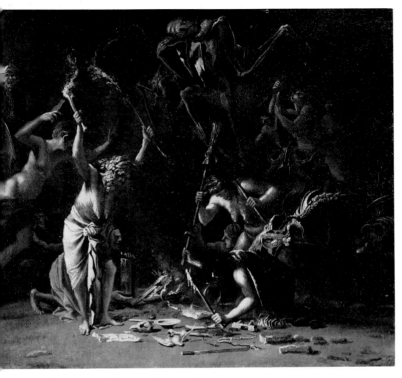

243 Salvator Rosa (1715–73). Witches

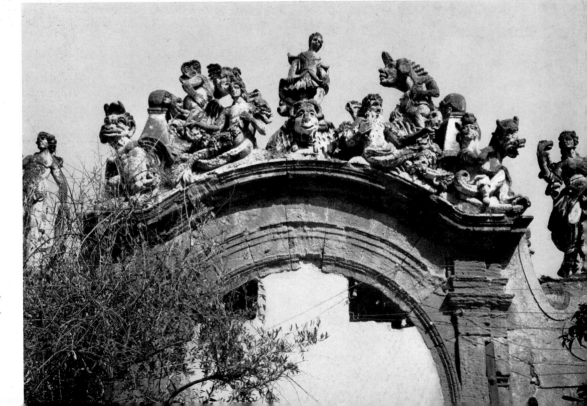

245 Grotesques, Villa Palagonia,
Bagheria, near Palermo, 1774–82

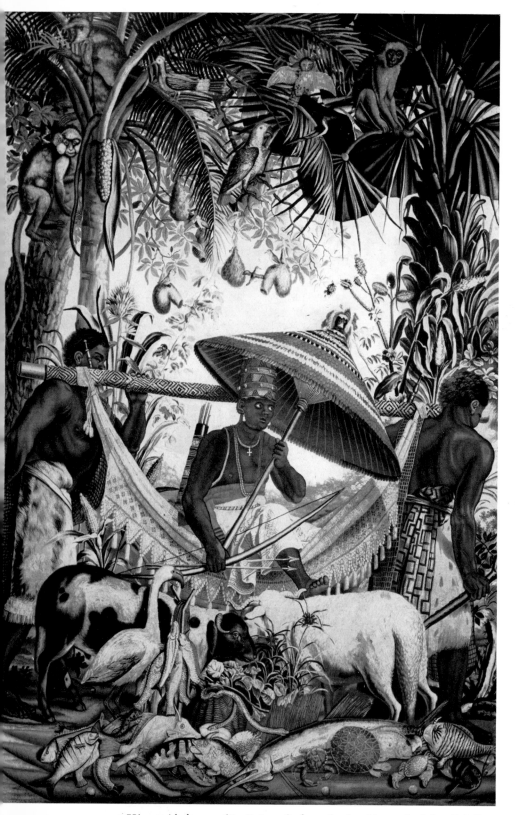

246 King with bearers (*Le Roi porté*), from the first *Tenture des Indes*, Gobelins, Paris, 1687

The *Tenture des Indes*

The documentary paintings of Van der Eeck-hout and Post (*pl. 249*), brought back from Brazil by the expedition led by John Maurice of Nassau, were given or lent by their owner to Louis XIV for the making of a series of tapestries which deal with the fauna, flora and inhabitants of the 'Indies', in this case Brazil. This series was so successful all over Europe that the cartoons wore out, and had to be remade, three times. In the eighteenth century, Jean-Louis Desportes reproduced the cartoons again, with certain modifications; this new series was called the *Nouvelles Indes* ('New Indies') to distinguish it from the earlier *Anciennes Indes*.

The captive

The defeated Moorish slave is a motif which appeared in art in the sixteenth century as a sign of triumph after the battle of Lepanto. At the end of the seventeenth century, the Colonna family added to their Roman palace a great gallery, the ceiling of which represents this great victory, in which Marcantonio II Colonna commanded the Papal fleet; and the gilt wooden console tables which adorn the gallery are supported by figures of Moorish slaves.

After the Moors, a further inspiration for the theme of the fettered slave was furnished by the defeat of the Turks in the 1680s by an alliance led by Austria. In the state apartments of the monastery of Sankt Florian, on Prince Eugene's bed, a Turk and a Magyar in chains commemorate the victories of this famous general.

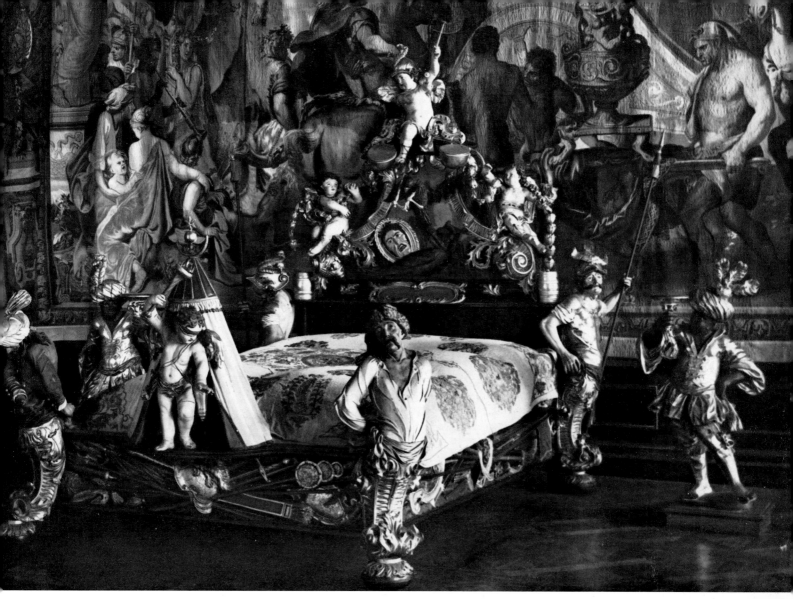

EXOTICISM

247 Prince Eugene's bed, in Kaiserzimmer, Sankt Florian, Austria, eighteenth century

248 Console table with figures of Moors, in Palazzo Colonna, Rome, seventeenth century

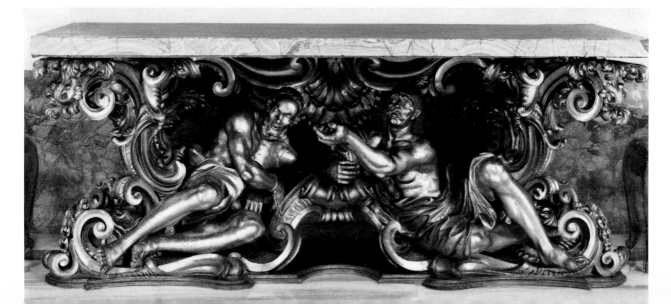

249 Frans Post (*c.* 1612–80). Oxcart in Brazil

250 Claude Audran III (1658–1734). Grotesques

251 Amédée van Loo (1719–95). Sultana with odalisques embroidering

Exoticism rarely proceeds from direct observation, as in the Brazilian studies of Frans Post. More frequently it is invested with a touch of theatricality, as in Van Loo's *Sultana,* or serves as a pretext for fantasy, as in Audran's grotesques.

Turquerie

The Turks were in fashion long before the Chinese, no doubt as a result of the conflicts which brought them into direct contact with the West, whether in the Mediterranean or in the Carpathians. Turkish life inspired numerous paintings, tapestries and garden designs.

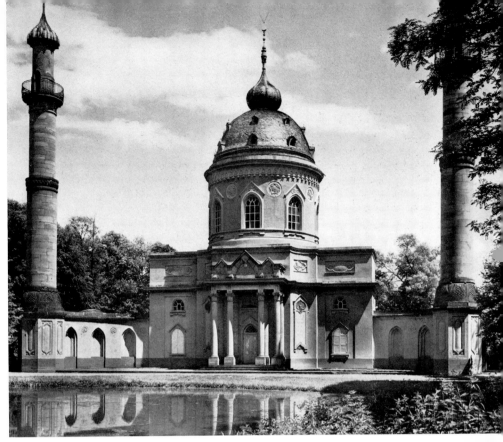

253 Nicolas de Pigage (1723–96). Mosque of the Moslem Troubadour, Schwetzingen, *c.* 1780

254 Carl Fredrik Adelcrantz (1716–96). Turkish 'tent', Drottningholm, Sweden, 1781

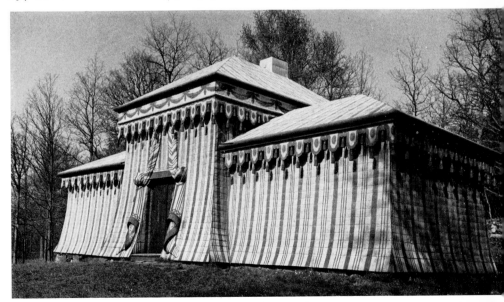

252 Jean-Etienne Liotard (1702–89). Countess of Coventry in Turkish costume

253

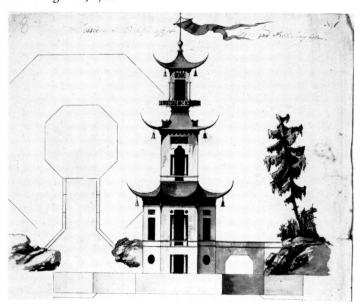

255 Jean-Louis Desprez (1743–1804). Design for Chinese pavilion, Drottningholm, 1788

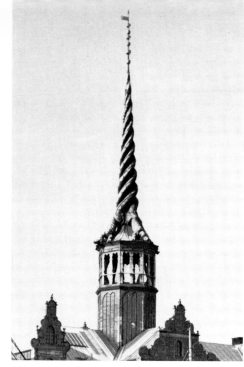

256 Christian IV of Denmark (1577–1648). Spire of Royal Exchange, Copenhagen, 1620–40

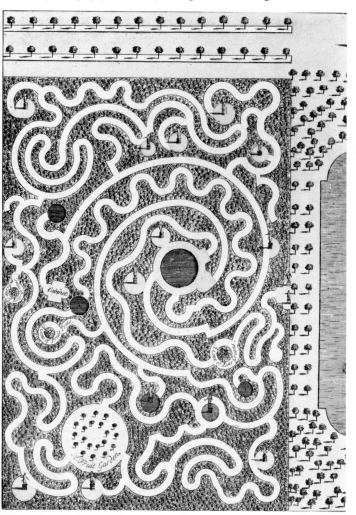

257 Batty Langley (1696–1751). Design for Chinese garden

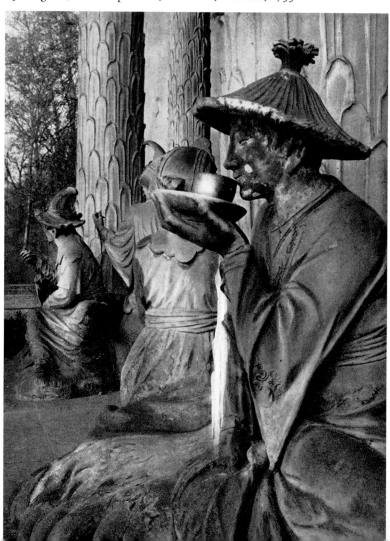

258 Figures, Chinese pavilion, Sanssouci, Potsdam, 1755

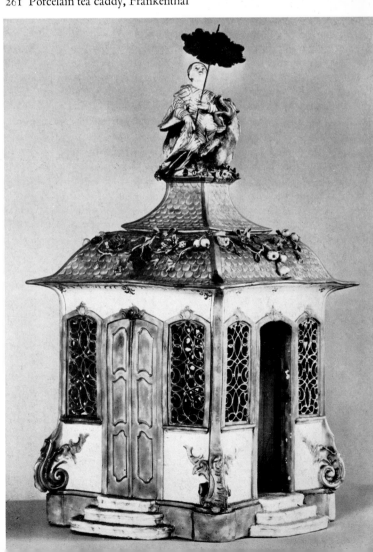

259 Décor in Gabinetto Cinese, Palazzo Reale, Turin, eighteenth century

Sharawaggi

Chinese art became so fashionable in the course of the eighteenth century that it exerted an influence on the development of rococo, notably in Great Britain, where there developed the English or 'Anglo-Chinese' garden, with its sinuosities and natural irregularities (*sharawaggi*), which subsequently displaced the regularity of the 'French garden' all over Europe.

260 Porcelain décor, oval room, Museo di Capodimonte, Naples

261 Porcelain tea caddy, Frankenthal

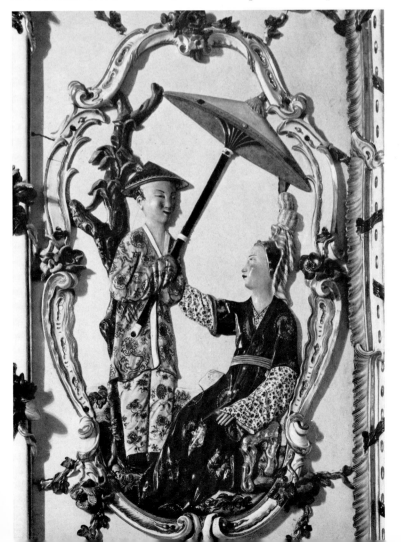

262 Porcelain barber's bowl, Kakiemon style, Saxony, eighteenth century

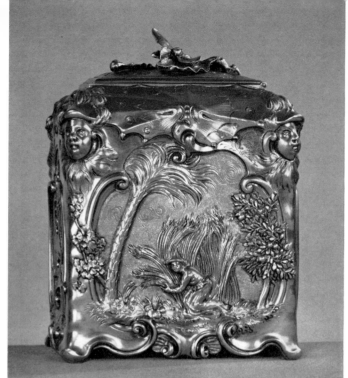

263 Silver tea caddy, London, 1748

264 R. J. Hoppesteyn (c. 1650–92). Jar, Delft, c. 1690

265 Plate with 'Hob in the well' motif, Chelsea, eighteenth century

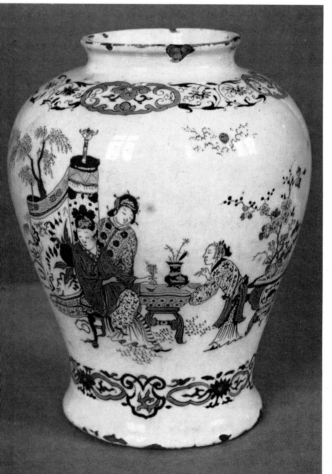

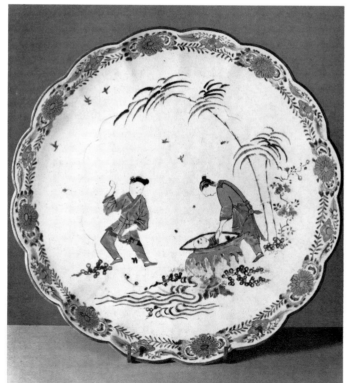

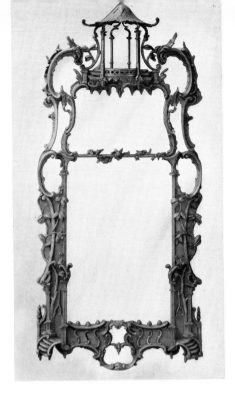

266 Thomas Chippendale (*c.* 1709–79).
Mirror, *c.* 1760

Chinoiserie

It was through the importation of porcelain, which was produced in China on an industrial scale, that Chinese decoration reached Europe. The makers of Delft and Nevers ware were the first to imitate this decoration, and in the eighteenth century the fashion spread to jewellery. The Chinese also exported lacquers, textiles, wallpapers, silks and painted fabrics; the various East India Companies of Europe were set up to handle the trade in these goods and in spices.

267 Jean-Philippe Carel (*fl.* 1712). Lacquer commode

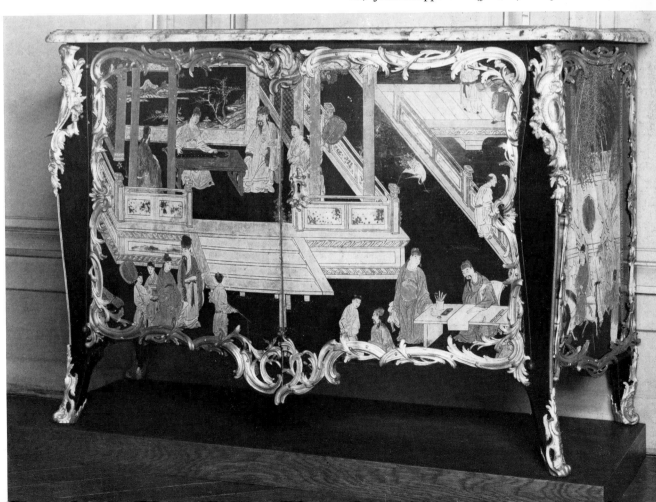

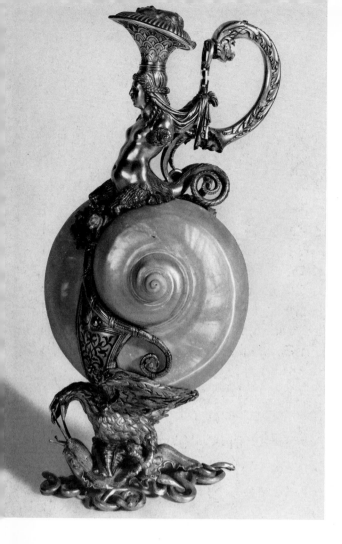

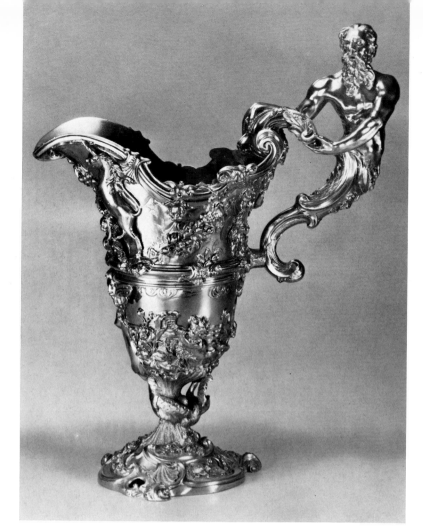

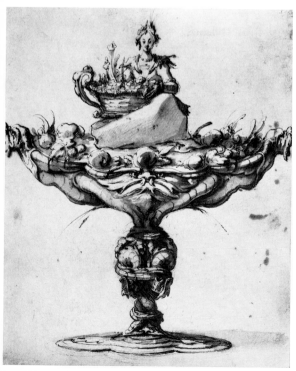

268 Wenzel Jamnitzer (*c.* 1550–99). Ewer

269 Paul de Lamerie (1688–1751). Gilt ewer

270 Jacques Callot (1592–1635). Design for centrepiece

271 Charles Kandler (*fl.* 1734). Wine-cooler

272 Adam van Vianen (*c.* 1569–1627). Ewer

ART NOUVEAU

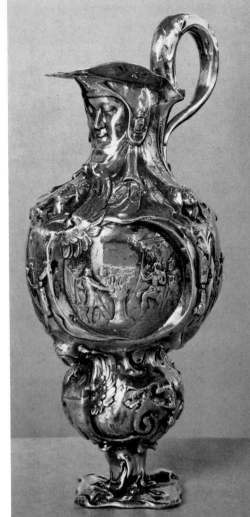

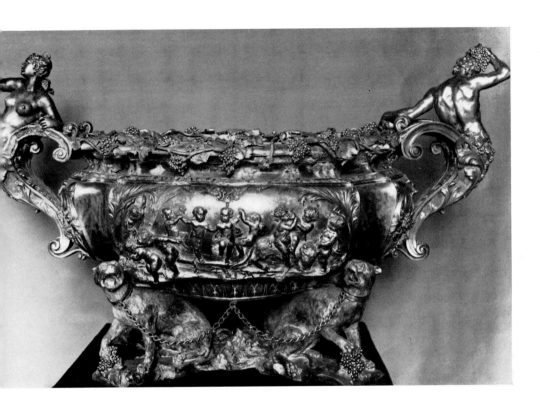

Metalwork

Baroque artists, to rid themselves of the antique formal vocabulary revived at the Renaissance, often succumbed to the temptation to turn directly to the forms of nature. It is this that often gives their creations an extraordinary affinity with Art Nouveau. The Dutch goldsmiths of the mannerist period were the first to introduce this new mode of expression; from the Dutch goldsmiths of the eighteenth century it reached those of England. It is curious that in the nineteenth century it was again the jewellers and goldsmiths who invented Art Nouveau proper.

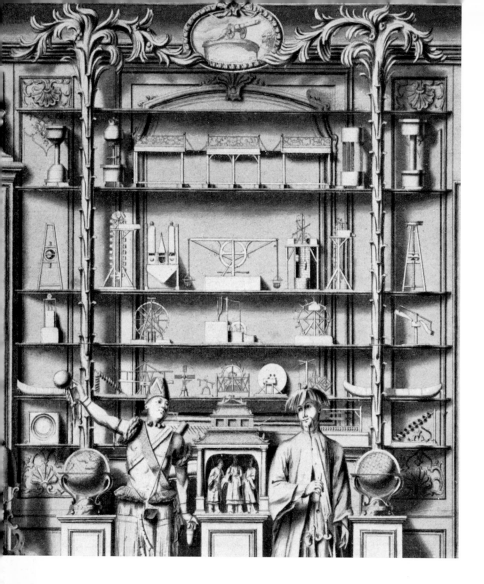

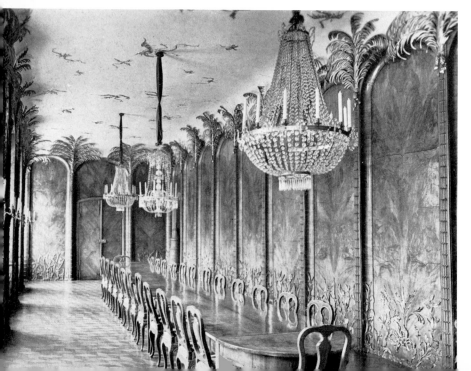

273 Physics exhibit, Cabinet Bonnier de la Mosson, Paris (engraving after Courtonne)

274 Base of fountain, Córdoba, eighteenth century

275 Johann Baptist Pedrozzi (1710–78). Zedernsaal, Neues Schloss, Bayreuth

Vegetable forms

Like the nineteenth-century craftsmen and designers of Art Nouveau, the baroque artists in their moments of greatest imaginative freedom transposed forms from the vegetable kingdom directly into their creations. The palm tree, which combines the charm of the exotic with the charm of intricate outline, was a frequent source of inspiration. The pulpit of Saint-Pierre in Louvain would be more at home in a setting built in 1900.

276 Jacques Berger (1693–1756). Pulpit, Saint-Pierre, Louvain, 1742

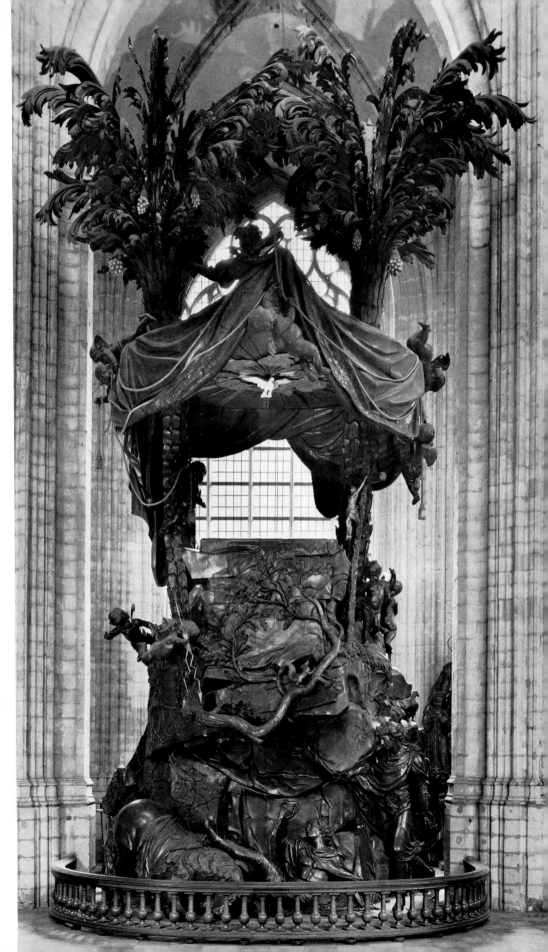

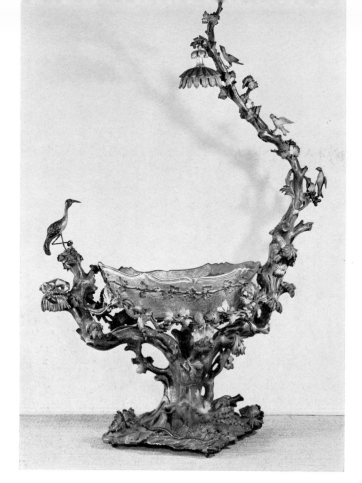

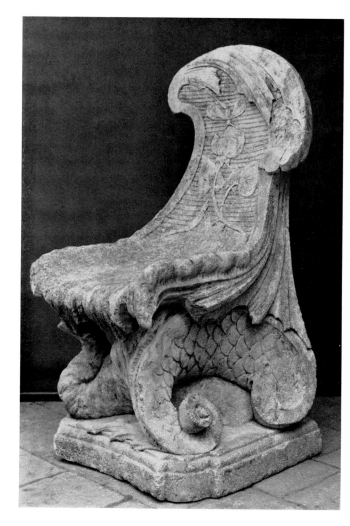

277 Wooden cradle, Venice, *c.* 1750

278 Stone garden seat, Germany, eighteenth century

279 Pavilion of the Hermits, Eremitage, Bayreuth, 1715

Like the practitioners of Art Nouveau, the baroque artists were occasionally tempted by nature in its crude state: jumbled 'rocks' (skilfully dressed to give the impression of nature), visions, indeterminate forms reminiscent of the depths of the sea.

With the exception of the monstrous furniture sculpted by the Venetian Brustolon, the Italian baroque remained faithful to traditional patterns of ornamentation. Spain, on the other hand, which in the nineteenth century was to be the home of Gaudí, produced in the baroque age some delirious premonitions of *fin-de-siècle* exuberance.

280 Narciso Tomé (*fl.* 1715–38). Transparente (detail), Toledo cathedral, 1721–32

281 Ignacio Vergara (1715–76). Doorway, Casa de Dos Aguas, Valencia

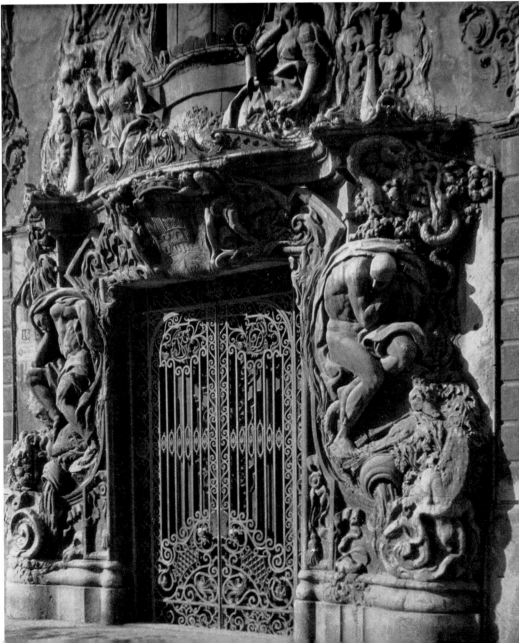

282 Raphael (1483–1520).
Virgin and Child with St John

283 Bachiacca (1494–1557).
Virgin and Child with St John

284 Sassoferrato (1609–85).
Virgin and Child

Academicism

The transmission across more than three centuries of types of *Virgin and Child* invented by Raphael is a typical example of the wilful inertia, founded on respect for the great masters, which is the basis of much art-school teaching and lies at the root of academicism.

286 Raphael (1483–1520). Sistine Madonna (detail)

287 Jean-Dominique Ingres (1780–1867). Vows of Louis XIII (detail: Virgin and Child)

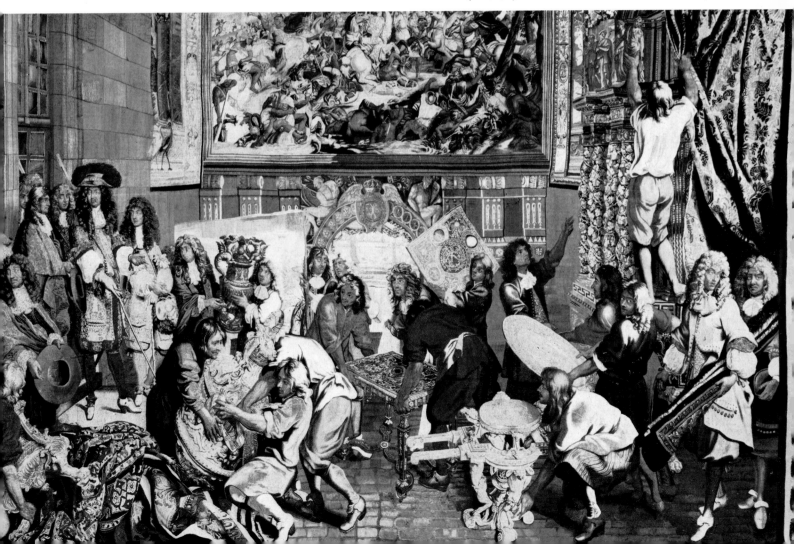

285 Pompeo Batoni (1708–87).
Virgin and Child

Governments intervene

The institutionalization of art teaching in official academies, and that of decorative craftsmanship in official factories, are two sides of the same coin; this is most clearly illustrated in the reorganization of artistic production carried out by Colbert in the reign of Louis XIV, when the Gobelins factory was set up.

288 After Charles Le Brun (1619–90). Louis XIV visits the Gobelins factory

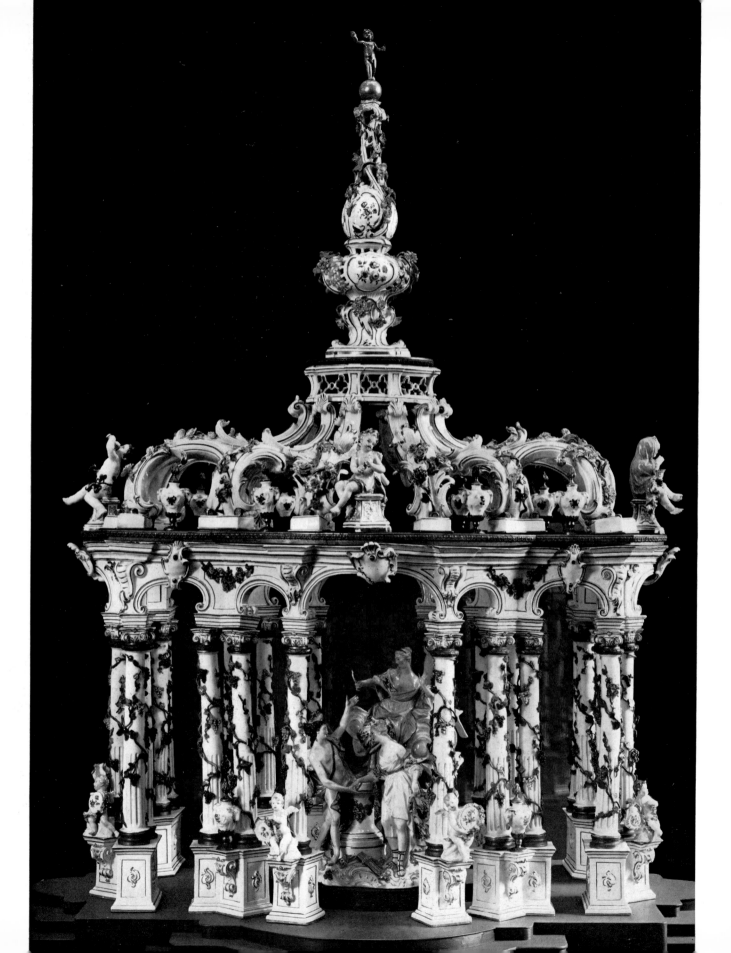

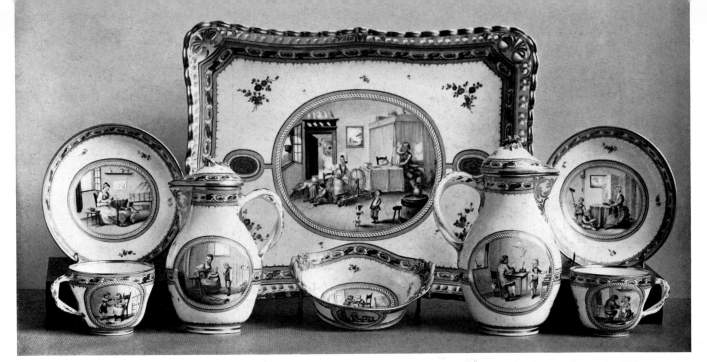

290 Porcelain coffee service, Vienna, 1760

289 Johann Joachim
Kändler (1706–75).
Porcelain love temple,
Meissen

Porcelain mania

Discovered in Saxony in 1709 by a researcher working for the Elector Augustus the Strong, the 'secret' of Chinese porcelain gradually spread throughout Europe. The manufacture of this translucent ware inspired a passionate rivalry among the aristocracy. Great lords, even kings, accorded their protection or their support to porcelain factories.

291 Porcelain plaque showing Maria Theresa, Doccia, 1745

292 Plate with allegory of Architecture, Alcora, before 1750

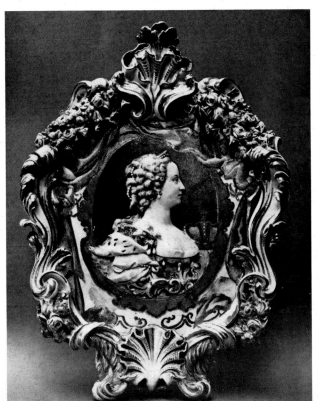

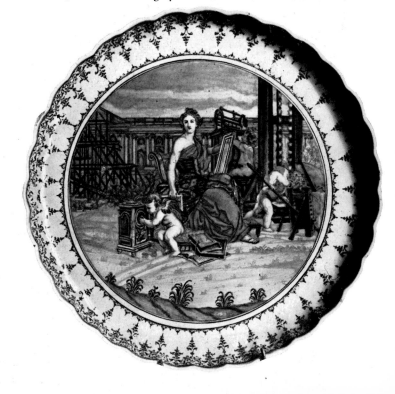

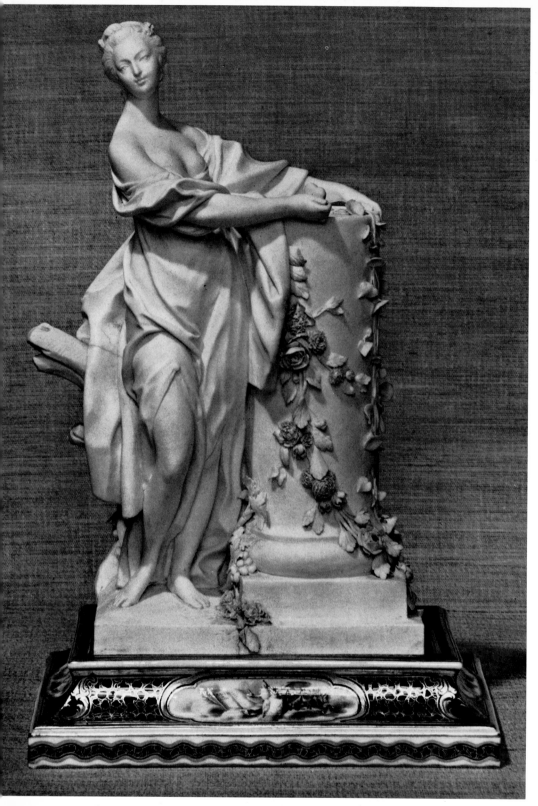

French factories (Rouen, Sceaux, Saint-Cloud, Chantilly, Mennecy) took up the manufacture of soft-paste porcelain, which contains no kaolin and is difficult to work. In 1745 a factory at Vincennes was granted a twenty-year franchise to imitate Saxon hard-paste porcelain; it moved to Sèvres in 1756. In 1759 it became the personal property of the king, and his favourite Mme de Pompadour took a particular interest in it. The products of Sèvres very soon fetched high prices and were in great demand. The king presented services made at Sèvres to Empress Maria Theresa, the Elector Palatine, the Duchess of Bedford, the king of Denmark, the king of Sweden and Emperor Francis II. Catherine the Great commissioned a service of 106 pieces.

293 Porcelain figurine of Mme de Pompadour as Friendship, Sèvres, c. 1760

294 Nicolas Ransonnette (1745–1810). Title page of *L'Art de la porcelaine*, 1771

295 Retrospective decree of Louis XV incorporating the Sèvres factory as a crown institution, 1760

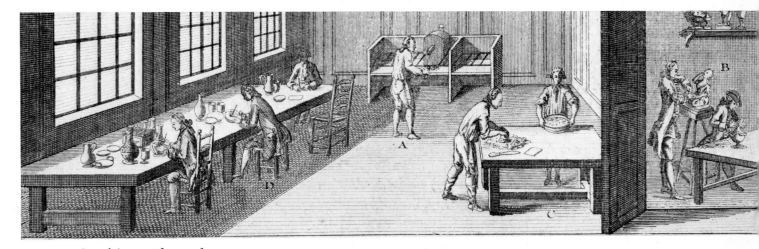

296 Porcelain manufacture, from the *Encyclopédie* of Diderot and d'Alembert, 1777

297 Porcelain teapot, Vincennes, *c.* 1750

269

298 Faience wine-cooler, Moustiers, France, eighteenth century

Faience

Throughout the seventeenth and eighteenth centuries, earthenware or faience enjoyed a period of splendour all over Europe, and most particularly in Holland and France. Chinese and other Oriental influences contributed to this process by emancipating potters from their Italian models. Dutch faience (tableware at Delft, wall tiles elsewhere in the country) was imitated all over Europe in the eighteenth century. Production in France (in Rouen, in the eastern provinces and in Provence) was powerfully stimulated by a royal prohibition on the use of gold and silver plate. The painters of the workshops of Marseilles and Moustiers, notably Olérys, demonstrate an inventive resource, a sense of ornamental rhythm and a delicacy of execution which set them on a par, as creative artists, with the great goldsmiths.

299 Faience figurine of William of Orange, Delft, eighteenth century

300 Faience dredger, Rouen, eighteenth century

The golden age of furniture

The rise of furniture design was a French phenomenon, reflecting the refinement of French high society. In the eighteenth century, French cabinet-makers created a profusion of forms adapted to all the purposes of life. They produced everyday pieces, but also a great number of luxury articles adorned with gilt, bronze and marquetries, which were in enormous demand at court and among the aristocracy.

301 Desk, France, eighteenth century

302 'BVRB'. Desk, Paris, eighteenth century

303 'BVRB'. Desk with Oriental lacquer, Paris, eighteenth century

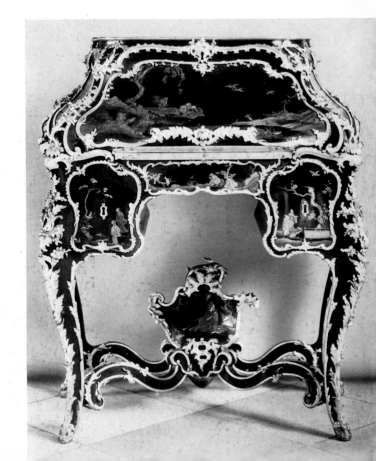

REGRESSION

304 Bas relief of
St Valentine, Veneto, 1662

305 Altar,
Fazen de Santo Antonio,
São Paulo, Brazil

306 Ivar Gundersen Övstrud
(1711–75). Stone coffer
(detail: Angel)

307 Jaguar (detail),
Embú, Brazil,
eighteenth century

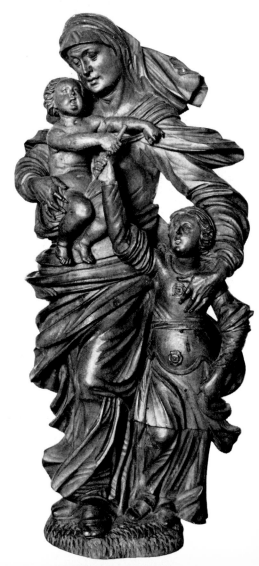

308 Christoph Daniel Schenk
(d. 1691).
St Anne, Einsiedeln

Reversion to the primitive

The art of the metropolitan élite in the baroque age was in a constant process of evolution; popular art, on the other hand, and the art of remote provincial and colonial centres, manifested the curious tendency to regress towards earlier stages of formal development, whether primitive (*pl.304*) or medieval (*pl.306*). In Brazil and Portugal this phenomenon took numerous forms: some pieces call to mind Chinese (*pl. 307*), Carolingian (*pl.305*) or Gothic (*pl.309*) analogies. In Spanish America, the techniques of pre-Columbian sculpture reappear in the work of native craftsmen.

309 Virgin, Santuario, Alcobaça, Portugal, 1667–72

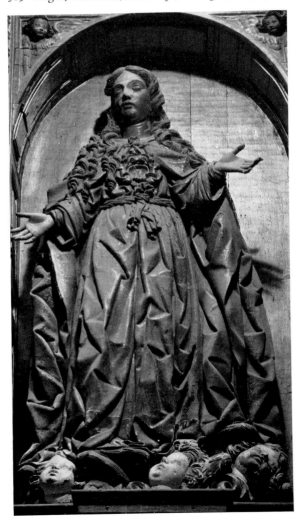

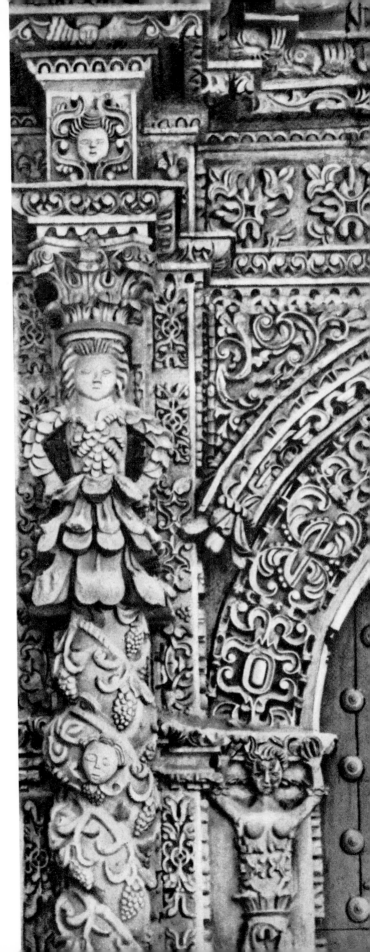

310 Doorway of San Lorenzo, Potosí, Bolivia

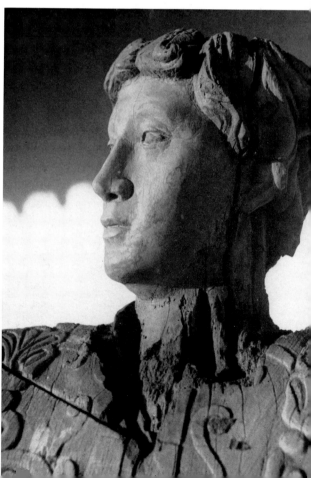

Medieval forms

In Brazil, in a province subject to the Jesuit mission which ruled Paraguay, where the only crafts-men were Indians, there have been found a group of statues which evoke all the great styles of Western art: Romanesque (*pl. 312*), Gothic (*pl. 311*), Renaissance (*pl. 314*), mannerism (*pl. 313*). This return to the sources of the European artistic tradition culminated in the work of O Aleijadinho, who recaptures on occasion all the expressive force of Claus Sluter.

311-14 Anon. Saints (details), São Miguel, Rio Grande do Sul, Brazil, seventeenth and eighteenth centuries

315 O Aleijadinho (1738–1814). Isaiah (detail), Bom Jesus, Congonhas do Campo, Brazil, 1800

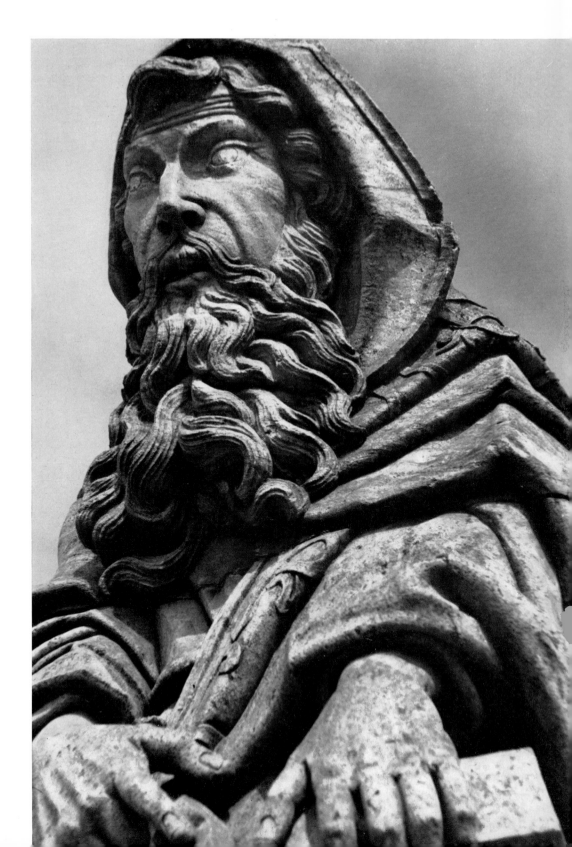

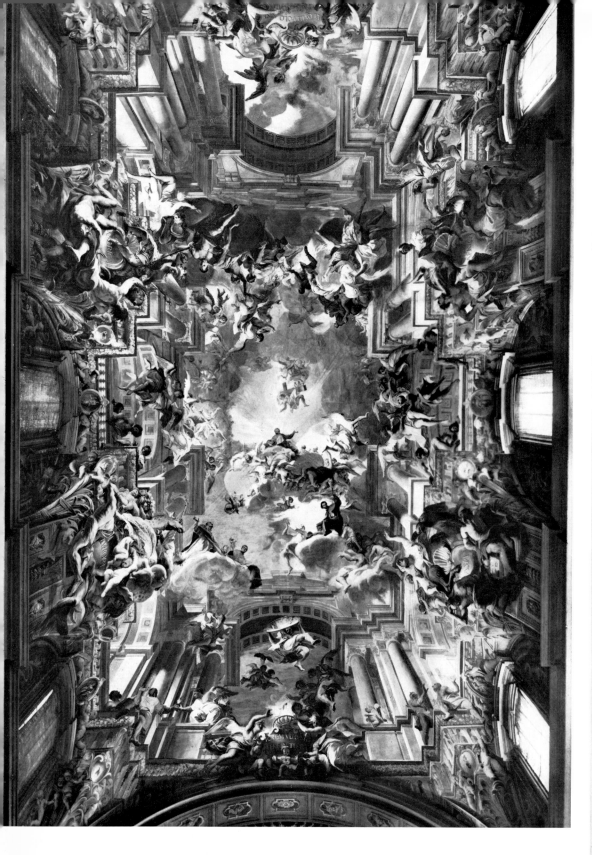

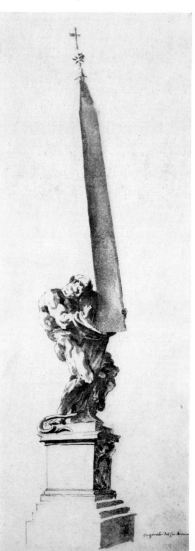

316 Andrea Pozzo (1642–1709). Allegory of the Jesuit missions, Sant' Ignazio, Rome, 1691–94

317 Giovanni Lorenzo Bernini (1598–1680). Design for fountain, Piazza Minerva, Rome

TROMPE-L'OEIL

The twofold illusion

The intentions may be poles apart, but Italian and Dutch artists seek the same goal: to deceive the eye. The Dutch would have us believe in the presence of the real objects which they paint; the Italians would have us believe in the reality of the imaginary world which they create on the ceilings of palaces and churches.

318 David Bailly (1584–1657).
Vanitas: still-life with portrait of young artist

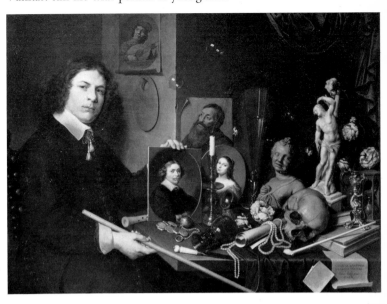

320 Giacomo Lecchi and Carlo Carlone (1686–1776).
Frescoes, Villa Lechi, Mortirone, 1745

319 Filippo Juvarra (*c.* 1676–1736), Stage design

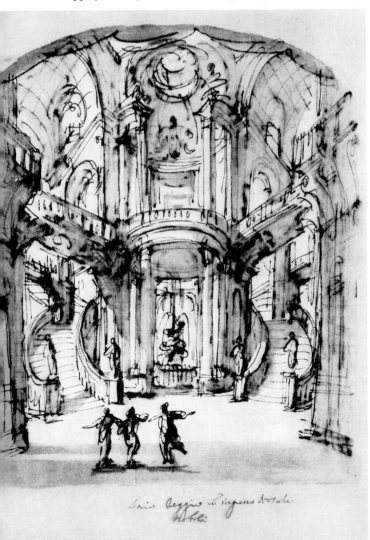

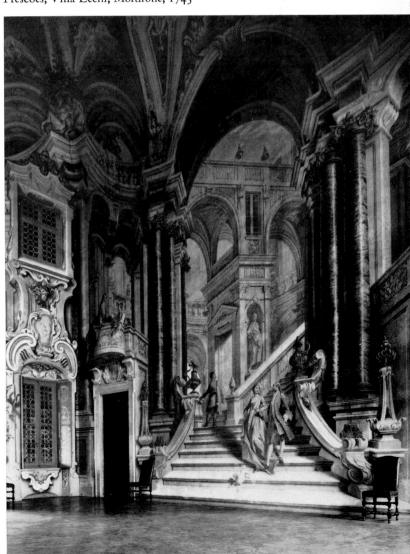

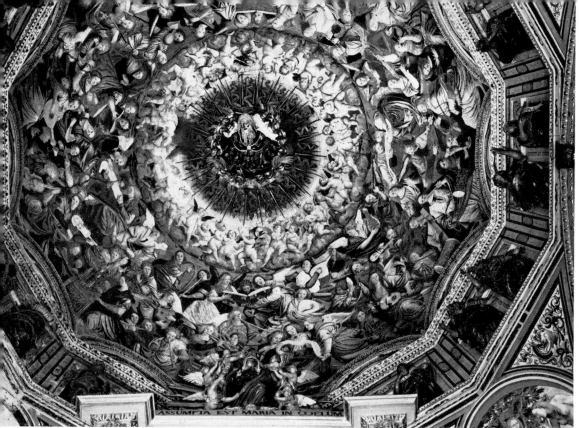

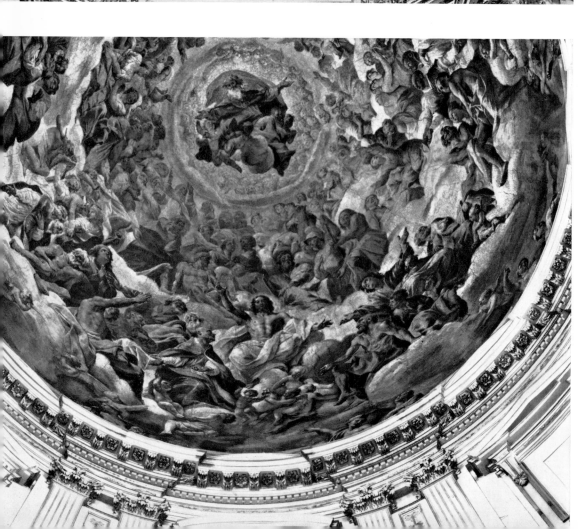

321 Gaudenzio Ferrari (c. 1480–1546). Dome of Madonna dei Miracoli, Saronno, 1534

322 (left) Giovanni Lanfranco (1582–1647). Dome of San Gennaro chapel, Naples cathedral, 1641

323 (above) Pietro da Cortona (1596–1669). Dome of Santa Maria in Vallicella, Rome

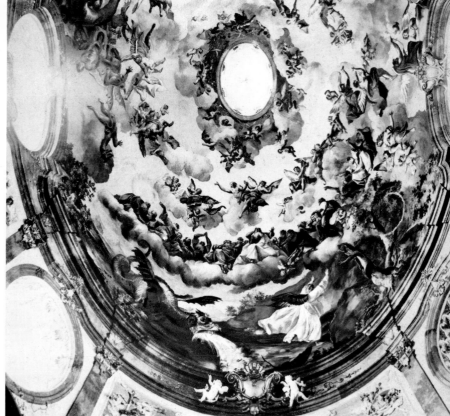

324 Paul Troger (1698–1762). Dome of Stiftskirche, Altenburg, Austria

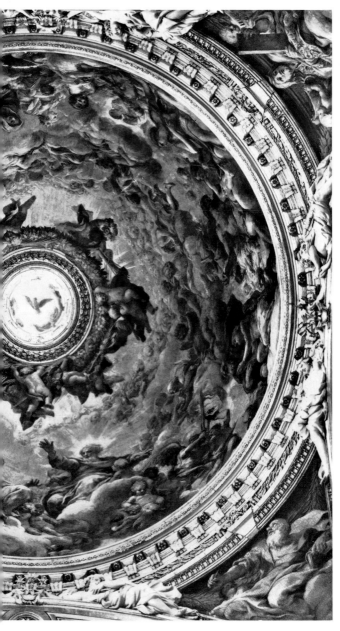

Celestial orbits

Since Correggio, the dome has been a favourite setting for the celestial spectacle of angels and blessed souls soaring in concentric orbits amid the clouds; in the eighteenth century circular motion was transformed on occasion into an ellipse, which gives the spectator the illusion of a dilation projecting the forms beyond the confines of the building.

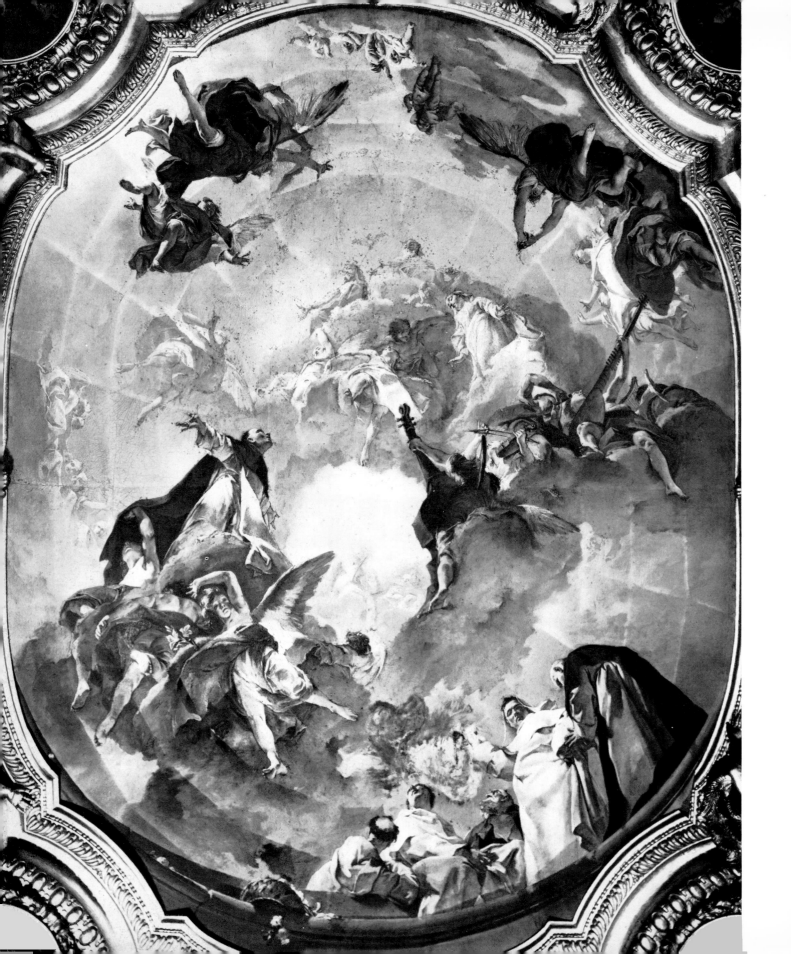

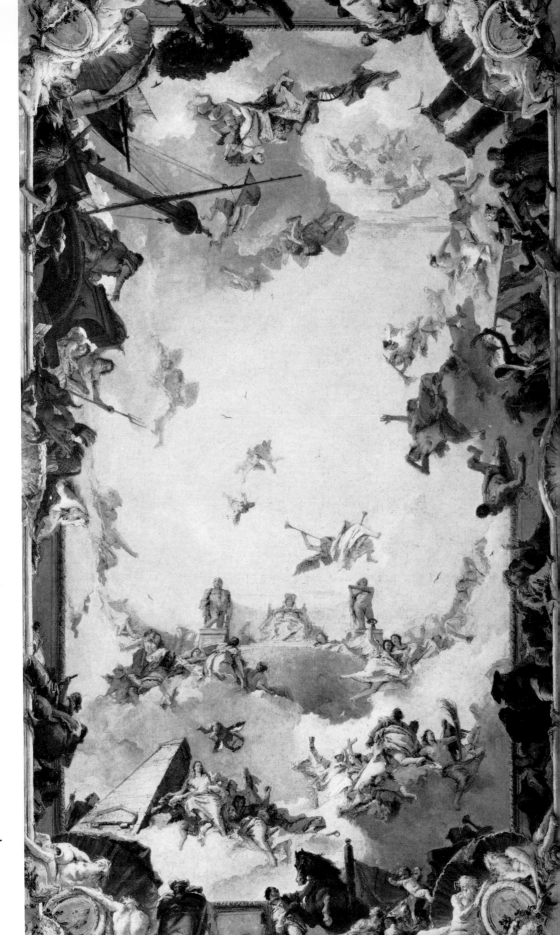

Venetian ceilings

The Venetians invented a form of *trompe-l'oeil* which is based neither on geometrical perspective (*pl. 327*) nor on orbital motion (*pl. 323*). Depth, or rather altitude, is suggested by gradations of lighting: the sky becomes more and more transparent as the forms recede from the spectator, losing themselves in the infinite.

325 Giambattista Piazzetta (1682–1754). Dome of SS.
Giovanni e Paolo, Venice, *c.* 1725

326 Giovanni Battista Tiepolo (1696–1770). The world pays homage to Spain

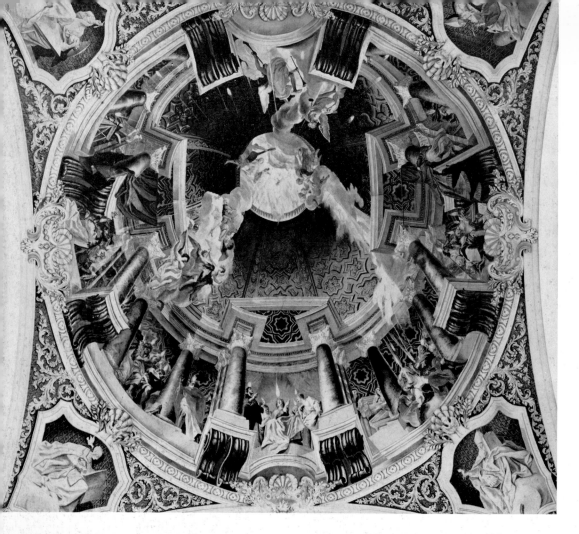

German ceilings

After drawing inspiration from the geometrical perspective system of Pozzo (*pls. 327, 329*), German artists launched into an exploration of spatial problems postulating a mobile, not a stationary spectator. They sought oblique viewpoints and compositions pivoting about several axes.

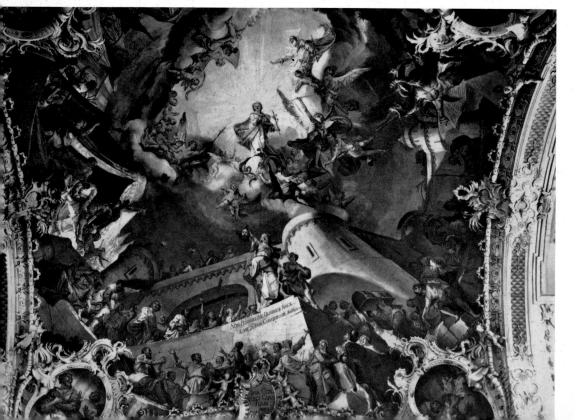

327 Kosmas Damian Asam (1686–1739). Ceiling of choir, Klosterkirche, Weingarten, Germany

328 Matthäus Günther (1705–88). Triumph of Judith, Pfarrkirche, Wilten, Bavaria, 1754

329 Johann Jakob Zeiller (1708–83). Pentecost, dome above crossing, Ottobeuren, Swabia, 1763

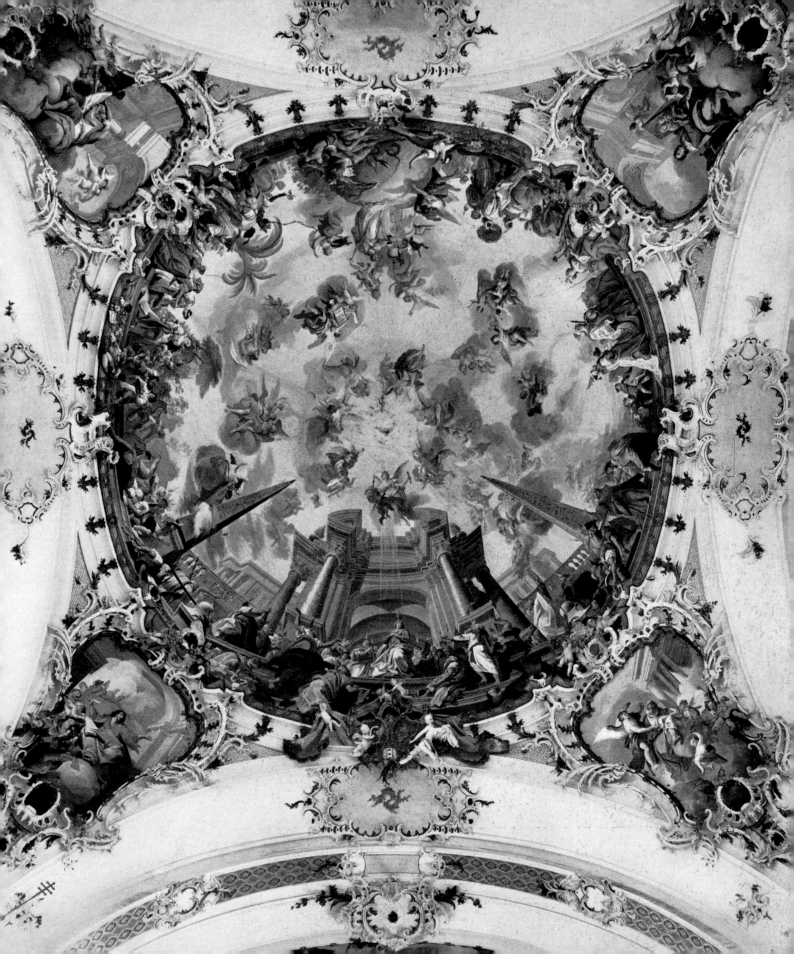

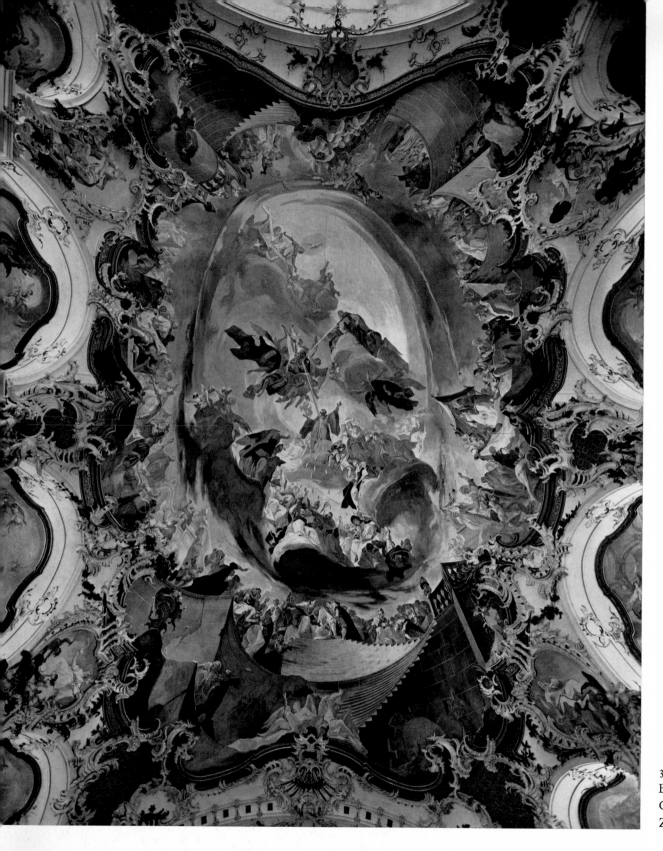

330 Johann Georg
Bergmüller (1688–1762).
Ceiling of nave,
Zwiefalten, Bavaria

The spiral

The serene orbital motion created by the Italian artists of the sixteenth
and seventeenth centuries culminated in the whirling spiral nebulae which
appear on some eighteenth-century German ceilings.

IV THEMES

1 The Church

*The Catholic
Church*
The period of the Counter-Reformation witnessed a great architectural debate; what was the most suitable plan for a church? In the Middle Ages, the central plan was not unknown; it was, however, reserved for certain categories of buildings. Medieval architects had concentrated on exploiting all the possibilities of the axial plan, with its nave and side aisles, the plan handed down from the very earliest days of Christianity, when this form had been adopted as best fitted to hold that 'assembly of the faithful'—*ecclesia*—from which the church itself took its name. The Italians disliked the multiple spaces of the Gothic cathedral, which suggest the infinity of a great forest; they were more at home with a unitary conception of space, with the dome as its centre of inspiration. Alberti declared that the central plan was better suited to symbolize divine unity. Nowhere did it seem more apt than in the new basilica of St Peter's, which Bramante designed as the 'centre of the world', expressing the light of the Catholic faith radiating from the Throne of St Peter. But on the death of Bramante opinions began to vary. Fra Giocondo returned altogether to the basilical plan, whereas Peruzzi, Raphael and Giuliano da Sangallo adhered to the combination of central and basilical plans which had already been used in San Petronio, Bologna, in Santa Maria del Fiore, Florence, in the cathedrals of Pavia and Granada and in the Santa Casa, Loreto. Antonio da Sangallo the younger retained the central plan, but gave the exterior impression of an axial plan by adding two towers and a piazza in front. It needed the strong will of Michelangelo to impose a return to the central plan.

In the latter half of the sixteenth century ecclesiastical opinion in Rome turned once more against the central plan, which was considered to have a pagan significance. The desire to return to the pure traditions of Catholic ritual brought with it a revival of the axial plan, modified by the elimination of the side aisles. The characteristically Italian demand for a unitary definition of space here coincided with the need to unify the congregation through an emphasis on preaching and on participation in the service. Paradoxically, that great collective achievement the medieval cathedral, with its innumerable divisions and its small chapels, promoted private worship and the dispersal of the faithful. In building the church of Il Gesù in Rome, the Jesuits obliged *fig. 5* Vignola to create a type of religious building which would fit the new conception of piety. In the simplicity of a single nave the faithful could receive the full impact of the preacher's words and easily follow the ceremonies in the short apse which replaced the long and complex choir of a Gothic cathedral. The idea of a central plan was not completely abandoned, for the gravitational pull of the vast dome drew together the different parts of the church; but this was

secondary, and its principal function was to mark the junction of the nave and the abbreviated transepts.

This development dealt the final blow to the fine harmony conceived by Bramante and Michelangelo for the basilica of St Peter's. On the orders of Paul V, Maderno added a nave with two aisles, to which he joined the great piazza which had been the idea of Antonio da Sangallo. He thus added a new form to the combination of the axial plan and the central plan. Architects of the seventeenth and eighteenth centuries in all countries exploited the possibilities of all three systems, axial, central and composite.

The simplified basilical plan of Il Gesù had a world-wide influence, though it did not entirely supersede existing systems, often maintained by tradition, and local styles. In Italy at the time of the Counter-Reformation and in Spain and Portugal in the seventeenth century, an even simpler plan, whose origins went back to the Middle Ages, was preferred; this was a vast assembly hall without a dome, in which the transepts, cut into the church's outer wall, are mere chapels with ceiling levels below the starting-point of the central vault. The Portuguese favoured this plan and took it to Brazil, continuing to use it well into the eighteenth century, whereas the Spaniards, accustomed since the Middle Ages to the central dome or *cimborio*, preferred the plan of Il Gesù. Portuguese architects, arguing that the plan of Il Gesù made it difficult for people to move to and fro in the interior of the church, revived the side aisle in the form of corridors along the lateral walls of the nave.

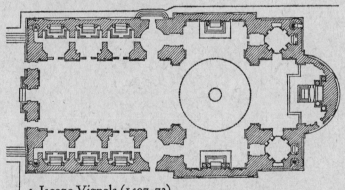

5 Jacopo Vignola (1507–73).
Il Gesù, Rome, 1568

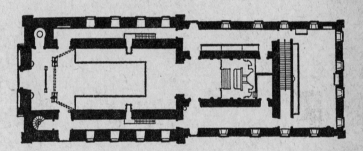

6 Manuel Francisco Lisbôa (d. 1767).
Nossa Senhora da Conceicão, Ouro Preto, Brazil, 1727

These Portuguese architects in fact succeeded in creating an integrated building, including within a single rectangular box corridors, galleries, annexes, consistories and sacristies. Although the Portuguese were the most successful at realizing this functional integration, which they carried through to the eighteenth century, the Italians, and even more the Spaniards, were often tempted in the course of the seventeenth century to unite all the elements of the church in this way. The Spaniards even created a name for this form, which they called the 'coffer church' (*cajón*); sometimes they even enclosed an elliptical church in the 'coffer', as in Los Desamparados at Valencia or Las Bernardas d'Alcalá at Henares (São Pedro dos Clerigos at Recife in Brazil provides a similar example).

figs 6–7

287

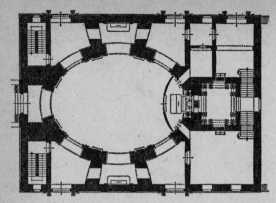

7 Nuestra Señora de los Desamparados, Valencia, seventeenth century

8 Giovanni Lorenzo Bernini (1598–1680). Sant'Andrea al Quirinale, Rome, 1658

9 Francesco Borromini (1599–1667). San Carlo alle Quattro Fontane, Rome, 1638

This instinct to gather the church into a single mass, a compact citadel of the faith, arose with the Counter-Reformation. It ran contrary to the general tendencies of the baroque, which inclined artists to seek for complex spaces, and eventually the baroque use of curves, inspired by the central plan, broke up the basilical scheme. The seventeenth-century Catholic Church, freed from the austerity of the Counter-Reformation, no longer showed the same distrust of the central plan. Bernini used it in the church of L'Ariccia, Borromini in Santa Agnese and Sant' Ivo in Rome; each of them also designed one church in the form of an ellipse, a characteristically baroque form which Bernini arranges transversally (Sant'Andrea al Quirinale), Borromini longitudinally (San Carlo alle Quattro Fontane). They enrich their curvilinear central plans with combinations of secondary curves (Santa Agnese, Sant'Ivo, San Carlo), and Guarini goes further still, creating elastic curves and counter-curves, and spaces which are intersected again and again, setting up a vibration which seems to expand the meagre dimensions of the church. In the church of Divina Providencia, Lisbon (destroyed by the earthquake of 1755) Guarini achieved the *tour de force* of combining the Gesù plan with a whole series of oval domes, a feat comparable with squaring the circle.

fig. 8
fig. 9

fig. 10

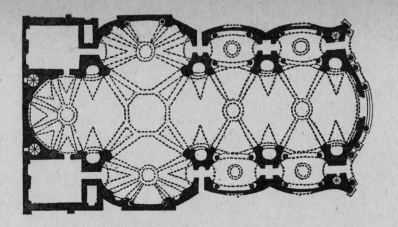

10 Guarino Guarini (1624–83). Divina Providencia, Lisbon

11 Dominikus Zimmermann (1685–1766),
Die Wies, Bavaria, 1746

12 Balthasar Neumann (1687–1753 Vierzehnheiligen, Bavaria, 1743

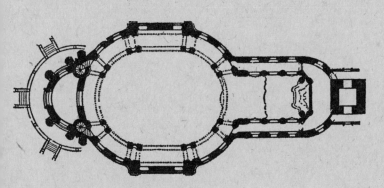

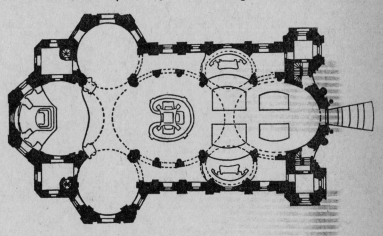

It was in the Central European rococo that the art of spatial harmony and counterpoint found its finest expression. The simple basilical plan persisted in Austria, however; and in Bohemia, Switzerland, Bavaria, Franconia and Swabia the Vorarlberg school maintained the basilical principle to the very end (Zwiefalten). The idea of reconciling the central and axial plans took many different forms. The central tendency is often marked by a dome in the middle of a long nave (Neresheim); sometimes there is a rotunda (Ettal), and many churches by Fischer von Erlach are based on a Greek cross. The ellipse inspired several plans by Fischer von Erlach, Hildebrandt and Munggenast in Austria and Ägid Quirin Asam in Bavaria; it was given its most poetic expression in the churches of Dominikus Zimmermann, above all those of Steinhausen and Die Wies, with their ambulatories. At Die Wies, as at Altenburg *fig. 11* in Austria, the axial tendency of the ellipse is emphasized by a long choir added to the oval nave. Johann Balthasar Neumann, the protean virtuoso of rococo architecture, might claim as his finest achievement the pilgrimage church of Vierzehnheiligen, where, taking inspira- *pl. 332, fig. 12* tion from Guarini's Divina Providencia, he sets the simple basilical plan to music by intro- ducing an array of elliptical domes. The rococo love of invention, comparable with the

289

musician's urge to improvise variations on a theme, led the architects (Andrea Maini, Dominikus Zimmermann, Simpert Krammer, Josef Effner, Johann Michael Fischer) who were called in as advisers on the building of the Benedictine church of Ottobeuren, to try out all the possible combinations of axial and central plans. This architectural research laboratory produced a church in the form of a Latin cross, in which the nave is no more than an approach by which the spectator is invited, as soon as he enters, to the dome, its gyration supported by two three-quarter rotundas.

The rigidity of neoclassicism checked this magnificent proliferation of forms and brought church design firmly back to first principles. Restraint was at its most rigorous in Spain, under the influence of Ventura Rodriguez and the Academía de San Fernando.

The Protestant Churches At the time when the Catholics of the Counter-Reformation were having to revise the plan of the church in the light of new policies, their Protestant contemporaries had to invent a completely new form corresponding to the needs of reformed religion. One of the essential features of the new worship, both Catholic and Protestant, was preaching. The complex plans of the Middle Ages were abandoned in order to group the faithful around the pulpit. The Protestants, although they too hesitated between the axial plan and the central plan, were freer to conceive buildings in terms of function, since they were less bound by tradition and tended, as iconoclasts, to reject decorative splendour and architectural rhetoric along with images.

The Church of England must be studied separately, since this Protestant sect retained many of the forms and ceremonies of Catholicism, although post-Reformation churches in England bear the mark of the Protestant dislike of graven images.

fig. 13 The London churches built by Wren and his disciples after the Great Fire offer an excellent field for study. St Paul's is a special case; although a Royal Commission rejected Wren's first design, based on a central plan, because it was too much like St Peter's in Rome, the design for which he finally succeeded in winning approval bore even more resemblance to the mother church of Catholicism, for it combined the central plan with the axial plan reintroduced by the Commission.

The other City churches show a great variety of plan. Some are compromises with circular and elliptical formulae, such as St Mary Abchurch which consists of a large circular dome set on a square base, or St Benetfink (now demolished) which was a decagon with a central elliptical dome. Most of the churches, however, tend towards a genuinely functional design:

pl. 338 a rectangular assembly hall, spacious (despite its modest dimensions) and well-lit, a perfect setting for the woodwork which plays so important a part in Protestant church building. Most of them retain the basilical convention of nave and side aisles, although some have only one side aisle; but the arches are so wide and the pillars so slight that they give the impression of a single space rather than a large nave with subordinate aisles. All these churches have tall steeples which Wren treated as an opportunity to display his resourcefulness and versatility.

pl. 182, fig. 14 The eighteenth century continued along the lines established by Wren. Hesitation between the axial plan and the central plan persisted. For St Martin-in-the-Fields, London, Gibbs

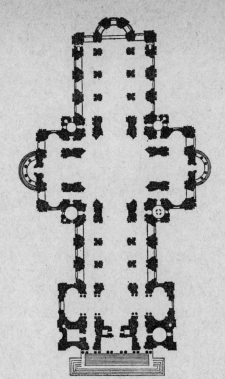

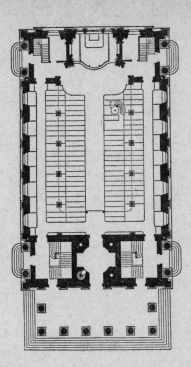

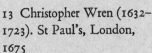

13 Christopher Wren (1632–1723). St Paul's, London, 1675

14 James Gibbs (1682–1754). St Martin-in-the-Fields, London, 1722

submitted designs of both types; the axial one was accepted, and this church became a model for churches in all the English-speaking countries.

Protestant churches built in France in the sixteenth and seventeenth centuries, now all destroyed, were particularly spacious; that of Charenton, built by Salomon de Brosse in 1623–4, *pl. 337* could hold a congregation of more than four thousand, divided between the large nave and the three tiers of galleries which ran right round the church—a design recalling that of the basilica of Fanum by Vitruvius. This system of galleries, whose purpose was entirely functional, was perhaps borrowed from Holland and Germany. Some Protestant architects favoured the central plan; the churches of Lyons and Rouen were circular, that of Dieppe, which could accommodate six thousand people, was oval, that of Montauban octagonal, and that of Petit Quevilly in Normandy dodecagonal.

The Dutch Calvinists occupied many Catholic churches which today, stripped of their images and their ornaments, seem to have lost all their spiritual quality. The painter Saenredam *pl. 335* has well expressed the melancholy of these great empty spaces, bodies without a soul. Protestant religious fervour must be sought elsewhere, in smaller churches in the Dutch country towns, *pl. 336* simple assembly halls whose ornaments are the woodwork, the pews, the pulpit and the organ. In the more ambitious churches in the large towns, Dutch Calvinists hesitated between the axial plan and the central plan. Hendrick de Keyser, who built the three great churches of *pl. 112* Amsterdam, adopted both formulae: a rectangular plan in the Zuyderkerk (1607–14), basilical

with two transepts in the Westerkerk (1620–30), and the Greek cross in the Noorderkerk (1620–5). The central plan was the most rational; this can be seen in the old Gothic cathedral (Johanniskerk) in Gouda, inside which at the end of the eighteenth century there was built a kind of wooden tiered amphitheatre centred on the pulpit. Many churches were built on an *pl. 334* fictagonal or Greek cross plan; a composite plan was used for the Nieuwekerk in The Hague, a one classical church built between 1649 and 1656 by Pieter Noorwits and Bartholomeus van Bassen.

The churches of Lutheran Germany show a very great variety of plans. The Marienkirche at Wolfenbüttel (1604) is a hall church in the mannerist style, and is indistinguishable from a Catholic church. Certain churches have two arms in the form of a set-square, such as Freuden-stadt (1601–88), and Elsfleth; many adopt the functional type of the rectangular hall surrounded by wooden galleries (Dreifältigkeitskirche, Worms, 1709–25, Pfarrkirche, Niederoderwitz, 1719, and Pfarrkirche, Grossenhain, 1744). Lutherans also built a number of rotundas. The *pl. 333, fig. 15* finest was the Frauenkirche in Dresden, built between 1726 and 1743. The rotunda, with its circular aisle, lined with six rows of galleries which were reached by four spiral staircases in corner turrets, was surmounted by a pear-shaped dome supported by eight tall pillars. Flooded with pure light, this church could hold a congregation of 3,600; its focus was the magnificent rising succession of pulpit, altar, and organ—the organ being a key point of the church in a religious community whose founder had given such importance to the musical expression of prayer. With the tiered benches and seats in its numerous galleries, the church resembled a vast theatre, or rather a large concert hall; it was the masterpiece of Lutheran church design, the magnificent crowning of an evolution timidly begun in the church of Wolfenbüttel in 1604. The architect, Georg Bähr, had achieved the greatest beauty possible in architecture, that which is derived from a harmony between form and function. Since the bombing in 1945 there has been nothing left but ashes and rubble.

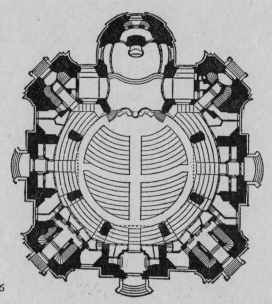

15 Georg Bähr (1666–1738). Frauenkirche, Dresden, 1726

It was only in Protestant and Slav countries that the Jews were able openly to build places of worship. In some points these resembled Protestant churches, the Protestants having adapted some Hebrew traditions. Just as preaching is the central activity in Protestant worship, the focal point of Jewish ritual is the reading of sacred texts; thus there is a need for a pulpit or dais around which the faithful may gather. A synagogue is generally a rectangular hall lined with galleries, in which the *hechal* or tabernacle, containing the *Sepharim,* the Books of the Law, faces a dais or *teba* from which the rabbi gives his readings of the Books. Various annexes, a bakery for unleavened bread and a *mikvah* or bath for the ritual purification of women, are grouped around the building or on a floor below. The principal decorative element in a synagogue consists in its lighting, numerous lamps being hung from the ceiling. Two fine eighteenth-century synagogues have been preserved in France, at Cavaillon and Carpentras, the Popes having paradoxically received in their territory of Avignon the Jews expelled from Languedoc; these are elegant buildings in the Louis XIV style. In the synagogue at Newport, Rhode Island, the architect Peter Harrison has taken advantage of the need for galleries (which are set aside for the women of the congregation) to create fine neoclassical colonnades.

The Synagogue

pl. 339

pl. 223

The thousands of monasteries which existed in Europe in the baroque age had retained, almost unchanged, the plan which can be seen in a ninth-century drawing preserved in the library of the Swiss abbey of Sankt Gall. The monastery buildings were grouped on one side of the church, preferably the south, which received more sun. Other buildings, used for agriculture, industry, art or study, were usually disposed without any overall plan. There was, however, in new monastic foundations, a tendency for the buildings to be arranged more rationally around several courtyards. The turning-point came with Philip II's Escurial, which created a new form for the monastery. In fulfilment of a vow made at the battle of Saint-Quentin (1557), Philip II began in 1563 an immense construction, which in several courtyards disposed about the central axis of the church incorporated various institutions—a royal palace, a house of Augustinian canons, a royal pantheon, a hospital, a museum, a college, outhouses, and a library rich in rare books. This huge complex included 16 courts, 88 fountains, 13 chapels, 9 towers, 15 cloisters, 86 staircases, 1,200 doors and 2,673 windows. The ancient dream of the 'City of God' took on a new meaning; the monastery became a microcosm of civilization, the symbol of the centralized monarchy of Divine Right.

The Monastery

The work soon became known all over Europe, thanks to the thirteen magnificent engravings of Pedro Perret, an artist who had come to Spain from Antwerp in 1584. Four thousand copies were printed from each plate, and distributed all over the world (three hundred sets went to Peru alone); a new edition had to be printed in 1619. Despite this wide circulation, it was only after the end of the seventeenth century that the idea of the palace-monastery as a microcosm of culture was taken up outside Spain. The signal for this development was the wave of triumph which swept through Germany and Central Europe following the decisive defeat of the Turks in 1687. This was felt to be a victory of civilization over barbarism, of the faith over the infidels. A new triumphal style now appeared which was to produce the last great achievements of

Christian art. In the last two decades of the seventeenth century the abbots of Austria and Germany began to rebuild their monasteries on a colossal scale; the Benedictine monastery of Kremsmünster, the Augustinian monastery of Altenburg, and the Premonstrant house of Obermarchtal were among the first to undergo this glorious metamorphosis. In the eighteenth century the movement spread into all the German-speaking Catholic countries, and until the 1780s the various orders feverishly strove to outdo each other. They all seemed to be possessed by what the Germans call the 'building bug', the *Bauwurm*. It seems incredible that enough artists could be found to meet such a demand; however, the native talent was supplemented by a strong contingent of Italians, and by numerous dynasties of architects who made up the Vorarlberg school. The finest of the plans directly inspired by the Escurial, in which the church *pl. 340* is the axis of symmetry, are those of Ottobeuren, Swabia, and Einsiedeln, Switzerland, by Moos-*pls 342–3* brugger (begun 1719), Göttweig, designed by Hildebrandt (after 1718, unfinished), Melk, designed by Prandtauer (begun 1700), Weingarten, by Moosbrugger (begun in 1714, unfinished), and Altenburg, all in Austria.

All these grandiose plans were attempts to symbolize the totality of the civilization which created them. There were lodgings for the abbot, divided into winter apartments and summer apartments, a suite of rooms for the Emperor, decorated with fantastic luxury, a marble banqueting-*pls 344, 392* hall (*Marmorsaal* or *Kaisersaal*), a library designed as a temple of knowledge, a theatre, a museum of art (often containing pictures from the original Gothic church, carefully collected when the *pl. 387* latter was demolished), a *Bildersaal* with its walls covered by contemporary paintings, a museum *pl. 101* of science, and often even an observatory, as at Kremsmünster where the *Mathematischer Turm* is both a meteorological observatory and a scientific museum. A colossal staircase, the emblem *par excellence* of a palace, led to the imperial apartments. The monastery buildings were also richly decorated, notably the refectory (often there were two, one for winter and one for summer). The pilgrims who came to venerate the relics were not forgotten, and a *Weinstube* was provided where they could sample the wines from the monastery vineyards. All around were farm outbuildings, kitchen gardens, and ornamental gardens in which the abbot sometimes had a pavilion for summer receptions. Innumerable stucco and painted images drew on an icono-graphic repertoire infinitely richer than that of the Middle Ages, incorporating elements of mythology, geography and history as well as the Bible. The general theme is the glorification of faith and of learning, the splendour of Christian civilization which could be attained only by the intimate union of religion and monarchy, priesthood and empire.

The abbots of those monasteries which possessed great estates were, perhaps even more than the princes, the true lords of the baroque age. These prelates, men like the abbot of Melk, Berthold von Dietmayr, imperial counsellor, who commissioned Jakob Prandtauer to rebuild his monastery in 1700, were inspired by a true aristocratic pride even when their own origins were humble. The abbots of Kremsmünster were such enthusiasts for stag-hunting that they built grandstands from which they and their guests could watch the kill.

pls 344–5 There was one imperial enterprise in Austria that was directly inspired by the Escurial—the rebuilding of the monastery of Klosterneuburg, near Vienna, no doubt on the advice of Dietmayr

of Melk and of the imperial minister Count von Altham. Charles VI, still nostalgic for his brief Spanish reign (1705–11), wished to follow the example of Philip II by building at the gates of his capital a palace-monastery which would affirm the transcendent glory of the Holy Roman Empire. The roof of each of the buildings was to be surmounted with one of the crowns borne by the Hapsburgs. Work on this project, begun in 1730 on magnificent plans drawn up by the Milanese architect Donato Felice Allio, was stopped in 1755 on the orders of the anticlerical 'enlightened despot' Joseph II.

The palace-monastery of Mafra in Portugal was more fortunate. Conceived as a baroque version of the Escurial, it was begun in 1717 under the overall supervision of Lodovice, a German-born architect who was strongly influenced by Italian (and later by Portuguese) styles. It was the fulfilment of a vow made by John V for the cure of his sterility. Works of art and materials were sent from all over the world for the building of Mafra, as they had been for St Sophia in Constantinople; Brazil contributed wood, while statues, devotional objects, bells and ecclesiastical ornaments came from France, Spain, Holland, Liège, Rome, Venice and Florence.

The idea of the monastery as triumphal monument spread all over Europe, except to Spain. Examples of it in Latin America are San Francisco at Lima and São Francisco at Bahia. The movement even spread to Orthodox Russia, where the Empress Elizabeth commissioned from her architect Rastrelli the great monastery of Smolny, modelled on the Escurial. Outside Central Europe, the destruction inflicted on the monasteries by the movement inspired by the French Revolution has obliterated almost all traces of this great monastic revival. In Italy there are still the Gerolamini and Santa Chiara in Naples, the colossal unfinished Benedictine monastery at Catania, and the enormous Certosa (Charterhouse) of Padula in Calabria, in which every monk was provided with a *palazzina* and the grand cloister is large enough to contain the Colosseum. Belgium still has the abbey of Parc, near Louvain, and France, though she has lost the wonderful abbey of Saint-Armand-les-Eaux, can still boast the monastery of Saint-Waast, Arras, that of Prémontre, cradle of the Premonstrant order, and the monastery and convent at Caen; but these are mere shells, stripped of their decoration, their libraries, and their furniture. The ancient and once noble monastery of Saint-Pierre in Lyons, now a museum, still has its *pl. 341* refectory, decorated with stuccos worthy of Serpotta. The finest of these French baroque mon-asteries was undoubtedly Les Genovéfains in Paris, which has now become a high school and is greatly disfigured. The abbey of Les Valloires in Picardy is a fine example of an eighteenth-century monastery comparable with those of Austria; the church is decorated with magnificent rococo wood carvings, quite unique in France—the work of an Austrian nobleman, Baron von Pfaff, who became a cabinet-maker and sculptor to earn a living after being exiled from Austria for his part in a duel. Such interchanges were at the heart of eighteenth century European civilization; every people expressed its own spirit with a freedom that was all the greater for its freedom from the pressures of nationalism.

2 The Court

Ideas beget forms. The royal palace, on the imperial scale on which it was conceived by antiquity, reappeared in Europe only when absolute monarchy itself reappeared. Until the sixteenth century the palace was imprisoned within the fortress; though Charles V of France adorned with finials the Louvre of Philip Augustus, it still remained a fortified castle. Even the Florentines, the originators of modern architecture, inherited this medieval form and proved incapable of creating another to replace it; the Palazzo Strozzi is withdrawn into itself, offering to the outside world only hostile façades. All Italy followed this model. Only Venice, where a wise government maintained civic peace, could afford the luxury of building palaces with façades opening wide on to the Grand Canal. If the fifteenth-century Florentine took refuge in the country, it was only to immure himself in another fortress; the first architect who conceived the country mansion as open to nature, in the style of the antique villas, was Giuliano da Sangallo, when he built for Lorenzo de' Medici the villa of Poggio a Caiano.

Rome carried on the tradition of Florence. The Palazzo Veneto, and seventy years later the Palazzo Farnese – the masterpiece of this type—keep to the introverted Florentine style. Weary of these dark abodes, Italian Renaissance potentates built themselves outside the walls of their ancestral palace—sometimes closely adjoining it—a *palazzo del giardino*, a garden palace which, since it was not the seat of power, had no need of an imposing exterior. This residence was of great symbolic significance in the life of the prince. It was a *delizia,* a pleasance, where he rested from the fatigues of government, not by a return to a more natural life, but by plunging into a world of even greater artifice; in contact with the gods and heroes who peopled palace and garden, he gained new strength and a consciousness of his own excellence. The ducal palace of Mantua and its pleasance, the Palazzo del Tè, are perfect examples of this duplication.

Since the sixteenth century the royal palace has been a combination of palace and villa. The two were sometimes built conjointly, according to an overall plan; thus, at Caprarola in the mid-sixteenth century Vignola built for Cardinal Alessandro Farnese a feudal castle, based on plans for a pentagonal *rocca* which had been drawn up years before by Baldassare Peruzzi and Antonio da Sangallo the younger; and on the hill he built a charming *casino* in a mythological garden. The first palace on a royal scale was the product of the union of official residence and pleasance; Julius II ordered Bramante to join together by two long galleries Sixtus IV's Vatican and Innocent VIII's Belvedere, producing the colossal complex which we known as the Vatican. In due course this procedure was imitated by two other sovereigns. The formidable

mass of buildings which constitutes the Louvre is the fruit of a 'grand design' conceived by Henry II, pursued by later kings and only completed under Napoleon III, to join the ancestral palace of the Louvre to the 'garden palace' of the Tuileries, which Catherine de Médicis had commissioned from Philibert de l'Orme. Later, in St Petersburg, Catherine the Great joined the Winter Palace built by Elizabeth to the Hermitage, the residence she herself had built for pleasure and relaxation on the banks of the Neva. These three palaces, the largest in the world, were not designed as a whole, but were the result of organic growth. The earliest palace complex on a royal scale in Western Europe was the grandiose complex of buildings which Giuliano da Sangallo (1445–1516) designed for the king of Naples; but this was ahead of its time, and had no imitations. The gigantic plan with numerous internal courtyards and one oval forecourt, drawn up by Inigo Jones for Charles I's Whitehall Palace, was neither carried out nor imitated. It took a Louis XIV to revive this form of royal palace, colossal and unified, with numerous outbuildings, opening on a wide front on to a nature transformed into an abode of the gods. The formula originated at Nero's Golden House.

Before Louis XIV had created this ideal royal residence, the dual palace in the Italian style had evolved. Under the influence of the villa, one side of the square had been removed so that a windowed façade overlooked the garden. The U-shaped plan, which had appeared early in the sixteenth century, with an open court before or behind, thus takes the place of the closed rectangle. A comparison between the Palazzo Barberini and the Palazzo Farnese is a good illustration of this development, which took place in Italy and France at the same period. The French *château* took an open form, by means of a vast courtyard which served as a monumental entrance. From the reign of Henry III in the late sixteenth century, architects transformed the fortified castle, turning it outward towards nature instead of inward upon the interior court. In the seventeenth century a similar process, but accomplished more slowly, was to transform the town mansion into a *hôtel entre cour et jardin,* its rooms overlooking an outer garden as well as an inner court.

pls 137–8, figs 16–17

16 Carlo Maderno (1556–1629). Ground floor of Palazzo Barberini, Rome, 1626

17 Giovanni Lorenzo Bernini (1598–1680). Palazzo Farnese, Rome

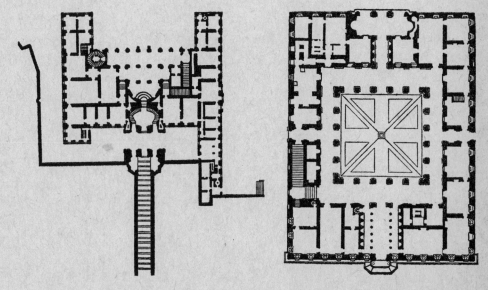

pl. 346 This, then, was the form of Louis XIV's first Versailles; on the entrance side was the Cour de Marbre, a relic of the hunting-lodge of Louis XIII; on the garden side was a terrace on which was later built the Galerie des Glacés. Louis XIV's intention in building Versailles was the same as that of Federigo Gonzaga of Mantua when he built the Palazzo del Tè—to make the palace a place set apart from the common run of men, filled with royal 'grace', a true 'sacred palace'. But when, on finally breaking with rebellious Paris, he transferred the seat of government to Versailles, enlargements had to be made to accommodate the court and the organs of administration, annexes had to be built for the ministries, and a town created.

The universal admiration that Versailles arouses even in its present mutilated form may help us to imagine the stunning effect it had on a Europe which knew it in its full glory. For a whole century the absolute monarchs of Europe, great and small, strove to imitate the inimitable. The German princes fell victim to the *Bauwurm* with a vengeance; at every court the *Kavalierarchitekt* (gentleman architect), often a Frenchman, held a position of great honour. They themselves dabbled in architecture; Max Emmanuel, Elector of Bavaria, could not refrain from scribbling his ideas on paper. 'This may always be of use in times to come, and the very thought of buildings to be created in the future gives me pleasure when I see my drawings and papers,' he wrote to his mistress. Members of the noble family of Schönborn, originally from the Lahn Valley, who possessed numerous principalities, both secular and ecclesiastical, in the Rhineland, Franconia and Austria, carried on a huge correspondence on the subject of buildings. The technical expert among them was Lothar Franz, bishop and Elector of Mainz from 1695 to 1729, who was the creator of the monumental staircase of Pommersfelden, and guided his nephew Johann Philipp *pl. 348* Franz, prince-bishop of Würzburg, in drawing up the plans for his residence.

Probably the first monarch to seek to emulate Versailles was the Emperor Leopold I, for whom in 1690 Fischer von Erlach drew the plans for a colossal palace to be built at Schönbrunn, then just outside Vienna. This Berninesque imitation of Versailles was reduced to more practical, but still very impressive, dimensions. In Germany the Margrave Louis of Baden, the famous *Türkenlouis,* seems to have given the lead; at Rastatt the Italian Domenico-Egidio Rossi built for him an immense palace inspired by Versailles. His neighbour the duke of Württemberg was not to be outdone; by 1704 he was planning to copy Versailles by erecting an immense palace and 'royal town' at Ludwigsburg. The transition from the closed palace in the Italian style to the open palace on the Versailles pattern is illustrated in the building of Schlessheim near Munich. Towards 1690 Enrico Zuccalli, director of buildings to Max Emmanuel of Bavaria, had prepared plans for a closed structure inspired by Bernini's plans for the Louvre; but in the course of construction the architect Effner, who had spent a long period in France under Robert de Cotte, altered these designs to bring them nearer to the Versailles model. The duke of Württemberg's palace at Stuttgart and that of the Elector Palatine at Mannheim, both destroyed in the Second World War, were designed by Frenchmen, Pierre de la Guépière and Jean-Clément Froimont. The prince would send his *Kavalierarchitekt* to study in France, where he visited palaces and followed courses of instruction at the Académie d'Architecture or at the private academy of Jacques-François Blondel. Boffrand's advice was much sought after by these artists;

he interested them particularly because he was the truest rococo architect of them all. Between 1720 and 1725 French architects almost everywhere supplanted the Italians who had been called in by rulers of the previous generation. Margravine Wilhelmina, sister of Frederick the Great of Prussia, wrote: 'Every Frenchman who has settled abroad is as noble as a king, though his grandfather may have been a steward or a lackey in Paris'—for these Frenchmen had a passion for status which their German protectors took care to satisfy. The importance of French ideas, and the 'Germanization' which they underwent, can nowhere be seen better than in the palace of the prince-bishops of Würzburg. The whole Schönborn family united to make this residence the finest in Germany. Balthasar Neumann was entrusted with designing it, but the Austrian Schönborns, feeling that he was young and needed support, sent him the great Lucas von Hildebrandt, and the bishop's uncle Lothar Franz, Elector of Mainz, sent his own architect Maximilian von Welsch. The foundation stone of the new palace was laid in 1720, but the Schönborns were still not satisfied with the design; Johann Philipp Franz Schönborn sent Neumann to Paris to consult Robert de Cotte and Boffrand, and Boffrand came to Würzburg in person in 1724. The way in which Neumann transformed Boffrand's plans is an illustration of how a German could infuse baroque feeling into a French design.

The *Bauwurm* spread far to the East. When Peter the Great, breaking away from Moscow and from Muscovite traditions, founded the new capital city of St Petersburg, he could think of no better way to Westernize his court than to have his own Versailles, which he created at Peterhof on the Gulf of Finland. His daughter Elizabeth surpassed her father's achievement by building the immense Tsarskoye Selo, which was continued by Catherine the Great. *pl. 347*

The spirit of Versailles reached Spain direct from its source, the Bourbon dynasty. In 1719 the grandson of Louis XIV, Philip V, decided to build a summer residence at La Granja near Madrid, on a site whose coolness contrasted with the heat of the Escurial. La Granja, designed by Juvarra, resembles the Escurial in that its focal point is a chapel. The Palacio Real in Madrid, begun in 1738, also departs from the Bourbon tradition. Sacchetti, who was in charge of its construction (his master Juvarra had died in 1736), reduced Juvarra's grandiose plan and, returning to the Spanish tradition of the *alcázar,* closed the palace in upon itself.

In England the inertia of the constitutional monarchs of the eighteenth century left it to the aristocracy to create residences in emulation of Versailles. The only English monarch who built on this scale was Queen Anne; but the resulting palace, Blenheim, was not for herself but for her *fig. 18* great general the Duke of Marlborough.

The movement spread to the courts of Italy. The hunting-lodge at Stupinigi near Turin, created in 1729 by Juvarra for the king of Sardinia, Victor Amadeus II, is one of the finest achievements in all architecture, inspired by the idea of expressing in the harmony of its conception the royal sport for which it was designed. The most colossal project of all was conceived in the megalomaniac brain of Charles VII of Naples and III of Spain. When he decided to move his court to Caserta, he asked Mario Gioffredo to design what was virtually a royal town, bringing together in one building, divided by eighteen courtyards, and with a dome in the centre, apartments for the royal family, a public library, a university, an observatory, a museum, a

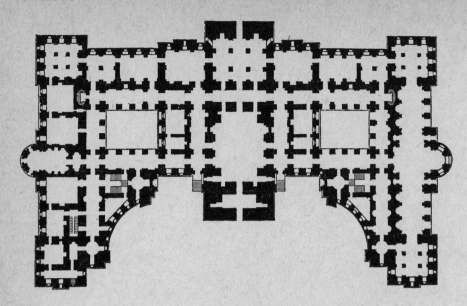

18 John Vanbrugh (1664–1726). Blenheim Palace, Oxfordshire, 1705

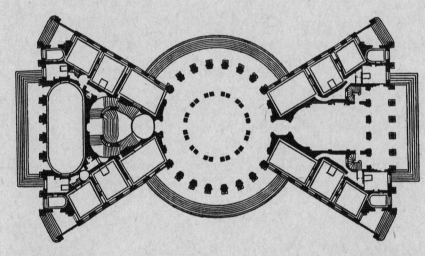

19 Germain Boffrand (1667–1754). Project for Château de Malgrange, after 1711

20 James Paine (c. 1716–89). Kedleston Hall, 1761

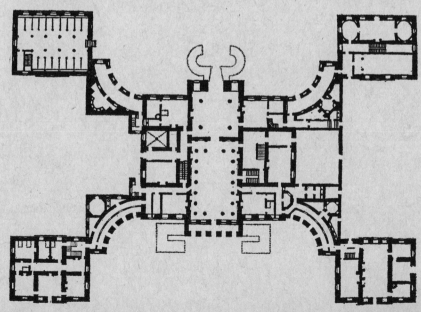

seminary, a cathedral, a bishop's palace, law courts, and ministries; all this was to be surrounded by a rampart after the style of the Kremlin. Luigi Vanvitelli had reduced the project to manageable proportions by the time the first stone was laid in 1752. He kept the idea of buildings organized around a centre, and to accentuate this centralized plan he recessed the entrance, so that the whole complex centred on the main stairway.

Following the examples of Louis XIV, sovereigns built country houses in a style more intimate than that of their official residences; the nobility imitated their lords, and Europe was soon dotted with *châteaux*. The abundant demand gave architects the opportunity to refine and perfect the conception of a country residence. The great oval hall on two floors that Le Vau had used at Vaux-le-Vicomte, in France, had a great success in Germany; Fischer von Erlach, who had a passion for the ellipse, planned palaces composed entirely of oval rooms. His finest achievement in this style is an early work, the Ahnensaal (Hall of the Ancestors) at Frain (Vranov) in *pl. 167* Bohemia (1693), the ceiling of which is lit by enormous *oeil-de-boeuf* windows—a theme which Donato Felice Allio later imitated in the palace-monastery of Klosterneuburg. Another *pl. 344* popular arrangement, four wings arranged in a St Andrew's cross around a central rotunda, was projected by the French architect Boffrand for Leopold of Lorraine at Malgrange. *fig. 19* Fischer von Erlach, who had used it before Boffrand, made several designs in this style, and it inspired Juvarra's plan for the hunting-lodge of Stupinigi; Paine employed it, with variations, for the complex design of Kedleston Hall (*c.* 1745). *fig. 20*

In the interior arrangement of these palaces, architects liked to concentrate their skill on two *bravura* pieces—the gallery and the staircase. The gallery, a spectacular long room, is sometimes thought to have evolved in Italy, but in fact it developed in France from the grand hall of the medieval castle. The Château de Fontainebleau had no less than six. The gallery came back to favour in seventeenth-century France, enriched by the version created by the Carracci in the Palazzo Farnese. The Galerie des Glaces designed by Mansart and Le Brun at Versailles spread the fashion all over Europe, though the Germans often preferred a hall with greater width (*Marmorsaal* or *Kaisersaal*). In England the long gallery also evolved from the hall of the Middle Ages. It was situated in the centre of the building and occupied the whole height of the house, often including an upper gallery supported by a row of pillars.

In the baroque age the stairway was a symbol of dominion. Since the élite always lived on the first floor (still often called in French *l'étage noble*) the ascent of the stairs of a palace was in the nature of an initiation. The Italian architects of the seventeenth century made great use of effects of perspective, even accentuating them artificially, as Bernini does in the Scala Regia of the Vatican. The guest who mounted the Escalier des Ambassadeurs at Versailles (1672-9), designed *PL. IX* by Le Brun from drawings by Le Vau, was surrounded by marbles, frescoes, gilded wood, painted stucco—a vast theatre arranged around the white marble bust of Louis XIV by Warin.

It was in the eighteenth century that the staircase became a real triumphal symbol. Queen Maria Giovanna Battista, wishing to rebuild the Palazzo Madama in Turin, began with the staircase—but the reconstruction was never completed and today Juvarra's monumental flight *pl. 361* of steps leads to a dark tortuous medieval building. At Caserta, as we have seen, Vanvitelli

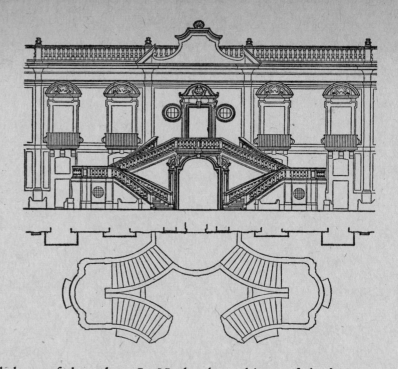

21 Villa Malvagna, Bagheria, near Palermo, eighteenth century

made the stairway the central theme of the palace. In Naples the architects of the baroque palaces, notably Sanfelice, showed endless ingenuity in their staircases, both interior and exterior, combining straight flights and spirals, and creating unexpected effects by the use of *trompe-l'oeil*. Staircases were nowhere more sumptuous than in Central Europe and Germany, where they constituted the true heart of the palace. Often supported by huge Atlantean figures, laden with stuccos, pillars, caryatids and statues, and decorated with a wealth of paintings, their function was to lead the guest into an enchanted world, to induce in him a kind of awed amazement. At Pommersfelden and Brühl the architect skilfully directs the eye of the visitor, as he climbs the steps, to enable him to take in, from one turn to the next, the entirety of the illusory *pl. 362* space which surrounds him. At Würzburg the staircase is a triumphal approach to the painted ceiling, on which Tiepolo summons the four corners of the earth and the gods of Olympus to celebrate the glory of Prince-Bishop Carl Philipp von Greiffenclau; the staircase is a theatre from which to contemplate the ceiling.

The Theatre The theatre was a vital element in the life of the court. Plays were part of the festivities marking *pl. 44* any great occasion; I have already mentioned how the Teatro Farnese at Parma, built in the early seventeenth century, constituted the very heart of the palace.

The rise of the theatre is associated with the renaissance of antique drama. In the Middle Ages, plays were given in public squares, churches or palaces. The first permanent theatre to be built in stone was the Teatro Olimpico in Vicenza, designed by Palladio in 1580 in imitation of an antique *odeon,* with tiers, stage wall and upper gallery. The stage had a permanent 'set' in the form of a wall with three bays, which could represent either the interior of a palace or its façade; behind the central opening there were three streets, created in wood and stucco by Scamozzi, who exaggerated the perspective to give an illusion of depth. This stage is designed

primarily as a vehicle for words, that is to say for antique drama; the theatre opened in 1585 with Sophocles' *Oedipus Rex*.

The theatre of the seventeenth century was designed for an entertainment that was both visual and musical, and was expected to provide comfort, in a lavish setting, for a noble audience. The modifications that architects made in the design of the theatre thus concerned both the stage and the auditorium. The invention of movable sets in the first half of the seventeenth century brought with it the widening of the stage; in the auditorium, tiers disappeared and were replaced by several storeys of balconies and boxes, leaving in the centre a pit, without seats, which normally accommodated members of the audience but could also be used for the performance of court ballets. Thus the auditorium became a spectacle in itself, a brightly-lit setting for a glittering cast—the audience.

These developments are already foreshadowed in the Teatro Olimpico, Sabbioneta, designed by Scamozzi in 1588. The amphitheatre is reduced to five tiers, so that the colonnade which runs along the side walls (in relief) and the proscenium wall (in *trompe-l'oeil*) is low enough to detach itself from the side walls and curve round in a semicircular *empore* at the back of the hall for the prince and his suite. The Teatro Farnese at Parma, designed by Aleotti and built *pl. 44* in 1617–18, is a mixed form. The auditorium is large enough to include twelve tiers of seats, and carries two rows of arcades, blind (i. e. attached to the walls) on the straight sides, but opening out to form boxes at the back. The most important transformation, however, is that of the stage; the proscenium wall disappears, to be replaced by an ornate proscenium arch which frames the stage. The stage is still very narrow and shallow, but it now has wings and machine rooms, its floor still being raked to improve the effect of perspective. The scenery consisted of a backcloth. From the early seventeenth century onwards theatres multiplied in Italy, their architects endeavouring to keep up with developments in stage design while increasing the comfort of the public. Bologna had three public and sixty private theatres. The prefect of Rome, Taddeo Barberini, built at Le Quattro Fontane a hall for three thousand spectators, equipped with complicated machinery and movable sets; Bernini worked on it, and it was opened in February 1632. The Venetians, passionately fond as they were of every kind of entertainment, especially at carnival time, played an important part in the development of the theatre. In Venice the composer Cavalli developed opera in the grand manner. The patricians built theatres, which were later organized on a paying basis, private individuals hiring boxes and the public being admitted to the pit and the 'gods' (the old upper gallery). It was in Venice that boxes were developed, extending to cover the sides of the auditorium, although from them the stage perspective was falsified (examples are the Teatro Grimani, 1639, and the Teatro San Samuele, 1639).

The Italian style of stage was brought north of the Alps by Cardinal Mazarin, Richelieu's successor as chief minister of France. Having sung in religious dramas in Rome, he wished to have an opera house. He called in the Italian Gaspare Vigarani, a specialist who had built several theatres in Italy, to design the Théâtre des Tuileries. The most remarkable feature of *pl. 45* this theatre, which was completed in 1662, was the deep stage, extended by an enormous machine room. The auditorium was still reminiscent of the old tiered amphitheatres; it was

composed of two superimposed orders; the upper order formed a balcony, while the lower contained projecting boxes supported by consoles. A few rows of seats were still to be found below the lower order, but this was a great advance on the theatre designed in the previous reign by Le Mercier for Richelieu; this was still an amphitheatre, with twenty-seven tiers rising up to a three-arched portico flanked by two tiers of balconies.

In the eighteenth century the Venetian type of theatre, with rows of boxes running up to the proscenium arch, became established. This circular or oval form, however, became the object of heated controversy in which national pride played its part, since Italians were called in everywhere both as stage designers and as builders of theatres. The famous Bibiena family, particularly, worked all over Europe. In France, where many theatres were built, the debate turned mainly on the question of whether to return to the antique semicircular amphitheatre plan. The *teatrino di corte* of the royal palace of Naples has the exceptional form of a simple rectangle, like that of the French real tennis courts, *'jeux de paume'*, where plays had been performed in the sixteenth century.

The main contribution of the eighteenth century to theatre design was in the realm of decoration; the interior, of wood and stucco, painted and gilded, was treated like a sumptuous banqueting-hall, and the royal box, standing out from the rest, became a stage facing a stage. Central Europe and Germany still have some very fine rococo theatres. One of the largest and richest is the Altes Residenztheater of Munich, which by being dismantled was saved from the fire which destroyed the Residenz itself almost completely in 1944. It was built from 1751 to 1755 to designs by the French-trained architect François de Cuvilliés. Its principal ornaments are the Atlanteans of the second row of boxes, and the trophies (ornaments representing arms and armour) treated in rocaille; the colours are white and gold for the stucco and wood, red for the fabrics—exceptional for this period when decoration was usually blue and gold (like that of *pl. 47* Margravine Wilhelmina's Markgräfliches Opernhaus at Bayreuth, the exterior of which is by her *Kavalierarchitekt* Joseph de Saint-Pierre, and the interior by Carlo Galli Bibiena after drawings by his father Giuseppe). The smallness of the auditorium lends particular prominence to the royal box. This exquisite little theatre, which miraculously survived the air raids of the Second World War, is undoubtedly a masterpiece of its kind.

The neoclassical style brought coldness to theatre decoration; the rococo was far better suited to the atmosphere of festivity and fairy tale which naturally belongs to the theatre. The last great court theatre of the *ancien régime* was the opera-house at Versailles, completed in 1769 by Gabriel, which has just been restored to its former splendour. Its interior, in tones of blue and gold, is based on the rhythm of the monumental orders so dear to the heart of its creator. However, this monumental rhythm defines the space too sharply; the elastic lines of rococo succeed better in joining the world of the auditorium to the imaginary world of the stage.

Meanwhile, the organization of the stage changed little; architects turned their attention to the structure of the building. They gave it a façade in the antique mode with a monumental portico; in some cases the pillars continued round the building to form a peristyle. This arrangement lacked the advantages of the earlier fashion for a high portico (as at Bayreuth), which

made it possible to have an outside balcony opening from a first-floor foyer which in turn gave access to the *loges d'honneur*. The number of exits was increased, and the architects sought to integrate the annexes into a unified plan. In the interior, in conformity with the style of the day, it was the staircase that was expected to produce the most striking effect; the finest of all was the one designed by the architect Victor Louis for the Grand Théâtre in Bordeaux (1772–80), *pl. 360* which occupies more than one third of the length of the building.

There were from the seventeenth century onwards numerous open-air theatres. They were usually set amid grass and trees, like the one at the villa of Marlia, near Lucca (*c.* 1652), where the layout of the stage, with its wings and podium, is marked by clipped yews. Rustic theatres might also be built of rocks, as were those at Hellbrunn and Bayreuth.

Tournaments and other open-air entertainments took place in a large court or square on which temporary buildings were erected. One of the most remarkable monuments of German baroque, the Zwinger at Dresden, built for Augustus the Strong, encloses a kind of oval open *pl. 349* space for the holding of tournaments, carrousels, balls, banquets, triumphal processions, crossbow contests, ladies' races, and sleigh rides. The Zwinger complex also included an indoor theatre for opera, another for comedy, and galleries of art and mathematics. These functions explain the theatricality of the architecture of the Zwinger, which is usually misunderstood by foreign visitors (particularly the French).

Many villas in Sicily, instead of opening on to a garden, were surrounded by a lobed precinct enclosing oval or circular courts, rather resembling the Zwinger. Such is the strange Villa Palagonia near Palermo, where the monsters carved in stone along the top of the wall hold a non-stop burlesque performance, an infernal charivari. *pl. 245, fig. 22*

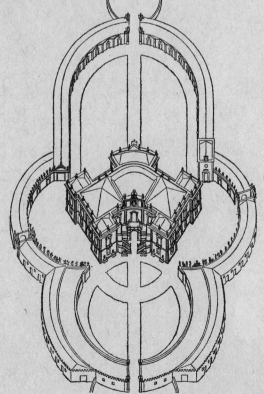

22 Villa Palagonia, Bagheria, near Palermo, begun 1715

The Garden

In accordance with their new conception of the antique, the men of the Renaissance had made the garden a sort of microcosm, furthering the illusion that the prince was the centre of the world. Baroque Italy made little change in this scheme. The Italian garden incorporated a steep slope with a succession of terraces, among which were placed grottoes, shrines of nymphs, and fountains. It was designed not simply to be seen, but to be walked in. The only innovation made by the Italian gardeners of the seventeenth century was to increase the size of the garden, and to make it give prominence to architectural features at the expense of nature. It was France that introduced a new conception of the garden, adapted to the needs of royalty. The first realization

PL. XII of this new ideal was the park of Vaux-le-Vicomte, created by Le Nostre for Louis XIV's finance minister, Fouquet, in 1656–61. Shortly afterwards the same artist was called upon to lay out the gardens of Versailles (executed, with many changes, between 1662 and 1688). Le Nostre's innovation was to make the garden into an ensemble of walks, ornamental parterres and fountains, arranged geometrically between formal groves of trees on either side of a vista completed by a grand canal—transversal at Vaux, longitudinal and continuing the view at

fig. 24 Versailles. This garden, peopled with statues, was a kind of theatre, a continuous drama unfolding beneath the monarch's first-floor windows; in order to enjoy this view the palace, which on the entrance side has wings flanking the courtyard, extends along a wide front on the side facing the park.

The sheer size of the gardens at Versailles gives them a truly royal aspect. From the central garden façade of the palace to the railing marking the end of the small park (surrounded by the large park containing hunting preserves), is more than 3,600 yards; the end of the vista, marked by the village of Villepreux, at the end of a grand avenue, is five miles away. On either

pl. 126 side of the central vista, grottoes, rocaille, theatres, architectural compositions, enchanted islands, pools, mythological ensembles and creations of every kind were hidden in groves of trees. Water became an increasingly important feature of the French garden, lending itself to many kinds of effects—mirrors reflecting the sky, a canal with a fleet of boats on which water carnivals could be held; its use added 'marine' entertainments to those of the land, and there were fountains of every kind, some of which could be grouped to form gigantic arches, bowers, gates, domes, or

pl. 352 organ-pipes. In the time of Louis XIV there were as many as 1,400 fountains at Versailles. Finally, under the direction of Le Brun, there was installed a profusion of statues, in a classical style very different from the naturalistic style of those in Italian gardens; they were made of marble or bronze or, for the fountains, bronze or gilded lead. The park itself, like the palace, had its subsidiary features—a menagerie on both banks of a transverse canal, and facing it a smaller palace, used as a retreat, which was first faced with faience and then rebuilt in pink and

pl. 122 white marble—the Trianon.

All the resources of mythology and allegory were called upon to celebrate the excellence of the monarch, and to symbolize the universe. Palace and garden, closely linked together, formed a theatre where all kinds of entertainments were put on all the year round; solemn receptions, operas, ballets, masquerades, balls, cavalcades and firework displays, all helped to make it an magical world where an exceptional race of human beings led an enchanted existence.

In contrast to this type of royal garden, which the French term 'classical' but which was the setting for a 'baroque' life (a proof of the pointlessness of setting these two terms up in opposition to each other), the eighteenth century created the garden that might be called rococo. This was the irregular 'English' or 'landscape' garden which flourished in England between 1720 and 1750; it has become associated with the name of William Kent, designer of the garden at Stowe. It was Alexander Pope who first popularized the genre, at his country house at Twicken‑ ham (after 1719). The myriad serpentine curves of the paths and streams are so capricious that *pl. 257* they look, as someone said at the time, as though the gardener had had too much to drink; they resemble nothing so much as the patterns of rocaille ornament. That the English should have invented this irregular rococo type of garden at a time when in architecture they were turning towards Palladianism is a characteristic paradox; it constitutes another proof that they were more drawn towards the baroque than they care to admit.

Nowhere is the contrast between the house and its surroundings more marked than at Chis‑ *pl. 358* wick, where Lord Burlington himself designed an irregular garden as the setting for a mansion built in imitation of Palladio's Villa Rotonda.

At the time when the 'English garden' came into being, there was a profound change to the significance of the garden. The park now became an encyclopaedia, full of plants of the most varied species (sometimes, indeed, with a temple dedicated to Botany), with every kind of landscape feature inspired by the paintings of Ruisdael, Salvator Rosa, Claude Lorrain and *pl. 357* Dughet. There were meadows, hills, ravines, groves, rocks, alpine gardens, dark caves, even a volcano—with water in the form of springs, streams, rivers, ponds (with islands) and all varieties of waterfall 'classified as "foaming" or "smooth"', according to M. de Girardin, Rousseau's host at Ermenonville and an authority on the English garden. Sometimes there was even a 'wilderness', as at Ermenonville, a vast stretch of sand where nothing grew but broom, heather and juniper. At Bresse, at the country house of M. de Beaurepaire, this wilderness was a miniature Thebaid with huts for the hermit saints Paul, Anthony, and Simon Stylites. The earlier Italian and French gardens had also been microcosms; but where formerly the approach had been allegorical, now the universe was represented by direct imitation. One might come upon a Swiss chalet, a Chinese tea pavilion, a Dutch windmill, or a Persian kiosk. History was well *pl. 258* represented; there were Egyptian obelisks and pyramids, tombs of the Pharaohs, medieval, Greek and Roman ruins, Palladian bridges. Comparative religion was not overlooked—there were Gothic churches in ruins (real or sham), Chinese pagodas, mosques and Druid temples. *pl. 253* The garden was full of allusions to great men (busts, epitaphs, cenotaphs, even real tombs); the gardens of Ablon, near Franconville, were a Pantheon, placing alongside the forebears of the Ablon family Montaigne, Rousseau, Homer, Pindar, Solon, Seneca, Cato, the contem‑ porary Swiss physiologist Haller and the Dutch physician Boerhave; there was even a 'Temple of the Dying Christ'.

This was a fuller microcosm than the old Italian garden, and its significance was a moral one. In it were numerous edifying inscriptions, and the virtues of Innocence, Friendship and Love all had their temples; the temple of Philosophy, says M. de Girardin, should be left

unfinished to symbolize the state of human knowledge. There was often a literary theme, such as Fénelon's *Aventures de Télémaque* in the gardens of Sanspareil at Bayreuth, or Rousseau's *Nouvelle Héloïse* at Ermenonville. The stroller found many spots for quiet meditation; houses of Confucius, hermitages temples and huts. The garden was no longer conceived as an illustration of the glory of the monarch—it had become human. It was the philosopher's garden, offering endless subjects for reflection. All these devices were hidden from view, only revealing themselves by the twists and turns of the path; every path chosen led the visitor to one surprise, but deprived him of another, returning him to the point where he started. The 'English garden' is the last Western manifestation of the ancient myth of the Labyrinth, which here takes on a new significance—the anxiety of a society at the crossroad of two ages, a society in search of itself. The anguish that baroque man had hidden beneath a cloak of make-believe is here on the very threshold of consciousness. In the gardens at Luzancy in France there was a Vale of Melancholy, with a symbolic altar.

Under the influence of Jean-Jacques Rousseau, the picturesque garden gained great popularity in France just as it was declining in England. There remain only a few scattered relics of the many creations it inspired, the most complete being the Petit Trianon, where Marie-Antoinette built a 'hamlet' for her pleasure on the eve of the Revolution. The most 'philosophic' of these gardens, that of Ermenonville (1766–74), contains the tomb of Rousseau, who died there.

In eighteenth-century Europe, however, the form that gained favour was the mixed garden, combining French, English and even Italian styles. On either side of a grand vista in the French style were groves of trees in which were both the exotic creations of the English garden and the mythological conceits of the Italian. Petty kings and princelings, megalomaniac in inverse proportion to the size of their domains, emulated the splendour of the Allée Royale of Versailles. *pl. 353* At Caserta the gardens could be toured only by carriage. The immense vista starts from beyond the palace, passes through it, and ends in the Italian style on the rising slope of a hill, where flows *pl. 351* a chain of cascades, an old Renaissance motif. At Wilhelmshöhe the Italian Guerniero designed for the Landgrave of Hesse a gigantic vista, connected with the town by a long avenue; it is closed by a hill on which stands a kind of fort known as the Octagon. This is a water tower, from which flow stepped cascades, grotto streams, and waterfalls of every size. It is crowned by a high pyramid which itself is surmounted by a colossal replica of the Farnese Hercules.

Gardens are more fragile than any other work of man. Fortunately, in Central Europe many have been preserved almost intact. The park of Schloss Hellbrunn, a pleasance built probably to designs by the Italian architect Solari for the Graf Hohenems, bishop of Salzburg from 1612 to 1619, is a charming garden in the Italian style, whose main features are its nymph grottos, *pl. 354* surprise fountains, and hydraulic machines. On a hillock surrounded by mythological figures there is a 'rock theatre' dating from the same period, where the first Italian operas given in the German-speaking world were performed. In the eighteenth century the garden was provided with a hydraulic mechanical theatre, which is still working today.

La Granja near Madrid and Caserta near Naples—royal gardens—were the finest to be built outside France on the model of Versailles. On the edge of the French garden at Caserta there

was laid out in 1782 an English garden, full of Mediterranean and exotic species of trees, which is a real paradise. The park of Veitshöchheim near Würzburg is a curious example of baroque treatment of the French garden. In the early eighteenth century it was laid out as a regular garden by Prince-Bishop Johann Friedrich von Greiffenclau; half a century later Adam Friedrich von Seinsheim brought drama to this calm spot with a whole frenzied world of extravagant statues. The sculptor Ferdinand Dietz, imitating the old 'fountain of Parnassus' at Versailles, turned the *pl. 350* peaceful haunts of Apollo into a pandaemonium, with the muses playing frenetic music more suited to a bacchanale; on the top of the fountain Pegasus seems to be stumbling into an abyss rather than taking wing.

In the sentimental genre, Poland still possesses the gardens of Arkadia. At Bayreuth the garden of Sanspareil, created by a caprice of the Margravine Wilhelmina, is an early example of a 'park with a theme'. Here the subject is *Les Aventures de Télémaque*. Joseph de Saint-Pierre, the Margravine's French architect, made use of an existing natural landscape containing rocks and a ruined medieval castle, which only needed a little retouching to create a setting evoking Fénelon's famous novel, a work which had had considerable influence in Germany. Rocks and grottoes were peopled with life-sized figures based on characters from the novel, and the central feature was the rock theatre which is still in existence today. The delicate Margravine could also enjoy a retreat to the curious Hermitage built by her father-in-law, where rustically furnished cells received the court when the Margrave felt the desire to play the hermit. In front of this hermitage *pl. 279* Wilhelmina had her architect build an orangery, a semicircular colonnade resembling the colonnade at Versailles, but with each arch leading into a nymph grotto.

Germany offers an intact example of a synthesis of the French garden and the English garden— the park of Schwetzingen near Mannheim. It was laid out in two stages by the French designer Nicolas de Pigage for Elector Palatine Charles Theodore, and still retains all its statues and structures, some of which came from the gardens of King Stanislas in Lorraine when these were broken up at the end of the eighteenth century. Beginning in 1758, Nicolas de Pigage laid out in front of the old palace a regular garden in the French style, with arrangements of fountains, lawns (*tapis verts*), statues, and a transverse canal (as at Vaux), all centred upon a vista which is continued beyond the canal by an avenue leading down to the Rhine. In 1775 the gardener Schell, after a study of parks in France and England, created groves of trees in the English style, including ornaments which were all the work of Pigage—a circular temple of Apollo upon a *pl. 355* pile of rocks, forming the background for an open-air theatre where pastoral plays were perform- ed, a very classical temple of Minerva, a ruined temple of Mercury, a rock of Pan, a Roman water-tower and its ruined aqueduct, a temple of Botany, a Chinese bridge, a mosque, and a *pl. 253* bathing pavilion. This elegant place, with its exquisitely designed interior, opens on to an arbour of trellis work ending in a dome, under which birds operated by hydraulic devices spout jets of water on to an owl—an amusement brought from the park of Malgrange, near Lunéville. On the edge of the park Pigage created a graceful court theatre. Was not Voltaire right to say that he had sworn he would enjoy one last consolation before he died: to see Schwetzingen again?

3 The City

The diadem of beautiful cities which present-day Europe is in the process of ruining is the creation of the baroque age. If we set apart the new towns (*villeneuves* and *villefranches*) created, notably in France, for political or military reasons, the towns of the Middle Ages were almost invariably spontaneous growths, developing anarchically within the circle of their ramparts; wonderful buildings fitted as best they could within the existing urban fabric, usually without any effort being made to set them off. Town planning came into existence in Italy in the fifteenth century under the influence of Vitruvius; but the Renaissance contribution was above all theoretical, its practical achievements being on a modest scale.

In the Rome of Julius II there began the great town-planning movement that gave a new face to the cities of Europe. Julius's sense of the greatness of the Church was to turn the capital of the Catholic world into one immense building site. In the course of the sixteenth century were built no less than fifty-three new churches—not counting St Peter's and the rebuilding of ancient churches—and sixty palaces, to which must be added the same number of villas. Everything was done to encourage building. According to city regulations which went back to Sixtus IV and Gregory XIII, and which remained in force until Rome became the capital of Italy, rich property-owners were granted the power to expropriate neighbours who were less wealthy or who owned houses which they rented to others. Assisted by an architect of genius, Domenico Fontana, a Pope with grandiose ideas, Sixtus V, succeeded during his short pontificate (1585–90) in giving Rome an overall plan, certain parts of which were not carried out until our own times. He provided the city with drinking-water, and improved the flow of traffic in streets thronged with thousands of pilgrims by means of *viae rectae,* vast straight thoroughfares linking the great churches, permitting redevelopment, and creating perspectives marked by an antique or modern monument: church, obelisk, triumphal column, or fountain. These streets were designed to radiate from some central point, in accordance with the radial principle so dear to the men of the Renaissance, for whom the circle was the perfect form. Usually this scheme has been carried out only in part; Rome contains many fragments of an ideal city, such as the three streets leading off the Piazza del Popolo which form an angle of which the bisector is the Corso; the resulting bird-foot pattern was to gain great popularity all over Europe.

The great straight avenues of Sixtus V satisfied the Renaissance taste for effects of perspective; they also expressed the organizing spirit of the Counter-Reformation. Roman city planning in the seventeenth century, dominated by the powerful personality of Bernini, was very different.

Bernini's object was beauty rather than utility; in his view the building of a city was primarily an aesthetic problem. He abandoned the rectilinear patterns used by Fontana and gave preference to curves. Far from seeking perspective effects, he sets out in his piazza before St Peter's to *pl. 139* minimize the perspective, by making the straight colonnades open out towards the façade of the basilica and by making the oval wider than it is long. He originally intended the colonnade to be closed by a great portico so that there would be no vista of St Peter's until the visitor had actually entered the piazza. Today the wide Via della Conciliazione built by Mussolini (reviving a project dating from Bramante and the Counter-Reformation) places St Peter's at the end of a long vista, thus ruining Bernini's intended effect of surprise. Spectacular surprise effects are the very essence of the baroque. The visitor to baroque Rome, as the Frenchman Charles de Brosses remarked in the eighteenth century, went from one surprise to the next. This effect was the reverse of what had been intended by Fontana and Sixtus V; Counter-Reformation town planning was intended to place the object in view well in advance. The approaching visitor could analyse the monument before him at his leisure as he proceeded along the *via recta*. His attitude was expected to be a rationalist one; one might say that it corresponds to the principles of classicism. Baroque planning, on the other hand, was addressed not to reason but to the senses. The baroque architect endeavoured to turn the meanest spaces to advantage by the fragmentation of planes, by the elasticity of curves. He had no desire to bring uniformity to the façades of different houses and buildings; these should charm the spectator by their variety. Towns which have grown spontaneously, such as Salzburg or Compostela, are by far the most *pl. 363* exciting to visit, the richest in discoveries. Seen from a distance, Salzburg appears gainst the backcloth of the Kapuzinerberg as a tangle of palaces and churches. Compostela is a maze of plazas and streets in which right angles and frontal views are rare; standing in one of the squares of this town, I found that the walls round its perimeter made up a total of seventeen angles. Spain, a country fundamentally baroque in temperament, contains many similar towns which grew up in the sixteenth, seventeenth and eighteenth centuries. An actual desire for irregularity seems to have governed the building of some new towns, such as Lerma near Burgos, a develop-ment planned by Francisco de Mora in 1604 for the Duke of Lerma, or a century later (1709) Nuevo Baztán near Madrid, designed by José Benito Churriguera for the banker Goyeneche.

In Sicily, south of Syracuse, there is a whole series of towns that were entirely rebuilt after the earthquake of 1693: Comiso, Ragusa, Modica and Noto. Here the architects started with a clean sheet; but instead of imposing the regular plan dictated by economic considerations, they treated each town as a work of art, playing with palaces and churches, varying façades and plans at will as if inspired by sheer caprice. In Modica the architect used an imposing site to turn the *pl. 364* town into a stairway of churches. At the foot of the slope San Pietro shows its stepped forecourt and magnificent façade, concealing the steps leading to San Giorgio. The summit is approached by a serpentine route which curves this way and that past palaces and churches which the visitor always come upon by surprise; just when he thinks he has seen the last one, he discovers at the very top the church of San Giovanni. The city can be experienced only as a sequence of varied and exciting events.

311

The key points of a town are its open spaces: the approaches to bridges, the open spaces before buildings, the commercial squares, the formal plazas that the French call *places royales*. The square in the baroque city was a secret place, set apart from the traffic of the busy streets, in which to walk or, in southern towns, to seek the shade of colonnades. It also served as an open-

pl. 369 air theatre, like the secluded Piazza Navona in Rome, which is in the form of an ancient circus; even today, the visitor comes upon it as if by accident. During carnivals it was transformed into a lake, and the Roman nobility staged displays to the great delight of the public. This idea of a square as a place apart, with no vista leading up to it, led to the creation in Spanish towns of the *plaza mayor,* in which plays, religious ceremonies, bullfights, and *autos da fé* were held. The

pl. 370 finest of all is that of Salamanca, designed by Alberto Churriguera in 1728, and completed by Andrés García de Quiñones, who built the town hall. Wheeled traffic was allowed only along two sides. In Paris the two squares built by Henry IV, the Place Dauphine and the Place Royale (now the Place des Vosges), were enclosed spaces until the intrusion of modern streets

fig. 27 altered their character. Under Louis XIV even the Place Vendôme and the Place des Victoires were away from the main streams of traffic.

French classicism brought with it regularity of design, unvarying façades, straight avenues on a checkerboard or radial plan. France, where in many respects the evolution of Renaissance styles continued after the interruption of mannerism, returned both in its gardens and in its towns to the concept of perspective. But in harmony with the spirit of the baroque age the vistas were now on a grandiose scale. This tendency, which began in the first half of the seventeenth century, increased under Louis XIV. The layout of certain towns shows the classical and

fig. 23 baroque conceptions juxtaposed. On the north-west side of the Cours Mirabeau, in Aix-en-Provence, is the picturesque *ville provençale* with its tortuous streets and its baroque palaces clustered around the university and the cathedral; on the south-east side is the *ville française,* with its dead-straight streets and its regular façades. Still more curious is the development of the

pl. 365 Grand'Place in Brussels. It was originally the market square, bordered by the houses of the guilds, built around two asymmetrically-placed medieval buildings, the town hall and the so-called Maison du Roi. When this square was destroyed by Marshal de Villeroi's bombardment in 1695, the municipal authorities hastened to rebuild it. The guilds rebuilt their houses, often merely reconstructing the ruins, but going out of their way to make each façade different from the next; the houses on the west side show the greatest variety. There is the same diversity on the south and north sides, but with a kind of asymmetrical rhythm. On the east side, where the destruction had been total, the architect could start from scratch, and here Guillaume de Bruyn grouped six livery companies behind a uniform façade known as the Maison des Ducs.

Sometimes baroque feeling lends a quality of flexibility to a regular French-style design, as

pl. 368 in the imposing eighteenth-century sequence of buildings built by Héré for Duke Stanislas of Lorraine (erstwhile king of Poland) in the capital city of Nancy, in order to link the old town with the new. The Place Royale (now the Place Stanislas) gives access, on one of its long sides, to a short avenue ending in a triumphal arch. This arch *conceals* an elongated square, an old tilting-ground known as La Carrière; the visitor who approaches it sees only the Hôtel du

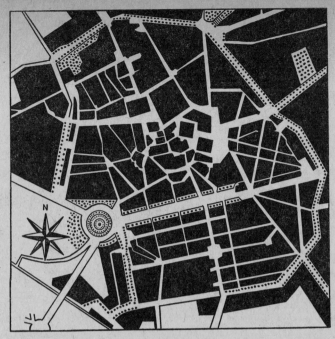

23 Aix-en-Provence

Gouvernement at the far end, but as he passes through the arch he has the *surprise* of seeing the space widen out on either side into an elliptical plaza. Two corners of the Place Stanislas are occupied by fountains and gilded wrought iron gates, one of which opens out into a large park called La Pépinière, laid out obliquely. Thus Héré, a disciple of Boffrand, succeeded in creating a regular and symmetrical arrangement in the classical French style while achieving surprise effects like those of a baroque architect.

The first wave of new city development in Northern Europe was neither Italian nor French, but Dutch. The Dutch, who had to contend with the problems of land reclamation and shifting, sandy soil, had won a reputation as builders of bridges, dykes, pile foundations and canals, and the Baltic countries, faced with similar difficulties, called on the help of Dutch civil engineers. It is characteristic of Dutch urban designers to reject perspective effects, to refrain from trying to show off a work of architecture to advantage or impose a 'plan' on individual property-owners, and to add to their streets the charm of canals. One of the most beautiful cities in Europe has come down to us intact; this is Amsterdam, laid out in the seventeenth century *pl. 365* along concentric canals forming a demi-ellipse backing upon the harbour. The marked individuality of the houses succeeding one another along the canals—canals whose curves the spectator follows without once being able to see a formal vista—would seem to class Amsterdam among baroque cities despite the early appearance of classical tendencies in Dutch architecture.

In the seventeenth century the kingdoms of Denmark and Sweden had a political importance out of proportion to the size of their populations, and Scandinavia was the most active centre of city development in Europe. Christian IV of Denmark (1588–1648) founded numerous towns for military or economic purposes which bear the stamp of the Dutch style; his capital, Copenhagen, illustrates a transition from the Dutch to the French manner, as does St Petersburg.

Before Peter the Great left Amsterdam for Paris in 1717 he was infatuated with Holland, and at first gave his new city the name of Pieterburg. He at first wished to build a town with canals

on the islands of the site chosen for the new capital, near the mouth of the Neva in the Gulf of Finland; he changed his mind, however, after his visit to France, and in 1717 sent for the Frenchman François Le Blond, who drew up a radial plan. Catherine the Great (1762–96) gave St Petersburg its decisive French stamp, but here and there in Leningrad one can still come upon corners of Holland.

Eighteenth-century France imposed its taste in urban design on the whole of Europe, as a result of the prestige enjoyed abroad by Versailles and by the transformation of ancient French cities.

A new kind of city appeared in Europe in the seventeenth century—the palace-city. It was not a king, but a minister—Cardinal Richelieu—who laid the foundations of this concept when he created in Poitou, near his new *château,* a new town bearing his name. In this case, however, town and palace were simply associated, not linked together in an organic unity. This *fig. 24* unity appears in the first plan of Versailles as it is shown in an engraving of 1665 (before the addition of the Grand Canal) which is essentially a repetition of the plan of Vaux-le-Vicomte. *pl. 346* The palace and park form a central axis for two groups of three avenues in the 'bird-foot'

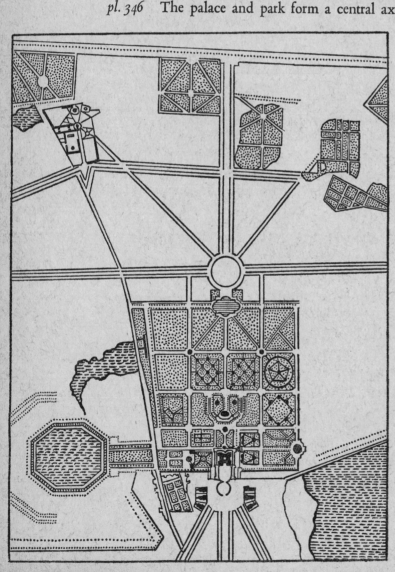

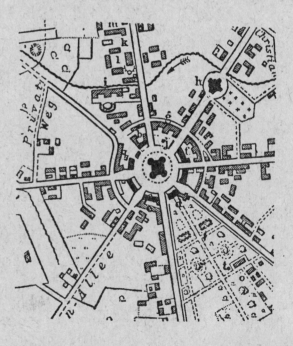

24 Versailles, *c.* 1665

25 Karlsruhe, 1715

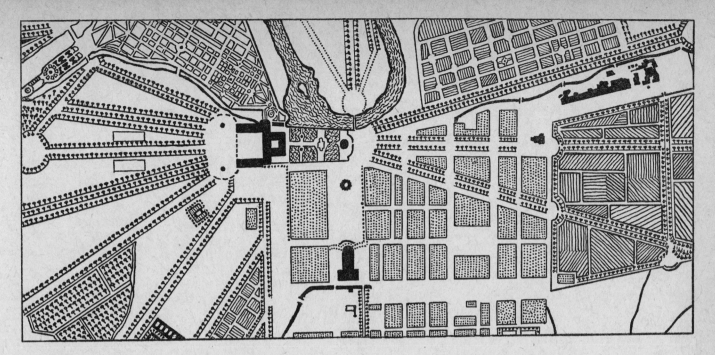

26 Aranjuez, 1748

pattern, one, in front, leading to the Place d'Armes of the town of Versailles, the other, in the rear, radiating out into the country. This return to the radial theme was to become very popular. Though the palace-city of Ludwigsburg, created in 1704, is still a mere annexe to the palace, that of Mannheim, as rebuilt by the Elector Palatine in 1699 after the ravages of war, has the palace as its axis, but this is situated at one end of an elliptical checkerboard plan. In 1715 the Margrave Charles William of Baden-Dürlach laid out Karlsruhe on a magnificent circular *fig. 25* radial plan, comprising nine streets in one quarter-circle and twenty-three park avenues in the other three. Elsewhere it was the 'bird-foot' pattern which was imitated. This plan is very clearly formulated in the palace of Aranjuez in Spain, as laid out after the fire of 1748 by the Italian *fig. 26* Bonavia; behind the palace, avenues radiate across the park as at Karlsruhe. The designers of great cities also sometimes used the same formula; Le Blond made use of it in St Petersburg where three diverging streets start from the Admiralty—one of them, the Nevsky Prospekt, is three miles long and ends at the great baroque monastery of Alexander Nevsky. Another Frenchman, L'Enfant, took the 'bird-foot' pattern to Washington at the end of the eighteenth century, making twenty streets converge on the Capitol. The advantages of a plan whereby several great avenues share a single point of perspective are obvious. Often, however, the checkerboard plan was preferred for economic reasons; this was the case in many towns in colonial Mexico—where it was often taken over more or less intact from the Aztecs—in most of the cities of North America, in certain Scandinavian towns, and in cities built rapidly for French Protestant refugees, such as Erlangen near Bamberg. Pombal, when he rebuilt Lisbon after the earthquake of 1755, linked the Praça do Recio with the Praça do Comercio (which overlooks the Tagus) by a checkerboard pattern based on three longitudinal streets. Wren, in his plan for the rebuilding of London after the Great Fire, adopted a checkerboard scheme, but

315

broke its monotony by great oblique axes and streets converging around squares in star forma‑ tion. The defect of Wren's design is that he does not plan his network of streets around key points, marked by open spaces around important monuments; his squares are little more than crossroads. What was lacking in the rebuilding of London, which was overseen by a committee, was the force of royal authority to impose a 'prestige' scheme.

It was French urban design that was to define the all‑important role of the square, destined to become the major element in the beauty of a city, by associating it with the splendour of state— creating the *place royale*. The origins of this concept are closely connected with the development of the royal statue, and of the equestrian statue in particular. In the Renaissance—which in this respect followed classical antiquity—the best way to celebrate the hero was to depict him on horseback. Two famous fifteenth‑century *condottieri* in bronze are each the point of departure for a different interpretation of the equestrian statue. They represent the two schools of military thought which existed in fifteenth‑century Italy, that of the *bracceschi* and that of the *sforzeschi*. The *bracceschi* (the school of Braccio di Montone) relied for success on the impetus of a direct frontal attack; the *sforzeschi* (the school of Francesco Sforza) preferred the complexities of strategy. The calm *Gattamelata* by Donatello, in the costume of an ancient Roman commander‑ in‑chief *(imperator)*, his face expressing intelligence, is a *sforzesco*; Verrocchio's *Colleone*, a fiery warrior standing up in his stirrups, is a *braccesco*. When Lodovico Sforza commissioned Leonardo da Vinci to create a statue of his father Francesco, the artist was faced with a choice; should he represent the general in the heat of action, displaying all his courage and daring, or was it more fitting to symbolize the power of command? Leonardo opted for the first alternative and showed Francesco on a horse at the gallop; to solve the problem of equilibrium he devised the clumsy artifice of a branch of a tree, and finally had the belly of the horse supported by a van‑ quished warrior. Faced by the practical difficulties of such a pose in the colossal proportions he had imagined, Leonardo finally came round to the antique theme of the *imperator*, master of himself, astride a slowly pacing horse, like the *Marcus Aurelius* of Monte Cavallo that had inspired Donatello. He returned to this theme in his project for the memorial to Marshal Trivulzio.

The grand dukes of Tuscany, who had a high idea of their princely virtues, celebrated them by commissioning portrait statues. To glorify the founder of the dynasty, Cosimo I, Grand Duke *pl. 371* Ferdinand I commissioned from Giovanni Bologna an equestrian statue in bronze which in 1594 was set up in the Piazza della Signoria. This was in the mannerist period, when the prestige of the antique was no longer so high; Cosimo is represented as a contemporary general, with spurs, on a calmly pacing horse. From this statue derive two others, also by Giovanni Bologna but executed with the aid of Pietro Tacca; the bronze figure of Henry IV of France, commissioned in 1604 and erected in 1614 on the Pont‑Neuf in Paris, and that of Philip III of Spain, erected in 1616 in the Casa del Campo, Madrid.

The attitude of the rearing horse had a vogue at the court of Philip IV of Spain, where Velázquez made use of it several times in his equestrian portraits of the king, the princes or members of the court; in painting, of course, it presented no practical difficulties. The rearing pose was forced on Pietro Tacca for his equestrian statue of Philip IV in Madrid, for which

he was sent paintings by Rubens as a guide; this is a mediocre composition in which the horse heaves itself ponderously off the ground.

The aesthetic of baroque Italy, in which expression was movement, made the horse into a symbol of power. In the two figures of Ranuccio and Alessandro Farnese in Parma, Francesco *pl. 372* Mocchi showed himself capable of expressing in the attitude of a walking horse a quivering animal energy, restrained by Ranuccio, driven forward to the attack by Alessandro. Bernini, returning to the style of his equestrian *Constantine* in St Peter's, seated his *Louis XIV* on a bounding monster more like a hippogriff than a horse, balanced by an awkward-looking rock. This bombastic statue greatly displeased the sovereign, who relegated it to the furthest corner of the park, after having Girardon transform it into a *Marcus Curtius*.

The statue of Louis XIV executed in 1689–99 by Girardon for the Place Louis-le-Grand in *pl. 373* Paris (now the Place Vendôme) was better calculated to satisfy the king. A monarch should be more than an intrepid general officer, and the attitude of the gallop is scarcely suited to the idea of royalty; a king on horseback should appear majestic and not impetuous. On his pacing horse, Girardon's *Louis XIV,* bewigged and dressed in the antique style, is an *imperator* riding in his triumphal procession. This masterpiece of monarchic art—now, alas, destroyed—became the accepted image of royalty. It is significant that a number of projects for figures of Louis XIV on a rearing horse (Le Brun's for a triumphal monument in the Louvre, Puget's for Marseilles, and Desjardins' for Aix-en-Provence) came to nothing. When Bouchardon received the order for a statue of Louis XV for the Place Louis-XV (now the Place de la Concorde) in Paris, he hesitated for a time over which attitude to give the horse, but finally adopted the type of the *imperator* in triumph. This formula was taken up in other countries. In his bronze figure *pl. 377* of the Great Elector, Frederick William III, for the Kurfürstenbrücke in Berlin, Andreas Schlüter took inspiration from Girardon's *Louis XIV,* which was not yet cast in bronze, but of which he must have seen a plaster model on his visit to Paris in 1695. In mood, however, Schlüter's work is different; had he seen Mocchi's statutes of the Farnesi in Parma during his *pl. 372* stay in Italy? This would appear likely; both Frederick William and his steed express not serenity, but impetuous energy. A mediocre imitation of Girardon's *Louis XIV* is the elder Rastrelli's *Peter the Great,* erected in St Petersburg in 1743.

There were monarchs, however, who found the baroque image of the galloping horse more in keeping with royal greatness. Charles II of the Two Sicilies ordered from Giacomo Serpotta, for a square in Messina, a statue in this attitude which was cast in 1681—a fine work, since *pl. 374* destroyed in a riot, but which we are fortunately able to know from a model which has been preserved in the Museo Pepoli, Trapani. The *Augustus II* prancing in the market place of the Neustadt, Dresden (1735) is also in this style. The most famous of all equestrian statues at a gallop is the one erected by Catherine the Great in homage to Peter the Great, for which she *pl. 375* summoned to St Petersburg the French sculptor Falconet, who executed it between 1766 and 1778. As in earlier equestrian statues, the tail is used as a device for balancing the bronze colossus (with the aid of a serpent, symbol of rebellion). Of all the royal effigies mounted on rearing horses, this is the only one to which the sculptor has succeeded in giving a real *élan*.

Several of these royal statues, on foot or on horseback, stand on rectangular pedestals marked at the corners by the figures of slaves in chains. This motif is derived from Renaissance symbolism.

pl. 378 At the foot of a royal statue its significance may be literal, as with the four Moorish slaves carved by Pietro Tacca between 1615 and 1624 at the foot of the statue of Grand Duke Ferdinand I erected at Livorno to commemorate his victories over the Barbary pirates; or it may be allegorical, symbolising Heresy, Discord or Rebellion. Around the statue of Louis XIV at the Place des Victoires, the slaves symbolize conquered nations.

pl. 376 Matthias Steinl's equestrian statuettes in ivory of the Emperors Joseph I and Leopold I show a symbolic figure trampled underfoot by a rearing horse; this is a return to a theme first used by Leonardo in his design for the statue of Francesco Sforza, and also envisaged by Antonio Pollaiuolo, to whom Ludovico, impatient of Leonardo's delays, at one time entrusted the project. It is probable that the idea of vanquished might, felt by the victorious Austrians in all
pl. 379 its epic grandeur, contributed to the spread of the Atlantean figures, supporting balconies, staircases, ceilings or entablatures, which gained great popularity in Vienna after 1700. Thus the princes of the baroque period were constantly reminded of their power, both in architecture and in decorative art, by this theme of the barbarian in chains—a testimony to the futility of strength when not governed by the wisdom which resides in the divinely appointed monarch.

Before the reign of Louis XIV, the only square to be designed expressly as a setting for a statue was the Piazza Capitolina in Rome, laid out in 1546 by Michelangelo to hold a statue of Marcus Aurelius brought there from Monte Cavallo in 1538. Situated in this place, the seat of the municipality of Rome, this statue had a symbolic significance; it bore witness to the continuity between the old Rome and the new, the Rome of the emperors and the Rome of the pontiffs. This idea bore no immediate fruit; all the statues of the late sixteenth and early seventeenth century that I have mentioned were erected wherever there was space available. In Paris, Henry IV does face the Place Dauphine, but on the Pont-Neuf he forms part of the scenery of the riverside. As for the Place Royale (Place des Vosges), it was not provided with a statue until the reign of Louis XIII, when it received an equestrian statue of that king, seated on a bronze horse made by Daniel de Volterra for a figure of Henry II that was never completed.

After the Peace of Nijmegen (1681) Marshal de la Feuillade presented to Louis XIV a standing marble figure of the king that he had commissioned from the sculptor Desjardins. The work was such a fine one that the Marshal ordered a replica of it in bronze, and a square was built to set it off. This was to be the Place des Victoires. Laid out by Mansart in 1683, it was circular in form, corresponding to the shape of the base of the statue, and its diameter was calculated so that the king should be viewed at the optimum angle of elevation, which was eighteen degrees. Mansart surrounded it with façades of uniform design on a colossal scale, in a style that Blondel was to call 'the court dress of French architecture'. A year later in Dijon, Mansart repeated this layout in the form of a semicircle, this time for an equestrian statue. The
fig. 27 finest expression of this theme was the Place Louis-le-Grand (Place Vendôme) in Paris, a rectangle cut off at the corners, originally intended as a setting for Girardon's masterly statue of Louis XIV. The provinces imitated Paris; Tours, Lyons, Caen, Rennes, Montpellier, Aix-

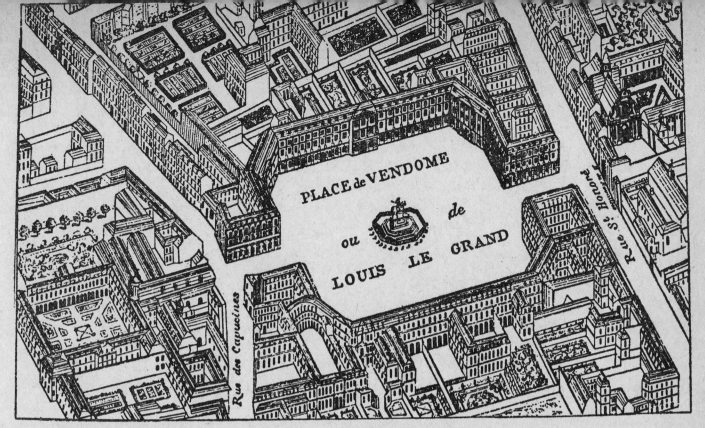

27 Jules Hardouin-Mansart (1646–1708). Place Louis-le-Grand (Place Vendôme), Paris, 1698

en-Provence, Marseilles and other cities endeavoured, not always successfully, to have their Place Royale as an expression of loyalty to the monarchy. In the eighteenth century Rennes, Nancy, Bordeaux, Valenciennes and Paris all built a 'Place Louis-XV' with a statue, either on foot or on horseback. In 1765 the architect Patte wrote a monograph on this subject, *Monumens erigés en France à la gloire de Louis XV*. The finest of these squares in the provinces was that of Bordeaux (now the Place de la Bourse), a harmonious ensemble laid out by Gabriel overlooking the har-bour. The building of these squares sometimes presented difficulties because occupiers were slow in coming forward; one solution was to build the façades first, as at Bordeaux, and then wait until the sites behind them found takers before building the houses themselves. The Place Louis-XV (Place de la Concorde) in Paris, also the work of Gabriel, followed an entirely new *pl. 224, fig. 28* scheme; built on the western side of the city, which was as yet little developed, it created a link between Paris and its natural setting. Only one of its short sides was occupied by buildings, while the other gave on to the Seine, and the two long sides on to the gardens of the Tuileries and the Champs-Elysées; long promenades were characteristic of eighteenth-century town planning in France. Gabriel's Place Louis-XV is not a focal point, like the Place des Victoires or the Place Vendôme, but part of a design in perspective. It was intended to be seen from the bank of the Seine, so that the spectator could see the statue of Louis XV framed between the two buildings by Gabriel (in imitation of the colonnade of the Louvre) in the background, and backed by the Rue Royale receding to the site of the proposed church of La Madeleine, which was not built until the next century. Here the statue is sacrificed to the grand scope of the design.

319

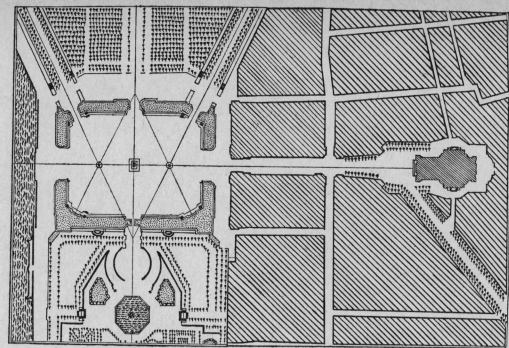

28 Jacques-Ange Gabriel
(1698–1792).
Place Louis-XV
(Place de la Concorde), Paris, 1755

Other European cities wished to have their *place royale,* Brussels as a setting for the statue of the Austrian governor Charles of Lorraine, Copenhagen to honour Christian VI. After the rebuilding of Lisbon the minister Pombal, loyal to the monarch beneath whose shadow he wielded absolute power, decided to pay him homage by setting his effigy on a bronze horse in the centre of the Praça do Comercio. In accordance with his belief in encouraging local arts and industries, he commissioned the statue (erected in 1775) from Joaquim Machado de Castro, who seated a helmeted and beplumed King Joseph on an unwieldy steed, trampling on thorns and serpents.

The architectural theme of the square received its apotheosis in the building of the town of Bath in England. This watering-place on the site of a Roman city was popularized by the elegant Richard 'Beau' Nash with the backing of several speculators, among whom was the architect John Wood. During the eighteenth century it was the setting for a glittering life which attracted the whole of London society, fashionable, literary and artistic, and even the royal family. The first plans were drawn up by John Wood in 1724 and the development of the town was continued until the end of the century by his son John Wood II, succeeded by Palmer. In order to show off the squares to the best advantage, the Woods concentrated architectural ornament within them, giving houses elsewhere a functional simplicity. The Circus, which is a hundred yards in diameter, has three classical orders superimposed, and the others have frontages adorned with giant columns or pilasters. The oldest, a rectangle cut off at the corners, is Queen's Square. *pl. 367* All the crescents are of imposing proportions; the oldest, Royal Crescent, built between 1767 and 1775, is five hundred yards from end to end. It was followed by others—Lansdowne Crescent, Camden Crescent, Somerset Crescent. Bath is another Vicenza under a misty English sky.

For a France of Gallicanism and the beginnings of free thought, the ideal monument for a square was a royal statue; for Rome it was a fountain or an obelisk. In the eighteenth century the wonderful series of Roman fountains was completed by the most monumental of all, the fountain of Trevi. This colossal composition, linked with the façade of a palace and created of rocks, water and sculptured stone, is the product of the inventive genius of Salvi (1732); it is set off, in characteristically baroque fashion, by a tiny square whose space it occupies almost completely. On the other hand the great fountain by Bouchardon in the Rue de Grenelle, Paris, a single jet, loses its effect if it is not seen from a distance. Conceived as a classical monument, it needs a 'viewpoint' to be fully appreciated; it consequently shows to its full advantage only in an engraving. In Central Europe, outbreaks of plague in the seventeenth and eighteenth centuries produced a quantity of votive columns (*Pestsäulen*) laden with statues and allegories, in which baroque fantasy is given free rein. Their sculptors were not deterred by any improbability; the column *pl. 381* at Mödling (near Vienna, 1714) is a twisted column made up of clouds. These artists did not seek to create a monumental effect; the object erected in the square must be marvellous, must provoke amazement. Naples, like Vienna, was ravaged by the plague, but also by the lava of Vesuvius. The cessation of these disasters, attributed to divine intervention, was celebrated by monuments that the Neapolitans call *guglie* (needles)—the ending of the plague of 1656 by the Guglia di San Domenico, that of the eruption of Vesuvius in 1631 by the Guglia di San Gennaro. The finest of them all, the Guglia del Gesù, was set up on a wave of popular piety initiated by a *pl. 380* Jesuit for the glory of his Order (1748). Milan was another pious city, erecting in the seventeenth and eighteenth centuries about a hundred columns dedicated to Christ, the Virgin and the saints. But Milan is the most ravaged baroque city in Italy, and only one of these columns exists today.

It would be wrong to consider the building achievements of the seventeenth- and eighteenth-century city only from the aspect of ostentation. This is what is most apparent today, whereas an effort of imagination is needed to understand the enormous labours which were required to provide a city with public services, house its citizens, care for them, teach them, and provide for roads and public health. The increase in urban population, a phenomenon which affected all Europe, especially in the eighteenth century, led municipal authorities to make plans for expansion necessitating the demolition of city walls and the creation of new housing developments, thus putting money in the pockets of architects, who then as now were men of business. No city could consist entirely of palaces; the connecting fabric was made up of modest houses, often built to a standard pattern. Many of these still stand today, particularly in cities reconstructed after some disaster, such as London and Lisbon, where the need to rehouse the homeless helped to establish the custom of large-scale development based on standard designs. Certain quarters of Copenhagen, and of Clermont-l'Hérault in France, can still show true working-class housing dating from this period. Venice, a town that has been preserved intact, can show from the Middle Ages to the eighteenth century the full range of types of habitation, from the patrician palace to mass-produced speculative housing. But the systematic setting apart of districts for inhabitants of a certain social standing is a product of the bourgeois instincts of the nineteenth

century. In Paris, a wealthy man who built himself a house with a frontage on the street formerly kept the *étage noble* for himself, and rented out the other floors at rates that varied according to position; the common people lodged on the lower floors, the mezzanine and the attic. The huge Roman palaces sheltered in their basements and attics a whole heterogeneous population which, more often than not, paid no rent; they lived there by tradition, being considered, according to the old Latin system, as 'clients' or dependents of the prince. In Paris as in Rome, nobles and plebeians rubbed shoulders at the entrance, which was a communal one. This led to a certain familiarity between the different classes of society, who did not regard one another as enemies as they were to do in the nineteenth century. To understand the baroque age in any country, one can never emphasize too much the attachment of the population in general to the régime which constituted its political backbone.

The population of a city always includes the homeless, the poor, the infirm, and the sick; for these there must be hospitals and poorhouses. The building of hospitals had flourished in the Middle Ages, when it was provided for by religious endowments. To the incitement of piety there were added, in later eras, civic considerations. It ill became the pomp of monarchy if a city was full of vagrants, cripples, sick people, prostitutes, beggars, robbers and pickpockets. Unfortunately the domestic and foreign wars that ravaged France in the sixteenth century, by increasing pauperism, had multiplied this element in the population. For the sake of public health, parliaments and kings issued 'edicts for the confinement of the poor' ordering the internment of beggars in prisons and of vagabonds in poorhouses. Despite these measures there were still forty thousand beggars in the capital at the beginning of the reign of Louis XIV, adding to congestion and demanding money from passers-by; the disturbances of the Fronde caused still more poverty and distress. To remedy these evils a royal declaration ordered the founding of a 'general hospital' in all large towns. This general hospital was at once a hospital, a poorhouse and an orphanage. The edict gave a great stimulus to the building of hospitals all over France; of those built under the *ancien régime* many examples still exist today, though much altered. The principle of the general hospital was still that of the hospices of the Middle Ages; the salvation of the soul was more important than that of the body. At the heart of the hospital, where we should today have the main clinical block, there was a church. In order to segregate the elements of the unhappy population, some of whom were infectious, this church is often made *fig. 29* up of several naves radiating around the high altar. This is the plan of the chapel of the Hôpital de la Salpêtrière, designed by Le Vau in 1660 and built in 1670, in which four naves and four cell-like chapels are arranged in star formation around an octagon. All the countries of Europe, ravaged by the wars of the seventeenth century, built hospitals. The megalomaniac Charles VII, king of the Two Sicilies, planned for his court the immense palace of Caserta, but did not forget the poor; he set out to institutionalize every beggar in his kingdom, a superhuman task on which he embarked by commissioning Ferdinando Fuga to build for Naples a colossal 'Albergo dei poveri' which would provide shelter for 8,000 people. This institution was to *fig. 30* measure 600 by 135 yards; the plan showed two wings (of which only one was belatedly completed) flanking a huge church with six naves, centred upon a rotunda with a high dome. The

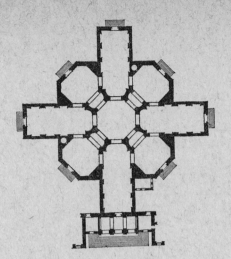

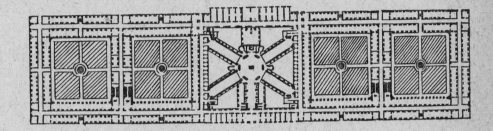

29 Louis Le Vau (1612–70). Hôpital de la Salpêtriere, Paris, 1660

30 Ferdinando Fuga (1699–1782). Project for Albergo dei Poveri, Naples, *c.* 1760

arrangement of the buildings was designed by Fuga in a most rational way to meet the needs of the various departments. After the burning of the Hôtel-Dieu in Paris in 1772, however, a new era began; the numerous projects submitted in the competition that was held to select a design for its reconstruction showed a new concern with technical considerations, and for architects planning a hospital the church was no longer the main preoccupation.

Among the hospitals of the baroque age were some that belonged to the luxury class; these were built by monarchs to ensure a tranquil old age for the pensioned or disabled soldiers who had served them. As early as 1604 Henry IV of France had founded an institution for this purpose. Perhaps the finest work of this type was the Hôtel des Invalides, which Louis XIV *pl. 382* first projected in 1670, and which was designed by Libéral Bruant on a plan similar to that of the Escurial. Jules Hardouin-Mansart later gave it a second chapel which is one of the master- *pl. 124* pieces of classical architecture. London also had its pensioners' hospitals; here the idea of the hospital as palace is perhaps even more touching, for Greenwich Hospital (now the Royal Naval College) was once a royal palace. It was in 1694 that William and Mary decided to alter and enlarge it to create a Royal Naval Hospital. In his design Wren succeeded in joining *pl. 383* the old buildings harmoniously with the new in a magnificent complex overlooking the Thames. Almost more than Louis XIV's Hôtel des Invalides, it is a true palace, containing a grand hall in place of the chapel. Here Sir James Thornhill was commissioned by Queen Anne to cele- brate the glory of the British Navy, and between 1708 and 1727 created the only great ensemble PL. XXIV of English baroque painting comparable to that of Germany and Italy.

Inside these hospitals many rooms were elaborately decorated, notably the dispensary. Against *pl. 386* a background of rocaille panelling, earthenware jars containing herbs and unguents were arranged like the collections of porcelain of the same period.

Baroque university building can now be appreciated almost only in England and Spain. Spain in this field continued the movement begun in the Renaissance period, when colleges were built like palaces, merely substituting baroque decoration for the 'plateresque' or silversmith's

323

style. Catalonia's six universities had been combined by Philip V into that of La Cervera, an imposing ensemble of baroque buildings begun in 1718, on which work progressed slowly enough for the last of them, the chapel, to be in the neoclassical style. New college buildings at Oxford and Cambridge took their place alongside the old, often adopting their style. Rebuilding *pl. 59* All Souls College, Oxford, Hawksmoor made it a Gothic pastiche.

The university of the modern era included a new feature, the dissecting theatre. When the study of anatomy from corpses, regarded as a sacrilege until the early sixteenth century, finally came to be tolerated by the Church, it was the duty of the university to practise and teach it. *pl. 384* A few European universities still have their old theatres; that of the university of Uppsala in Sweden, built in 1662–3 by the famous professor Olov Rudbeck, is purely functional, lighted by a double lantern and with steep tiers of seats to enable the students to have a good view of the demonstration. On the other hand, the anatomical theatre at Bologna (1638–49), destroyed in the Second World War but now restored and incorporating a few pieces of its original fabric, is decorated with fine panelling and statues of the founders of the art of medicine. The school of surgery of the university of Paris has kept its rotunda, but it is without its interior furnishings. That of Barcelona, founded in 1762 by the physician Pedro Virgili, is intact; here, too, the theatre is a rotunda, with a diameter of forty feet. It is generously lit, with stone tiers, and has kept its baroque walnut seats for the professors, and its four cabinets in the same style. From this form was to be derived the amphitheatre which is the classic pattern for the lecture rooms of modern universities.

Certain of the ceremonial rooms of European universities are often sumptuously decorated; that of the university of Breslau (Wroclaw) in Silesia (*c.* 1732) resembles a church, with its ornate stuccos and paintings. That of the university of Coimbra, built in the seventeenth century, is remarkable for its walls tiled with *azulejos de tapete,* its portraits of the kings of Portugal, and its fine ceiling in the form of an upturned boat painted with a decoration of acanthus flowers. Several new buildings were added to Coimbra in the eighteenth century; it possesses one of the finest of university libraries, a masterpiece of gilt woodwork (*talha dourada*), excellently designed from the functional point of view. In the second quarter of the eighteenth century a large chemistry laboratory was built, adorned with a harmonious classical façade.

With the revival of learning the library underwent a major transformation. The large number of books made available by printing eventually made it necessary to abandon the system of transverse desks still in use in the Renaissance (as in the Laurentian Library, Florence, built by Michelangelo), and to arrange books along the walls on shelves or in presses, often ornamented with perpendicular finials, and frequently divided into two levels, the second being reached by a gallery. The library of the Escurial, with its wonderful bookcases in precious wood designed by Herrera, is arranged in this way. The passion for knowledge that possessed the men of this time is expressed in the rich decoration of the libraries of universities, colleges, monasteries and palaces; the library became the shrine of the arts and sciences. Its earliest form of decoration was an imitation of that of the libraries of antiquity, known from many descriptions, and consisting essentially of portraits of famous scholars, writers and philosophers, usually in the form of busts;

this style was used for many years (as witness the university library of Bologna and the Bibliothè-que Mazarine, Paris) and was the style adopted by the libraries of English colleges, which rely chiefly for their effect on their panelling and woodcarving; an example is the library of Trinity College, Cambridge (1691) with its Grinling Gibbons busts. There has recently been discovered in the Bodleian Library, Oxford, a painted frieze 230 yards long decorated with two hundred *pl. 391* portraits of classical authors, Fathers of the Church, and theologians and scholars of the sixteenth and the first years of the seventeenth centuries. This frieze served a 'functional' purpose, constitut-ing an illustrated guide to the most important works possessed by the library at the date it was executed; its content corresponds to the catalogue of 1620. This ingenious device seem to have been fairly widespread; it is found at the Chapter Library, Durham, where the frieze was painted in 1668, in the Biblioteca Corsini, Rome, which dates from 1754, and in the city library of Valenciennes, built in 1742 at the expense of the rector of the Jesuit college. In addition to the portraits of famous men there were often inscriptions taken from their works, another heritage of antiquity; the ceiling of the library in Montaigne's house still bears the favourite sayings and quotations of the author of the *Essais,* and on the ceiling of the Benedictine library of San Giovanni in Parma similar inscriptions are combined with a graceful decoration of grotesques.

The ceiling of the library of the Escurial (1587) develops an encyclopaedic theme inspired by Christian humanism and the parallels between theology and philosophy, revelation and natural law. This encyclopaedic theme appears, embellished by every decorative device known to the baroque genius, in many libraries in Austria and Germany. Sometimes it is pursued even at the expense of the books; in the library of the monastery of Altenburg, which—with that of Ardmont—is the finest in Austria, the bookcases are so minute that it requires an effort to distin- *pl. 392* guish them amid the sumptuous decoration. Approached by a magnificent staircase ornamented with the four elements and the four seasons (cosmic symbols), the library, with its three domes, is built over a curious funerary crypt, decorated at the same period with a kind of rococo Dance of Death. This chapel was used for the funeral services of the monks, its position under the library reminding them that human knowledge is but vanity, and that the temptations of science are a snare set to lead mankind from the way of salvation. We are in the house of God.

In the house of Caesar, the Hofburg in Vienna, a library was built betwen 1723 and 1726 *pl. 170* by Emmanuel Fischer von Erlach to an original design by his father Johann Bernhard. The enormous hall is bisected by one of those oval domes beloved by Johann Bernhard, decorated with a painting glorifying Charles VI; it is a cathedral of the written word, a symbol of the universality of the Empire.

The museum, an institution whose development began in the Renaissance, prospered during the baroque period. In 1727 a Latin treatise on the subject was published under the title *Museo-graphia* by Caspar F. Neickel, a merchant of Hamburg. The museum gathers together all the expressions of human knowledge, the products of art and the creations of nature. The splendid baroque galleries in which were displayed the works of the masters of antiquity, of the Renaissance and of modern times, and the collections of curiosities, wonders of a Nature whose mysteries were in process of being discovered, were attributes of the noble life. All life, human and

natural, all the past and its marvels, must be drawn into the orbit of the prince, in order to make his house a place of excellence, a dwelling for the spirit of the universe. Others were invited to see this display, for these private museums were entirely open to a public of aristocrats, amateurs, scholars and artists; from the seventeenth century onwards museum guides and tourist itineraries were best-sellers just as they are today. England had its public museums, such as the Ashmolean Museum, Oxford, presented to the university by Elias Ashmole, who had inherited the collections of John Tradescant and undertook to preserve them for posterity. Museums of the *ancien régime* might take the form of collections of objects crammed together with the greatest economy of space, or collections forming part of the furnishings of a grand reception room in a noble house, often a gallery. Hence the modern use of the term 'gallery' for a museum of art: Rome still retains from the seventeenth and eighteenth centuries the magnificent Colonna, Pamphili-Doria and Pallavicini galleries, with all their contents. The French word *cabinet*, on the other hand (in German *Wunderkammer*), is used more for scientific collections; there were collections of exhibits concerning mathematics, physics, chemistry, natural history, conchology, mineralogy, history, and numismatics. Other *cabinets* contained *objets d'art*, porcelain, glass or *pl. 387, fig. 1* even paintings, the latter crowded together frame to frame. In all these collections overcrowding was the rule, not only because of lack of space, but because the baroque aesthetic identifies wealth with profusion. Nearly all these collections were housed in fine cupboards in precious wood, often decorated in rocaille. The most extravagant décor was undoubtedly the Art Nouveau woodwork which housed the collection of Bonnier de la Mosson in Paris. France has *pl. 390* lost all its *Wunderkammern*, apart from that of Clément Lafaille, which is preserved intact with all its furnishings in the Musée de La Rochelle. However, there are still many in Central and Northern Europe. No expense was spared to display rare Chinese porcelains, which were given magnificent settings of carved and gilded wood; the Dresden porcelain collection was dispersed during the last war, but others survive intact in Germany, notably the exquisite collections of Potsdam. The palace of Rosenborg in Copenhagen still has on its top floor a *pl. 389* unique glass collection placed on show in 1714 by Frederick V, who on a visit to Venice in 1708 had become an enthusiast for Murano glass.

Before the eighteenth century, museum architecture is barely distinguishable from that of the palace. Galleries were conceived as grand reception rooms; their architecture was designed so that the objects could be incorporated as features of the decoration (as in the 'Antiquarium' in the Residenz, Munich, about 1600). It was in the eighteenth century that the décor began to be created specially to set off the objects; this 'functional' tendency began with galleries of antiques, and derived from the renewal of Graeco-Roman influence. In the second half of the eighteenth century galleries in various parts of Europe were designed in the neoclassical style, considered to be the noblest and best setting for the masterpieces of antiquity. In the Uffizi, Grand Duke Peter Leopold built a gallery to display the famous *Niobid* brought in 1775 from the Villa Medici in Rome. In Stockholm in 1792, in accordance with the will of Gustav III, who had just been assassinated, a public gallery of antiques was created in the royal palace. *pl. 388* A similar enterprise, more in the character of a museum in the modern sense of the word, was

the Museo Pio-Clementino in the Vatican, built by Clement XIV. The architect, Simonetti, did not hesitate to destroy part of the Belvedere, the heritage of the Renaissance; in the layout and architecture of the rooms and galleries he took inspiration from the Roman baths and their decoration. This 'Roman' style was to persist for a long time to come in museums of antiques. The St Petersburg Antiquarium by Klenze (1840–9) is based on the Museo Pio-Clementino.

Utilitarian buildings interest us today only in the exceptional cases where they constitute works of art. This was by no means so rare in the baroque age as it is today; indeed, the difficulty was for anyone to conceive of an object that was not a work of art. Stock exchanges were designed as artistic monuments. Dutch architects lavished the same care on offices of weights and measures, meat markets and fish markets as on their ornate and beautiful town halls. Even the industries that developed in the eighteenth century contrived to produce masterpieces of architecture. The Bourbons stimulated the industrial growth of Spain by founding textile factories and glass and porcelain works; these owed much to a corps of military engineers formed in 1709–11 by a Fleming, José Prospero de Verboom. One of these officers designed the Real Fabrica de Tabacos which the Government had decided to rebuild in Seville. Work on this was begun in 1728, and after a certain period of delay made rapid progress after 1750. It is a large rectangle 200 yards by 159, surrounded by a moat and wholly self-contained; it incorporates a chapel, a prison, and a residential mansion approached by a monumental staircase. In the tobacco factory proper everything has been designed functionally, including provisions for maintaining the necessary relative humidity by means of an underground water system and ventilation shafts. On the entrance side the building has an ornamented façade like that of a baroque palace; the Spanish crown spared no expense to make a factory a finished work of architecture. But the State tobacco monopoly was so profitable that the cost of this magnificent building (now the university) was no more than half the net annual income.

In the latter part of the eighteenth century the geometrical forms of antique architecture were found to be particularly suitable for industrial buildings. Furnaces lent themselves readily to the shape of Egyptian pyramids, as in the Marie-Antoinette glassworks at Le Creusot, or the cannon foundry proposed by Ledoux. For the Salines de Chaux salt mines (1775–9) Ledoux created a magnificent Grecian ensemble in which the spirit of industry is symbolized by the severity of the Doric order and the vigour of the rustication. But Ledoux belonged to another world—that of neoclassicism; he comes within our field because he is moved by a spirit of fantasy which, though finding expression in classical forms, is none the less an offshoot of baroque utopianism.

In the eighteenth century progress in the art of tactics caused the art of war to evolve in the direction of mobility; in the seventeenth century military operations had consisted essentially in the siege and defence of fortresses. Throughout Europe old cities were surrounded by ramparts, and new ones built to be used as fortresses. Military engineering had become a science in the fifteenth century, in answer to the need to create new forms of fortification, which could resist artillery fire. From the latter half of the fifteenth century there was scarcely an architect in Italy who did not concern himself actively with the subject; and the design of fortresses was an

327

opportunity to apply geometrical knowledge in conjunction with ballistics and the art of siege. The principle of medieval fortification lay in the command of towers and curtain walls standing on prominent features of the landscape. The introduction of artillery made it necessary for fortresses to be dug in, so that often the natural relief is perceptible only in relation to the moats. Traditional forms were so slow to die that the medieval idea of a 'commanding position' persisted in plans that had been completely transformed by the new art. A work like the machicolated tower (*Maschikuliturm*) which Balthasar Neumann built in 1728 in front of the lower curtain-wall of the citadel of Marienberg, Würzburg (based on plans by Maximilian von Welsch, a 'mediocre' architect), might have been dated two centuries earlier.

The art of modern fortification was spread throughout eighteenth-century Europe by means of the innumerable treatises and essays on the subject by Marshal Vauban, military engineer to Louis XIV. Vauban was not only an engineer but a gunner, a sailor, a town planner and an economist. He built in France about a hundred fortified towns, in which the severity of outline of purely military structures is sometimes relieved by a certain showiness, notably in the gates. The 'porcupine' principle of defence required, as well as the oblique lines necessitated by flanking, the adoption of polygonal and star-shaped plans which show profound and inescapable analogies with the expanding forms beloved of baroque decorators, such as the sunburst. Every period has its own style, creating a secret affinity between the various forms it engenders. What lover of architecture could remain unmoved by so perfect and compact a form as that of the

pl. 393 Fort Carré in Antibes? It has the beauty that consists in the exact relation of each part to another, and of all parts to the whole. Here art is the equal of nature in her most mysterious creations, those which are ruled by the spirit of geometry—shells, crystals, starfish. By the union of the circle of the courtyard and the threatening star of the bastions, this form, at once intensive and extensive, is the symbol of the classicism of the baroque age, the consciousness of great strength mastered.

At the mouth of the Gironde, on the limestone islet of Cordouan, a lighthouse was built in the reign of Henry IV. Its upper portion was reconstructed in 1788, and it is still in use, this western outpost, just as the eighteenth century bequeathed it to us. It is a fine classical work

pl. 394 which, like many utilitarian buildings of the *ancien régime,* contains a chapel, which occupies the second floor. This is an elegant rotunda, richly decorated with a Corinthian order and festoons and garlands of stone, surmounted by a coffered dome, and richly paved in black and white marble. Thus God is at the heart of this tower of light, the *Pharos* which in the Christian paintings of the ancient Catacombs was the symbol of salvation. What avail man's efforts to triumph over tempests, if God does not sustain him? A long inscription celebrates the virtues of the creator of this marvel, the engineer Louis de Foix: BY THIS, it reads, THOU HAST ACQUIRED AN INFINITE HONOUR, WHICH WILL END ONLY WHEN THIS BEACON OF GLORY, BY THE ENDING OF THE WORLD, ITSELF MEETS ITS END. A richly significant play on words here at this 'land's end', on the edge of infinite space.

Beacon of glory . . . This phrase, which sums up the whole subject of our study, is a fitting one to mark its completion.

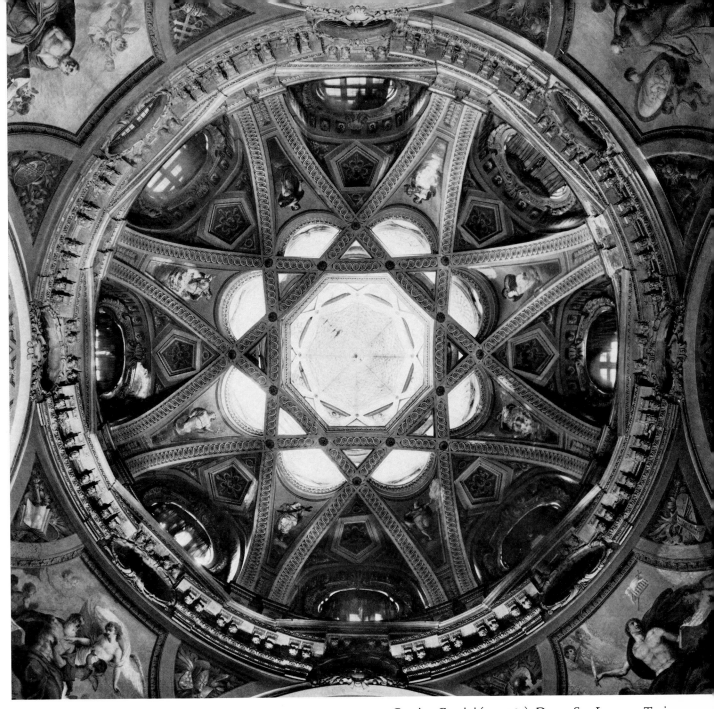

331 Guarino Guarini (1624–83). Dome, San Lorenzo, Turin

THE CHURCH

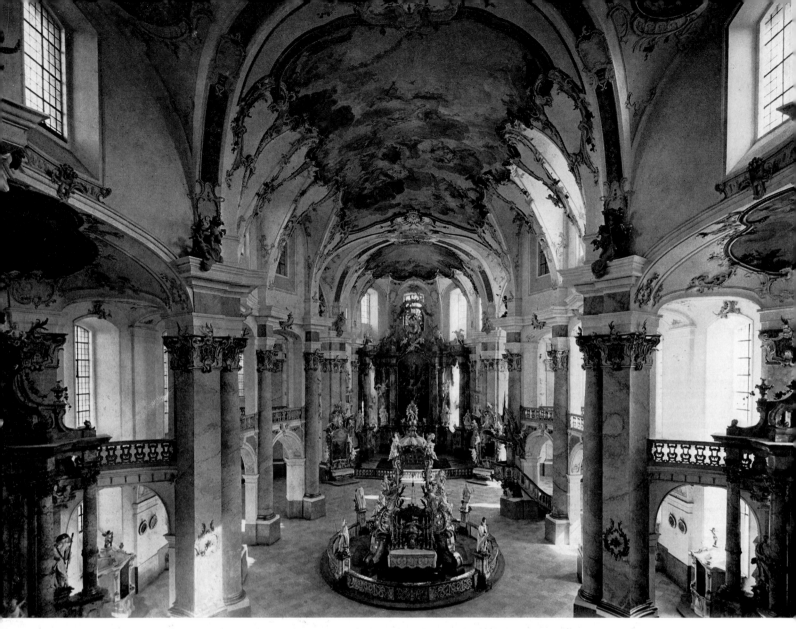

332 Balthasar Neumann (1687–1753). Wallfahrtskirche, Vierzehnheiligen, Bavaria, 1743–72

Two cults Catholic churches are focussed on the altar; Protestant churches on the pulpit and the organ. This is especially so in Germany, where choral music plays a central role. With its tiered balconies, the Protestant Frauenkirche in Dresden (destroyed in 1945) was laid out like a concert hall.

333 Georg Bähr (1666–1738). Frauenkirche, Dresden, 1726–43

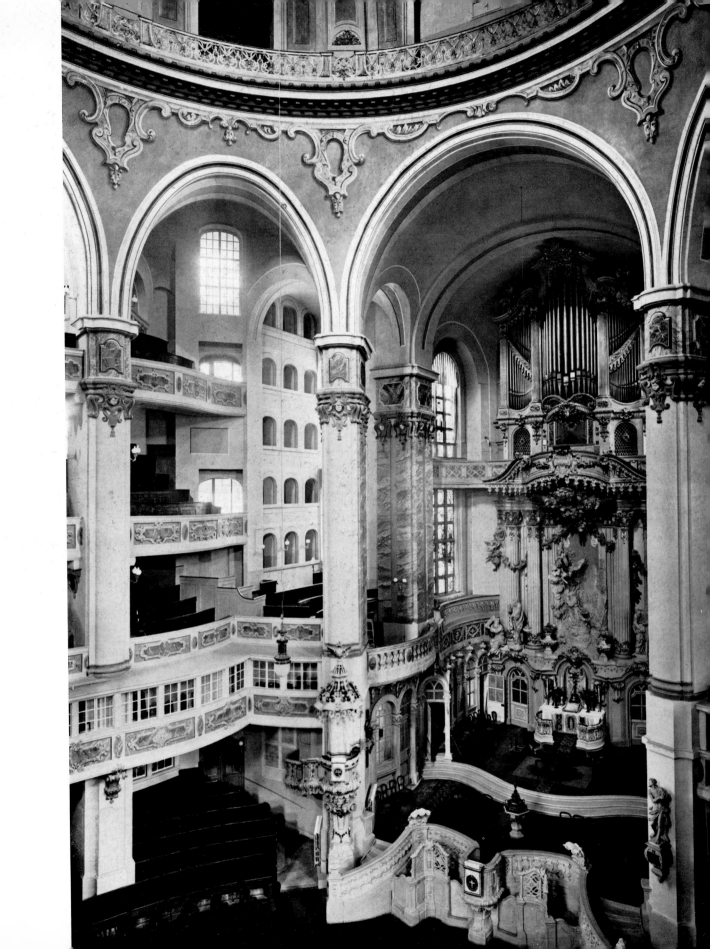

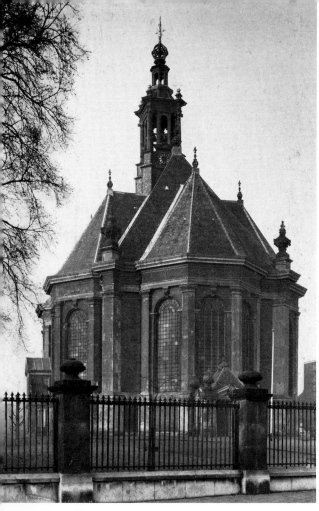

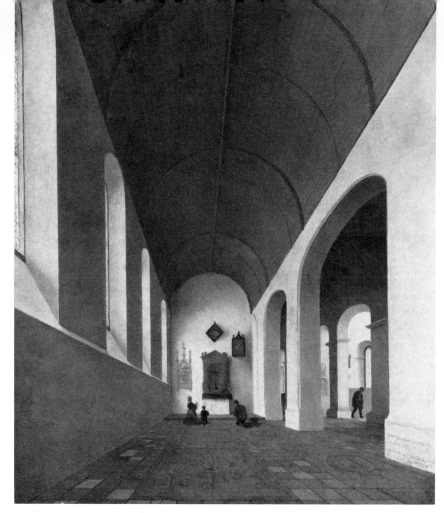

334 Pieter Noorwits (d. 1669). Nieuwekerk, The Hague, 1649–56

335 Pieter Jansz. Saenredam (1597–1665). View of St Janskerk, Utrecht, 1645

336 Kerk, Alkmaar, seventeenth century

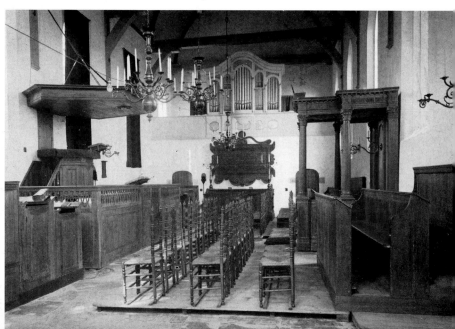

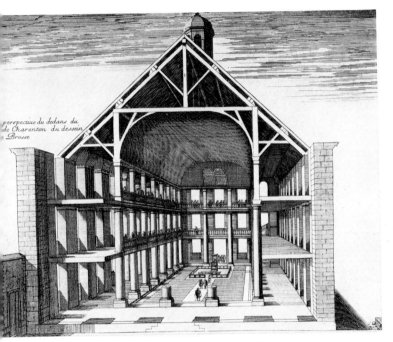

337 Salomon de Brosse (1571–1626). Temple, Charenton

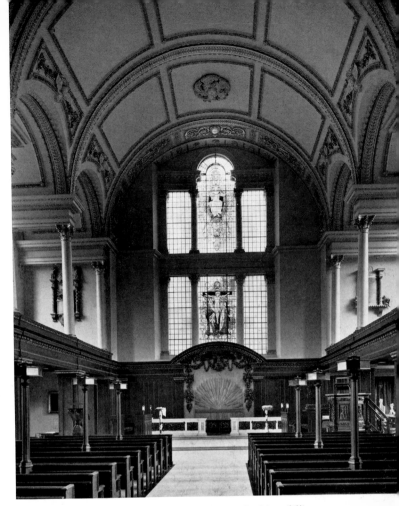

338 Christopher Wren (1632–1723). St James's, Piccadilly, London, 1700

Protestant church building

Whether or not it has been built specially for a Protestant form of worship, the Protestant church tends to be devoid of images and correspondingly free of ornament. Its purpose is to gather worshippers round the preacher; hence the widespread use of balconies.

339 Synagogue, Carpentras, France, eighteenth century

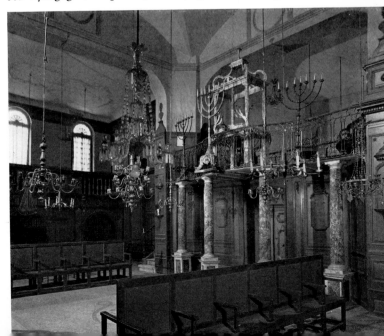

The synagogue

The design of the synagogue is not very different from that of the Protestant church; its purpose is to enable the congregation to hear readings from sacred texts (see *pl. 223*).

The monastery

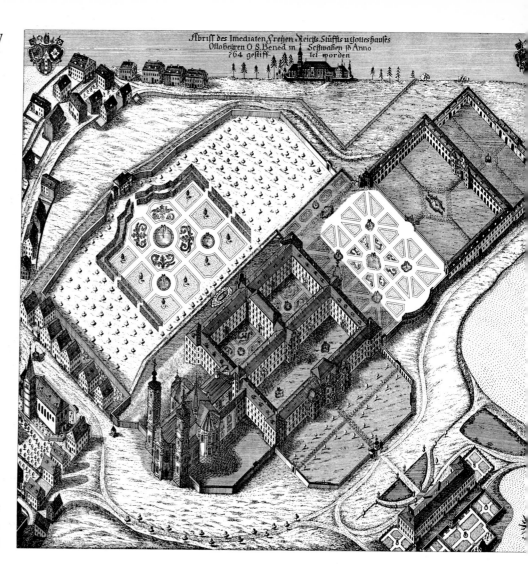

340 Johann Michael Fischer
(1691–1756) and others.
Ottobeuren, Swabia, 1719

341 Refectory, Couvent Saint-
Pierre (Musée des Beaux-Arts),
Lyons

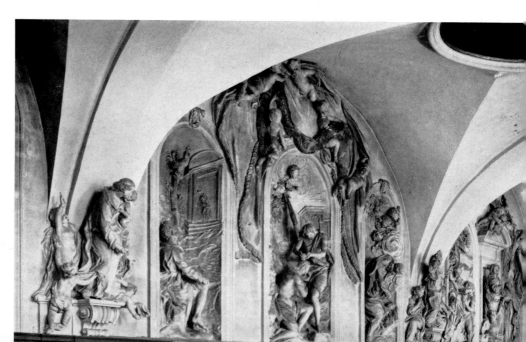

334

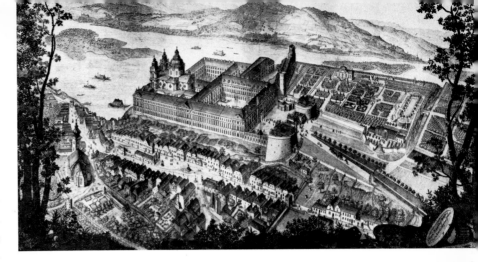

In the eighteenth century, all over Europe, the ancient
monastic orders rebuilt their houses on a grand scale.
The movement began in Italy in the seventeenth
century, and spread into Central Europe, the Low
Countries, France and even Orthodox Russia.

Abbots and their architects abandoned the asym-
metrical medieval plan for a layout consisting of a
number of courts centred on the church, a plan
derived from the Escurial. In Central Europe the
monastery is a palace, comprising luxurious apart-
ments for the abbot, magnificent guest rooms known
as 'imperial apartments' *(Kaiserzimmer)*, for distin-
guished visitors, a banqueting-hall *(Kaisersaal or
Marmorsaal)*, a theatre, a library decorated like a
church, an art gallery, a scientific museum, and
sometimes ornamental 'French gardens'.

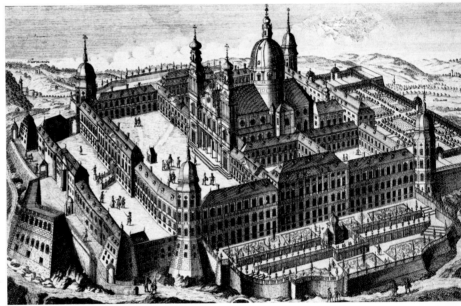

342 Jakob Prandtauer (1660–1726). Melk, begun 1700,
engraving after F. Rosenstingl

343 Lucas von Hildebrandt (1668–1745). Göttweig,
Austria, after 1718, engraving after F. B. Werner

344–5 Donato Felice Allio (c. 1690–c. 1780). Marble hall
and overall view, Klosterneuburg, Austria, 1730–50

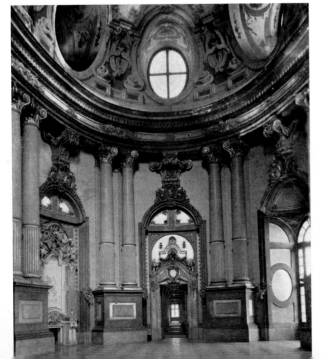

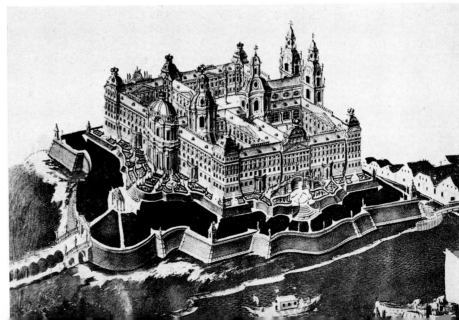

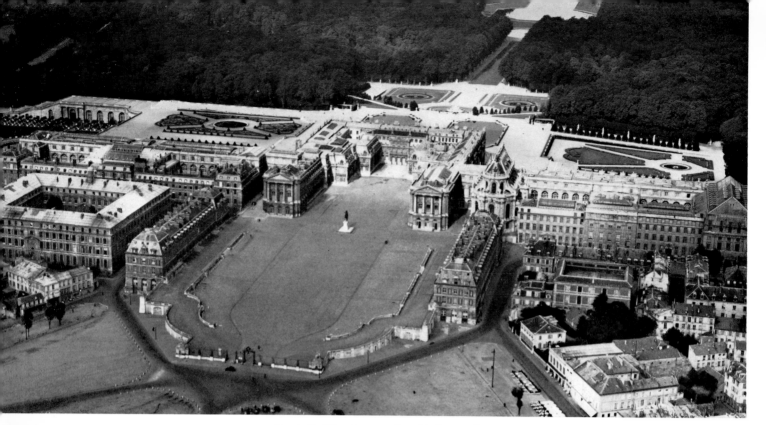

346 Louis Le Vau (1613–70) and Jules Hardouin-Mansart (1646–1708). Château de Versailles

THE COURT

The royal palace

347 Bartolommeo Rastrelli (1700–71). Façade, Peterhof (Pyetrodvorets), near Leningrad, 1715–57

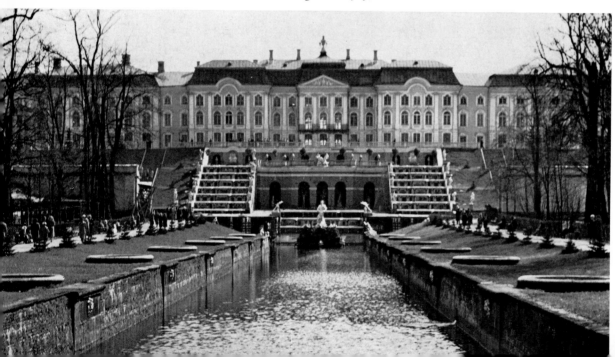

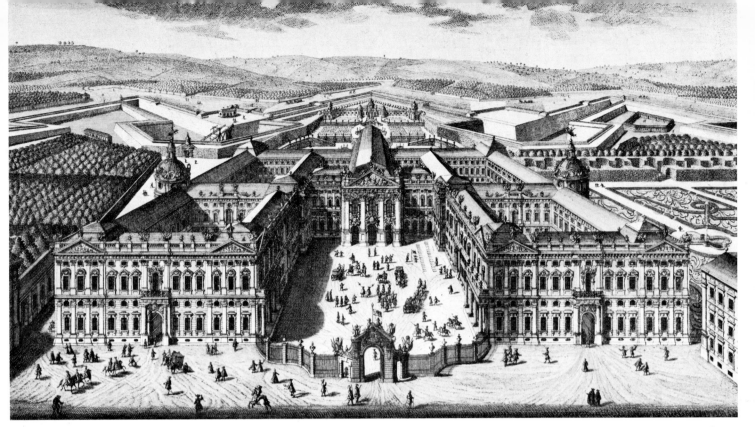

348 Balthasar Neumann (1687–1753). Residenz, Würzburg, engraving after Salomon Kleiner

Of the two types of princely residence, it was the French pattern rather than the Italian which prevailed. In the course of the eighteenth century palaces all over Europe were, modelled on Louis XIV's Château de Versailles.

349 Daniel Pöppelmann (1662–1736). Zwinger, Dresden, 1709-19, engraving showing a carrousel

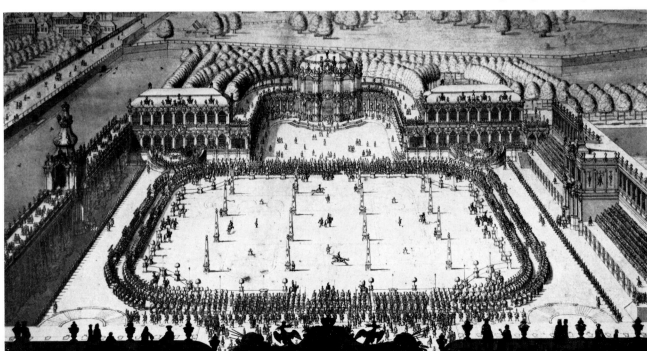

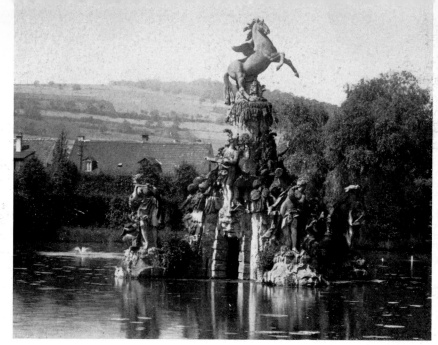

350 Ferdinand Dietz (d. *c.* 1780). Lake with Parnassus group, Veitshöchheim, near Würzburg, 1765

The French garden

More even than the French *château*, the French ornamental garden, created by Le Nostre at Vaux-le-Vicomte (PL. XX) and developed by the same designer at Versailles, was imitated as far afield as Russia; however, the noble classicism of Versailles was in general interpreted in baroque terms, both in the statuary and in the grandiloquence of the vistas.

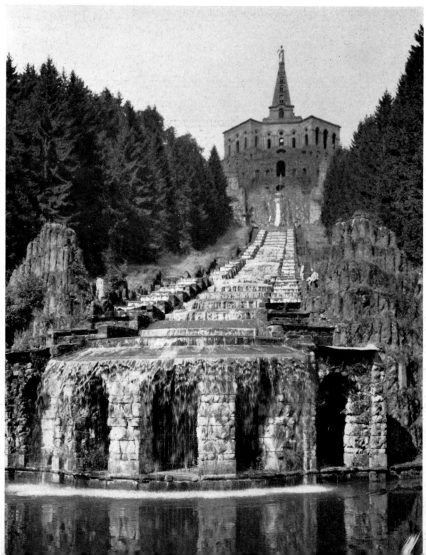

351 Giovanni Francesco Guerniero (*c.* 1665–1745). Cascade, Wilhelmshöhe, Cassel, with *Hercules* by Johann Jacob Anthoni, 1701–17

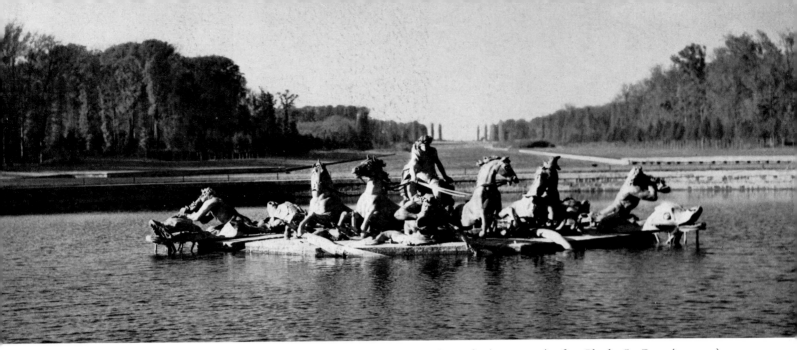

352 Jean–Baptiste Tuby (1635–1700), after Charles Le Brun (1619–90).
Lake of Apollo, Versailles, 1668–70

353 Cascades, Giardino Reale,
Caserta, near Naples, begun 1773

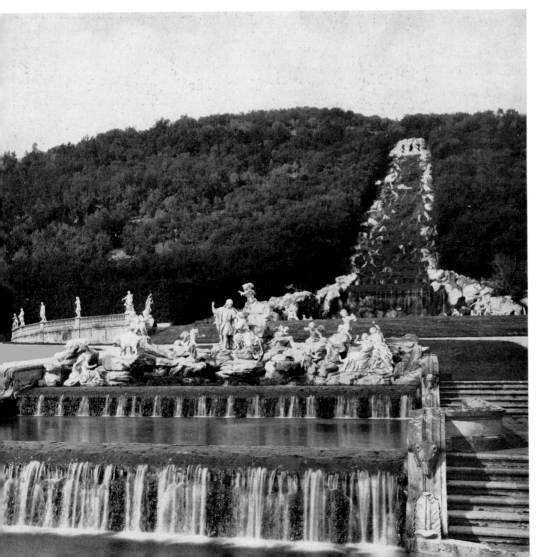

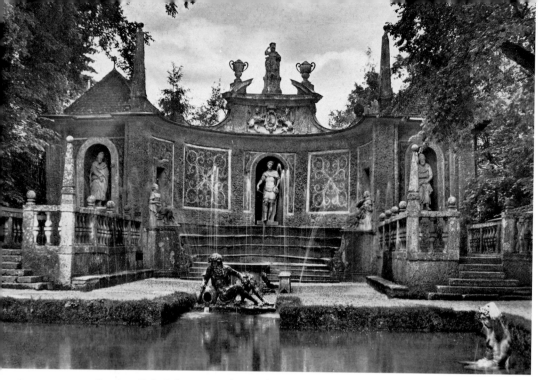

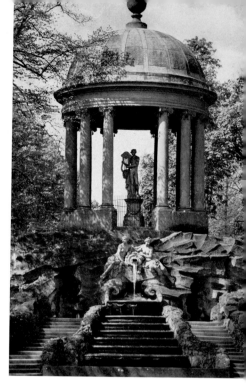

354 Santino Solari (1576–1646). Trick fountains in Roman theatre, Schloss Hellbrunn, near Salzburg, c. 1610

355 Nicolas de Pigage (1723–96). Temple of Apollo, Schwetzingen, near Mannheim

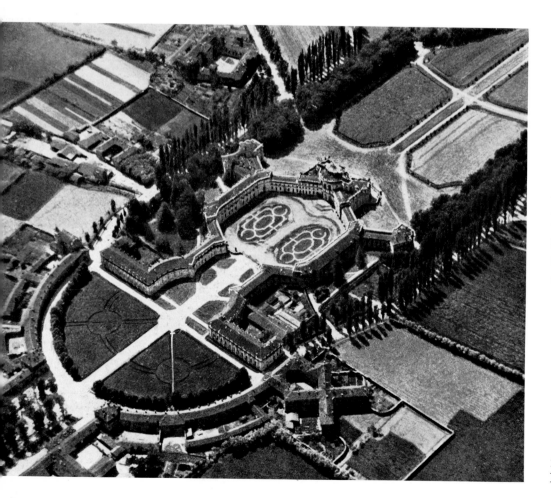

The garden as microcosm

In the course of the seventeenth and eighteenth centuries the three forms of garden, Italian, French and English, came together in grandiose garden designs which had something of the quality of all three.

356 Filippo Juvarra (c. 1676–1736). Stupinigi, Piedmont, begun 1729

Chinese influence and the 'English' garden

The formal French garden was followed in the eighteenth century by another type known as the 'English' garden, perhaps better described as 'Anglo-Chinese'. It was created in the 1720s under the influence of William Kent. Sometimes it appears in juxtaposition with a French garden, as at Versailles and at many places in Germany. In spite of the ostentatious 'return to nature' implied in its serpentine forms, this form of garden is crowded with monuments which carry a moral significance. Mythology gives place to philosophy as a theme.

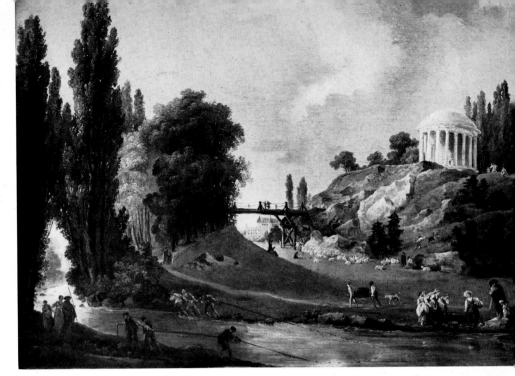

357 Hubert Robert (1733–1808).
View of park, Méréville

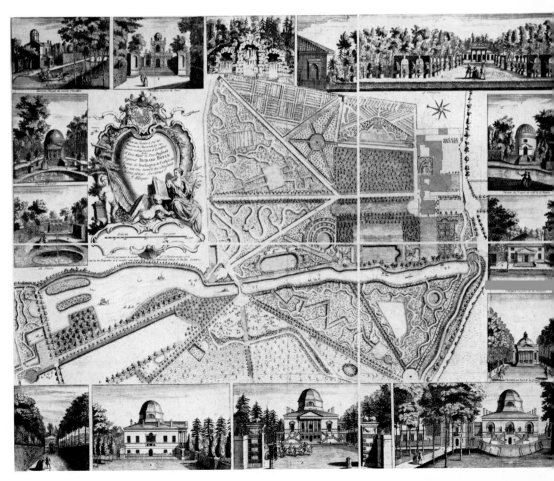

358 Richard, Earl of Burlington
(1695–1753). Grounds of Chiswick
House, 1725, engraving after
J. Rocque

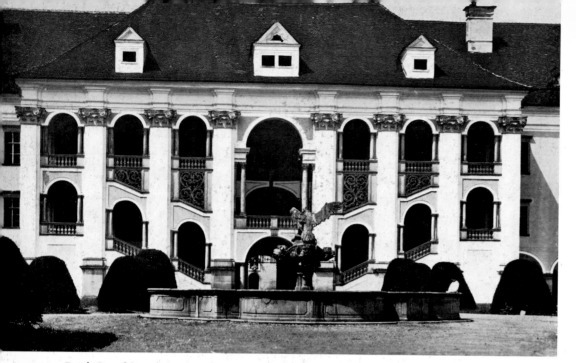

With the gallery, the staircase is the major element in the residence of the eighteenth century. Louis XIV had created the prototype at Versailles. In southern Italy, and in Germany, the staircase became the favourite theme of eighteenth-century architects; it allowed them to exercise their talent for spatial invention.

359 Jacob Prandtauer (1660–1726). Staircase, Sankt Florian, Austria, eighteenth century
360 Victor Louis (1731–1800). Staircase, Grand Théâtre, Bordeaux, 1772–80
361 Luigi Vanvitelli (1700–73). Staircase, Palazzo Reale, Caserta, near Naples, begun 1752

362 Balthasar Neumann (1678–1753). Staircase, Residenz, Würzburg, c. 1750

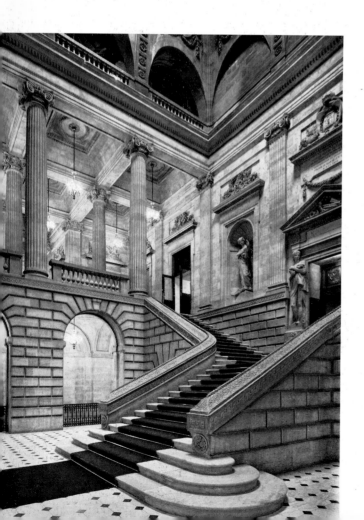

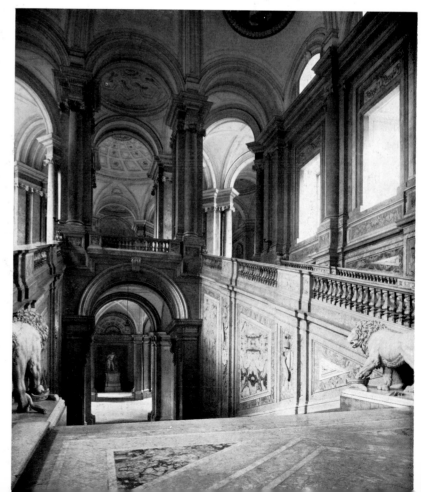

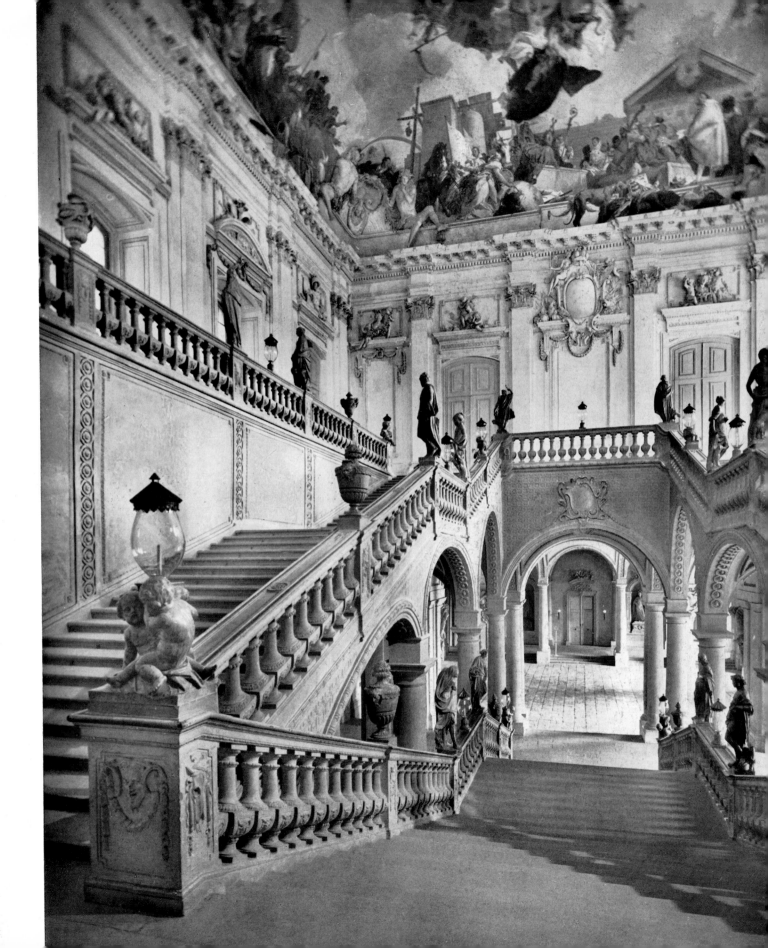

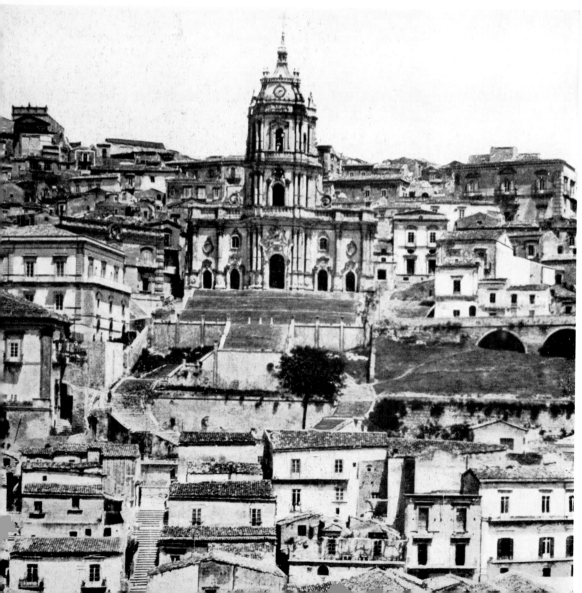

363 Salzburg, Austria

364 Modica, Sicily

THE CITY

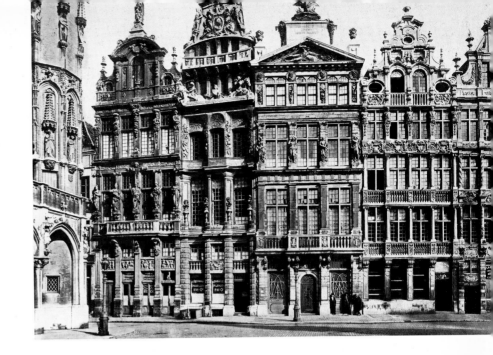

365 Grand' Place, Brussels, c. 1700

366 Amsterdam

Town planning

The timid attempts at urban design which had been made in the Renaissance were succeeded in the baroque age by planning on the grand scale. Architects extended their imaginative scope to comprehend an entire city, treated as a single work of art. The designs are immensely varied; some are based on rigid geometrical patterns, while others take account of the lie of the land. It was during the seventeenth and eighteenth centuries that the great cities of Europe first acquired the overall arrangement that they still have today.

367 John Wood I (1704–54). Royal Crescent, Bath, Somerset, c. 1750

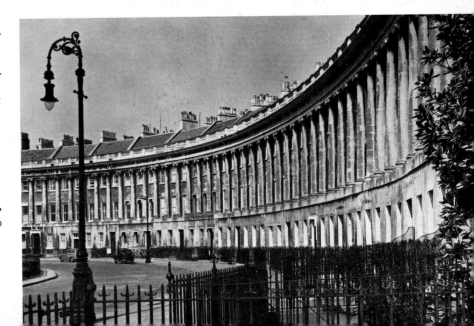

The square A vast open-air theatre, the central square is the focus of interest in any city. It takes many forms. Some follow the configuration of an ancient site (such as the Piazza Navona in Rome, which has inherited the form of a Roman hippo-drome). Others are the result of a long process of organic growth (the *plazas mayores* of Spain). Others are created in order to serve as forecourt to a palace, like the Place Stanislas in Nancy.

368 Emmanuel Héré (1705–63). Place Royale (Place Stanislas), Nancy, Lorraine, eighteenth century

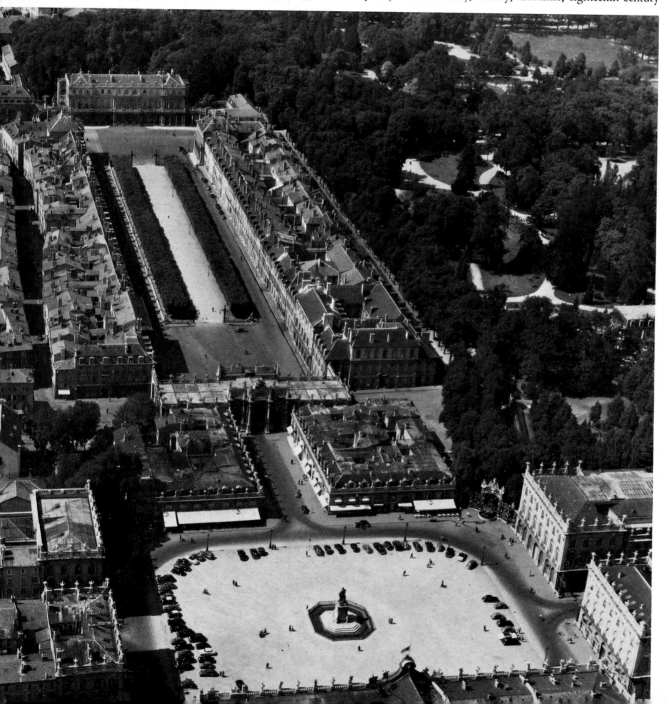

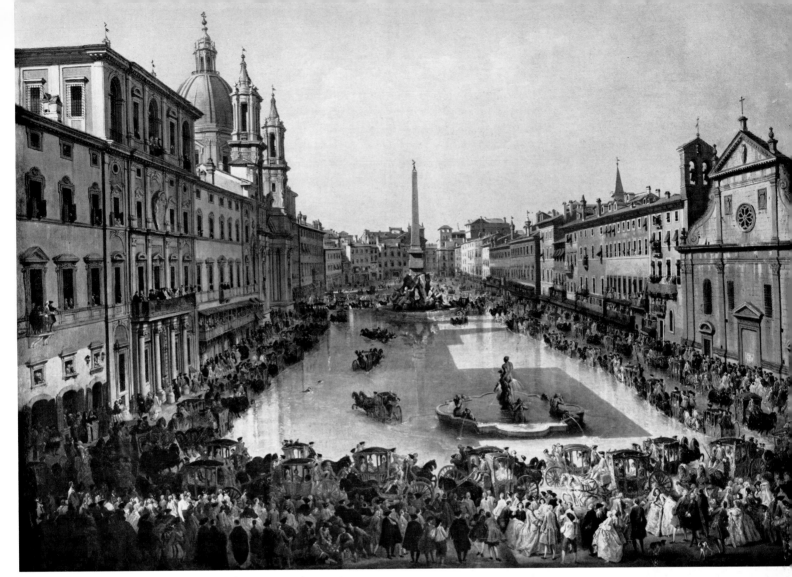

369 Giovanni Paolo Pannini (*c.* 1692–*c.* 1768). Piazza Navona flooded, Rome

370 Alberto Churriguera and Andrés García de Quiñones. Plaza Mayor, Salamanca, 1728–50

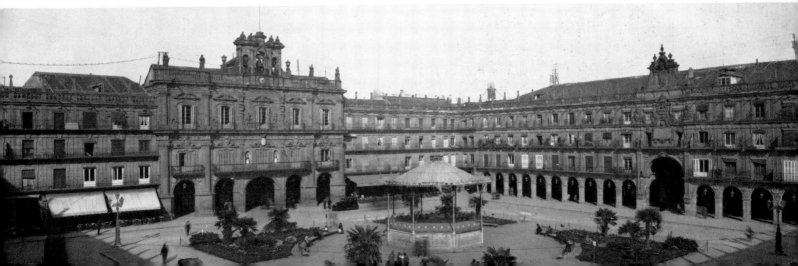

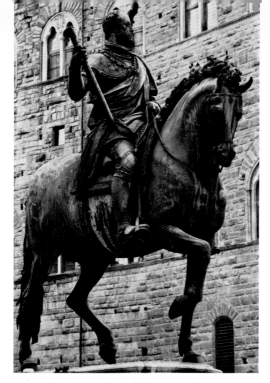

371 Giovanni Bologna (1524–1608). Cosimo I de' Medici, Piazza della Signoria, Florence, 1594

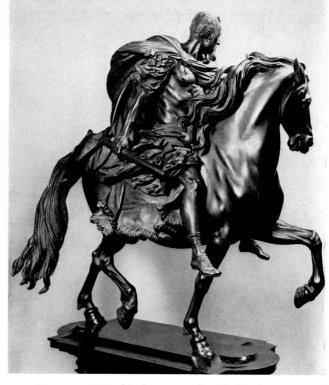

372 Francesco Mocchi (1580–1654). Model for statue of Alessandro Farnese

374 Giacomo Serpotta (1656–1732). Model for statue of Charles II of the Two Sicilies

375 Etienne Falconet (1716–91). Peter the Great, St Petersburg (Leningrad), 1766–82

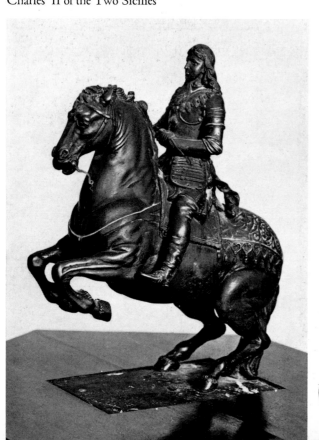

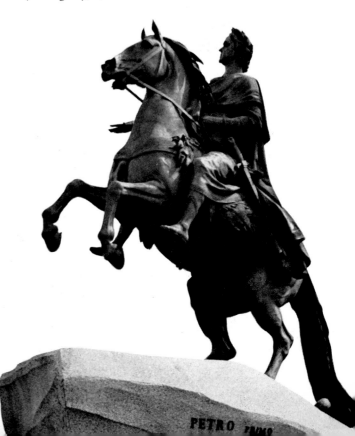

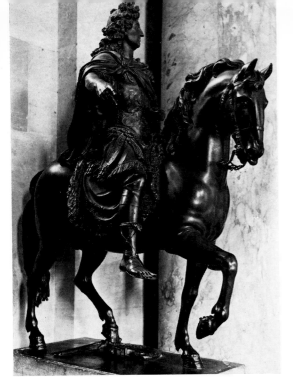

373 François Girardon (1625–1715). Model for statue
of Louis XIV

376 Matthias Steinl (1644–1727). Ivory figurine of Emperor Leopold I

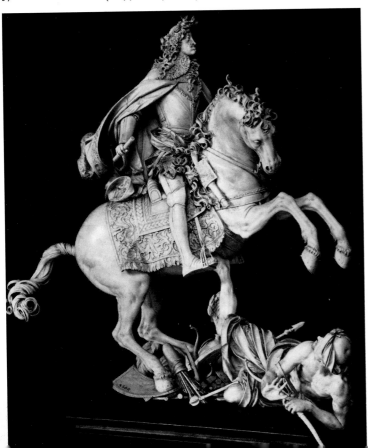

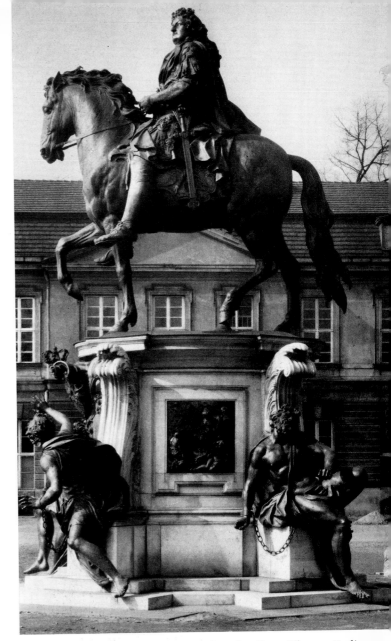

377 Andreas Schlüter (c. 1660–1714). The Great Elector, Berlin

Place royale

Of French origin, the *place royale* is an urban focal point
centred on a royal statue: it is a symbol of monarchic
centralization. With rare exceptions, the statue is an eques-
trian one, designed in accordance with one of two alternative
traditions dating back to the Italian Renaissance; the prince
on a walking horse, reflecting the serenity of a triumphal
procession, and the warrior curbing a rearing, fiery steed. The
image of Louis XIV as a Roman general in triumph, created
by Girardon, made its influence felt all over Europe.

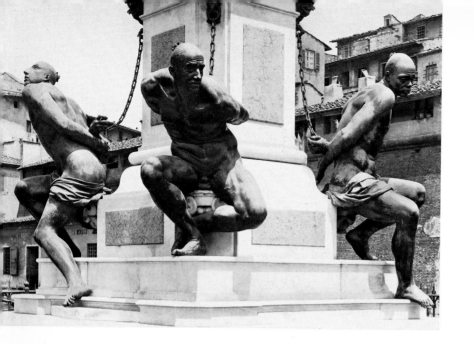

Strength subdued

The theme of strength subdued frequently served to embellish equestrian statues where it symbolized the victories of the prince concerned. The theme of the strong man in chains was invented by Michelangelo. From the late sixteenth century onwards, the victories of the Imperial forces over the Turks established a fashion for fettered Moorish or Turkish slaves in art (see *pls 247–8*) which spread to royal statues. The Michelangelesque theme of strenuous effort was much used in the baroque world in the form of the Atlantean figure.

378 Pietro Tacca (1577–1640). Moorish slaves on base of statue of Ferdinando I de' Medici by Giovanni Bandini, Livorno, 1620–23

379 Lucas von Hildebrandt (1668–1745). Oberes Belvedere, Vienna, 1714–21, with Atlantean figures

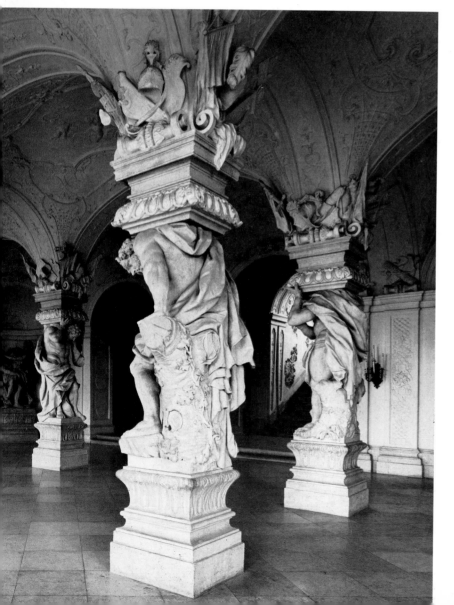

Commemorative monuments

All over Europe monuments were set up in public squares. Many were votive columns, as are these, erected in thanksgiving for the end of outbreaks of plague.

380 Guglia del Gesù, Naples, 1748

381 Dreifaltigkeitssäule, Mödling, near Vienna, 1714

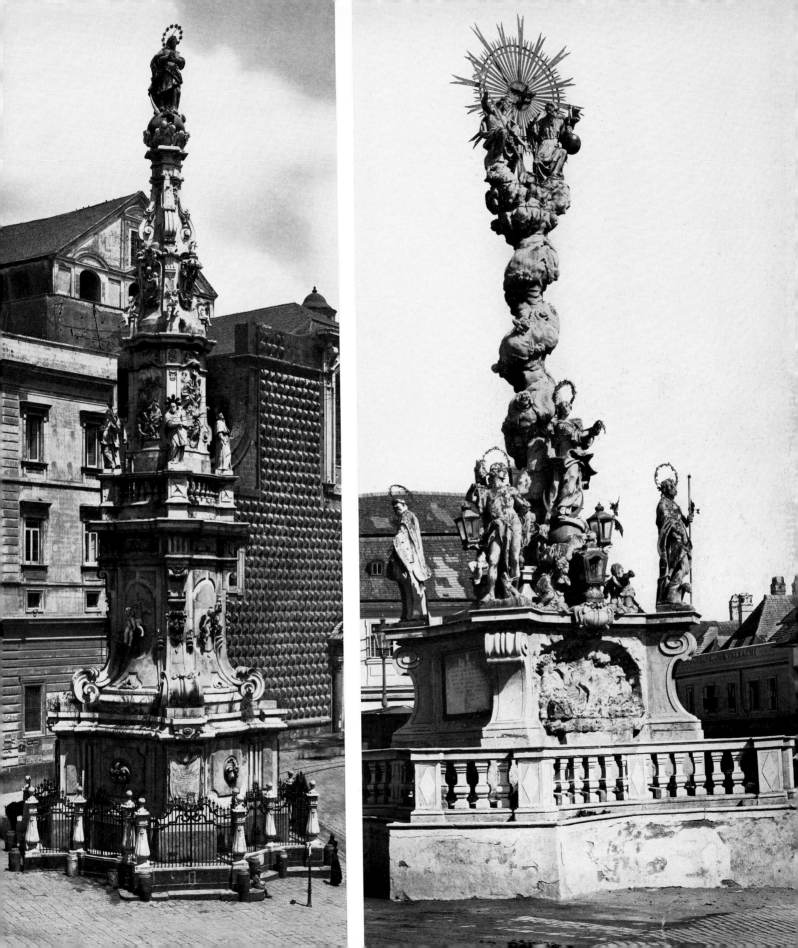

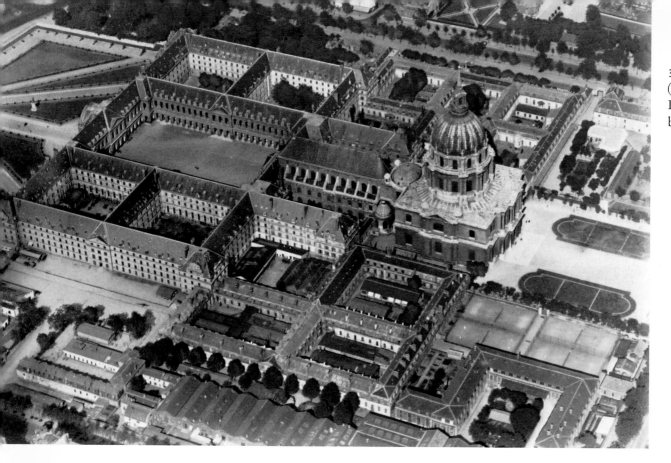

382 Libéral Bruant
(c. 1637–97). Hôtel des
Invalides, Paris,
begun 1690

383 Christopher Wren (1632–1723). Royal Hospital (Royal Naval College), Greenwich, 1694

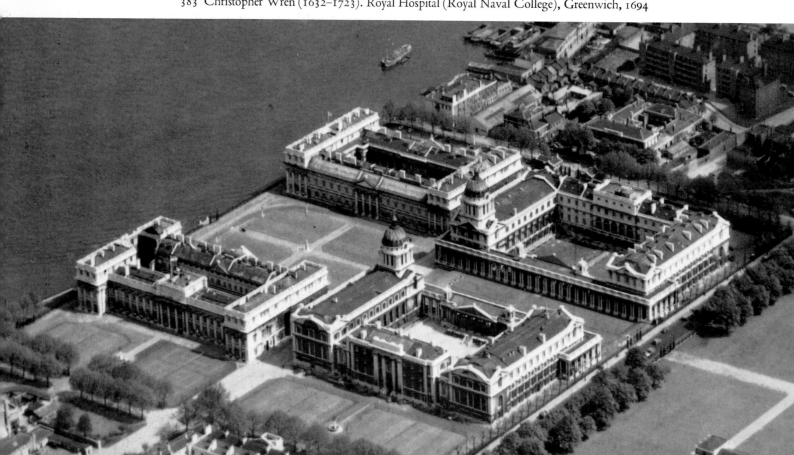

384 Olov Rudbeck (1630–1702). Anatomy theatre, Uppsala, 1662–63

385 Jan Cornelisz. van 't Woudt (c. 1570–1615). Anatomy theatre, Leyden, 1616

Public buildings

Baroque town planning incorporates functional essays in the design of such public buildings as universities and hospitals. But these utilitarian structures, as they take their place in the urban panorama, always have the external appearance of palaces.

386 Dispensary of hospital, Besançon, France, eighteenth century

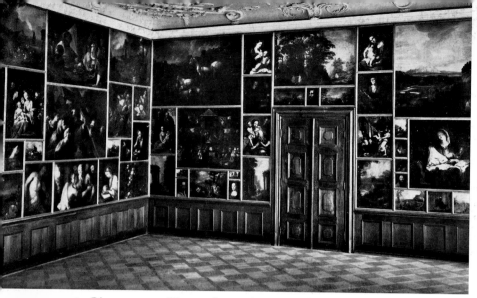

387 Picture room, Herzogenburg, Austria, eighteenth century

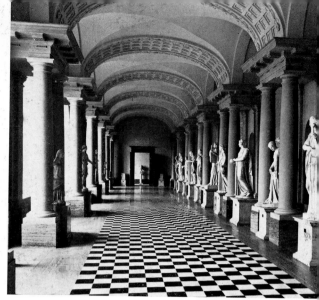

388 Gustav II's Antikmuseum, Stockholms Slott, 1792

Museums

The museum is one of the most remarkable of the creations of the baroque age. Monarchs, princes, rich citizens and monastic communities had rooms crowded with scientific specimens (see also *pl. 273*), *objets d'art,* antique sculptures and paintings.

389 Glass collection, Rosenborg, Copenhagen, 1714

390 Cabinet Lafaille, La Rochelle, eighteenth century

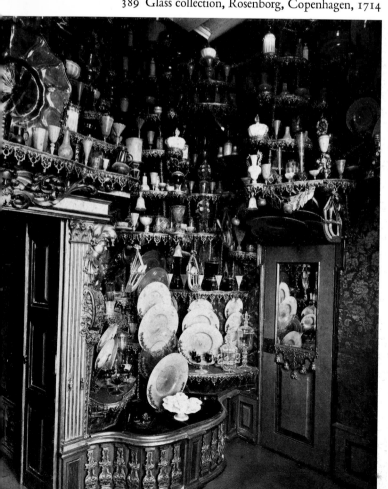

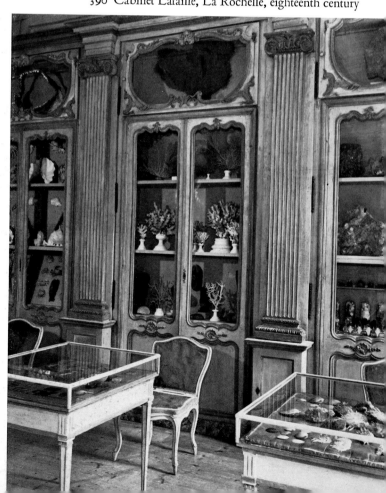

391 Frieze, Bodleian Library, Oxford, *c.*1630

Libraries Whether in a palace, a monastery or a university, the baroque library is a particularly sumptuous institution. The oldest examples are decorated with portraits of great men. In eighteenth-century Central Europe they became temples of learning, laden with allegory and symbol (see also *pl. 25*).

392 Bartholomäus Altomonte (1702–79). Library, Ardmont, Austria, 1776

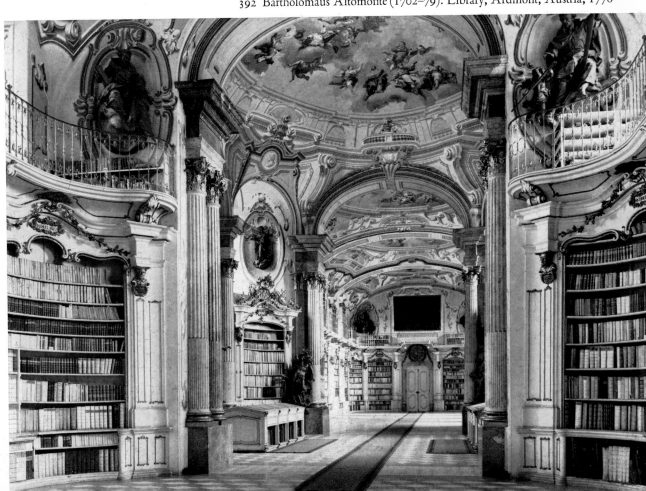

393 Sebastien Le Prestre,
Marquis de Vauban (1633–1707).
Fort Carré, Antibes

394 Louis de Foix (b. 1535).
Chapel of lighthouse, Cordouan,
France, begun 1585

Utilitarian buildings

Public works in the baroque age were treated as works of art. Sometimes, as in Vauban's fortifications, beauty springs from the logic of form perfectly suited to function. But even in purely utilitarian buildings such as lighthouses, the engineer could rise to the occasion and make himself an architect.

BAZIN, Germain. 'La notion de "l'intérieur" dans l'art hollandais', *Gazette des Beaux-Arts*, Paris January 1952; *L'Aleijadinho et la sculpture baroque au Brésil*, Paris 1963; *Baroque and Rococo*, London 1963.

BLONDEL, Jacques-François. *Architecture française, ou recueil des plans, élévations, coupes et profils des églises, maisons royales, palais ... de France*, Paris 1752-6.

BOFFRAND, Germain. *De architectura liber... (Livre d'architecture ...)*, Paris 1745.

BROSSES, Charles de. *L'Italie il y a cent ans, ou Lettres écrites d'Italie ... en 1739 et 1740 ...*, Paris 1836.

CORTE, Marcel de. *L'Homme contre lui-même*, Paris 1962.

CROCE, Benedetto. *Storia dell'età barocca in Italia*, Bari 1929; *La Letteratura italiana del settecento*, Bari 1949.

DE DOMINICI, Bernardo. *Vite de' pittori, scultori ed architetti napoletani*, Naples 1742-3.

DOUBROVSKY. 'Cinna et la dialectique du monarque', *Table ronde*, Paris September 1961.

EVELYN, John. *Sylva ...*, London 1664.

FÉLIBIEN, André. *Entretiens sur les vies et les ouvrages des plus excellens Peintres anciens et modernes*, Paris 1685-8.

FÉLIBIEN, Jean-François. *Les Plans et les descriptions de deux des plus belles maisons de campagne de Pline le consul; avec une dissertation touchant l'architecture antique et l'architecture gothique ...*, Paris 1699.

FORSSMAN, Erik. *Dorisch, jonisch, korinthisch. Studien über den Gebrauch der Säulenordnungen in der Architektur des 16.-18. Jahrhunderts*, Stockholm 1961.

FRANÇOIS, Réné (i. e. Etienne Binet). *Essay des merveilles de nature, et des plus nobles artifices*, Rouen 1622.

GIRARDIN, René-Louis de. *De la composition des paysages, ou des moyens d'embellir la nature autour des habitations*, Paris and Geneva 1777; tr., *An Essay on Landscape*, London 1783.

GRACIÁN, Baltasar. *Oráculo manual y arte de prudencia*, 2nd ed. Madrid 1653; tr., *The Courtier's Oracle*, London 1694, *The Oracle*, London 1953.

GUIDO, Angel. *Redescubrimento de América en el arte*, Rosario 1941 and Buenos Aires 1944.

GURLITT, Cornelius. *Geschichte des Barockstiles*, Stuttgart 1887-9.

KIMBALL, Sidney Fiske. *The Creation of the Rococo*, Philadelphia 1943.

KUBLER, George, and Martin Soria. *Art and Architecture in Spain and Portugal and their American dominions, 1500-1800*, Harmondsworth 1959.

LAPRADE, Albert. *François d'Orbay, Architecte de Louis XIV (Les Grands Architectes)*, Paris 1960.

LEONI, Giacomo. *The Architecture of A. Palladio*, London 1715-16; *The A. of L. B. Alberti*, London 1726.

LARSEN, Erik. *Frans Post, interprète du Bresil ...*, Amsterdam and Rio de Janeiro 1962.

LE BRUN, Charles. *Conférence... sur l'expression générale et particuliere ...*, Amsterdam and Paris 1698; tr., *The Conference... upon Expression*, London 1701 etc.

LÉONARD, Emile G. *Le Protestant français*, Paris 1953.

MÂLE, Emile. *L'Art religieux du XIIIe siècle en France ...*, Paris 1898 etc.; tr., *Religious Art in France, XIII. Century*, London and New York 1913 and 1961.

MALVASIA, Carlo Cesare. *Felsina Pittrice. Vite de Pittori Bolognesi ...*, Bologna 1678.

MORGAN, Sydney. *The Life and Times of Salvator Rosa ...*, London 1824.

ORS ROVIRA, Eugenio d'. *Lo Barocco*, Madrid 1944.

OZZOLA, Leandro. *Vita e opere di Salvator Rosa, pittore, poeta, incisore (Zur Kunstgeschichte des Auslands)*, 1900-8.

PANOFSKY, Erwin. *Galileo as a Critic of the Arts*, The Hague 1954.

PICARD, Jean. *Degré du Méridien entre Paris et Amiens déterminé par la mesure de M. Picard, et par ... les observations de Mrs. de Maupertuis etc. ...*, Paris 1740.

RÉAU, Louis. *L'Europe française au siècle des lumières (L'évolution de l'humanité, 70)*, Paris 1938.

ROSE, Hans. *Spätbarock, Studien zur Geschichte des Profanbaues in den Jahren 1660-1760*, Munich 1922.

ROUSSET, Jean. *Atti del quinto congresso internazionale di lingue e letterature moderne*, Florence 1951; *La Littérature de l'âge baroque en France*, Paris 1953; *Don Juan et le baroque*, Paris 1956.

SANDRART, Joachim. *L'Academia todesca della Architectura, Scultura e Pittura: oder Teutsche Akademie der edlen Bau-, Bild- und Mahlerey-Künste*, Nuremberg 1675-9.

SANTOS, Reynaldo dos. *L'Art portugais*, Paris 1938.

SIEBER, Friedrich. *Volk und volkstümliche Motivik im Festwerk des Barocks*, Berlin 1960.

STRZYGOWSKI, Josef. *Aufgang des Nordens*, Leipzig 1936.

TAPIÉ, Victor-L. *Baroque et classicisme*, Paris 1957.

'Triumpho eucharistico exemplar de christandade luzitana em publica exaltação da Fe na solemne trasladação de divinitissimo sacramento ... aos 24 Maio 1733 (Lisbõa occidental 1734)', in *Rivista do Archivo Publico Mineiro* VI, Ouro Preto 1901, pp. 996 sq.

VARAGNAC, André. *Civilisation traditionnelle et genres de vie*, Paris 1948.

WILHELMINA OF BAYREUTH. *Mémoires de Frédérique Sophie Wilhelmine de Prusse, Margrave de Bareith*, Paris 1811; tr., *Memoirs ...*, London 1812, 1887.

WINCKELMANN, Johann Joachim. *Gedancken über die Nachahmung der griechischen Wercke in der Mahlerey und Bildhauer-Kunst*, Friedrichstadt 1755.

357

MONOCHROME PLATES

TEXT FIGURES

Index